FLAWN
WILLIAMS

*the acoustic musician's
guide to* **SOUND
REINFORCEMENT
& LIVE
RECORDING**

0134335090

W0013918

the acoustic musician's guide to SOUND REINFORCEMENT & LIVE RECORDING

BY MIKE SOKOL

Illustrations by Mike Sokol
Executive Editors: Diane and Walter Rapaport

A Jerome Headlands Press Book

Prentice Hall

Library of Congress Cataloging-in-Publication Data

Sokol, Mike, 1954–
 The acoustic musician's guide to sound reinforcement & live recording / by Mike Sokol ; illustrations by Mike Sokol.
 p. cm.
 "A Jerome Headlands Press book."
 Includes index.
 ISBN 0-13-433509-0 (paperback)
 1. Sound—Recording and reproducing. 2. Theaters—Electronic sound control. I. Title.
TK7881.4.S65 1998
621.389'3'02478—dc21
 97-5075
 CIP

Prentice-Hall, Inc.
Simon & Schuster/A Viacom Company
Upper Saddle River, NJ 07458

Copyright © 1998 by Mike Sokol

All Rights Reserved. No part of this book may be reproduced, in any form or by any means, without permission in writing from the publisher.

Produced by:
Jerome Headlands Press, Inc.
Jerome, AZ 86331

Executive Editors: Diane and Walter Rapaport
Editor: George Glassman
Design: Sullivan Scully Design Group
Cover photography: Peter Williams Photography
Illustrations: Mike Sokol
Index: James Minkin

Special thanks to production manager P.J. Nidecker (Sullivan Scully Design Group), Noel Fray (Ravenworks), Kate Thompson, and Sue Tillman (Jerome Headlands Press, Inc.).

Manufactured in the United States of America

10 9 8 7 6 5 4 3 2 1

ISBN 0-13-433509-0

Prentice-Hall International (UK) Limited, *London*
Prentice-Hall of Australia Pty. Limited, *Sydney*
Prentice-Hall Canada Inc., *Toronto*
Prentice-Hall Hispanoamericana, S.A., *Mexico*
Prentice-Hall of India Private Limited, *New Delhi*
Prentice-Hall of Japan, Inc., *Tokyo*
Simon & Schuster Asia Pte. Ltd., *Singapore*
Editora Prentice-Hall do Brasil, Ltda., *Rio de Janeiro*

Portions of chapter 12 of the present work appeared in a slightly different version in *How to Make and Sell Your Own Recording,* Copyright 1992 by Diane Sward Rapaport, reprinted with permission from the publisher, Prentice-Hall, Inc.

To my wife, Linda, and my children Alan, Kevin, and Mark, for supporting me through the process of sonic experimentation and learning plus the sometimes tedious chore of writing and editing. Much of the practical engineering in this book was developed during gigs and after midnight, and as any spouse of a musician or sound engineer will attest, there should be a special medal awarded to those who stand by their partners when they have got the "muse."

Contents

Preface .. xvii

Acknowledgments .. xix

Introduction ... xxi

Chapter 1: Sound System Basics .. 1
 Sonic Purity and Artistic Validity 1
 The Unsound System .. 2
 Design Parameters ... 2
 Evaluating Your Current Sound System 2
 Practice with Your Sound System 3
 The Role of the Sound Engineer 3
 A Basic Vocabulary of Sound Reinforcement 3
 Dynamic Range ... 3
 Dynamics .. 3
 Frequency ... 3
 Frequency Range ... 3
 Subsonic Frequencies .. 4
 Ultrasonic Frequencies .. 4
 Timbre .. 4
 Spectral Signature .. 4
 Transient ... 6
 Loudness .. 6
 Decibel (dB) .. 6
 Decibel Sound Pressure Level (dB SPL) 6
 dBm ... 6
 dBv ... 6
 dBu ... 6
 dB VU ... 6
 dBV ... 6
 Volume Unit (VU) .. 6
 VU Meter .. 6
 Gain .. 7
 Electricity ... 7
 Current (Amperage) .. 7
 Voltage ... 7

Watt .. 7
Resistance .. 7
Ground Loops .. 8
Electrical Interference ... 8
Impedance .. 8
Source Impedance (Output Impedance) .. 8
Buffer .. 9
Unbalanced Signals .. 9
Balanced Signals ... 9
Matching Signal Levels ... 9
Pad ... 10
Attenuators (Pots, Faders and Volume Controls) .. 10
In-Line Pads ... 10
Transformers .. 10
In-Line Microphone Transformer .. 10

Connectors and Cables ... 10
XLR Connector .. 11
Quarter-Inch Phone Plugs in Mono or Stereo ... 11
RCA Plugs ... 11
Musical Instrument Digital Interface (MIDI) Connector 11
Reverse Polarity Cable ... 12
Insert Cables ... 12
Shielded Cable .. 12
Unshielded Cable ... 12
Audio Snake ... 13
Microphone Splitter .. 13

The Audio Chain ... 13

Chapter 2: Microphones ... 15
Microphone Types ... 15
Dynamic Microphone .. 16
Condenser Microphone ... 17
Electret Condenser Microphone .. 18
Pressure Zone Microphone ... 19
Ribbon Microphone ... 19
Wireless Microphone .. 20
Frequency ... 20
Diversity System .. 20

Directional Response Patterns ... 21
Polar Response ... 21
Omnidirectional Microphone ... 22
Unidirectional (Cardioid) Microphone .. 22
Supercardioid Microphone ... 23

 Hypercardioid Microphone..24
 Bidirectional Microphones ..24
 Lavaliere and Shotgun Microphones ..24
 Technical Characteristics..**25**
 Sensitivity..25
 Frequency Response ..25
 Distortion ..26
 Dynamic Range...26
 Transients ...26
 Transients and Slew Rate ..26
 Sound Pressure Level (SPL)...26
 Self-Noise (Output Noise) ...27
 Noise Floor ...27
 Proximity Effect ..27
 Output and Input Impedance...28
 Phantom Power..28
 Electrical Interferences ...**29**
 Microphone Features..**29**
 On-Off Switch ..29
 Humbucking Coils ..29
 Pop Filters ..29
 Shock Mounts ..30
 Buying a Microphone ...**30**
 Microphone Stands...**32**

Chapter 3: Internal Pickups, Direct Boxes and Instrument Amplifiers....33
 Passive and Active Pickups..**34**
 Signal Matching ...35
 Magnetic Pickups ..35
 Piezoelectric Bridge Transducers..36
 Choosing a Pickup ..**37**
 Direct Boxes..**37**
 Active Direct Boxes ...37
 Passive Direct Boxes ...39
 Speaker Simulator Direct Boxes...40
 Instrument Amplifiers ..**40**
 Power Output ..41
 Instrument Amplifier Speakers...41
 Transistors and Tubes...43
 Transistor Amplifiers ..43
 Tube Amplifiers...44
 Field-Effect Transistor Amplifier ...45
 Hybrid Tube/Transistor Amplifier ...45

 Total Harmonic Distortion..46
 Tone Control...46
 Signal Routing...46
 Grounding..47
 Choosing an Instrument Amplifier..48
 Volume Wars ..**48**

Chapter 4: Effects, Sound Processing and Outboard Preamplifiers........51
 Limiters and Compressors..**52**
 Attack Time...53
 Release Time...54
 Threshold ..54
 Compression Ratio ..54
 Noise Gates and Expanders..**54**
 Reverb and Echo..**55**
 Flangers..**55**
 Phase Shifters...**56**
 Aural Exciters ...**56**
 Enhancers...**56**
 MIDI Controllers..**57**
 Outboard Preamplifiers ..**57**
 Outboard Equalizers...**58**
 Signal Routing..**59**
 Serial Routing: Effects Used with Instruments59
 Serial Routing: Processing Devices ..60
 Parallel Routing: Processing Devices...61

Chapter 5: Monitoring Systems ...63
 Why Performers Need Monitors..**64**
 Avoiding Volume Wars..**64**
 When Music is a Backdrop...65
 Controlling Your Own Dynamics ...**65**
 Engineered Dynamics...**66**
 Providing Musicians with the Same Mix the Audience Hears**66**
 Separate Monitor Mixes ...**66**
 Hearing the House Mix..67
 Mixing from the Stage..67
 Using Instrument Amplifiers as Monitor Speakers**67**
 In-Ear Monitor Systems ...**67**
 Instrument Amplifiers and Monitor Speakers..........................**69**
 Hearing Impairment ...**70**
 Monitor Speaker Selection ..**70**
 Side-Fills..70

Floor Wedges..71
　　　Spot Monitors (Close Field)..72
　　　A Custom Spot Monitor System ...73
　Which Monitors Do You Need? ...**74**

Chapter 6: Main Speaker Systems ...75
Speaker Components..76
　　　Drivers ..76
　　　Speaker Driver Failures ..79
　　　Cabinets..80
　　　Cabinet Dispersion Patterns...81
　　　Heat Buildup ..83
Crossovers ..84
　　　Passive Crossovers ...84
　　　Active Crossovers ...85
Technical Characteristics ..86
　　　Average Power Versus Peak Power...86
　　　Headroom...86
　　　Power Ratings ..86
　　　Impedance ..87
Single Cabinet Systems...87
Processed Speaker Systems ...88
Component Speaker Systems...88
　　　Placement of Bass Speakers...89
　　　Placement of Midrange and Tweeter Speakers ..89
One-Stack Speaker Systems ..90
Wide Dispersion Satellite Speaker System..90
　　　Delay Stacks ...91
　　　Cabinet Selection ...92
　　　Hookups ...92

Chapter 7: Sound Reinforcement Amplifiers95
Using Compressors and Limiters ...97
Spectral Balance..97
Size and Number of Amplifiers...98
　　　Amplifier and Speaker Hookups...99
Power Loading...100
　　　Transistor Amplifiers ..100
　　　Tube Amplifiers...100
Routing ...101
　　　Bridge Mode ...102
　　　Amplifier Speaker Connections ...103
Amplifier Controls..103

Inputs ..103
 Stereo or Bridge Mode ..104
 Attenuators ..104
 Turn On Protection ..104
Limiters ..**104**
Fans ...**104**
 Methods for Reducing Fan Noise ..105
Technical Characteristics ...**105**
 Power Ratings ..105
 Reactive Load ...105
 Total Harmonic Distortion ...106
 Transient Intermodulation Distortion ...107
 Intermodulation Distortion ..107
 Crossover Notch Distortion ...107
Choosing an Amplifier ...**107**
Shipping ..**108**

Chapter 8: Mixing Boards ..109
Sound Quality ...**110**
Multiple Boards ..**110**
Maintenance ..**111**
Routing Signals ...**111**
Built-In Preamplifiers ...**111**
Built-In Amplifiers ..**111**
Signal Conversion ..**112**
Transformers ..**113**
Mixing Board Features and Controls ..**114**
 Input Channels ..114
 Volume Control ...114
 Equalizers ..116
 Buses and Auxiliary Sends ...117
 Pan Pots ..118
 VU Meters and LEDs ..118
 Microphone/Line Switch ..119
 Pad and Trim ...119
 Mute Switch ...119
 Low-Cut Filter ...120
 Polarity Reversal Switch ...120
 Auxiliary (B-Mix) Inputs ..120
 Phantom Power ...121
 Submaster ...122
 Microphone Level In ...123
 Line In ...123

Tape In ... 123
Direct Out .. 123
Channel Inserts .. 123
Submaster Channel Insert .. 123
Main Mix Fader .. 124
Auxiliary Return ... 124
Auxiliary Send Masters .. 124
Monitor Level Control .. 124
Bus Assign Switches ... 124
Monitoring ... **124**
Headphones .. 125
In-Ear Monitors ... 125

Chapter 9: Microphones and Pickups: Placement and Usage 127
What You Hear ... **127**
Choosing Microphones .. **128**
Microphones and Room Dynamics ... **129**
Outdoor Effects ... 129
Learning Microphone Techniques ... **129**
Microphone Selection Chart .. **130**
Microphone Positioning ... 132
Voice Training with a Microphone ... 132
Feedback ... **132**
Miking Vocalists ... **133**
Miking Wooden Bodied Stringed Instruments ... **134**
Using Only Microphones ... 135
Solo Guitars .. 136
Magnetic Pickups .. 136
Microphone and Bridge Pickup Combinations .. 137
Nylon-Stringed Guitars .. 138
Violins, Cellos and Other Bowed Instruments .. 138
Stand-Up Bass .. 138
Resonator Guitars .. **140**
Banjos .. **140**
Microphone Only ... 140
Pickups ... 141
Reeds, Brass and Woodwinds ... **141**
Clarinets and Saxophones .. 142
Flutes, Recorders, Andean Flutes and Pipes, Wooden Pan Pipes 143
Percussion Instruments ... **144**
Trap Sets .. 144
Talking Drums and Djambos .. 145
Steel Drums .. 146

 Scrapers and Gaelic Drums ..146
 Congas ..146
 Shakers ..146
 Tambourines ..146
 Accordions ..**146**
 Bagpipes and Uilleann Pipes ..**147**
 Harmonicas ..**147**
 Harps (String) ..**148**
 Hammer Dulcimers ..**149**
 Vibraphones and Xylophones ..**149**
 Pianos ..**149**
 Grand and Baby Grand Pianos ..149
 Upright Pianos ..150
 Microphone Maintenance ..**150**

Chapter 10: Preparing for the Show ..151
 Touring with Your Own Sound System ..**151**
 Room Dynamics ..**152**
 House Systems ..**152**
 Stage Plot ..**154**
 Sound Reinforcement Contracts ..**155**
 Load-In and Sound Check Times ..155
 Sample Sound Reinforcement Contract ..**156**
 Mixing Board ..158
 Microphones and Direct Boxes ..158
 Monitors ..158
 Power Outlets ..159
 Sound System Setup ..**159**
 Band Setup ..**159**
 Instrument Amplifiers ..160
 Power Soaks ..160
 AC and Phantom Power ..160
 Direct Boxes ..160
 Instrument Stands ..160
 Fix Bad Cables ..160
 Pack a Soldering Tool and Solder ..161
 Sound Checks ..**161**
 Quick Sound Checks ..163
 Sound Engineer Setup Basics ..**163**
 Normalize the Mixing Board ..163
 Label Everything ..163
 Adjust Gain ..164
 Equalization ..164

Effects and Other Sound Processing Equipment ... 165
Setting the Main Mix .. 165
Matching Amplifier, Speaker and Mixing Board Output Power 165
Setting Up the Monitors and Monitor Mix .. 166
Monitor Mixing from the Stage ... 167
Monitor Mixing from a Remote Location ... 167
Microphones and Monitor Levels ... 168

Mixing ... **169**
Mono, Stereo, and Beyond ... 169

Special Problems ... **169**
Fires .. 169
Electrical Shock .. 169
Buzzes and Hums ... 170
Bad Cables ... 171
Feedback or Rattles .. 171
Difficult Room Acoustics .. 171

Chapter 11: Recording Performances ... 173
Choosing the Venue .. **173**
Tape Recorders .. **174**
Analog: Reel-to-Reel .. 174
Analog Cassette ... 175
Analog-to-Digital Conversions ... 177
Digital Audio Technology (DAT) ... 177

Microphones .. **178**
Follow the Rule of Thirds ... 179

Method of Recording .. **179**
Use a Separate Bus on the Mixing Board .. 179
Remote Mixing Board .. 180
Acoustic Stereo Microphones to 2-Track ... 181
Multiple Microphones/Direct to 2-Track ... 182
Multitrack Recording ... 182
Multitrack Monitoring .. 183

Ensuring a Good Live Recording ... **184**
Pick Your Songs in Advance .. 184
Do the Simple Stuff First .. 184
Know the Words to the Songs ... 184
Put Fresh Strings on Your Instruments, New Reeds
 in Your Wind Instruments, and New Heads on the Drums 184
Check Your Tuning Before Each Song if Possible 184
Fix Your Instruments Before the Gig ... 184
Trim the Arrangements .. 184
Listen to the Mix in a Different Location ... 184

 Practice with Headphones...185
 Do Not Play Too Loud ...185
 Tracking Sheets ...186
 Tape Care ..186
 Location Recording Services..187
 Sample Tracking Sheet ..188

Chapter 12: Mastering and Manufacturing Cassettes and CDs..............189
by Diane Sward Rapaport

 Preediting..190
 Sequencing and Editing ...190
 Cassette Masters..191
 Master Tape Preparation: Analog ...191
 CD Premastering ...192
 CD Master Preparation ...192
 Safety Masters ...193
 Editing DATs for Mastering...193
 Choosing a Manufacturer...193
 Time and Money ...194

Resources and Selected Bibliography ...195

Index ..197

About Jerome Headlands Press, Inc. ..208

Preface

There were only two types of music for me when I first started performing music in the early '70s: hard rock and everything else. Sound systems were getting bigger, my keyboard stacks got higher, and the guitars got louder. On occasion, we'd do an acoustic tune using a 12-string guitar that had an electric pickup jammed in its sound hole, which must have sounded pretty bad by today's standards but showed our versatility. We didn't know or care about other types of music, but when you're 16 years old you think you know everything. I was also something of an inventor and began designing speaker cabinets, crossovers, amplifiers, and the other equipment needed to raise our decibel levels to 110 plus. In our world, there were always more cabinets to build, more amplifiers to hook up, and bigger trucks to buy. Eventually we had over 6000 pounds of equipment that took two roadies and four musicians three hours to set up. No wonder we were always broke.

In the early '80s, after I had burned out from dragging tons of equipment to gigs, my guitar player, Karl, had a proposal. He was starting a two-piece acoustic guitar act with another performer and wanted a portable sound system that would sound good in the acoustically challenged rooms in the area. I was, by then, trained to be a design engineer and I approached this problem by setting up the following parameters:

1) The system had to be lightweight.
2) It had to fit in the back of a car.
3) It had to sound good even in clubs that had horrible room acoustics.
4) It had to be affordable.
5) It had to have engineering balance.

After some experimentation and a lot of woodworking this first sound system was deemed a success and became a test bed for a variety of experiments such as surround sound and direct to two-track field recording. Ultimately I got hooked on acoustic acts and began to define what an acoustic act's ideal sound system might be. The following chapters cover those parameters and discuss how they affect your choice of equipment and the operation of your sound system.

You are about to get an inside view of the world of the sound engineer. This is useful, especially if you will be acting as your own engineer. But, even if you always enjoy the luxury of having someone else turn the knobs, this book will help you understand what is required to get the best possible job done with as little hassle as possible.

Finally, remember this—the goal of sound reinforcement is to help musicians put on a good show for the audience, the critics that really count!

Acknowledgments

Special thanks to Karl Shrader for helping me develop my theories on "alternative" sound reinforcement techniques while playing together in a band in the early '80s back before "acoustic" was cool, and to David Fitzwater for having the confidence to let me experiment on a bunch of other acoustic musicians that sometimes did not want to try new things. Thanks for your support.

The writing and editing process would not be possible without the unwavering editing support and talent of Judi Martin (JMS Productions) and George Glassman (Glassman Enterprises), who have probably read through and faxed an entire encyclopedia's worth of writing between Maryland and Arizona. Thank heavens for fax machines and e-mail. The book cover and interior design by Sullivan Scully Design Group is wonderful!

Thank-you to Diane and Walter Rapaport for their hospitality in Jerome, Arizona, and for taking on this immense project. This has been the single largest and most rewarding writing project I have ever worked on.

Thank-you to the following musicians for the use of their photographs and other graphic materials: Mr. Doubtchild, Ralph Gordon, Phil Wiggans, and Robin and Linda Williams.

Finally, thank-you to the following companies that provided their photographs for use in the book.

AKG Acoustics, U.S., 1449 Donelson Pike, Nashville, TN 37217

Alesis Corporation, 3630 Holdrege Avenue, Los Angeles, CA 90016

AMPEG, St. Louis Music Inc., 1400 Ferguson Avenue, St. Louis, MO 63133

Aphex Systems, 11068 Randall Street, Sun Valley, CA 91352

Apogee Sound, Inc., 2180 South McDowell Boulevard, Petaluma, CA 94954

A R T, Applied Research and Technology, Inc., 215 Tremont Street, Rochester, NY 14608

Atlas/Soundolier, 1859 Intertech Drive, Fenton, MO 63026

Audio-Technica U.S., Inc., 1221 Commerce Drive, Stow, OH 44224-1760

Barcus-Berry, BBE Sound, Inc., 5381 Production Drive, Huntington Beach, CA 92649

Behringer, c/o Samson Technologies Corp., P.O. Box 9031, Syosset, NY 11791-9031

Bellari, a Division of Rolls Corporation, 5143 South Main Street, Salt Lake City, UT 84107

Beyerdynamic, 56 Central Avenue, Farmingdale, NY 11735

Boosey and Hawkes, 1925 Enterprise Court, Libertyville, IL 60048

Bose, Borman Associates, 932 South Avenue, Westfield, NJ 07090

Crown, 1718 West Mishawaka Road, Elkhart, IN 46517

dbx Professional Products, 8760 South Sandy Parkway, Sandy, UT 84070

Electro-Voice, Inc., a MARK IV Company, 600 Cecil Street, Buchanan, MI 49107

Fishman Transducers, Inc., 340-D Fordham Road, Wilmington, MA 01887

Garwood Communications, Inc., P.O. Box 1505, Newtown, PA 18940

K & K Sound Systems, 1260 Anderson Avenue, Coos Bay, OR 97420

L.R. Baggs, 483 North Frontage Road, Nipomo, CA 93444

Mackie Designs Inc., 16220 Wood-Red Road N.E., Woodinville, WA 98072

The Martin Guitar Company, C.F. Martin & Co., Inc., P.O. Box 329, Nazareth, PA 18064-0329

Meyer Sound Laboratories, Inc., 2832 San Pablo Avenue, Berkeley, CA 94702

Neumann/USA, 6 Vista Drive, Old Lyme, CT 06371

Peavey Electronics Corporation, 711 A Street, Meridian, MS 39301

Rane Corporation, 10802 47th Avenue West, Mukilteo, WA 98275-5098

Rice Audio, 3724 Amsterdam Terrace, Burtonsville, MD 20866

Sabine, Inc., 13301 Highway 441, Alachua, FL 32615-8544

Sennheiser Electronic Corporation, 6 Vista Drive, Old Lyme, CT 06371

Shure Brothers Inc., 222 Hartrey Avenue, Evanston, IL 60202-3696

TASCAM, TEAC America, Inc., 7733 Telegraph Road, Montebello, CA 90640

Taylor Guitars, 1940 Gillespie Way, El Cajon, CA 92020

YAMAHA, Yamaha Corporation of America, P.O. Box 6600, Buena Park, CA 90622-6600

—Mike Sokol

Introduction

The purest acoustic act is one in which musicians use voices and instruments to create sounds without any amplifiers or speakers. If you mix in some electric instruments or add some processing power, and that sound is integrated with other nonprocessed acoustic instruments, the act could still qualify as acoustic as long as the audience interprets it as such.

The performance opportunities for acoustic artists have not been better since the musical takeover of rock 'n' roll. Before the development of large high-fidelity sound systems, acoustic acts had to limit the size of their audiences because of the relatively low acoustic output of the performers' instruments. Only under perfect acoustic conditions could you reach audiences of over a few hundred people. Amplifiers and loudspeakers changed all that, with tens of thousands of listeners becoming the normal size for large concerts. And much research was done in acoustic pickup design to allow pianos and acoustic guitars to co-exist on loud "electric" stages. This exposure of the listening masses to pop icons performing acoustically has had the positive effect of causing many casual listeners to search for the origins of modern popular music.

There has never been a better time to get out and play acoustic music. The new sound systems are great, audiences are receptive to your message, and sound engineers are beginning to understand what a bagpipe is really supposed to sound like. This can all make for a great show, with all of us learning from each other. As an engineer I always get a real adrenaline rush when an acoustic artist brings out an instrument I have never heard or miked before. This is what audio engineering is really about, trying to get the sound and personality of the human/instrument symbiosis out to the audience. And when it all comes together, the hours of work put in by the musicians and the engineer are all forgotten during that tiny moment when the musical experience envelops the audience. There are few things more moving than the sound of a virtuoso musician playing a beautiful song on a well-crafted instrument through a great sound system. I have seen it bring whole audiences to tears with the beauty of the shared experience. Being a musician myself, I know that it is one of the most special feelings in the world.

Unplugging Your Band

Changing from an electric act to an acoustic act can be a pretty strange experience. Acoustic instruments react with sound systems very differently from their electric counterparts. You might think you could just stick a contact pickup in the guitar, place a microphone in front of the performer, crank up the monitors, and let it rip. And unfortunately, that is the treatment a lot of acoustic musicians get from sound reinforcement companies that are used to doing rock acts, and it does not work very well. Since you no longer start with loud levels from the instruments, the needed gains and equalizations are different and feedback and monitoring problems result. The formerly electric musicians may complain their guitars do not sound right in the monitors or the house mix. The singers may not be able to hear their own

voices, which makes harmonies and proper timing next to impossible, and the sound engineer will go crazy while the whole system teeters on the edge of feedback.

Sound systems for acoustic acts are smaller and deliver a cleaner, less processed sound to the audience. At first, musicians that are used to playing in electric bands will find that performing with lower volume in their monitors is strange. If those monitors do not have to overcome the level of a 100-watt guitar amplifier and a double kick drum set, there is a noticeable drop in stage volume that takes getting accustomed to. For this reason, rehearsal at realistic acoustic monitoring levels is mandatory. It may take hours of practice before the habit of needing loud monitors is unlearned and you can work at the lower levels required by acoustic instruments. This is a special challenge to musicians whose hearing is damaged from years of performing at loud levels, as is learning to play without tall stacks of speakers and monster mixing boards. For damaged hearing, a lot of practice at low volumes is needed and in-ear monitors may be the only way to hear a true mix.

You may find that you have to re-arrange your songs for the bare soundstage of an acoustic set. Songs that were written for a large band must be distilled to their essence. You need good tunes, good words, and tight arrangements to pull off a successful acoustic set. You will not be able to hide behind walls of effects, big cabinets, and pyrotechnics. Playing unplugged means relying less on the monitors and more on the musicians who are performing with you onstage. You must really listen to the whole performance rather than just your own instrument. And, yes, you will have to know all the chords and the words, since the audience will have the opportunity to hear it all.

Attention has to be paid to the placement of the musicians onstage. Placing soft instruments next to loud ones, for example a mandolin next to a drum set, introduces unneeded difficulties for the musicians and the sound engineer. In that situation, at venues that seat fewer than 1000, it is impossible to adjust the sound in the monitors and house at reasonable volumes. The drum set will control the minimum sound from the stage and the mandolin must be made loud enough to overcome this level. The smaller the room, the worse the effect.

Playing unplugged means that your drummer should play at softer volumes with light sticks, reed bundles, brushes or even handheld percussion instruments. Once drummers break out of the kick/snare/high-hat style of drumming, they can find hundreds of percussion instruments from around the world that are really fun and interesting to play and hear.

If you are performing an acoustic set of your original rock tunes, you may need to redo your arrangements. You will not be able to use extended leads and effects to cover up weak writing; and you cannot plug every empty musical space with rhythm guitars and keyboards to provide a continuous wall of sound. You must simplify arrangements to showcase the beautiful tones of your acoustic instruments and refine and strengthen your vocal harmonies. Since the audience will hear every note you play and sing, straining to hit high notes will be painfully evident. By acquiring the confidence and ability to play individual chords and notes so that their natural decay is heard, you will allow the true sound of your instrument to be heard. Those little squeaks, gasps, and rattles of acoustic instruments are some of the reasons that digital samplers do not sound quite real. Imperfections are part of the charm and realism of an acoustic performance. Sometimes a complete rewrite of your songs is required. Eric Clapton's acoustic version of "Layla" has an entirely different groove from the electric

original. If you do a good job, acoustic versions of your music can be quite powerful.

Electric acts can get away with musical mistakes and bad tuning. Acoustic acts do not have that luxury. Feedback, drawn-out microphone checks, tuning problems, playing mistakes or forgotten words are often remembered by audiences more than the solo highlights. There you are, a musician with your instrument and nothing between you and the audience but a few good microphones. There are fewer effects to clutter the sound and there is more emphasis on the melodies, rhythms and lyrics. It is the hardest, yet most rewarding, performance you can do. Every nuance of your playing and singing will be presented for your audience's approval or disdain.

Is learning to play unplugged worth all the trouble? I think so. There is something almost magical about a good acoustic performance. You are tapping into what your minstrel ancestors did for thousands of years, and bringing that experience to larger audiences than they ever could. Rock artists like Eric Clapton, Aerosmith, and Crosby, Stills, and Nash that have switched to playing unplugged have proven what a wondrous experience this can be.

Sound System Basics

Chapter 1

At best, the sound system for an acoustic act becomes an extension of the musicians' instruments. If the system sounds great, they have a better chance to play great. If it sounds bad the performance is compromised. An act is at a disadvantage when it performs with a sound system that is less than ideal. Feedback, hum and distortion will disturb the performers' concentration and diminish the audience's enjoyment.

A sound system and sound engineer that reduce musicians' stress can mean the difference between a terrible or excellent performance.

Sonic Purity and Artistic Validity

There are two schools of thought regarding sound reproduction and they are equally valid. I call them the schools of "Sonic Purity" and "Artistic Validity."

Adherents to the school of sonic purity want to reproduce the actual sound of an instrument or vocal. Anything added or left out detracts from the goal of pure reproduction. They do not want a lot of sonic processing and excessive volume, just reinforcement of the natural sound. They believe that musicians should strive to provide the illusion that they are performing without any sound system. Processing and effects are best used sparingly as enhancements to the original sounds of the instruments. A guitar should sound like a guitar, a voice

like the actual voice. Sound pressure levels (SPLs) should not exceed 95 dB for the audience (the level of normal speech from about 3 feet away).

Within certain limits, most acoustic acts adhere to this purity protocol. Audiences have preconceived ideas of what standard acoustic instruments are supposed to sound like and most people will agree on the sound of a good instrument versus a bad one, no matter what the musical style.

Serious performers sometimes try dozens of instruments, searching for the one that is perfect for them. Great instruments can move performers to artistry beyond their basic talents. They do not need effects to sound beautiful. The pure sound of a fine instrument can speak in ways that are impossible to replicate electronically.

Adherents to the school of artistic validity say that anything that modifies the sound of an instrument to make it interesting and different is part of an artist's creativity. Electric guitars are the perfect example. Since they have no acoustic sound of their own, anything that works is valid and this sends many electric guitarists on a quest for interesting guitar sounds. Every element in the sound chain is scrutinized and modified in the guitar, amplifiers, effects pedals, speakers, cabinets and etc.

Since there is no original sound to compare it to, anything created with an electric instrument is musically valid.

The Unsound System

Many acoustic musicians have also performed with electric instruments and some of them use processed effects, like delay or flanging, for emphasis. Tasteful effects can enhance acoustic music, but heavy-handed use can detract from the performance.

For an acoustic act, the focus is on the musicians and their music. In fact, sound reinforcement systems are not always needed or desired. Many small restaurants and clubs hire jazz, bluegrass, classical and ethnic musicians to perform without microphones, mixers, amplifiers or speakers. The musicians listen to each other and learn to balance their own sounds. There is no reason to amplify something that is already loud enough to fill a particular room. If the venue seats less than 50 people, a sound system may be unnecessary.

Design Parameters

Every sound system design demands the balancing of engineering parameters and each project will necessitate compromises. You must know what is important to you and be able to set a budget you can live with. In this book I discuss the components that can optimize your acoustic experience. But, as you figure out your own parameters, please remember that a sound system will not do everything for everyone at all times.

It is important to allow the audience to experience what the musicians want them to hear. A properly designed sound system is very honest and will transmit every nuance of your performance.

Evaluating Your Current Sound System

Here is a quick way to evaluate your current system. Take a CD player and hook each output to an input of your mixing board. Set the channel equalization flat and play a CD of your preferred music. Better still, if you have a CD or professionally produced tape of your own act, use it. How does it sound through your sound system? Now play that same CD or tape on a good home stereo. Is the sound better than that of the sound reinforcement system? (Be honest.) If it is, then some redesign of your sound system is needed.

As you upgrade your system think about what worked for you in the past and what did not. That broken cable you threw back in your guitar case

last month will surely surface during the most important gig of your life, so fix it or get rid of it. The speaker that has a buzz will not get better by itself, and batteries will not magically recharge themselves. "Murphy's Law" is certainly in effect during performances: If anything can go wrong, it will at the worst possible time. Do not leave anything to chance.

Practice with Your Sound System

If you have your own sound system, practice with the microphones and monitor speakers you will use onstage. The stress generated by trying to get a new mixing board or amplifier working for the first time during a show can ruin a performance. Hook them up at practice and make sure they work before going onstage. Learn good microphone technique. It is critical in acoustic work, as is acclimating your ears to acoustic stage volumes.

The Role of the Sound Engineer

Sound engineers set up and operate sound systems. They are technicians that interconnect dozens of pieces of equipment and are the first to arrive at the gig and the last to leave. When the sound is great, the band gets the credit. When it sucks, the sound engineer gets blamed, even if the band showed up 15 minutes before show time with a new set of stage charts and a bad attitude.

Sound engineers can also act as arbitrators between members of the band, each of whom may have a different opinion about what is desired in the monitors and the house mix. A good engineer will calm and reassure those musicians that lack confidence.

In short, after the talent, the engineer is the single most important person to the success of the show. Music comes first, but it is the job of the sound engineer to facilitate the musician/audience interface. Musicians must be comfortable with the setup so they can ply their craft.

A Basic Vocabulary of Sound Reinforcement

Dynamic Range

In musical terms, dynamic range is the ratio of the softest sound that can be made by an instrument to the loudest sound that it can produce.

In electrical terms, dynamic range is used interchangeably with signal-to-noise ratio (S/N ratio), defined as the ratio of the largest (loudest) possible undistorted signal to the smallest signal that disappears into the noise floor.

Both are expressed in terms of decibels (dB).

Dynamics

The softest to loudest decibel levels produced by a sound source, such as a musical instrument.

Frequency

Frequency refers to the pulsations-per-second a sound is making. This used to be abbreviated CPS (cycles-per-second) but has been renamed Hertz (Hz), in honor of the German physicist Heinrich Hertz. One Hz equals one cycle-per-second. Frequencies are perceived as pitch and 440 Hz is middle A on a properly tuned piano. Higher frequencies have higher pitch; lower frequencies, which have fewer cycles-per-second, have lower pitch. Very small deviations in frequency are easily discerned by most listeners.

Frequency Range

The nominal frequency range that most people can hear is from 30 Hz to 15 kHz (15,000 Hz). Some youngsters that have not been exposed to really loud sounds can demonstrably hear above 18 kHz and people that have had a lifetime of sonic abuse may not be able to hear much above 10 kHz.

Subsonic Frequencies

Subsonic (infrasonic) frequencies are those below the range of human hearing, generally under 20 Hz. They tend to overload amplifiers and can cause speaker damage if not controlled.

Ultrasonic Frequencies

Ultrasonic frequencies are sounds that are higher than we can hear (above 20 kHz). These are problem makers when we attempt to record percussive instruments. Even though they cannot be heard, they can overload circuitry and cause sonic degradation. Some audiophiles that have "golden ears" claim they can hear harmonics in the 20 to 40 kHz range, but there is no empirical evidence to substantiate that.

Timbre

Each sound produces a unique set of harmonic overtones that contain a variety of frequencies. For that reason, when two instruments, or two voices are reproducing the same note, they sound different. The number of harmonics that are present, and their relative strength, determine the timbre (tone color) of the sound. As the sound decays (dies out), these harmonics fade, the higher frequencies more quickly than the lower.

The primary note or frequency that is produced when a single note is played is called the fundamental frequency. The other frequencies that are produced are multiples of this fundamental frequency and they are called harmonic overtones.

Instruments and voices produce at least two different types of harmonic overtones, odd-order (third, fifth, and seventh, etc.) and even-order (second, fourth, and sixth, etc.). Some, such as bells, also produce unrelated overtones. The proportions of these overtones give instruments their inherent characteristic sound or timbre. Even-order harmonics generally produce sounds that are perceived as "warm." Odd-order harmonics produce sounds that are perceived as shrill and dissonant. One reason for this may be that the natural supportive resonances caused by large surfaces and chamber resonances are generally even-order harmonics.

Luthiers work hard to build string instruments that produce tremendous amounts of even-order harmonics and bass resonances. Everything about their construction from the wood and varnish selection, string material, sound hole position and dozens of other parameters has been adjusted, tweaked, and agonized over countless times, to produce warm, beautiful timbres. Woodwind instruments, like saxophones and clarinets naturally produce more odd-order harmonics because of their internal buzzing reeds whose travel is continually interrupted by a mouthpiece and the teeth or lips of the musician.

Like musical instruments, amplifiers produce either more odd-order or even-order harmonic overtones depending on their design and construction. Musicians can choose to match their instrument's harmonic overtones to an amplifier's overtones, or mismatch them, depending on taste.

Spectral Signature

Every instrument produces a combination of fundamental frequencies and overtones. This is what makes a flute sound like a flute and a saxophone sound like a saxophone. Many instruments have a combination of fundamental tones and chamber resonances. Percussive instruments such as bells and cymbals have a fundamental tuning and lots of harmonically unrelated overtones that extend into the ultrasonic.

You can divide an instrument's spectrum into various ranges (lows, mids, and highs), which is what many mixing board equalizers do. By manipulating frequency ranges, you can change the sound.

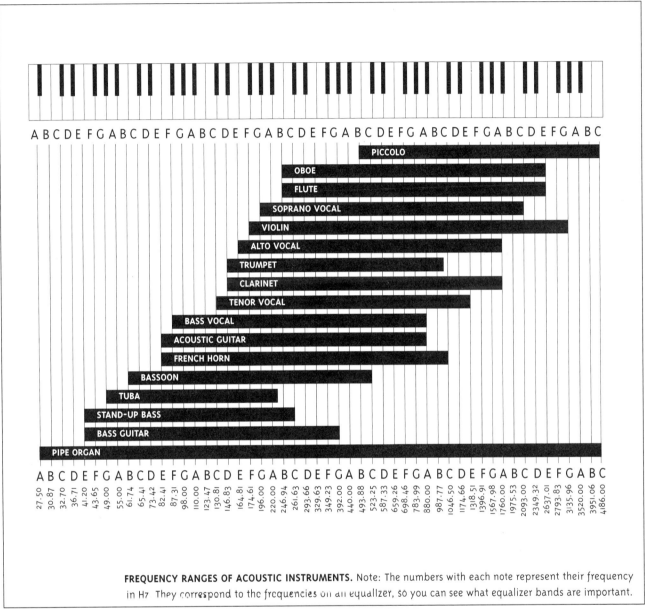

FREQUENCY RANGES OF ACOUSTIC INSTRUMENTS. Note: The numbers with each note represent their frequency in Hz. They correspond to the frequencies on an equalizer, so you can see what equalizer bands are important.

Bass is usually defined as 20 to 200 Hz. Low E on a bass guitar is 41 Hz, low C on a synthesizer is 32 Hz. This is the stuff that rattles walls and shakes your chest. Most bass controls are designed to affect frequencies in the range of 20 to 200 Hz to give control over the fundamentals and leave the midrange alone. Common descriptions of bass include warmth and bottom. Twenty to 200 Hz is the normal range of most subwoofer cabinets and into the range of most woofers (usually 60 to 1000 Hz).

Midrange is usually defined as between 200 and 4000 Hz and is where most voices and instrument fundamentals reside. This is the normal range of most woofer and midrange speakers. Simple midrange controls are usually designed to affect frequencies around 1000 Hz to cover most vocal overtones. Sophisticated midrange controls have sweepable frequencies that allow you to select the center frequency range (200 to 2000 Hz) so that you can pick exact areas to boost or cut. Normal

human speech has fundamental frequencies around 200 Hz for men and 400 Hz for women, with singing going an octave or two above the nominal speaking range. The upper midrange is where the so-called presence area exists and many microphones have a boost around 3500 Hz to make voices and instruments sound more upfront.

Highs are the frequencies above 4000 Hz and they extend to the upward limits of our hearing (usually 18,000 Hz). This is the normal range of midrange horns and tweeter speakers and where the interesting overtones reside.

Transient
A transient is a sudden, abrupt increase in signal level above an average signal level, such as when a string is plucked or a drum is struck.

Loudness
The amount of energy expended in making a sound is called the power of the sound and it is measured in watts. That energy causes air to vibrate. The greater the air pressure per square meter, the louder the sound. However, for a sound to be perceived as twice as loud, its power level must be increased ten times.

Decibel (dB)
A logarithmic unit used to express the size of change in sound intensity, voltage, current or power. A decibel must be referenced to some other value to be useful.

Decibel Sound Pressure Level (dB SPL)
The lowest sound pressure level a human can hear under perfect conditions is .0002 dynes/cm^2 or 0 dB SPL, which is the reference value against which the loudness of other sounds can be compared. Audio engineers use the term dB SPL to express the logarithmic ratio between differing sound intensities, with 0 dB SPL representing the threshold of hearing and 120 dB SPL the threshold at which sound causes pain. Unless otherwise indicated, decibel sound pressure levels are listed in the text as dB, such as a 20 dB reduction in volume.

dBm
dBm is referenced to 1 milliwatt (0 dBm equals 1 milliwatt). Zero dBm equals .775 volts across 600 ohms.

dBv
dBv is a reference voltage level used to calibrate professional audio gear and signal meters. Zero dBv equals .775 volts.

dBu
dBu is equivalent to dBv. Zero dBu equals .775 volts.

dB VU
dB VU is also equivalent to dBv. Zero dB VU equals .775 volts.

dBV
dBV is a reference voltage level for professional sound gear. Zero dBV equals 1 volt.

Volume Unit (VU)
VU is a standard unit for expressing the perceived loudness of an audio signal.

VU Meter
A VU meter reads and indicates average sound levels, which correlate to how loud a sound is perceived to be. It does not indicate momentary peaks, which can be 10 to 20 dB louder than the average signal. This is important because even though a mechanical VU meter reads "0" you may in fact be sending a signal that contains +20 dBv peaks that will cause clipping and general mayhem in recording and processing gear.

Gain

Gain is the increase in voltage or signal power that is produced by an amplifier when it transmits a signal. The amount of gain is expressed in dB above a reference level. A 0 dB gain passes the signal along with no increase or decrease in its level. An amplifier circuit that produces 10 dB of gain will raise a .1-volt signal to 1 volt and a 1-volt signal to 10 volts. The two circuits in series produce a gain of 20 dB (100 times the original voltage).

Gain is used to amplify signals so that the next circuit can process them without adding noise.

Electricity

Electricity is the motion of electrons through a conductor. This allows power to be transferred between devices such as microphones and input channels on a mixing board and from power amplifiers to speakers. Electricity can be stored directly by devices such as capacitors and indirectly by chemical processes in batteries.

Direct current (DC) is the flow of current in one direction. Batteries are sources for DC current.

Alternating current (AC) changes direction at regular intervals. Audio signals travel through wires via alternating current.

Current (Amperage)

Current is electrical flow measured in amperes (amps). It is the number of electrons moving past a point in the wire per second. Think of it as gallons-per-minute of water flow and you will have the right visual model. Materials that allow electrical flow, like silver, copper and gold, are called conductors. Materials that impede electrical flow, like glass, rubber and plastic, are called insulators. Insulators are used to cover conductors for protection against shock and for isolation from other conductors.

Voltage

Voltage is the force (pressure) that causes current to flow through a complete circuit and it is measured in volts. Think of it as water pressure in a pipe.

A volt is a unit of electrical pressure named after Alessandro Volta, who discovered and defined it. One volt of electricity will produce 1 ampere of current flow through 1 ohm of resistance. Common usages include 120-volts AC in wall outlets, 9-volts DC in standard batteries, and about 40- to 60-volts RMS AC from common power amplifiers. Once you get above 50 volts there is a shock hazard. The 120-volts AC from a wall outlet can cause heart stoppage and death, so do not be careless around electrical sources.

Watt

A unit of measure for electrical power—the energy used to drive an electrical current through a load resistance or impedance. Voltage (the force or pressure) multiplied by current flow equals watts. Power amplifiers will draw in excess of 2000 watts and convert them into heat (that enters the environment via heat sinks) and electrical energy that is sent to the speakers.

When voltage across a load, such as a speaker voice coil, is doubled the current flow is also doubled and a power increase, expressed in watts, of four times will occur.

Resistance

The restriction of the flow of electrons in a conductor is called resistance and is measured in ohms. One ohm will cause 1 ampere of current to flow with 1 volt of electrical pressure. The amount of current (amperes) flowing in a circuit is dependent on the amount of resistance that is placed in opposition to it and the voltage that is moving it through the circuit. The thickness and length of the wire and its

type of conductive material affect the rate of current flow. Thicker wires and better conductors have less resistance. Silver wire is the best, but it is expensive. Copper wire has good conductivity and flexibility. The rate, in amperage, at which current flows is directly proportional to the amount of resistance in its path so the lower the resistance, the higher the current flow.

Ground Loops

Ground loops occur when two or more audio devices are plugged into different power outlets but are connected together by a common signal wire. This creates two or more sets of electrical pathways between chassis and produces hum. Common fixes are—providing audio transformers in the signal line, lifting the chassis ground on one piece of equipment with a ground-lift switch, or providing a heavy, well-designed grounding system to all pieces of equipment.

Electrical Interference

Electrical interference is caused by two effects, inductive coupling and the pickup of radio frequencies (RF).

Inductive coupling occurs between two wires that are parallel to each other. Running microphone cables next to power cords will induce a rather loud 60-Hz hum as will running a microphone snake and AC cable next to each other. Separating the cables by a foot or two will usually solve that problem. When signal cables and AC cables meet, they should cross at a 90-degree angle.

RF pickup comes from sources such as light dimmers, nearby radio stations, CB radios and cellular telephones.

Impedance

Impedance is a measure (in ohms) of electrical resistance to current flow at a given frequency. It includes the combined effects of resistance, inductance, and capacitance. A high-impedance load exhibits greater resistance to current flow than does a low-impedance load. A lower impedance will cause greater current flow (amperes) for a given voltage.

Higher impedance devices draw less wattage from a given voltage than lower impedance devices. That is why loudspeakers that have 4-ohm impedance draw about twice as much power from an amplifier than 8-ohm impedance speakers do. Lower impedance audio signals (600 to 2,000 ohms) are less corrupted by the effects of capacitance and inductance in long cable runs.

A capacitor is formed when any two conductors are separated by an insulator. Normally this is two plates separated by wax paper, but can be two parallel wires. A capacitor passes more signal (has less resistance) at higher frequencies. This can produce a shunting effect in long wires, where the capacitance between the two conductors is enough to short out the highest frequencies of an audio signal that has a high initial source impedance.

An inductor is normally made by wrapping an iron core with copper wire and is the electrical opposite of a capacitor. Inductance results when a wire magnetically interacts with a magnetic field. This field grows and collapses with the strength of the current flow and stores energy in much the same way that a flywheel in an engine does. The lower the frequency of the signal, the lower the inductor's resistance and the more the inductor will react with the signal.

Source Impedance (Output Impedance)

The source impedance is the output impedance of a circuit rated in ohms. It determines the power transfer parameters that are required at the next input stage. The source impedance is usually rated much

lower than the input load that it will drive. For instance, most processing gear is designed to drive a 600-ohm load, even though its actual output impedance may be 50 to 100 ohms. This very low impedance acts like a shunt to help prevent other signals and complex line impedances from causing interference. Power amplifiers will have source impedances of 1 ohm or less. This allows them to drive low-impedance loads (such as 2-ohm speakers).

Impedance matching involves properly selecting the appropriate load for the output impedance of a device. It is needed only on power transfer circuits such as when a speaker is hooked up to an amplifier.

As long as the output impedance of a device is lower than the one it is driving, impedance matching is not a concern. For instance, a 600-ohm microphone can be hooked into the input of a mixing board that has an input impedance of about 2000 ohms. Problems arise when a piece of gear that has incorrect output characteristics is incorporated into the sound chain. Signal distortion and severe attenuation can occur if you try to transmit an unbalanced high-impedance signal through more than 20 feet of cable to an input stage in audio equipment that has low impedance.

Buffer

A buffer is an impedance converting circuit, located in an amplifier or preamplifier, which lowers the impedance of an output stage, thereby improving its ability to drive a more complex reactive load (that has capacitance and inductance), such as a long cable.

Unbalanced Signals

Unbalanced signals are used by most instrument amplifiers and by preamplifiers that are connected to acoustic instrument contact pickups. Unbalanced signals are carried by a two-wire cable. One of the wires acts as both the ground and the return path for the audio signal so each wire carries different levels of signal. Cables that carry unbalanced signals commonly have quarter-inch mono phone plugs or RCA plugs.

Balanced Signals

Balanced signals are produced by mixing boards, equalizers, compressor/limiters, digital reverbs, active crossovers, power amplifiers and professional microphones. A balanced signal is carried by a three-wire cable. Two wires (a twisted pair) carry the audio signal (plus and minus); the outer wire shields the signal from interference. The wires that carry the signal are of equal potential difference from the shielding wire and are balanced relative to the signal ground. Cables that carry balanced signals commonly have XLR connectors or TRS (stereo) quarter-inch phone plugs.

Matching Signal Levels

In order for different pieces of equipment to transfer signals effectively, their signal levels must be matched. Intermixing levels indiscriminately can cause distortion, excessive noise, and susceptibility to radio frequency interference (RFI).

When hooking up the various pieces of equipment, sound engineers are careful to match the output level from one piece of equipment to the input requirements of the next. Mismatches between balanced and unbalanced signals, and high- and low-level signals should be avoided.

The use of the proper cables and connectors, together with devices like direct boxes, preamplifiers and transformers help sound engineers match signal levels.

Although any unbalanced output can be connected into a balanced input without harm, some balanced outputs can be damaged if they are connected into unbalanced inputs. Check specifications to be sure.

Pad

A pad is a passive resistive circuit that is inserted in a signal path. Its job is to reduce the voltage from a loud (hot) signal to a level that the following circuit can accept without distortion. For instance, a 14 dB pad will reduce a +4 dBv signal down to -10 dBv. Pads that are rated at 30 dB are commonly used before the input channels on mixing boards to reduce the signals from microphones that are picking up loud guitar amplifiers or percussion to levels that will not overload preamplifier circuits and cause distortion (clip).

Pads are often found in the preamplifiers of condenser microphones, passive and active direct boxes, and in mixing board preamplifiers.

Attenuators (Pots, Faders and Volume Controls)

Attenuator controls on a piece of equipment allow the operator to vary the amount of attenuation from 0 dB (full on) to 90 dB or more (off). Examples are the rotary controls on the auxiliary sends of a mixing board, the linear faders on the output of each channel and the equalization controls. Essentially, every control on a mixing board that is not an on/off switch is an attenuator. Often, the first stage of an input channel has a "trim" control, an attenuator that reduces the signal level to where the rest of the circuitry can handle it without distortion.

In-Line Pads

In-line pads are external resistive pads that have XLR or RCA connectors. They reduce a signal by a fixed amount, such as 10 or 20 dB. They can be used between the output from a mixing board that is +4 dBv and a consumer tape deck that requires a -10 dBv signal. Some in-line pads are used between microphones that output loud signals and a mixing board's input channel that does not have a built-in pad.

Transformers

Transformers are impedance and signal level matching devices. They were used extensively in professional equipment before the introduction of integrated circuits (small devices that contain dozens or hundreds of transistors) and differential amplifiers, which act like balanced transformer inputs. Transformers are still the best way to provide electrical isolation to prevent ground loops.

In-Line Microphone Transformer

An in-line microphone transformer steps down a microphone's impedance and changes its unbalanced signal to a balanced one before sending it out through an XLR output.

Connectors and Cables

Connectors and cables are specifically manufactured to interface with various pieces of equipment and produce a clean signal throughout a system. Cable and wire inherently add resistance to a signal. Some transmit different frequency ranges better than others. For example, long wires that carry high-impedance signals tend to lose or roll off high frequencies more easily than those that carry low-impedance signals. This tendency increases as the cable gets longer. That is why low-impedance microphones are generally used in performances where long cables are required to reach the mixing board.

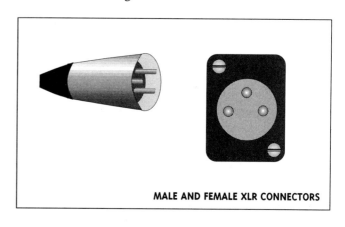

MALE AND FEMALE XLR CONNECTORS

Two of the keys to trouble-free performance of a sound system are using cables properly and ensuring that they work. Broken cables are the Achilles' heel of sound reinforcement. Devices that provide efficient methods for testing cables are available from many manufacturers and they should be a standard part of every band's gear.

XLR Connector

An XLR connector is a three-pin connector that is used for microphone and professional gear connections. According to the current United States wiring convention established by the Audio Engineering Society (AES), pin one is shield, pin two is positive (+) hot and pin three is negative (-) or signal return. In some older equipment and in some mixing boards manufactured overseas, pin one is shield, but pins two and three can be either positive or negative. So it is important to check the polarities of each piece of gear in the signal chain. A reverse polarity cable can be used to correct polarity problems. In audio, the three-pin XLR connector usually indicates the presence of balanced circuitry. Male and female ends can be sequentially connected, allowing easy extension of cables.

Quarter-Inch Phone Plugs in Mono or Stereo

Quarter-inch phone plugs are designated as either TRS (tip/ring/sleeve) for two audio channels (balanced circuits), or TS (tip/sleeve) for mono or unbalanced circuits. These connectors are used to connect balanced and unbalanced audio signals. They are also used as speaker connectors on most semipro gear. Speaker wire and signal wire should not be interchanged even though the connectors will fit.

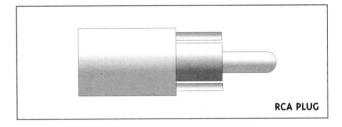
RCA PLUG

RCA Plugs

RCA plugs are small mono connectors used on consumer and semipro gear. Their general lack of ruggedness make RCA connectors a poor choice for field use. They are used on many studio mixing boards because of their cost-effectiveness and small size. RCA plugs are sometimes used as speaker connectors on home stereo equipment.

Musical Instrument Digital Interface (MIDI) Connector

A MIDI connector is a five-pin connector that is used to interconnect electronic keyboards and the control section of most modern processing gear. It allows you

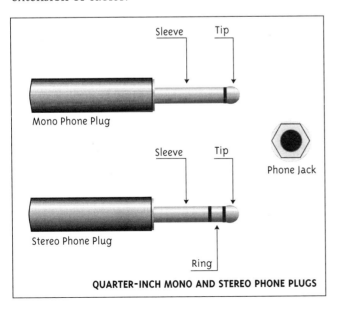
QUARTER-INCH MONO AND STEREO PHONE PLUGS

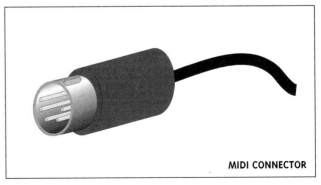
MIDI CONNECTOR

to access the internal settings of digital delays, reverbs, and other processors via a single controller. This allows hundreds of setups to be recalled as desired.

Reverse Polarity Cable

A reverse polarity cable (reverse phase cable) is a short male to female XLR cable that has pins two and three reversed in one of its connectors, which reverses the polarity of the signal.

Insert Cables

Insert cables are shaped like a "Y" and have a quarter-inch stereo plug at the base and quarter-inch mono plugs on each end. They are used to feed a signal from a microphone input channel to a processor and return it. They can also be used to split a stereo signal to two mono amplifiers. The ends should be clearly marked since incorrectly hooking up the input and output connectors to processing gear will result in no sound at all.

Shielded Cable

Shielded cable is designed to carry audio signals that would be degraded by the normal electromagnetic fields around us. A braided or foil shield

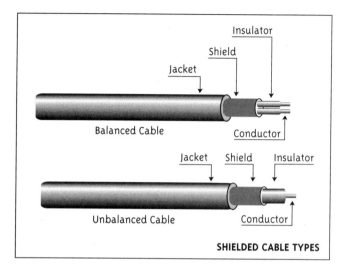

SHIELDED CABLE TYPES

encircles the conductors and protects them from hum, CB radios, and fluorescent light ballast noise. Because the currents involved are relatively small, the wires can be of small diameter (22 to 26 gauge).

Unshielded Cable

Unshielded cable is designed to carry the relatively high currents and voltages that are found in AC distribution systems and speaker hookups. Because of the high voltages and low impedances involved, these wires are not as susceptible to interference from other sources. However, they can act like little radio stations and transmit undesirable signals to other wires that are in close proximity. Do not mix

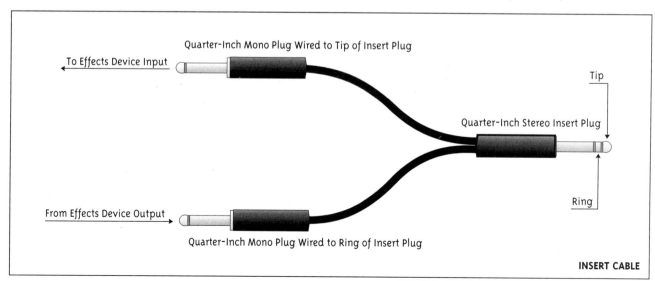

INSERT CABLE

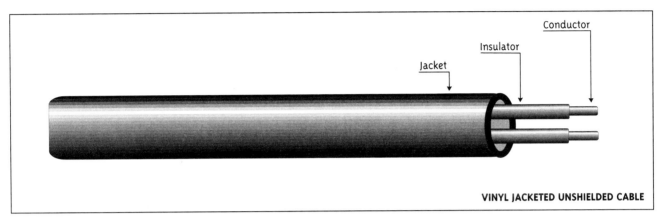

VINYL JACKETED UNSHIELDED CABLE

unshielded power cables and shielded microphone cables in the same run, or a 60-Hz hum may be introduced into the microphone lines.

Audio Snake

An audio snake is a device that enables individual signals to be carried through one long multichannel cable. The signals from microphones and direct boxes are plugged into an input module, called a stage box or "head." This module is connected to the multichannel cable that terminates in a breakout configuration called a "squid" that allows for individual connections to a mixing board, tape recorder, etc.

A digital stage box (head) will digitize microphone or line-level balanced signals and transmit them through a fiber optic cable or single coaxial cable to a digital-to-analog converter before they are sent to a mixing board, tape recorder, and etc.

Microphone Splitter

A microphone splitter takes the signal from a microphone, direct box or instrument amplifier and splits it into two circuits each of which has its own output. The circuits are routed to different pieces of equipment, such as two mixing boards or a mixing board and preamplifier that is connected to a tape recorder.

There are four types of splitters: resistive, transformer isolated, active and hard "Y" cable.

Resistive splitters use resistors to divide the signal between two different paths. There will be some signal loss with this method and it may result in ground loops.

Transformer splitters use audio transformers to split the signal. Because they are inductive devices they eliminate ground loops. They cause little signal degradation and are used for cable runs as long as 250 feet.

Active splitters use amplifiers to boost the signal as it is split, allowing for cable runs of 1000 feet without signal degradation. They can also provide multiple splits with many outputs per channel possible.

Hard "Y" cables are hardwired cables that split the signal into two connectors without providing any isolation. Often there are signal degradation and signal matching difficulties. If you use a hard "Y" cable to send phantom power it can feed back into another device, such as a second mixing board. Ground loops are almost certain and sometimes the cable will pick up radio interference.

The Audio Chain

Every sound system can be divided into four basic parts.
1) Input transducers (microphones, pickups, etc.).
2) Mixers and processing equipment (mixing boards, equalizers, etc.).

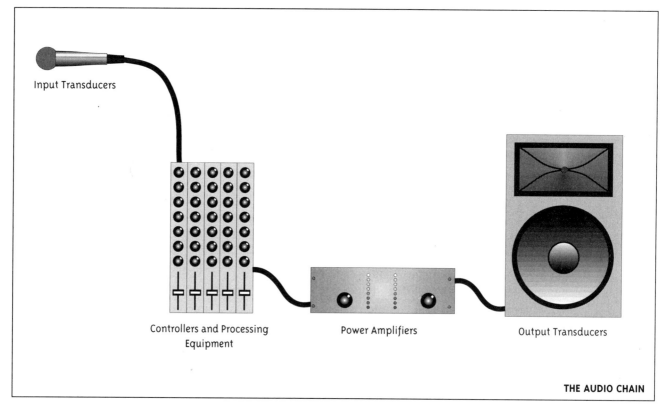

THE AUDIO CHAIN

3) Power amplifiers.

4) Output transducers (loudspeakers and their associated cabinets and crossovers).

All four parts exist in various sizes and guises, depending on what a system is required to accomplish. Sometimes the parts are integrated, as in a powered mixing board, where a common chassis holds both the controls and power amplifiers, which are usually limited to around 300 watts-per-channel because of heat and weight constraints. Some packages even contain loudspeakers, as is the case with the popular electric guitar amplifiers known as combos. These self-contained units are really small but complete PA systems. All you add is the signal from the transducer in your guitar and you have instant sound.

A typical system may consist of a mixing board, a processing rack, outboard power amplifiers, stage monitor speakers, and two banks of two-way or three-way speaker systems.

The following chapters describe how the parts of a sound system work, the correct way to set up and use these components at a performance, and how to effectively record a live performance.

Microphones

Chapter 2

The sound reinforcement audio chain begins when sound from a vocalist or instrument is first captured and changed into electrical energy to produce an audio signal that resembles the original sound. How microphones accomplish this is the subject of this chapter. Chapter 9, "Microphones and Pickups: Placement and Usage" discusses the variables that affect choosing microphones and pickups and describes how they are set up for live performance.

Microphone Types

Microphones transform fluctuations in acoustic energy (sound waves) into electrical energy (audio signals). Engineers refer to them as transducers—something that changes one form of energy into another.

There is little resemblance between a microphone's components and an eardrum. The ear transforms sound into mechanical vibrations at the eardrum. These vibrations are then conducted to the interior through a series of intertwining bones, where they finally vibrate hairs in the inner ear. These hairs are tied to nerve bundles that go to the brain. Studies have shown that the location of the hairs on the Eustachian tube affects their sensitivity to particular frequency

bands and helps the inner ear act like a one-third octave frequency analyzer that divides each octave's frequency spectrum into three bands.

In addition to frequency sensitivity, there is the binaural stereo recognition of our two ears. Because our ears are spaced about 6 inches apart, there is a delay of up to .6 milliseconds for sounds that occur at one ear to reach the other. This stereo effect allows us to determine the location of a sound source by comparing the time differences of sounds. Your brain can tune-in desired sounds while ignoring others. To see how important two ears are to recognition try this—next time you are at a place where there are a lot of conversations try plugging one ear and listening. Single voices will be difficult to pick out and figuring out where particular voices come from will be nearly impossible without looking. Additionally, the ridges in our external ears act as mechanical filters that color sounds coming from the front differently than those from the rear. They also play a part in vertical sound source identification. What a great setup. From just two transducers (our ears) we can easily locate and recognize sounds emanating from anywhere in a sphere around us.

Microphones do not have the advantage of built-in frequency analyzers or intelligent binaural processing. How they convert (transduce) the mechanical signals that are produced by air vibrations into electrical signals is determined by their type—ribbon, dynamic or condenser.

Dynamic Microphone

In a dynamic microphone acoustic energy vibrates a plastic or phenolic diaphragm with varying air pressures. The vibration of the diaphragm moves a coil of wire located in a magnetic field, which causes current to flow. The rate at which the diaphragm vibrates corresponds to the frequency of the sound.

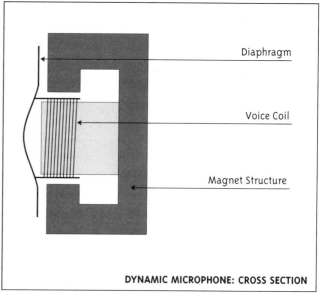

DYNAMIC MICROPHONE: CROSS SECTION

In most dynamic microphones, the electrical signal that is produced by the air vibrations is a low-impedance signal (around 600 ohms), which allows long cable runs without loss of high frequencies and eliminates electrical interferences from radio frequencies and fluorescent lights.

However, some manufacturers produce dynamic microphones that contain internal transformers that generate high-impedance signals so they can be plugged directly into the unbalanced, high-impedance input of a stage amplifier.

The Audio-Technica ATM25 is a high SPL dynamic microphone commonly used on kick drums.

Some instruments, harmonicas for example, can use special high-impedance microphones that allow them to be plugged into guitar amplifiers to modify their tonal qualities.

Because of their minimal electronic circuitry, dynamic microphones are extremely durable and require almost no maintenance.

Some dynamic microphones are small enough to be clipped to an instrument's sound hole.

Condenser Microphone

A condenser microphone (true condenser) uses a thin conductive diaphragm, often gold coated, which is suspended close to an electrically charged surface, termed a "back plate." The small volume of air that separates them forms an electrical component called a capacitor or condenser. A direct current (DC) of between 48 to 110 volts is applied between the diaphragm and the back plate. As sound pressure waves vibrate the diaphragm, the electrical capacitance changes and induces a measurable alternating current (AC) voltage in the back plate element. This voltage is in direct proportion to the original sound pressure.

Because of the small currents involved, the condenser microphone has a high-output impedance which requires conversion to low impedance. This is accomplished with an internal preamplifier that is located in the microphone's body. The power supply, usually located near the mixing board, has three output connector cables: one plugs into AC power; one, which has an XLR connector, goes to the mixing board; and the third goes to the microphone. The preamplifiers of many condenser microphones have pads, which are passive resistive circuits inserted in the signal path prior to the preamplifier's electronics, to reduce the signal level and prevent overloading the preamplifier when it is used in a high sound pressure environment, such as with percussive instruments.

Some professional condenser microphones have a switch at their power supply that allows you to change their directional patterns through use of multiple elements that are electrically combined to produce omni, cardioid or bidirectional responses.

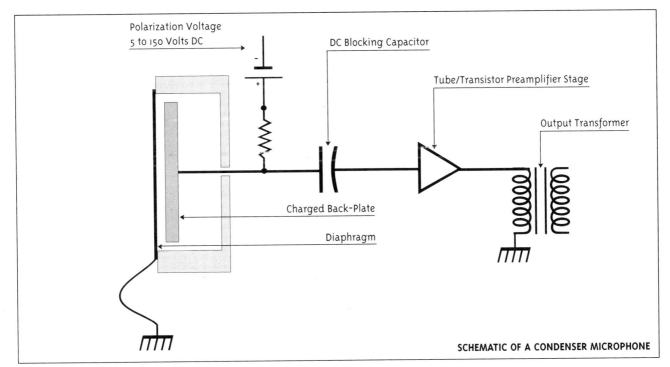

SCHEMATIC OF A CONDENSER MICROPHONE

Electret Condenser Microphone

Electret condenser microphones contain an electret (a permanent electrostatically charged element), instead of a capacitive element that is charged by a battery or an external power supply. This allows miniaturization of the element to a fraction of an inch. Miniature electret condenser microphones can be mounted either inside an instrument, or externally an inch or two below the sound hole, where many of the wood tones can be picked up. There are a variety of special mounting clips that facilitate this without marring instruments.

The Audio-Technica PRO 95 is a fixed-charge (electret) condenser microphone with a cardioid polar pattern. Its power supply is designed for use with batteries, not phantom power.

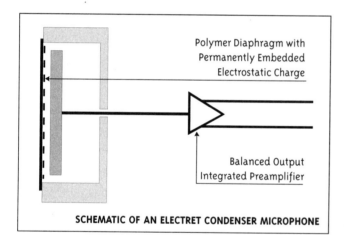

SCHEMATIC OF AN ELECTRET CONDENSER MICROPHONE

Electret condenser microphones have miniature preamplifiers built into their XLR connectors and they require from 1.5 to 48 volts to power them. This voltage can be supplied by an internal battery, an external battery pack or from 48-volt phantom power supplied by a specially designed circuit in the mixing board. (The word "phantom" is used because there is no visible power cord.) Higher voltages allow these microphones to reproduce sudden, abrupt increases in signal levels ("transients") more evenly by allowing the microphones to accept higher sound pressure levels without distortion. Lower voltages tend to cut off ("clip") the transients and produce a more jagged sound. Using the mixing board's phantom power also ensures that dead batteries won't affect the gig. Electret condenser microphones can have pads built into their circuitry to prevent preamplifier overload when there are sudden loud sounds. These pads are generally factory set.

You must never lengthen the cable that is supplied to the electret condenser's power supply because the longer cable will lose ("roll off") high frequencies and pick up unwanted frequencies from CB radios and fluorescent lights.

Many manufacturers provide miniature condenser or electret condenser microphones that are attached to flexible goosenecks that can be clipped directly to instruments, thus allowing the microphones to be positioned from 2 to 6 inches away. Pictured here is the MicroMic II series from AKG®.

Some manufacturers also supply miniature condenser microphones that have built-in mixers. These are most often used for instruments such as pianos, accordions and bagpipes.

Most electret condenser microphones come with mounting kits that permit varying where and how they are placed on instruments.

Pressure Zone Microphone

The pressure zone microphone (PZM™), manufactured under a special licensing agreement from Crown International, uses a miniature electret condenser element that is mounted over and close to a flat plate. A small slot between the plate and the microphone's element responds to pressure variations in the air and feeds them to the element. The larger the surface of the plate the better its response to low bass frequencies. To obtain true bass response, the small plate that is supplied with the PZM needs to be mounted on another surface that is at least 2 feet square: a wall, floor, tabletop, piano lid, Plexiglas panel, etc.

PZMs are popular conference pickups, where people sit at a table with a single microphone in the middle. They work well with choirs when mounted on 2-foot square Plexiglas panels that are suspended above the choir. Sometimes they are placed directly on the floor in front of a band to record a practice (check) tape. They can also be mounted on the face of an acoustic guitar, next to the strings, with good results.

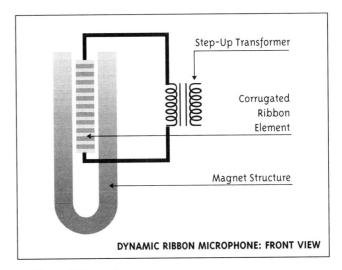

DYNAMIC RIBBON MICROPHONE: FRONT VIEW

Ribbon Microphone

The ribbon microphone has a thin metal foil ribbon that is suspended in a magnetic field. As air velocity moves the ribbon it produces a small electrical current in the foil, which is stepped up to standard voltage levels by a transformer. Since the ribbon responds to the velocity of the air, not its pressure, these microphones are sometimes referred to as velocity microphones.

Ribbon microphones are bidirectional (figure-eight) microphones. They are designed to pick up sound equally well from the front and back and cancel sound coming in from the sides. Some ribbon microphones allow you to change their directional response pattern.

Many engineers prize their warm sound, an effect that results from the way their large internal transformers work to emphasize even order harmonic frequencies and smooth out transients.

Modern ribbon microphones such as the Beyerdynamic M 160 offer many of the characteristics of the classic ribbon sound and are built to withstand damage from wind and mechanical shock.

Crown® PZM®-6D electret condenser pressure zone recording microphone.

However, most early ribbon microphones were not made to withstand the rigors of sound reinforcement: a strong wind or breathy vocalist can stretch or blow out the ribbon, which requires an expensive repair. Although modern designs have mostly eliminated the blowout problems, their large size limits their use in live performance.

Wireless Microphone

Wireless, handheld microphones have become very popular in the last few years because advancements in technology have improved their performance and reduced their price to affordable levels. Although their frequency response and dynamic range is not as good as that of a microphone that is connected to a balanced XLR cable, the freedom of movement they offer may be worth the trade-off.

The three basic parts of all wireless microphone systems are the microphone capsule, the transmitter and the receiver. Microphone capsules of varying quality and directional response patterns are available. There are handheld and miniature lapel-types. Some manufacturers supply a special wireless instrument transmitter that has a quarter-inch cable that plugs into a pickup's output jack.

The receiver's job is to pick up the radio signal from the transmitter and produce an audio signal that can be plugged into the microphone snake via an XLR output or into an instrument amplifier via a quarter-inch unbalanced line level output.

Frequency

All wireless microphones are miniature radio stations. Each type has a radio frequency band it transmits in, as well as a specific frequency (channel) for each microphone in a system. Within each band are a number of channels that allow multiple wireless microphones to be picked up by the appropriate receiver.

The three radio frequency (RF) bands that can be legally transmitted in are called low-band VHF (about 49 megahertz), high-band VHF (about 180 megahertz) and UHF (about 450 megahertz). As you go up in frequency antenna components are smaller and audio performance generally improves. The problem with the low-band VHF is that the 49 megahertz region is where CB radios operate, which can result in interferences from passing motorists. Although the high-band VHF is generally immune from outside interference, some police communication systems operate there. The high-end UHF systems are generally used in live TV and theater where a dropout (loss of reception due to radio wave cancellation) or interference could ruin a whole show. Most musicians select high-band VHF for good performance and reasonable price.

Diversity System

A diversity system has two antennas that are connected to a common receiver by a circuit that can choose the antenna that is sending the best signal. This discriminator circuit decides on which antenna to use and quickly switches to it, as often as many times per second. The best receivers are able to silently switch to the best signal before a human can hear any problem.

The Beyerdynamic SDM 350 uses a TG-X 60 dynamic microphone with its built-in 12-channel high-band VHF transmitter.

A diversity system is necessary because of a phenomenon called "multipath interference" where multiple radio frequency echoes cause dead spots where a microphone's signal cannot be picked up

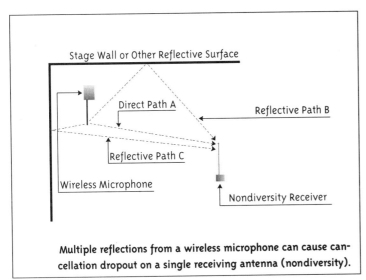

Multiple reflections from a wireless microphone can cause cancellation dropout on a single receiving antenna (nondiversity).

by its receiver. Having a second antenna that is separated from the primary antenna by a foot or more increases the chances that at least one of them will not be in a multipath null area. Distance of the transmitter from the receiving antenna has little to do with this effect since you can cause a nondiversity dropout from just a few feet away. Most musicians choose diversity receivers for the security they provide. However, bands should carry a backup set of microphones and cables that can be plugged into an audio snake in the event that one or more wireless channels are jammed by local interferences.

Directional Response Patterns

A microphone's ability to receive the acoustic energy coming to it from various angles of a sphere defines its directional response classification—bidirectional, omnidirectional or unidirectional.

Polar Response

The polar response pattern is a graph that represents a microphone's directional response at different frequencies. It shows what a microphone hears if someone were to walk in an exact circle singing a constant note at a constant volume. That response changes with distance (how close the vocalist or instrument is to the microphone) and frequency (what notes are being played or sung).

These patterns can help you judge how well a microphone will respond for a particular instrument or vocal.

A microphone that picks up sounds equally well from all directions has a circular pattern, such as the pattern for the omnidirectional microphone shown below.

The concentric circles radiating from the center, in gradations of 5 dB, show the relative volume you can expect at various frequencies. The edge of the graph, at 0 dB is the threshold of hearing.

Most polar response patterns (graphs) have a series of three or more curves that show the microphone's directional response at various frequencies. Of course, there are many peaks and dips in these response curves that color the sound of each microphone. Knowing a microphone's polar response is important. If a performer or instrumentalist misses the ideal center point/distance at which a particular microphone best captures sound, the frequency response to the off-axis sound will be distorted and will color the sound.

The combination of frequency response, polar response pattern, and the distortions from

Beyerdynamic EED 200 plug-in VHF diversity receiver.

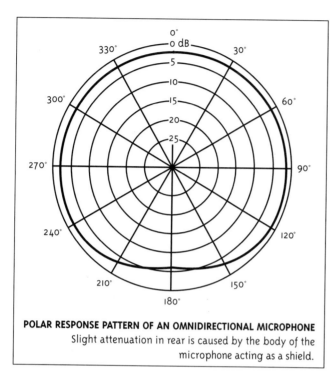

POLAR RESPONSE PATTERN OF AN OMNIDIRECTIONAL MICROPHONE
Slight attenuation in rear is caused by the body of the microphone acting as a shield.

preamplifiers and output transformers in power supply boxes gives each microphone its characteristic sound. No two microphones sound exactly the same, even if they are the same brand and type.

It is also important to understand the relationship between a microphone's polar response and the frequencies it is receiving. All instruments have different energy projection patterns which give them their characteristic signature or sound. How well these are captured depends on the microphone and the skill with which it is used. Different microphones can make the same instrument sound totally different.

Omnidirectional Microphone

Omnidirectional microphones capture sound equally well from all directions and will consistently reproduce the entire range of frequencies from any direction and exhibit a flat frequency response no matter how close the sound source. The sound they produce is very natural, which is especially useful when recording symphonic instruments, or where acoustic realism is paramount. The better ones do not generate much self-noise (the hiss you hear when you plug them in and don't supply any signal to them).

However, their spherical acceptance range means that during performances they will also pick up sounds of other stage instruments, ambient noise, monitor speakers, etc. This produces sonic clutter and increases the potential for feedback. In a quiet concert hall, omnidirectional microphones can do a wonderful job of picking up the full sound pattern of an acoustic guitar and a cappella singing. But if there are multiple instruments the sound engineer may not be able to avoid sonic clutter and feedback.

Unidirectional (Cardioid) Microphone

Unidirectional microphones (cardioids), reject sounds from the sides and rear while receiving sounds directly on-axis (their "capture window") of about 130 degrees. An acoustical cancellation system helps null out the sounds from the rear and sides. This does not happen equally well at all frequencies: there is better cancellation at the higher frequencies and no cancellation at lower frequencies. Where that low-frequency point is and how smooth the cancellation is differs by brand and type.

Cardioid microphones do not exhibit their directional characteristics until they receive frequencies above 200 to 300 Hz. Below these frequencies they act like omnidirectional microphones and allow

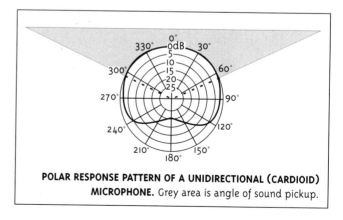

POLAR RESPONSE PATTERN OF A UNIDIRECTIONAL (CARDIOID) MICROPHONE. Grey area is angle of sound pickup.

all the bass frequencies being produced on stage to come through loud and clear. (This is one reason why the bass frequencies in vocal monitors are attenuated [rolled off]—to keep them from leaking into the vocalist's cardioid microphone.) However, you can aim cardioid microphones precisely at a sound source and away from other instruments and the monitor speakers, which allows the engineer to boost that signal, without incurring feedback, by turning up the microphone's gain control. This has the effect of making the volume of a soft instrument equivalent to that of other louder stage instruments. Cardioid microphones are very useful in venues where there are a lot of extraneous sounds that should not be amplified.

When vocalists sing off-axis (outside the microphone's capture window), their tones will be altered, which produces a distinct coloration that degrades the sound and causes them to sound muddy, distorted or jagged. Off-axis coloration is one of the reasons that microphones can sound so different, even though their frequency response ratings are basically the same. The rating only refers to the capture of sound on-axis. Off-axis coloration will be more noticeable with instruments that produce large, complex sound fields, such as harps and accordions, because some of that field will inevitably be captured off-axis.

Most directional cancellation systems also produce a large bass boost that occurs when the sound source gets very close to the microphone ("proximity effect"), making it prone to bass buildup and feedback. Proximity bass boost can be a benefit for vocalists, where the added bass adds testosterone quality to male voices or warmth to female. However, when an acoustic guitarist gets too close to the microphone, the guitar will sound boomy and produce feedback.

When a vocalist or instrumentalist constantly moves in and away from the microphone, and the proximity effect is not desirable, the sound engineer

The Electro-Voice® RE20 with Variable-D® ("D" stands for distance) eliminates the bass boost buildup.

may try to produce a consistent sound by using the mixing board's equalization controls to continuously adjust the frequency. For example, when an acoustic guitarist leans into the microphone, the sound engineer will reduce the bass frequency and use a limiter to remove the extra bass and loudness. As soon as the guitarist moves a few inches back from the microphone, the bass boost is gone, and with it the natural "bottom" of the instrument. The sound engineer must modify the equalization to bring back the natural low frequencies. This continuous adjustment of equalization is called "chasing the equalization."

Some cardioid microphones have a more constant bass response at all distances because of slotted frequency cancellation chambers that cancel out the proximity effect. The addition of these chambers means that these microphones will sound the same no matter how far the user is from the sound source. Unfortunately they are heavy and cumbersome.

Supercardioid Microphone

Supercardioid microphones have tighter acceptance patterns (capture window of 115 degrees). They are used in situations that do not allow close miking or when very high gain is required before feedback occurs. However, they tend to have off-axis frequency

irregularities and exhibit problems with picking up sounds from the rear. As with cardioid microphones, they are useful for soft instruments because the engineer can boost their signals by turning up the gain control on the mixing board's microphone input channel and make them as loud as the other stage instruments without incurring feedback.

Hypercardioid Microphone

Hypercardioid microphones pick up sound only from a very narrow angle directly in front of the microphone (capture window of 105 degrees). They come close to being totally directional microphones. They can be used to pick up remote speech and are often used with a pistol grip, or on a long pole that enables the microphone to be aimed directly at the sound source. However, they have a fairly large amount of sound pickup directly from the rear that makes placing monitors directly to their rear unworkable. They must be used directly on-axis by the performer since singing or talking into them from the side results in a very unbalanced sound.

Bidirectional Microphones

Bidirectional (figure-eight) microphones pick up sound equally well from the front and back, but not from the sides. A ribbon or condenser element is most often used to achieve this response. Some

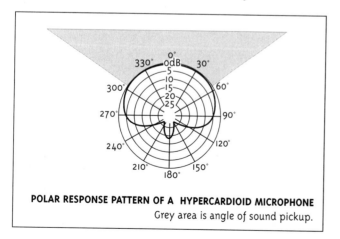

POLAR RESPONSE PATTERN OF A HYPERCARDIOID MICROPHONE
Grey area is angle of sound pickup.

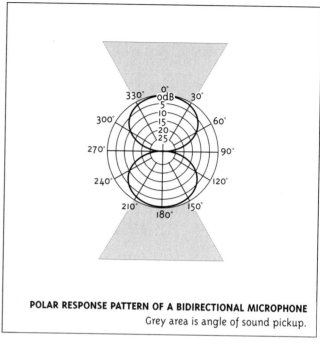

POLAR RESPONSE PATTERN OF A BIDIRECTIONAL MICROPHONE
Grey area is angle of sound pickup.

of the more expensive bidirectional microphones allow you to vary their polar response pattern with a control on the microphone.

Lavaliere and Shotgun Microphones

Although these microphones are not normally used in music reproduction, most performing musicians will be exposed to them at one time or another because of the increase in audio and video recording for interviews and promotion.

Lavaliere microphones are very small and are designed to be placed on the chest or lapel of a performer. The newer ones have electret condenser elements and can provide either unidirectional or omnidirectional response patterns. The better ones have built in equalizers that boost the presence of midrange frequencies. They are most often used for interviews.

Shotgun microphones are hypercardioid microphones that are used for video productions where there is lot of ambient noise clutter or where an operator cannot get close to the sound source. Shotgun microphones can pick up a person's voice

from as far as 8 feet away without picking up room echo or reflections. They can be either dynamic or electret condenser and usually take the form of a long tube (up to 24 inches) that resembles a gun barrel.

Technical Characteristics
Sensitivity

The sensitivity of a microphone is defined as the relationship between the level of signal output at a given sound pressure level (SPL) to the sound level it receives. The strength of the signal that is generated affects how it travels and is processed through the rest of the audio chain and to some extent it determines how well the microphone will perform with a preamplifier. The more sensitive the microphone, the stronger the signal it will generate for the same input level or SPL. Generally, condenser microphones are more sensitive (have more signal level output) than dynamic and ribbon microphones.

The more sensitive the microphone, the stronger ("hotter") the signal it will generate for the same level input. However, a hotter microphone does not necessarily sound better, just louder for a given amount of sound. For instruments that produce relatively soft sounds like an Irish harp or a nylon-stringed guitar played with the fingers, or low, soft overtones, such as those produced by violins, the more sensitive microphone will produce a stronger signal from those low volumes and counteract the noise from preamplifiers and cable induced hum.

Conversely, if you use a sensitive microphone on instruments that generate a loud signal, such as bagpipes or drum snares, you may cause an overload at the microphone and distort the signal to the mixing board. If the microphone does not distort, it will send a large voltage to the mixing board and possibly cause its preamplifier to distort. To avoid this, most modern mixing boards provide a switchable pad before the mixing board's preamplifier's electronics (before any transistors) to reduce the voltage produced from these loud signal sources.

The sensitivity rating of a microphone is shown in its specifications as a negative decibel rating, referenced to 0 VU with -50 dBv being stronger (hotter) than -60 dBv.

A hotter microphone will enable the sound engineer to keep the signal higher than the noise floor of the mixing board's preamplifier (noise generated before any electronics are passed through the preamplifier section in the board). A mixing board with quiet preamplifiers will have padded inputs on the input channel that can be engaged to prevent overload and avoid distortion from hotter signals. A board with padded inputs is very forgiving of low-level signals, even though it may force the engineer to turn up the signal gain to get the volume up in the mix.

If you have a board with a noisy preamplifier, a more sensitive microphone will sound better on a quiet instrument because less preamplification will be needed, which will reduce the background preamplifier self-noise.

Boards with preamplifiers that have specifications of noise greater than -120 dBv are very quiet; if the specifications of noise are greater than -90 dBv, some hiss and hum from self-noise can be heard.

Frequency Response

Frequency response is a measure of the upper and lower limits of pitch that a microphone will accurately track from a sound source. The lowest and highest reproducible frequencies are listed, with an error tolerance level of plus or minus so many dB. The wider the frequency range and the smaller the error margin, the more accurate and realistic the microphone will sound.

If a microphone picks up all frequencies equally well, without boosting or cutting some more than others that is called "flat response." Although a microphone that has perfectly flat response is impossible to manufacture, good microphones come close. Cheap microphones have many frequency response irregularities ("peaks") which make them prone to feedback.

Some microphones are designed to boost certain frequencies. For instance, some cardioid microphones are designed to boost bass notes around 100 Hz. Some condenser microphones boost the frequencies around 8 to 15 Hz to add the "sheen" or "air" that helps bring out string detail in plucked instruments. The "presence" boost on some vocal microphones accentuates the frequencies at around 3 to 5 kHz. Good microphones, even those with boosted frequency responses, will provide smooth response, without sudden peaks and dips.

Distortion

Distortion is any frequency variation from the natural sound of a voice or instrument that results from a sound reinforcement component. The distortion may be pleasing, such as the warmth added by ribbon microphones, or sought after, such as the cardioid microphone's bass boost that adds a breathy tone to a vocalist.

Dynamic Range

This is the difference between the loudest sound that can be captured without distortion and the softest sound that can be captured before the microphone's self-noise interferes. Suppose your instrument can achieve a maximum of 100 dB of sound at the microphone and the mixing board electronics generate hiss or hum at 40 dB. You have a 60 dB window to work within. Sounds below 40 dB will be lost in the hiss or room noise and sounds above 100 dB are not possible from your instrument. This is a good example for a live stage, since there will certainly be at least a 40 dB ambient room noise on the stage even when there is no playing. However, if you take the same microphone and board into a quiet room to record you will be disappointed by the degree of hiss in your recording.

In a controlled acoustic environment, such as in a recording studio, ambient noise is not an issue, even if performers are 4 feet away from a microphone. But in a live situation, you must get the microphones as close as possible to the sound sources so they do not pick up unwanted sounds.

Transients

A transient is an abrupt, sharp, short duration increase or swing in signal level, such as that produced by a drum stick striking a drum or a sudden, hard pick on a guitar string. Transients produce sharply increasing and decreasing wave forms. Clipping the transients means cutting off parts of those wave forms.

Transients and Slew Rate

The slew rate indicates the ability of a circuit to handle very fast and large signal swings, such as those produced by transients, in volts per microsecond. A circuit with a higher slew rate, such as 30 volts per microsecond, will be more stable under large transient signals than one with a 15 volts per microsecond rate. That is why amplifier and preamplifier circuits with low slew rates of a few volts per microsecond will clip the transients of high-level signals, which results in distortion.

Sound Pressure Level (SPL)

Sound pressure level is a measure of the energy of a sound. Microphone specifications will include the maximum SPL that will be tolerated before distortion. This is expressed in decibel SPL (dB SPL).

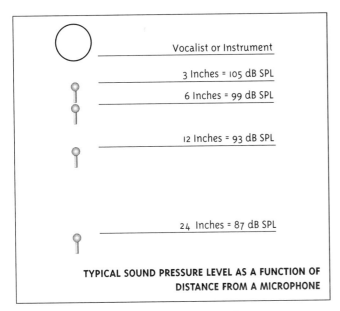

TYPICAL SOUND PRESSURE LEVEL AS A FUNCTION OF DISTANCE FROM A MICROPHONE

Two types of overload commonly cause microphone signals to distort. One is more SPL than the microphone can handle, such as putting a ribbon microphone next to drums. The other occurs when the microphone can handle high SPL and overloads the input of the mixing board's preamplifier with a loud signal. Many condenser microphones have a switched pad in the microphone capsule itself that helps avoid internal microphone distortion. The pad should be engaged in high SPL environments. Avoid preamplifier distortion at the mixing board by using its pad and trim controls to match the signal level's requirements.

It is important to understand that the SPL ranges of microphones are influenced by the SPL volumes from the instrument itself and from the monitor speakers' sound field. If the stage monitors produce a level of 100 dB and the singer needs to be heard above the monitor clutter, then the microphone may be hearing in excess of 110 dB, which is a combination of the background sound of the monitors and the volume of the singer. Microphones that are designed for use in recording studios are sensitive to high SPL volumes and will produce a clipped output signal (distortion). Most microphones designed for sound reinforcement do not exhibit this sensitivity to high SPL volumes except with very loud percussive instruments such as bass drums.

Self-Noise (Output Noise)

Self-noise indicates how noisy the microphone is when there is no signal sent to it (hiss). The lower the self-noise the quieter the microphone. At low levels, subtleties such as the decay of a guitar tone will be picked up by low-noise microphones with more detail, until it fades into the ambient noise floor or the self-noise from other electrical components further down the circuit.

Unfortunately, only studio microphones include specifications for self-noise that are rated in equivalent dB SPL. Microphones used for live performance usually exhibit more noise than their studio cousins, but this is normally masked by ambient room and sound reinforcement noise. Below 20 dB SPL is considered low self-noise, which is equivalent to a 20 dB SPL ambient room noise. (Zero dB SPL is at the lowest threshold of human hearing.) Microphone specifications generally indicate self-noise as "output noise."

Noise Floor

The noise floor is the point at which an audio signal gets masked by other noise, such as the self-noise generated from other electrical components or ambient noise.

Proximity Effect

This is the increase in bass response that occurs as a singer or instrumentalist moves closer to a microphone that has a directional pickup pattern. This boost to the bass signal will muddy or distort the sound, an effect that may or may not be desired. A frequency response graph of a microphone's on-axis response will show a hump in the bass region at less than 6 inches.

The KMS 150 Neumann handheld hypercardioid microphone has a bass roll-off switch to reduce the proximity effect. The microphone safely transmits signals of 148 dB SPL when the -10 dB attenuation switch is activated. The total dynamic range of the microphone amplifier is 124 dB. The KMS series microphones are also available with a cardioid pattern.

Output and Input Impedance

A microphone's source or output impedance is an indication of how well its circuit can drive the next input device. Microphone specifications provide the source impedance in ohms. Generally, low-impedance microphones will be under 600 ohms (most are in the 100 to 200 ohm range). High-impedance microphones generally start at 2000 ohms and can go as high as 10,000 ohms.

An impedance mismatch occurs when the source or output impedance of a microphone is not appropriate for the input impedance. To avoid this, make sure that the output impedance of a device feeds into an input impedance that is higher. For instance, a 600-ohm microphone will feed a 2,000-ohm input channel perfectly, but a 10,000-ohm microphone will feed the same 2,000-ohm input with severe distortion and attenuation.

Microphones that were manufactured in the 1960s and earlier were designed to be plugged into matching impedance loads. Using these microphones without proper loading will result in strange frequency response curves. If the microphone is rated at 150 ohms, proper loading can be accomplished by soldering a corresponding 150-ohm resistor across pins two and three in the microphone's XLR connector. Modern mixing boards use an input impedance of about 2000 ohms and expect a microphone source of 200 to 600 ohms, the so-called bridging mode.

The signal quality of dynamic microphones with impedances of less than 600 ohms is improved by using the low-impedance microphone input of the mixing board. Most professional mixing boards provide low-impedance inputs that have XLR connectors. Microphones that have quarter-inch phone plugs need to use a high-to-low-impedance input transformer or direct box with a standard quarter-inch female plug at its input and a male XLR connector at the output. This will allow the signal to be sent down an audio snake to the mixing board without hum or high-frequency loss.

Balanced signals require an XLR connector, two electrical wires to transmit them (+ signal, and - signal), plus a third wire that is connected to a braided or foil shield that shields the signal from outside interference. This provides a signal that can survive long cable runs without rolling off high frequencies and picking up electrical interferences from outside sources such as fluorescent lights and transformers.

Unbalanced signals require only two wires (shield and hot) and are identified by an RCA or phone connector. Microphones that provide unbalanced signals are less expensive to manufacture, but are not suitable for cable runs of over 15 feet because of their high-frequency roll-off and susceptibility to electrical interferences.

Phantom Power

Phantom power is the power supplied to a condenser microphone's power supply from a specially designed mixing board circuit. This circuit's voltage level (normally 48 volts) must be matched to the microphone's

phantom power requirement. However, even though a board's specifications may indicate that it supplies 48-volt phantom power, some only put out 18 to 28 volts, instead of the full 48 volts. The only way to check is to put a voltmeter between pins one and two of this circuit. Since many phantom powered microphones will run on such reduced voltage, the problem will not be noticed until a microphone that requires the full 48 volts is used. Check this before you buy.

Electrical Interferences

Cable and wire inherently add resistance to a signal. Some transmit different frequency ranges better than others. For example, long wires that carry high-impedance signals tend to lose or roll off high frequencies more easily than with low-impedance signals. This effect increases as the cable gets longer, which is why low-impedance microphones are generally used where long cables are required to reach the mixing board.

Electrical interference in a microphone and its cabling is caused by two main effects, inductive coupling and the pickup of radio frequencies (RF).

Inductive coupling occurs when two wires are parallel to each other. Running microphone cables next to power cords will induce a rather loud 60 Hz hum as will running a microphone snake and AC cable next to each other. Separating the cables by a foot or two will usually solve that problem. RF pickup comes from sources such as light dimmers and nearby radio stations. Improper grounding of the shielded microphone cables caused by corrosion and bad connectors usually is the culprit.

Low-impedance microphones won't necessarily get rid of all electrical interference, although they are less susceptible. High-impedance microphones with long runs of wire (over 20 feet) will usually pick up hum and radio stations. These microphones are identified by their quarter-inch phone plug connectors. When they are used in a live reinforcement situation, you should use an impedance matching transformer (direct box) or an in-line microphone transformer to change their output to low impedance.

Microphone Features
On-Off Switch

Some microphones have on-off switches. Generally, sound engineers dislike them because musicians turn them off, and then forget to turn them back on. The same on-off feature can be achieved by using the mute switch on a board or by taking the input sound level down to zero. Some microphones have an on-stand sensor that performs this function automatically. These work by using a small infrared sensor that mutes the signal after a few seconds if no one is in front of the microphone.

Humbucking Coils

Some microphones contain humbucking coils—a coil of wire that is wound out of phase (in opposite direction) to the coil in the magnetic field that cancels out the 60-cycle hum induced by power cables, computers, cash register noise and fluorescent lights.

A microphone with a humbucking coil is needed when a musician uses MIDI-equipment onstage and the computer is operating less than 6 feet from the onstage video monitor. Color video monitors produce a huge amount of radio frequency energy that can get into microphones and instrument pickups and cause a high-frequency buzz.

Pop Filters

Pop filters mask the extraneous low frequencies produced by pops, breath noises, and wind ("low-frequency rumble"). The bigger and rounder the

filter, the more it will mask. In outdoor performances where there is a lot of wind, sound engineers often put foam filters on all the microphones to avoid low-frequency rumble. Audiences will tolerate a few pops from the sound system in most indoor performances, but not in a recording. If you are recording a live performance, the only way to avoid pops is to use filters on the microphones.

Many microphones have built-in filters, which are easily visible large balls, but most high-priced condenser microphones do not. They require that you provide an external pop filter or shield. Generally, larger diameter filters do a better job at controlling unwanted frequencies. However, the denser the material (mesh, foam, cloth), the duller the sound. This is usually corrected by adding some high-frequency boost on the microphone channels' equalization controls.

The Audio-Technica AT8106 metal frame pop filter.

The Audio-Technica AT8410a shock mount.

Shock Mounts

Shock mounts (suspension mounts) help avoid low-frequency vibrations that come from extraneous sources such as kick drums, feet tapping on the base of a microphone stand, people walking around, etc., which are conducted through the floor to the microphone stand and the microphone.

Some microphones have built-in shock mounts. You can tell if a microphone has one by turning the sound system on and seeing if the microphone picks up finger or foot tapping vibrations. Shock mounts can be added externally.

When sound engineers have to deal with microphones that do not have shock mounts, they can engage a special filter on each input channel of their mixing board, called a "rumble filter," "LF cut-off," "LF shelf" or "low cut" that rolls off the low frequencies and eliminates unwanted bass sounds and other infrasonic noise. (Not all mixing boards provide this capability.)

Buying a Microphone

Since microphones are your primary link to the sound chain, they are the most important thing to get right. It is impossible to fix bad microphone selection or technique.

Unless bands have their own microphones, their selection is dictated by what the sound engineer has available. If you know your preferences, find out if

the engineer has them or can rent them. Or buy your own and let the sound engineer know that you will be providing them.

Personal preferences, combined with budget realities, usually dictate choice of microphone or pickup for musicians that buy their own. A musician can choose a microphone that will capture the subtleties of the high-frequency harmonics and tonal richness of a guitar or one with directional characteristics that can produce distorted effects.

A word about price. Some may consider the use of studio-grade microphones during performances to be extravagant, but when you are miking a $3000 acoustic guitar, you will want to use something better than a $50 microphone. Nothing influences what we sound like more than the microphones we use; so budget accordingly.

Microphone Stands

Correct microphone stand placement and ease of use help a performer to be comfortable on stage. A stand that rattles or cannot be easily adjusted adds to the difficulties of performance.

Here are some things to watch for:

- Does the microphone easily adjust up and down? Stands from Atlas and Peavey have a clutch, where twisting a knob allows you to raise or lower them. Improperly tightened stands can "walk" down, which can be terribly annoying to a performer. USS (Ultimate Support Systems) markets a stand with a grip clutch, when you squeeze it you can easily adjust the height. Release the grip, and it is locked. Pretty neat idea.
- Are boom stands counterweighted so they will not tip over? Some booms have no counterweight. While this is fine for short extensions, a microphone on a long noncounterweighted boom is an accident waiting to happen. Be sure the boom is stable before you walk away from it.
- Do booms have multiple control knobs? One knob means that you cannot adjust one axis without affecting the rest. Some inexpensive booms have one knob that adjusts everything. This seems handy at first, but will quickly become unpopular when you try to move the microphone out by a few inches and the whole thing drops into the drum kit.
- For folding microphone stands—do they have a way for their bases to lock in so they will not collapse? Relying on friction to hold the legs of a collapsible stand can be trouble in a stage environment. The best stands have a locking cam that does not allow collapse.
- Does it rattle?

Atlas Soundolier's full line of boom stands.

- If it has an extension tube, is there an expandable support bushing that keeps it from rattling? Try the shake test. Extend the stand about halfway and shake it back and forth. If there is any rattle at all when it is new, imagine how it will sound after a few years of use.
- Look for stands that will accommodate your accessories. Atlas makes a series of add-on clamps to accommodate water glasses, extra microphones, and set lists. Heavy bases are best.
- Make sure that bases and tubes are compatible. Some brands are not compatible with others.

Internal Pickups, Direct Boxes and Instrument Amplifiers

Chapter 3

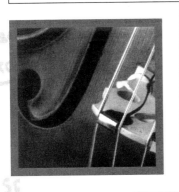

Pickups, like microphones, are transducers. They transform acoustic energy into electrical energy. Most internal pickups are used with acoustic guitars, but pickups can be connected to just about anything that will make noise. They allow your audience to hear what you are playing. However, they may not reproduce the pure sound of the instrument. You will not achieve perfect reproduction nor match the sound obtained with great microphones in a quiet recording studio. Internal pickups use different physics than our hearing to reproduce sounds and they often sound different from what we naturally hear. The better the pickup and its positioning, the more faithful the reproduction of the sound of the instrument.

Many performers that are accustomed to performing with electric guitars want to use internal pickups when they perform with acoustic instruments, because they are not accustomed to the stationary postures that are necessary to provide uniform sound to their microphones. This is a major requirement for a sound engineer who is trying to get a good, stable mix.

Some musicians use the term "pickups" for all devices that are attached directly to instruments, even though some of them are actually miniature

electret condenser microphones and some are pickup preamplifiers that are attached to the instrument with a clip or adhesive. These were discussed in Chapter 2, "Microphones."

The high-impedance signals generated by most pickups require a certain amount of signal modification before they can be sent to a mixing board. That is where the direct box and preamplifier come into play. These devices convert a high-level output (-10 to +4 dBv), high-impedance (more than 50,000 ohms), unbalanced signal into a low-level output (-20 to -70 dBv), low-impedance (less than 600 ohms), balanced signal. The outgoing signal is transferred to an audio snake, a device that enables the signals carried by individual cables to be combined and carried through one long multichannel cable to the mixing board.

The signals from pickups can also be sent to an instrument amplifier, where they will be modified in the same manner.

Passive and Active Pickups

Pickups that require no external power source are called passive pickups. They rely on the mechanical energy they collect from the instrument to produce their output signal. Passive pickups generally have a low-level output signal (-40 to -60 dBv) and fairly high-output impedance (greater than 5000 ohms). Their signals cannot survive a trip down a 100-foot audio snake to a mixing board without degradation and they can be buried in the hiss produced by the self-noise of cheap mixing board preamplifiers or instrument effects devices.

Pickups that require a power source are called active pickups. Although they contain built-in preamplifiers that convert the high-impedance signal to low impedance (600 ohms or less), the signal is still unbalanced and will need to be converted to a balanced signal, which is accomplished with the use of a direct box.

High-impedance, high-level output pickups should be connected into a direct box or instrument amplifier. Low-level output pickups (-50 to -70 dBv) will require an external preamplifier to get the levels up above the hiss produced by self-noise of the input stage of the next piece of equipment that it is connected to.

Many pickups have built-in equalizers that are accessed from controls on the instrument. The preamplifiers provided with many pickups have

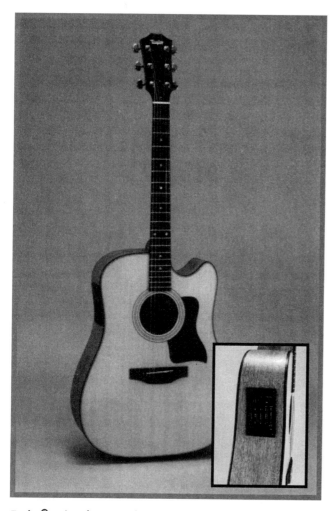

Taylor® Guitars' 410-C-E features an Acoustic Matrix Natural I under-saddle active pickup and a PREFIX™ onboard preamplifier with user-adjustable volume and equalizer controls. The pickup and preamplifier are designed and manufactured by Fishman Transducers®.

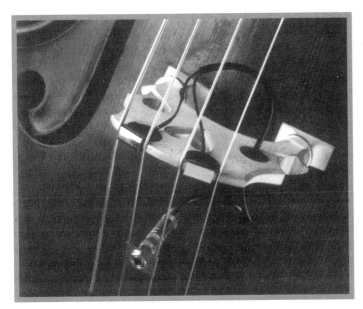

The BP 100 Bass pickup from Fishman Transducers®.

built-in equalizers. The preamplifiers are mounted on the instrument so that their controls can be easily accessed.

Signal Matching

Musicians should match the output level from their instruments to the input requirements of the next piece of equipment in the chain. Mismatches between balanced and unbalanced signals, and high- and low-level signals should be avoided. Signal levels are reduced by inserting a passive resistive circuit (pad) in the signal path. Attenuator controls on direct boxes enable the operator to vary the amount of attenuation.

You must know the output levels that your pickup, microphone or instrument is putting out, as well as the levels required by what you are plugging into. Although the type of connector provides information about whether the signal will be balanced or unbalanced, it will not tell you whether the signal is high level or low level. This information is usually provided by the manufacturer's specifications.

An unbalanced signal is transmitted through an audio circuit of two wires: the audio signal is carried by one wire; it is shielded by another wire that is also the ground. Because the outer wire picks up more interference than the inner wire, the wires have different levels of signal and are said to be unbalanced. Cables that carry unbalanced signals are commonly designated by their quarter-inch mono phone plugs.

A balanced signal is transmitted through an audio circuit of three wires. Two wires (a twisted pair) carry the audio signal (plus and minus); the third wire shields the signal. Cables that carry balanced signals commonly have XLR connectors or TRS (stereo) quarter-inch phone plugs.

Some new built-in acoustic guitar pickups provide both a XLR (balanced) and a quarter-inch (unbalanced) output. The XLR output indicates that the guitar has a built-in preamplifier that produces a balanced signal anywhere from -40 dBv to 0 dBv depending on the output volume control. The cable from the XLR output can be routed to a mixing board's input channel, providing a clean signal. The quarter-inch output can be cabled to an instrument amplifier for additional effects or for stage monitoring. However, if the quarter-inch output is not going to be used with another device, it must be plugged with a quarter-inch plug (cheater plug) to turn on the battery and activate the pickup's internal preamplifier.

Magnetic Pickups

Magnetic pickups have a coil of wire wrapped around a magnet. They fit in the sound hole of steel stringed instruments and pick up only the vibrations of the strings. But because of their general lack of bass response and inability to reproduce resonances that occur from the body of the instrument, they do not reproduce the instrument's acoustic sound and often sound shrill or brittle.

Their high-impedance (50,000 to 250,000 ohms), high-output (-10 to +4 dBv) unbalanced signals need to be converted to low-impedance (less than 600 ohms), low-level (-20 to -60 dBv) balanced signals with a direct box or instrument preamplifier.

A few manufacturers mount their pickups in wood covers and claim that they add "wood tone" to the sound of steel strings, but magnetic fields do not respond to wood and these covers have no effect. These pickups have built-in equalization that boosts bass frequencies and reduces treble frequencies, which adds warmth to the sound.

Piezoelectric Bridge Transducers

Bridge pickups are passive devices that utilize piezoelectric (piezo) elements, thin wafers of Rochelle salt crystal that produce an output voltage (or audio signal) when flexed. Two types of vibrations cause the piezo element to flex: the mechanical vibrations produced by sound traveling through the body of the instrument; and the direct vibrations of the strings. As a result, piezo transducers produce a more natural acoustic tone than do magnetic pickups.

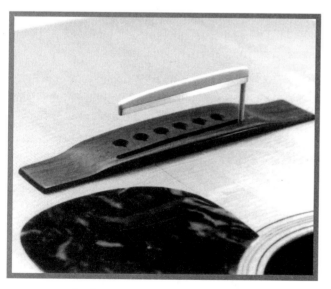

L.R. Baggs™ classic LB™ series acoustic guitar pickup uses piezoelectric transducers that are cast into a saddle that replaces the instrument's original one.

There are two basic piezo transducers: the add-on transducer that fits inside the instrument directly underneath the bridge; and a transducer that is mounted internally in a replacement bridge. Some replacement bridge transducers have a separate piezo element for each string. This allows separate balancing and processing of each string and better control of the overall sound of the instrument. They are popular among acoustic string players because they can be interfaced to MIDI sound modules.

Although most piezo pickups are high-impedance devices, some do provide low-output signals. The manufacturer's specifications include a rating for nominal signal level: -10 to +4 dBv is high; -20 to -60 dBv is low. If the specification is missing, the easiest way you can determine the pickup's output signal is to use one of the mixing board's microphone input channels to test it. To do this, set the gain control on the input channel to its minimum setting and the signal level or attenuation control (trim or pad), to its maximum setting (-60 dBv). Plug the pickup into the microphone channel input and slowly turn the gain up and the trim or pad control down until the VU meter reads zero. At that point, you can read the signal level from designations on the trim or pad control.

The biggest problem with add-on piezo bridge transducers is that even though they do not have a great deal of bass sound to begin with, low-frequency sounds from stage monitors tend to feed into them. If the engineer boosts the bass on their channel to balance their tone, bass feedback becomes a problem. The louder the monitors, the greater the problem. The stringed instrument's resonating chamber will amplify low-frequency sounds and the other vibrations that are produced by other instruments on stage. The problem will be exacerbated if the musicians are playing on a surface that reflects low frequencies, such as concrete or stone floors.

Some acoustic musicians solve the problem of low-frequency feedback by using two different pickups: a magnetic or bridge piezo pickup for direct string sound, whose signal is routed to a direct box; and an internally mounted microphone for chamber resonance whose signal is routed to the mixing board's microphone input channel. The magnetic pickup signal is routed from the mixing board to the stage monitors, which allows the sound engineer to give the musicians louder volume in the monitor speakers without incurring low-frequency feedback. The signal from the internal microphone can be the primary sound for the audience mix and a small amount of the piezo or magnetic pickup signal is mixed in to provide string detail.

Choosing a Pickup

Well-designed pickups have few frequency response peaks, smooth overall sound, small feedback potential, and built-in equalization. Generally, they require very little external equalization to make them sound good.

The only way to really know how one sounds is to try it in your instrument. Plug it in through the sound system and ask the sound engineer not to add any equalization. Listen through a good set of headphones. If you play with a pickup that doesn't sound good the sound engineer will have to try to balance the equalization on almost every note. This makes for extended sound checks and mixing problems.

Direct Boxes

A direct box converts a high-level, high-impedance unbalanced signal into a low-level, low-impedance balanced signal that is suitable for transmission down an audio snake to a mixing board. The term "direct box" is used interchangeably with the terms "direct injection devices," "direct instrument sends," and "DI boxes" by manufacturers, audio engineers and musicians.

Most direct boxes can route signals directly to the mixing board's microphone input channel via their XLR outputs and to an instrument amplifier via their quarter-inch phone plugs. Many direct boxes have a ground lift switch that can be activated to eliminate any hum and noise that can be caused by ground loops. When two devices are plugged into different power outlets, thereby creating two sets of electrical pathways, ground loops occur. If you use instrument amplifiers avoid using direct boxes that do not have a ground-lift switch because grounding problems will result.

An in-line transformer is a very basic direct box that looks like a cable. It has a quarter-inch input and a transformer that steps down the impedance and changes an unbalanced signal to a balanced one before sending it out through its XLR output.

Active Direct Boxes

Active direct boxes can be plugged into an AC outlet or powered by 9-volt batteries or phantom power from the mixing board. These high-output devices use tubes or transistors at the input stage to convert the high-impedance unbalanced signals from pickups to low-impedance microphone level (-40 to -60 dBv)

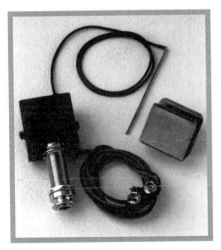

Martin® Guitar's Thinline Gold+Plus® acoustic guitar pickup and active pre-amplifier. The under-saddle transducer senses the motion of the entire saddle, eliminating issues of string balance. The pickup and the surface mounted preamplifier are designed and manufactured for Martin Guitars by Fishman Transducers®.

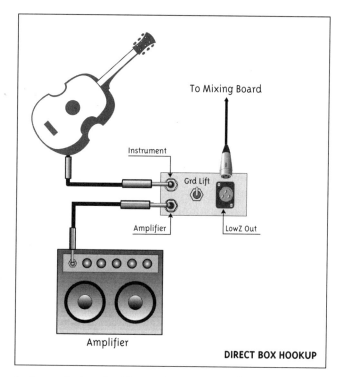

DIRECT BOX HOOKUP

balanced signals. Direct box input impedances are rated at 200,000 ohms or more. They should be at least 10 times the output impedances of the pickups they serve so that they can receive incoming signals and not reduce their voltage levels, which would cause a loss of high frequencies ("loading the signal down").

Active direct boxes often have signal level or attenuator controls, labeled "Attn." or "Pad." These allow the musician to adjust the level of the incoming signal from low microphone level (-20 to -60 dBv) to high-output line level (-10 to +4 dBv) or anything in between, to match incoming pickup signals. For example, if you plug in a pickup with a high-level signal you adjust the attenuator control to its line level setting. If you plug in a pickup that has a low-level signal (-30 to -70 dBv) you adjust the attenuator control to its microphone level setting.

Direct box transistors are either bipolar transistors, which are current driven devices that distort odd-order harmonics, or field effect transistors (FETs), which are voltage driven devices that distort even-order harmonics and sound more like tube driven devices.

Direct boxes that use tubes and tube circuitry add warmth to the audio signal, since they inherently add emphasis to even-order harmonics. Although this emphasis alters the original signal, many musicians like the way it makes their instruments sound.

The signals from direct boxes that use FETs or tube circuits rated in excess of 1,000,000 ohms are smoothly interfaced with other electronic equipment. However, most people will not be able to tell the difference in the sound quality between direct boxes that use bipolar transistors, FETs or tubes unless they are in a recording studio or are using a fantastic sound system. Still, every improvement in signal quality helps, since each stage of signal conversion or processing is important to the overall sound.

Active direct boxes cost from $150 to $400 each. The higher priced ones use FETs and tube circuitry. All-tube direct boxes cost anywhere from $150 to $1000 per channel. Make sure your direct

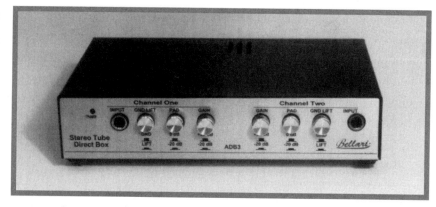

The Bellari® ADB3 stereo tube direct box with ground-lift switch, a -20 dB input pad, a +20 dB gain switch and a -40 to +20 dB output level.

high-frequency detail and the boosting or attenuating of certain frequencies, which results in equalization peaks and dips.

If you have paid big bucks for a beautiful acoustic guitar and an internal pickup, you should not skimp on this important link of the sound chain. Use an active direct box. Although you may not hear the difference when the sound system is less than perfect (since a passive pickup might not be the weakest link in the electronic chain), it will be noticeable when the sound system is very good.

Passive direct boxes are generally used by musicians that play electric keyboards because the low-impedance signals of the keyboard output (600 ohms or less) are easily handled without signal degradation.

Some keyboards manufactured in the 1970s have output impedances of 10,000 ohms or more and unbalanced signals. They sound best when interfaced with keyboard instrument amplifiers that have full range speaker systems that include three different drivers in their cabinets (bass, mid range and tweeter). If they do not have an XLR output, however, the signal must be routed to a direct box to provide a balanced signal to the mixing board. Older keyboards can also be interfaced with an active direct box to convert their high-impedance signals to low ones and provide a balanced signal.

Sampled or digital pianos must be interfaced to the mixing board with a direct box even though they have low-impedance signal outputs because they have unbalanced signals.

Passive direct boxes are widely available and prices range from $25 to $150. The more expensive ones have ground-lift and attenuator switches. The attenuator allows you to reduce the hot preamplifier output of an instrument amplifier down to realistic microphone levels.

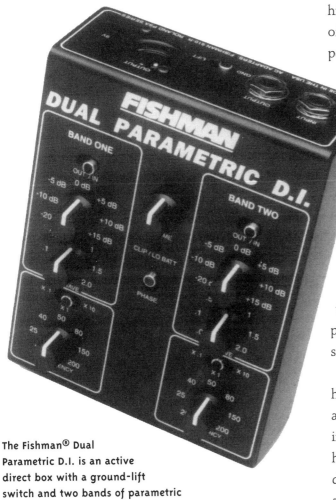

The Fishman® Dual Parametric D.I. is an active direct box with a ground-lift switch and two bands of parametric equalization.

box can run off of the mixing board's phantom power or some other external power supply so you do not have to depend on batteries.

Passive Direct Boxes

Passive direct boxes use internal transformers (rated at a maximum of 50,000 ohms) to convert a high-impedance/mid- to high-level signal from an internal pickup to a low-impedance/low-level signal.

The impedance of these transformers is not sufficiently high to handle the high-input loads of instrument pickups without significantly loading the signal down and degrading its quality. The most notable sound differences are the loss of

Here is how to make a fair comparison between an active and passive direct box (A-B comparison). Plug the pickup into a switch box (hand or foot operated) that contains two outputs. Route the outputs to each of the direct boxes and connect their outputs to separate channels on the mixing board. Listen through headphones. By playing your instrument and switching between them, you should be able to tell the difference and make your choice.

Speaker Simulator Direct Boxes

Speaker simulator direct boxes ("emulator boxes" or "speaker emulators") are designed to emulate the sound coming out of an instrument amplifier's cabinet, particularly those that produce the stylized, distorted sound that is sought by many electric guitarists and acoustic steel string players.

Musicians use this device to avoid using a microphone in front of their instrument amplifier's speaker cabinet. No matter how close to the front of the instrument amplifier's cabinet a microphone is placed, it will also reproduce sounds from other stage instruments, particularly the low bass frequencies. By using emulator boxes, musicians can achieve a sound they like and send an unadulterated signal to the mixing board.

Emulator boxes reduce the instrument amplifier's incoming signal level from about 40 volts to about -40 dBv (about 100 millivolts). They contain equalization devices (frequency bandwidth filters), that roll off frequencies above 5000 Hz. They can be active or passive. Some emulator boxes provide a switch that allows the musician to choose which size instrument amplifier speaker cabinet it will emulate (4-inch by 12-inch closed back or 4-inch by 10-inch open back).

Instrument Amplifiers

Amplifiers take an electrical signal from a source and amplify it (make it larger) so that it is strong enough

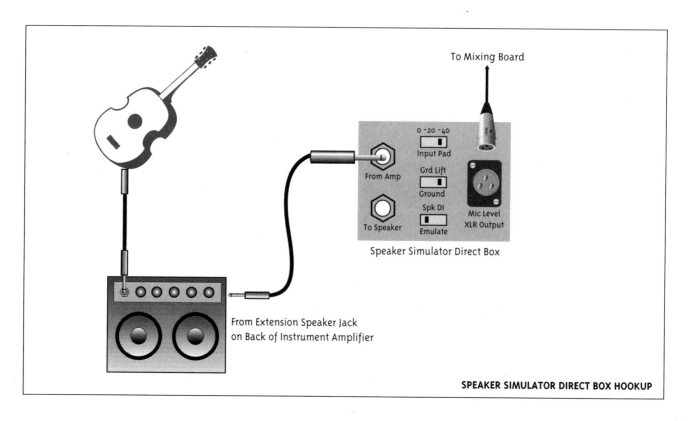

SPEAKER SIMULATOR DIRECT BOX HOOKUP

to set speaker cones in motion to reach a desired volume level. Sound reinforcement amplifiers usually have no tone controls or preamplifiers and are used to drive stage monitors and main speakers, while instrument amplifiers have preamplifiers and tone controls and drive their own speakers.

Acoustic musicians use instrument amplifiers because they provide opportunities for sound processing, such as adding distortion or equalization, to produce a more stylized sound. Many instrument amplifiers can also be connected to outboard effects processors.

Power Output

Power amplifiers that drive monitor and main speakers provide a continuous power rating and a peak power (music power) rating in watts. Sometimes, the power rating includes the acronym RMS, which stands for root mean square. This refers to the mathematical formula used to calculate the amplifier's average power. It is based on using sine waves as reference sources. The difference between average power and peak power (headroom), designates how much reserve capacity a system has for accommodating additional signal levels beyond its average level. Having good headroom means that transients can be accurately reproduced. When the headroom is inadequate transients will be clipped, which distorts the sound. Accurately reproducing the transients makes the sound seem more open and spacious, attributes sought after by many acoustic musicians.

An instrument amplifier's apparent volume depends on the frequency spectrum and dynamics of the instrument, the harmonic overtones generated by the amplifier's power section, and the bandwidth and efficiency of the speakers. Instrument amplifiers generally specify *only* an average continuous power rating and this is equivalent to their maximum output just before clipping occurs. When instruments are played at maximum output there is very little headroom to accurately reproduce abrupt increases in signal levels (transients).

Acoustic musicians need to use less than the average continuous power of their instrument amplifiers to effectively transmit an instrument's transients. This is accomplished by sizing the amplifier to the music that is being played and properly using the gain (volume) control. A rule of thumb is that running an amplifier at half its available average power is sufficient to reproduce the transients.

The amplifier's output controls how much power is routed to its speakers and ultimately to the musicians on the stage and to the audience. This can range from a couple of watts to hundreds of watts. Most instrument amplifiers are built so that they will not blow up their own speakers regardless of any combination of tone and level settings. When different speaker cabinets are substituted, or speaker drivers are replaced in the amplifier's original speaker cabinets, make sure that they can absorb all the output the amplifier is capable of delivering. Simply unplugging the connection into your guitar can cause a strong 60 Hz hum and make confetti of any lower power capacity speakers in its path.

Instrument Amplifier Speakers

Full range instrument amplifiers are used to accurately reproduce the full range of audible frequencies (30 Hz to 20 kHz). They have three types of speaker drivers in their cabinets: a bass driver (woofer) that reproduces low frequencies (30 to 50 Hz up to about 1,000 Hz); a midrange driver that reproduces frequencies of 800 to 3,000 Hz; and a compression driver ("horn") that reproduces the upper end of the audio frequency spectrum (2500 Hz to 20 kHz). They are most often used for instruments such as electric

The Fishman® Acoustic Performer Pro amplifier and monitor features 270 watts of biamped power, which ensures the headroom needed to capture the entire audible acoustic spectrum. Features include multiple inputs and outputs, a feedback-control notch filter, built-in digital reverb, equalizer controls, phase-reverse switch and ground-lift switch. It weighs only 29 pounds.

piano, acoustic guitar, mandolin, violin, etc. They are not used with electric guitars because the high-frequency harmonic overtones that are generated by their amplifiers, which sound harsh, shrill and unpleasant, will be reproduced.

Instrument amplifiers that are designed to produce very stylized sounds, like electric guitar amplifiers, generally contain one, two, or four 10- or 12-inch limited range speakers that only reproduce signals in the middle frequencies (70 Hz to 5 kHz). The amplifiers produce added distortion effects by boosting the gain in their built-in preamplifiers so that they clip at certain volume levels, or at specific frequencies to compress the signal and add harmonic overtones to the distorted signal. The effect of these conditions is an artificially fattened sound.

Many of these amplifiers are designed to not distort at low volumes and some even provide a "clean" channel that produces an undistorted signal and a "dirty" channel that produces a distorted one. Because they are occasionally abused, these amplifiers are designed to be run at full distortion without blowing up their internal speakers. Playing them at full volume is not desirable in an acoustic or unplugged setting where their loud volume levels may overpower the monitor speakers and other instruments and cause volume wars.

Instrument amplifiers that have limited range speakers and built-in distortions are commonly used by electric and steel string guitarists, electric bassists and harmonica players. They can also be used by acoustic instrumentalists that want to add tonal and distortion effects, although the sound will bear little resemblance to the original sound of the instrument.

An amplifier that is producing stylized, distorted signals is perceived as being much louder than an amplifier that is reproducing the full range of frequencies and transients from many instruments simultaneously. Consequently, when the gain is turned all the way up, a 40-watt electric guitar limited range amplifier can easily overpower a 1000-watt sound reinforcement system that has

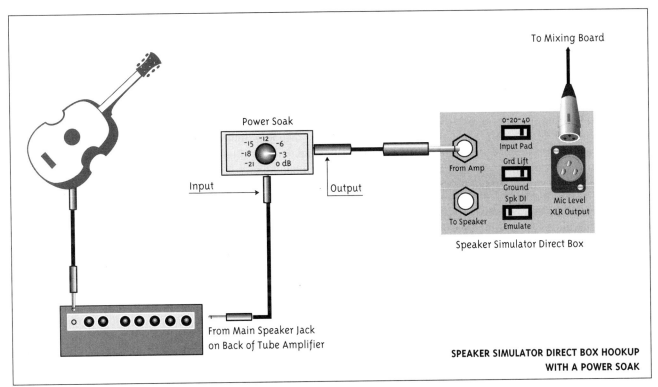

SPEAKER SIMULATOR DIRECT BOX HOOKUP WITH A POWER SOAK

full range speakers. The speakers and amplifiers in the main sound system are designed to simultaneously reproduce the entire frequency ranges of all the instruments being played without adding distortion. If the sound engineer turns up the volume so that the main or monitor speakers are using all the continuous power for which they are rated, the narrow band of frequencies that is produced by an instrument amplifier running at maximum output (full clipping) could overload them and cause their drivers to burn out.

To run a limited range instrument amplifier at full power to emphasize all its distortion effects but not produce a loud volume onstage or overpower the speakers in the main system, a power soak should be used. This device contains a large resistor circuit that "soaks up" or absorbs the large wattage power (load) and sends a small amount of it to the speaker. The signal from the output of the amplifier is connected with a quarter-inch phone cord to the power soak, which in turn is connected to the input of the speaker cabinet with another quarter-inch phone plug. This will tame a 100-watt amplifier down to a 10-watt output and reduce the instrument amplifier's volume on stage.

Transistors and Tubes

Instrument amplifiers have characteristic timbres and tone colors that become pronounced when the amplifiers are driven hard. All amplifiers will clip and distort when their output level reaches maximum. Depending on the types of transistors and tubes used, they produce either more odd-order or even-order harmonic overtones. Musicians can match their instruments' harmonic overtones to those produced by their amplifier or mismatch them, depending on taste.

Transistor Amplifiers

A full range transistor amplifier has little or no characteristic sound of its own when it is not driven into clipping. This is desirable when you want to faithfully reproduce the sound of your acoustic instrument with all the transients.

However, when driven into clipping, full range transistor amplifiers will rapidly clip and produce sudden odd-order (brighter sounding) harmonic overtones that sound shrill and harsh. This may be desirable when you want to use your instrument amplifier to produce a distorted sound for an effect. The musician can further emphasize the distortion by increasing the volume, or further color it with added tone controls and other effects.

Some limited range amplifiers that produce a stylized and distorted sound have additional processing capabilities to help improve the sound of instruments that are driven into clipping. For example, many bass amplifiers have a built-in compressor/limiter that cuts off transients and evens the volume level from note to note. Some transistor designs try to emulate the overdrive and compression of tube amplifiers without the heat, weight and expense. The main advantage of transistor amplifiers is that they are less expensive than equivalent tube amplifiers, weigh less and operate for years with no maintenance.

Tube Amplifiers

Tube amplifiers are designed to match the even-order harmonic overtones of acoustic stringed instruments. Even when used at low power levels, a tube amplifier emphasizes second or fourth order harmonics, technically distorting the sound coming into it. However, many musicians like this because it adds

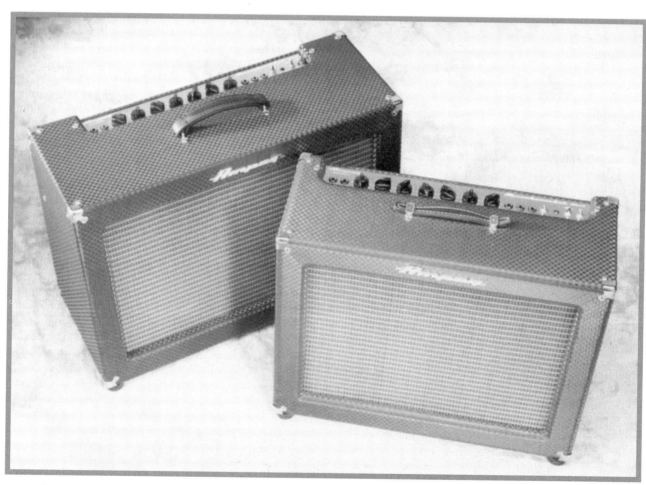

Ampeg® Reverberocket R-12R and R-212R all-tube guitar amplifiers with 12-inch Ampeg vintage speakers.

warmth and sensitivity. Tube amplifiers are usually combined with limited range speakers, which help attenuate some of their high overtones.

When driven into clipping, tube amplifiers produce a distorted sound that gradually escalates as the volume is increased. This effect is not instantaneously harsh and tube amplifiers are said to distort more gracefully than transistor amplifiers. At clipping levels, volume compression and distortion occur, which produces the classic electric guitar sound. Acoustic guitarists can turn up the gain in their tube amplifiers to get this effect, but the sound will be very "electric" and have little of the original sound of the instrument.

Before turning a tube amplifier on, make sure that its speaker is connected. If it isn't, a short can occur in its output tubes that may blow the output transformer as soon as any sound is produced from an instrument. A open or shorted speaker cord can produce the same results and cause amplifier destruction in a few seconds.

A tube amplifier should only be run when not connected to its speakers under the following special circumstance: when it is used as a processor to produce a distorted effect at high gain settings that is not reproduced through its speakers. This can be accomplished with the following method. Before any power is turned on, the tube amplifier's head is disconnected from its speaker. A phone plug cable is used to connect the tube amplifier head to a power soak device. The pass-through signal from the power soak is routed to a speaker simulator direct box by the microphone level out. This will safely absorb the tube amplifier's output and retain its distortion and compression characteristics, while it sends a microphone level signal to the mixing board, which can be routed to the stage monitors and main speakers. This technique allows the sound engineer to reproduce the tube amplifier's loud distorted signal for the audience and avoid overpowering the sound of the other instruments in the monitor speakers.

Tube amplifiers are more expensive to manufacture than transistor amplifiers, and are more fragile. They run hotter than transistor amplifiers because of tube filaments and a lower efficiency. The tubes have a two- to five-year average life span under normal use. Some tube amplifiers have cooling fans, which must be evaluated for the noise they produce on stage.

Tube amplifiers need to be maintained on at least a yearly basis, as the tubes will develop contact corrosion. Their heat will melt the solder in their sockets and age can cause cotton insulated wires to fray and plastic insulation to harden and break.

Unless you are highly skilled and experienced, do not try to maintain tube amplifiers by yourself. They have up to 700 volts DC on most of their components, easily enough to kill you in a heartbeat.

Field-Effect Transistor Amplifier

A field-effect transistor (FET) amplifier emulates the valve action of tubes and has a high-input impedance (1,000,000 ohms or more). It produces more even-order harmonics during distortion and therefore sounds more like a tube amplifier than a standard transistor does. A few instrument amplifiers utilize FETs, which can sound more musical when clipped or distorted, in their output stages.

Hybrid Tube/Transistor Amplifier

Some amplifiers have a tube preamplifier section, which allows musicians to add emphasis to even-order harmonics, and a transistor output section that enables the signal to be cleanly amplified. Since you will (hopefully) seldom drive these transistor output stages into clipping, you can get all the distortion and compression you want from the tube

preamplifier section and the muscle for the speakers from the transistor power output section. Most of these amplifiers have limited range speakers and are designed to be used by electric guitars and bass.

Many of these amplifiers allow for MIDI control of presets, which lets you design sound for each song.

Total Harmonic Distortion

Total harmonic distortion (THD) measures the accuracy of the sound reproduction. It is rated in percent, such as 1% or .1%. Sound reinforcement amplifiers are always rated for THD, since accuracy is paramount. However, since many instrument amplifiers are designed to distort, harmonic distortion ratings are not very useful. Although few manufacturers provide a THD rating for instrument amplifiers, schematics sometimes show the distortion levels that the amplifier is putting out at its maximum output power, usually between 2% and 5% distortion. Limited range speakers are manufactured to produce a stylized sound, even at low volumes; and tube amplifiers tend to emphasize even-order harmonics, even when not driven into clipping.

The question is how cleanly does the instrument amplifier distort the signal? Some amplifiers seem to distort effortlessly and allow individual notes to be heard within the distortion, while other amplifiers turn everything to mud once they start clipping. Your ears are your guides.

Tone Control

Instrument amplifiers provide equalization controls that allow musicians to adjust the relative strength of the frequencies being reproduced. Some amplifiers provide control over only the bass and treble frequencies; others provide a graphic equalizer, which breaks the frequency spectrum into a fixed number of bands; others use a parametric equalizer, which features tunable frequency controls and the ability to cut or boost each selected frequency. Most full range instrument amplifiers provide more complex equalization controls than their limited range counterparts. If the amplifiers do not provide ample tone control, the sound engineer can add tonal qualities by using the equalization controls on the microphone input channel of the mixing board.

Some limited range instrument amplifiers have an overall volume control between the tone controls and the output stage (master volume control). This allows the musician to turn the output of the amplifier down and still produce the desired distortion effects from the amplifier's tone controls or other effects devices. (Effects devices are discussed in Chapter 4, "Effects, Sound Processing and Outboard Preamplifiers.")

Some limited range guitar amplifiers provide two internally programmed amplifier sounds ("lead" and "rhythm"), each boosts or attenuates certain frequencies. A switching control, accessible via foot pedal enables the musician to rapidly switch from one to the other.

Some of the more expensive instrument amplifiers are programmable and have a built-in MIDI-controller that allows the musician to program hundreds of different sounds.

Signal Routing

The sound of an instrument amplifier is captured by placing a microphone within two to three inches of the amplifier's speaker. The microphone's signal is transferred to an audio snake that enables the signals of individual cables to be combined and carried through one long multichannel cable to the mixing board. The disadvantage here is that sounds from other instruments, particularly the low bass frequencies, can be captured by the microphone and clutter the sound.

Some instrument amplifiers that are designed for bass guitar or keyboards have XLR outputs to provide a clean, balanced signal to the mixing board. If the instrument amplifier has only a quarter-inch phone plug connector output, route the signal into an active or passive direct box (if the amplifier is not being used to produce a distorted signal) or into a speaker simulator direct box if the amplifier is being used to produce a distorted signal. In both cases, the direct box's attenuator control should be turned to line level. The direct box will change the instrument amplifier's high-level unbalanced signal into a microphone level balanced one.

Some sound engineers like to use two different signals in different microphone input channels. They will place a microphone on the instrument amplifier's speaker cabinet and also send a clean signal to the mixing board from a direct box or XLR output from the instrument amplifier, which gives them greater control over the volume of the signal in the main and monitor speakers.

Some instrument amplifiers have a switch that gives musicians the choice of whether to route its direct send output signal from before or after the tone controls ("Pre" and "Post"). The "Pre" send gives the sound engineer a signal that is not affected by adjustments of the instrument amplifier tone controls. Adjustments made to the tone controls routed as "Post" sends will affect the signal that is sent to the sound engineer.

Some instrument amplifiers have an output and input labeled "FX out" and "FX in" for effects devices such as flangers, limiters, and delays. (Information on these devices is explained in Chapter 4, "Effects, Sound Processing and Outboard Preamplifiers.") An input of an effect can be connected to the "FX out," and its signal is returned to the "FX in." A foot switch enables the musician to engage or cancel the effect.

Grounding

Most modern instrument amplifiers have a grounded chassis to reduce electrical shock hazard. Many old amplifiers had an ungrounded power cord with only two prongs on the plug and a grounding switch, designated "ground" or "polarity" on the back of the amplifier that could be switched one way or the other until the hum went away. Unfortunately, if a capacitor in that circuit shorted out, the chassis voltage could be raised instantly to 120 volts, making it a death trap for the musicians playing through it. An amplifier of this type should have its power cord changed to a standard grounded three-prong power cord by a qualified technician. (Do not plug in a three-pronged adapter.)

The newer amplifiers have a grounded power cord that grounds the chassis at all times. However, if you use a direct box, be sure to use one that has a ground-lift switch and make sure the ground is lifted to prevent ground loops with the mixing board. (An amplifier with an XLR output will usually have a ground-lift switch to prevent ground loops that occur when you connect it to the mixing board.)

If the XLR output of an amplifier does not have a ground-lift switch, you should first route the output signal from the instrument amplifier into a direct box that does and then route that signal to the mixing board.

Never use a ground cheater plug or break off the ground pin that plugs into the 120-volt wall outlet. This is inviting disaster for both personnel and equipment. If a power transformer shorts to an amplifier chassis, the full 120 volts can be sent into the mixer and wreak havoc on the equipment and the user.

Musicians should do the following when confronted with a venue that does not have grounded outlets. Plug sound reinforcement equipment and instrument amplifiers into a common power strip

that is plugged into the wall with a ground cheater plug. Be sure to attach the collar of the cheater plug to the outlet with the cover plate screw. Be aware that although this will prevent getting electrical shocks from the stage equipment and the microphones it is still a dangerous setup. A person who touches any other grounded surface such as a radiator or cold water pipe while playing an amplified instrument could be instantaneously electrocuted. The best plan is to run a long, heavy-duty grounded extension cord from a properly grounded outlet to the stage and mixing board.

Be careful when plugging in the signal from a nongrounded instrument amplifier into a mixing board. You can get shocked from the voltage difference between two pieces of equipment, especially if one has a leaky power transformer. If you are holding a cable in one sweaty hand and touch the amplifier chassis with the other, the shock will hurt and can be deadly.

Choosing an Instrument Amplifier

If you want to reproduce the sound of the acoustic instruments as accurately as possible, your best bet is to use a full range system and use much less power than the amplifier provides so that it can reproduce the full range of your instrument's frequencies and not clip its transients. Amplifiers that are rated at 100 watts are ample for acoustic guitar, fiddle, mandolin and etc.; 200 watts are ample for electric keyboard, synthesizer, violin, string bass and digital piano.

If you want a limited range system that still reproduces most of the frequencies, use one with 40 to 80 watts and use only half its power. If you are going to use the amplifier for its distortion effects, 10 to 40 watts will be adequate for instruments like guitar or bass.

However, be aware that many limited range systems have high self-noise and produce very high levels of hum and hiss, which are especially noticeable at low volume. Tube amplifiers tend to have more self-noise than transistor amplifiers (this noise level is increased if they contain cooling fans). Although self-noise is acceptable for loud electric performances where it is masked by the sheer volume of other instruments, it is distracting in a quiet acoustic performance.

If you are selecting a limited range amplifier for the stylized distortion effects it produces, let your ears be your guide.

Some high-end instrument amplifiers have built-in XLR outputs and a ground-lift switch. This simplifies stage hookups and assures the most consistent sound under all conditions.

Volume Wars

The loudest instrument on stage determines the minimum volume of the mix of sounds from all instruments that the sound engineer provides to the monitor and main speakers. When an instrument amplifier is used at a loud volume on stage, the engineer will first increase the volume of the other instruments in the mix to be equal and then increase the volume of the other instruments in the monitors to allow each musician to hear their own instrument. At the same time, the engineer will adjust the volume of the mix for the audience. This may cause a musician who is used to hearing the instrument amplifier to turn up its volume and start a new cycle of volume escalation in the monitor and main speakers that results in a "volume war." Even though a sound engineer could overpower almost any stage amplifier with a powerful sound reinforcement system, the result could drive the sound to painful levels and cause hearing damage.

Acoustic performers should not use instrument amplifiers to project sound to the audience. Instead, they should adjust the volume just high enough to

hear the tone controls they are using and let the sound engineer amplify the sound in their monitor speakers and in the mains. Musicians that switch from playing electric instruments to acoustic instruments sometimes have a difficult time becoming accustomed to hearing what they are playing through full range and relatively low-volume stage monitor speakers. Although they may use smaller wattage instrument amplifiers, downsizing from 100-watt amplifiers to 40-watt, they often set the gain controls to full continuous power so that they can hear their instrument at the volume they were accustomed to when playing electric. They need to retrain themselves to listen through the monitor speakers at realistic stage volumes.

The only situations that warrant an acoustic musician using an instrument amplifier to project to the room are a solo guitarist playing in a relatively small room, where the amplifier serves as both the monitor and main speaker or, when the volume can be kept to a minimum, an instrument amplifier that is designed for piano or electronic keyboard and has two channel inputs might be used for a guitar pickup and a vocal microphone. The differing and competing frequencies produced by the guitar and voice will not be noticeable until more power is put through the amplifier's speaker. If a cardioid microphone is used for the voice, its proximity boost characteristic can be used to emphasize the vocal bass frequencies without increasing the instrument amplifier's volume.

Effects, Sound Processing and Outboard Preamplifiers

Chapter 4

Sound processing devices are used by musicians and sound engineers to change and control the sound of instruments and alter the sound of an individual instrument, a group of instruments or the final mix. Processing can vary from adding a simple echo or reverb to a complete metamorphosis that leaves no clue as to the original instrument.

Acoustic musicians generally use much less processing than electric musicians, and their effects need to be of higher quality. It is better to buy a few high quality effects, than numerous cheap ones.

There are two types of electronic signal processing, analog and digital. Analog processors manipulate the signal with electronic components. Digital processors convert the audio signal into binary code by breaking down the information into audio bits. The higher the rate at which the musical bits are sampled, the better the sound quality. A 20-bit sampling rate will be cleaner than a 14-bit sampling rate and will be of CD quality or better. After processing, the binary code is changed back to analog format by a digital-to-analog converter.

Effects devices can be divided into two types of packages, instrument and board. Instrument effects are stand-alone units that have quarter-inch unbalanced inputs and outputs and are engaged by foot

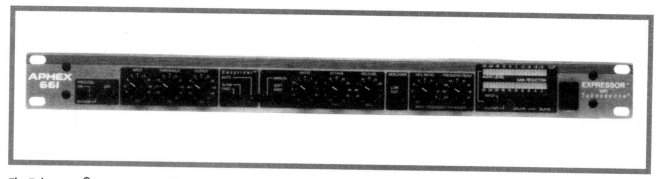

The Tubessence® Expressor™ Model 661 with Easyrider® is a single-channel tube compressor/limiter with automatic and manual operation from Aphex® Systems.

operated pedals. These foot pedal effects are powered by either an internal battery or a wall mounted power transformer (wall wart).

Many instrument effects that were manufactured before 1975 had high self-noise, which added a great deal of hiss to their signal. Modern units are quieter. However, instruments that use low-output passive pickups will not produce sufficient signal levels to overcome the self-noise of even modern effects boxes. Routing a passive pickup's signal through an outboard preamplifier will boost it above the hiss produced by an effect device.

Instruments that have active internal pickups generally produce strong enough signals to overcome effects devices that have noise problems.

Board effects are normally mounted into standard 19-inch racks and have balanced quarter-inch or XLR inputs and outputs that provide routing flexibility. These effects are generally engaged and disengaged by switches on the mixing board's microphone input channels. The circuits of board effects are designed to be low self-noise and high-fidelity.

Some devices combine multiple effects in one unit and provide switching via analog components or MIDI controllers. Both instrument and board effects can be controlled by a MIDI controller that enables the user to preprogram multiple effects for different songs.

Limiters and Compressors

The main job of limiters and compressors is to get as much level (loudness) as possible out of a sound system or onto a recording tape without distorting the signal or allowing the speakers to be damaged.

Limiters and compressors do the same thing to different degrees. They detect the level of the signal and compress its dynamics. This can mean anything from just lowering the level of the screams to complete automatic level control that eliminates any of the music's dynamics. When the dynamic peaks are controlled the volume of low-level passages can be made louder. A musical program that has been compressed or limited will sound louder than an identical musical program that has not, even though the peak signal level is the same for both.

Moreover, once the signal is limited, the overall gain and volume of the entire musical program can be raised without distortion on the transients. You cannot tell a singer not to shout into the microphone, and limiters offer a convenient method to produce an even, undistorted mix. If musicians want the sound engineer to attenuate their volume if it starts getting too loud, the engineer would use a limiter or compressor instead of continuously turning the microphone channels' gain controls louder and softer (riding the gain).

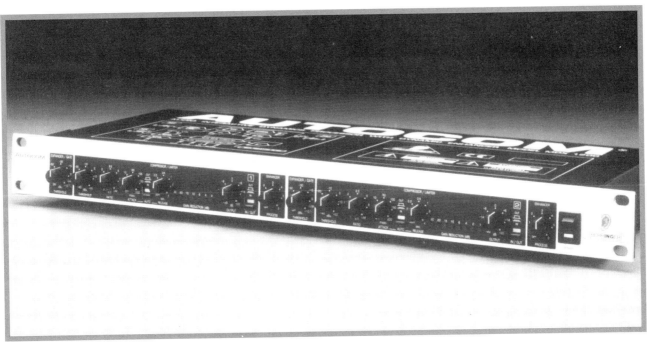

The Behringer® MDX-1200 interactive Autocom compressor/limiter and interactive expander/noise gate with dynamic enhancer.

Limiters and compressors also protect the high-compression speakers (tweeters) in main and monitor systems against overloading and burning out from the violent increases in power produced by sudden loud transients, such as when a cellist or bassist begins slapping their strings.

Limiters clamp any volume rise above a given threshold. Once the sound reaches the given preset level, input (volume) increases are clamped and not allowed to get louder. If the rise in volume is slow and steady, limiters do their jobs without much of a problem.

Limiters and compressors may be used on the entire musical program during the final mixdown; or on a single instrument. However, using a limiter on a musical program that has lots of changing dynamics and bass frequencies can produce a surging or pumping effect because the bass notes cause other instruments to drop in volume with each beat.

Limiters and compressors have four adjustable parameters: attack time, release time, threshold and compression ratio. These parameters are often preset in inexpensive units; high-end units have controls that allow you to adjust each individual parameter. Some compressors are user friendly, others are very touchy. Some will allow you to put almost anything through them without distortion, while you will have to struggle with others to get them to sound good at all.

Attack Time

The attack time specifies how quickly the compressor or limiter will react to the incoming signal, usually from 20 microseconds (.00002 seconds) to 300 milliseconds (.300 seconds). One millisecond (.001 second) is sufficient for most material. Very fast attack times will clamp down all the transients and slow attack times will allow some dynamics through before they are limited. For example, if a short attack time is used to limit the transients that are produced by sticks hitting drums the sound will be muffled because the overtones and transients will be lost.

A longer attack time will allow some of the transients and overtones through and give one a feel for the actual dynamics of the instrument while reducing them enough to prevent system overload.

Release Time

The release time specifies how long the compressor or limiter takes to let the signal return to its original volume level, usually from 50 to 1500 milliseconds (.050 to 1.5 seconds).

If the release time is set at too fast a duration some of the music will be severely attenuated. For example, one stroke of a stick on a drum will cause vocals and other instruments to disappear for a fraction of a second and then rise again. Sound engineers call this a "punch-down effect."

If the release time is set for too short a duration the signal will be distorted and will produce a kind of pumping effect that is similar to a tremolo.

Threshold

The threshold defines the minimum volume level that you want to engage, usually from -40 to +20 dBv. For example, if you specify that the threshold is -10 dBv, no compression effects will be engaged on signal levels that are below that.

Compression Ratio

The compression ratio specifies the degree to which a compressor keeps the audio signal at a constant volume level above the specified threshold. Volume levels are compressed proportionately. A 1:1 ratio means that no signal will be compressed. A 2:1 ratio indicates that as the input signal is raised by 6 dB, the output signal is raised by 3 dB. A 10:1 compression ratio indicates that as the input signal is raised 10 dB, the output signal will change by only 1 dB. Ratios above 10:1 make the compressor act like a limiter. Once the input level reaches the threshold volume the output signal will not go any higher, no matter how high the level of the input signal.

Noise Gates and Expanders

Noise gates are used to eliminate low-frequency hum, hiss and other unwanted noise from an instrument or a microphone channel. They are voltage controlled amplifiers that can be set to attenuate or cut-off any signal that is below a given threshold. As soon as the signal level comes up the gate opens and allows the sound to pass through. They are often used with compressors to kill the sound of a microphone that no instrument is being played into during a performance where musicians are

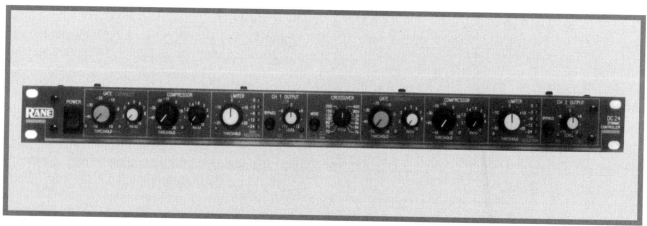

The Rane® Model DC 24 Dynamic Controller from Rane Corporation is a two-channel compressor, limiter and expander gate with separate compressor and limiter controls.

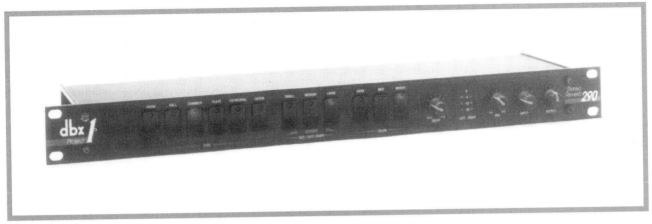

The dbx® stereo reverb features six standard reverb sounds—room, hall, chamber, plate, cathedral and gated—and three ambience colors—dark, medium and bright.

continuously changing instrumentation and microphones. By preventing sounds from getting into open microphones a cleaner mix can be provided as well as more gain without feedback.

If not properly set, noise gates can alter the attack and decay characteristics of the original sound. They are used extensively on drums and electric guitars to clean up their tracks. Noise gates are finicky at best and are very sensitive to sound level changes and ambient noise. They are used infrequently for sound reinforcement of acoustic instruments, which are normally played with a great amount of dynamic range.

Expanders are noise gates with a slow turnoff ratio. When music gets below a preset volume expanders cause the signal to be attenuated at a controllable speed, which increases the dynamic range and eliminates unwanted noise. They are of limited use for acoustic acts.

Reverb and Echo

The terms reverb and echo are often used interchangeably, even though they are two different effects. Echo produces a distinctive repeat of a word or musical phrase. Reverb is the natural sound scattering that occurs in all large rooms as sound waves bounce from surface to surface. It is heard as an even wash of sound that gradually decays over several seconds.

How much echo and reverb are used in an acoustic performance is a matter of taste. Live sound reinforcement seems to tolerate more added reverb than live recordings. If you are recording live to two-track from the main outputs of a board, mix with as little added reverb as possible, as you can always add more later when you remaster the tape. It is impossible to remove a dense wash of reverb from a recorded live performance after the fact.

Some outboard reverbs have a special control called a "gated reverb" that produces an effect that has a dense reverb sound that is abruptly cut off with a gate. A gated drum sound is commonly used by acoustic and electric acts.

Flangers

A flanger creates a swishing, swirling effect by using a low-frequency oscillator (LFO), a circuit that sweeps the delay time up and down very slowly, usually less than once per second.

Typical controls include speed, depth, amount and regeneration. The speed control allows you to adjust how fast the LFO cycles, anywhere from

once every 10 seconds to many times per second. The depth control changes how much this signal will change the length of the delay. The amount control adjusts the loudness of the affected signal before it is mixed back with the original signal.

The regeneration control is a feedback generator that allows some of the modified output signal to be mixed back into the input of the effect, which loops it and produces the metallic, ringing sound reminiscent of feedback.

The flanger can produce anything from a very light "swish," all the way to a frequency shift where a particular note is bent up and down. Although flanging is not a natural sound, some acoustic musicians use it for special effects.

Most digital delays can produce a flanging effect by creating a 2- to 20-millisecond time delay and using an LFO to modulate the delay.

Phase Shifters

Phase shifters produce an effect similar to that of flangers, but work on a different principle. The incoming signal is split into two circuit pathways: one adds nothing; the other adds a series of fixed time delays that are continuously modulated by a low-frequency oscillator. When the signals are recombined, they are out of phase with each other, which produces a swirling, whooshing sound without the pitch shift caused by flangers. While interesting, this effect does not occur naturally, so its use with acoustic instruments is limited. Phase shifter pedals can be purchased for as little as $60, but listen carefully before you buy. Inexpensive units have a lot of self-noise and will introduce a tremendous amount of hiss into your signal.

Aural Exciters

An aural exciter works by using a low-pass filter that is set to a frequency range a little higher than the normal range of the instrument or voice that is to be processed. The signal is then sent to a distortion circuit where harmonic overtones are added. When this distorted signal is mixed back with the original, the sound is harmonically enriched. Aural exciters are great at adding top end to a signal that was frequency limited by tape or transmission losses. They can boost the highs on an old cassette tape without boosting the hiss. Also, they can be used to "thicken up" a sound that has a thin top end. This is similar to the warming effect of tube preamplifiers, which add harmonics to signals to make them seem warmer.

Enhancers

An enhancer is a final processing device used to produce the illusion of more bass and treble without extra amplification or equalization. While not really an effect, it can add perceivable highs to a dull

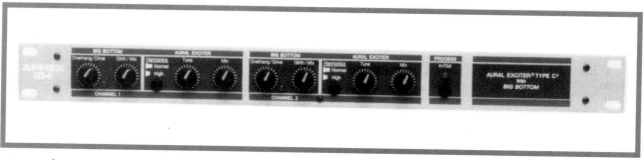

The Aphex® 104 Aural Exciter® type C² from Aphex Systems features the BIG BOTTOM™ circuit that increases bass presence and impact without significantly increasing transient peaks.

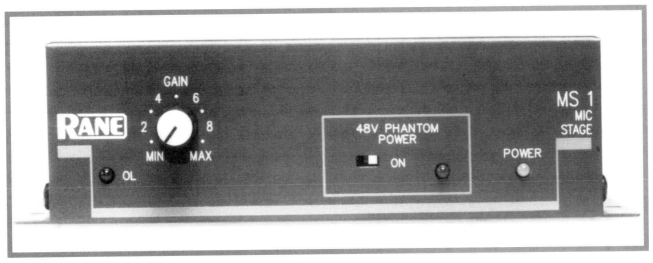

The Rane® MS 1 microphone stage preamplifier from Rane Corporation is used with dynamic, condenser or electret microphones and provides 48-volt switchable phantom power, rotary gain, overload LED and three-pin balanced input and output.

sounding system and make an inexpensive speaker system sound better than it really is. It uses a built-in multifrequency band compressor to attenuate midrange frequencies when a high-frequency sound is present. This allows the output to sound like it has more highs when in actuality there is less midrange. Consequently, you avoid the penalties for boosting the high frequencies: increased tape distortion, blown tweeters, and overloaded amplifiers.

MIDI Controllers

A MIDI controller can "remember" settings. They are used for everything from lighting controls to programming effects devices so that all programmed effects can be recalled with the push of a button.

Hundreds of patches can be easily set and recalled in a fraction of a second, even midnote. With patch mapping (MIDI function that allows a single controller message to access a variety of MIDI effects, each with its own group of settings) multiple effects can be programmed to respond to the same signal. For instance, a single patch can set up reverb, echo, compressor, and equalizer without missing a note.

Outboard Preamplifiers

A preamplifier boosts a low-level signal from a microphone, pickup or other source to the level where other circuits can accept it without adding noise. Preamplifiers can be separate pieces of equipment (outboard preamplifiers) or can be built-in, such as the preamplifier section of a mixing board's microphone input channel.

Outboard preamplifiers use more expensive (sometimes hand-selected and/or custom) components than are found in most mixing boards. They generally have superior signal-to-noise ratios and better frequency response. They sometimes utilize transformer isolation to reduce the possibility of ground-loop induced hum from radio frequencies, etc., and are quieter than the input stages of many mixing boards.

Outboard preamplifiers are used to precondition the signal before it enters the board. They take the place of microphone preamplifiers in the mixing board and compensate for any self-noise or distortion the built-in preamplifiers may produce. If the output of the outboard preamplifier is an unbalanced signal it is plugged into an unbalanced line

level input of the mixing board and bypasses the microphone channel inputs.

Musicians use instrument preamplifiers that are designed for use with pickups and electret condenser microphones. Many come with multiple inputs. A musician can use two pickups on one instrument and combine their signals before routing them to the mixing board's microphone input channel. They lower impedances and provide a way to adjust signal level and tone. Acoustic bands find them useful because they are quieter and lower the noise floor and reduce hiss and hum. They can be used with condenser microphones that require phantom power even if the mixing board does not supply it.

Outboard Equalizers

Equalizers adjust the relative strength of frequencies by dividing the audio spectrum into separately controllable ranges. They are super tone controls that can be used to make instruments sound different and fix problems by boosting or attenuating problem frequencies and feedback.

Although equalizers are found in microphone preamplifiers, instrument amplifiers, mixing board input channels, etc., they are also manufactured as stand-alone pieces of equipment. The simplest equalizers consist of treble and bass controls; more complex equalizers break the frequency spectrum into a number of bands—from 3 to 31, and each band is controlled by a fader or rotary control. This provides control over many frequencies simultaneously. The relative positions of the faders in a graphic equalizer provide a visual ("graphic") display of the overall frequency response curve. A one-third octave graphic equalizer breaks up each musical octave into three bands.

A stereo equalizer provides two equalizers in the same chassis so that the sound engineer can route each equalizer's signal to two different mixes, such as to the monitor speakers and mains; or to two separate monitor mixes.

A parametric equalizer has controls that broaden or narrow a selected frequency band and zero in on a particular range or tone that needs to be accented or attenuated. It offers more specialized control than a graphic equalizer. There are independent controls for gain, frequency and bandwidth (including a continuously adjustable "Q,"

The Behringer® DSP 8000 mainframe Ultra-Curve® one-third octave digital equalizer includes such extras as a real-time analyzer.

The Sabine™ FBX-SOLO 620 Feedback Exterminator® features switchable narrow one-fifth to one-tenth octave filters. It automatically senses feedback and quickly places a narrow digital filter directly on the resonating frequency to eliminate the feedback. The SM-620 is used for microphones with XLR connectors and features switchable 48-volt phantom power. The SL-620 is for quarter-inch connections.

the control that varies the width of the affected frequency band. A very wide frequency range is affected when "Q" is set to .1 and a narrow frequency range is affected when "Q" is set to 10.

Signal Routing

Each type of processing gear and effects device needs to be hooked up in the appropriate part of the signal chain to work properly. The way they are routed also affects who controls their sound. Processing gear that is designed to be used by musicians with their instruments usually hooks up differently from gear designed to be used by the sound engineer. The way they are routed allows further manipulation of the sound. The engineer can set up a variety of routing pathways to provide flexibility in manipulating the sound on individual instruments, groups of instruments or the sound of all instruments together in the final mix.

Serial Routing: Effects Used with Instruments

When effects devices are used in a typical instrument sound chain, all effects go in a line, in daisy chain fashion. Each device feeds the next one, until the signal is delivered to an instrument amplifier. The most commonly used chain connects the instrument to a compressor then a time delay effect (like a flanger), and ends with reverberation. The signal is then routed to the mixing board's microphone input channel. The musician controls the level and volume of the signal and the sound engineer does not add any further coloration.

Each device will have a bypass signal switch and a mix control (when appropriate). The bypass switch provides a straight through path for the signal when no processing is desired in a particular effect.

The mix control varies the amount of processing to be added or mixed into the original signal, while it passes some of the original signal intact.

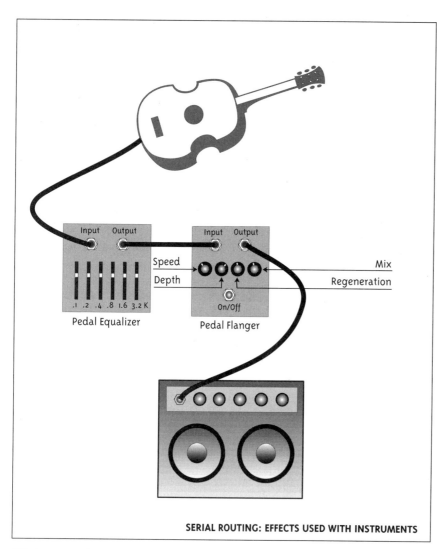

SERIAL ROUTING: EFFECTS USED WITH INSTRUMENTS

When using processing devices on individual instruments, the sound engineer connects an insert cable that is shaped like a "Y" to the channel insert that is located on the mixing board's microphone input channel. The channel insert reroutes the instrument's signal to an outboard processor or group of processors and returns it to the input channel. The output end of the insert cable feeds the signal into a processor and the other end returns it. An insert cable consists of a quarter-inch stereo plug that is connected to two quarter-inch mono plugs.

When using processing devices on a group of microphone inputs, the engineer will route their signals, by using the bus select controls, to a subgroup channel (submaster) on the mixing board before routing them to the processing devices via an insert cable. Grouping all vocals to a subgroup channel and using a compressor/limiter is an excellent way to prevent vocal peaks from getting into the mix.

Sometimes outboard processors are placed on every instrument and voice, which requires an insert cable for each channel. Then separate processing of each instrument can be adjusted as needed. Since many insert cables will be required, clearly marking one end as input and the other as output will ensure that the cables are plugged into the processors correctly. Plugging in the cables backwards will result in no sound at all. Generally, the sleeve of the TRS plug is the output of the channel and the tip is the return from the external processor.

Without such a control you might hear only the echo of a digital delay and not the signal that is actually being delayed. Also, effects like flanging require a mix of the original and delayed signal. Without this interaction of straight and delayed signals there would be no flange effect, just a mildly annoying vibrato.

Serial Routing: Processing Devices

When sound engineers use outboard equalizers and compressors to control dynamics and tone of a single input or group of inputs, their signal paths must be isolated before their signals reach the final mix bus.

EFFECTS, SOUND PROCESSING AND OUTBOARD PREAMPLIFIERS 61

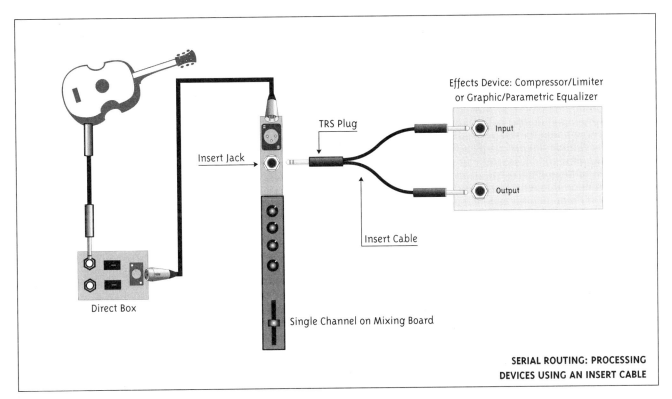

SERIAL ROUTING: PROCESSING DEVICES USING AN INSERT CABLE

Parallel Routing: Processing Devices

Parallel processing is used to vary the amount of reverb, flanging or echo for different instruments before routing their signals to the final mix. The effects devices are connected to the auxiliary outputs of the mixing board (mixing boards may supply more than one, designated as "Aux 1," "Aux 2," or "EFX 1," "EFX 2" etc.) and are mixed from the microphone input channels. The auxiliary send control ("Aux" or "EFX") on each microphone input channel controls the amount of the signal that is sent to that auxiliary bus and finally to the effects device. The engineer can determine how much signal (relative volume) from each channel gets sent to the effects box, and how loud the total effect will be. If the auxiliary send control is turned off, the signal is sent unaltered to the final mix via the subgroup or main mix bus.

The sound engineer controls the sum of the signals from instruments, to which effects have been added, by using the auxiliary return control

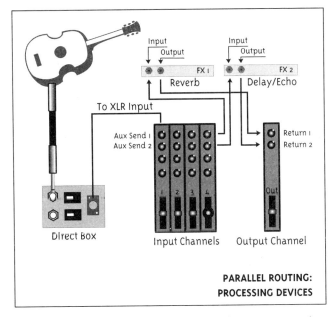

PARALLEL ROUTING: PROCESSING DEVICES

that is located on the mixing board's main panel. This is a master volume control for the auxiliary mixes. The signal is then returned from the effects device to the main mix bus via an auxiliary return control, which determines how loud the affected signal will be in the final mix.

Monitoring Systems

Chapter 5

The monitor system is generally more problematic than any other part of the sound system. Performers certainly need to hear themselves, but from a sound engineer's perspective, the fewer monitors, instrument amplifiers and mixes, the better. The sounds from the stage monitor speakers tend to bleed into open microphones and pickups, which muddies the low frequencies and causes a time delay echo that smears the sound. The sound of loud monitors echoes from ceilings and other hard surfaces and leaks into the audience. This adds up to a several hundred millisecond time delay to the sound from the main speakers, which colors it and increases the chance of feedback. The higher the stage volume, the greater the problem. Note definition is not clean and will contribute to audience listening fatigue (a psychoacoustic phenomenon that makes a person tire of listening to music for no apparent cause).

Monitor systems can attain painful levels of feedback and muddiness. There have been numerous occasions when stage monitors produced enough volume in the audience so as to make the use of main speakers unnecessary. Unfortunately, the balance of this reflected sound is usually less than ideal. However, a properly designed, implemented and

operated monitor system can provide the performer with needed sound cues without the embarrassment of feedback and poor sound.

Why Performers Need Monitors

Monitors help performers hear what they are singing or playing. Without monitors, you would have to contend with sound delays of up to a few hundred milliseconds that are caused by the time it takes for the sound from the main speakers to make the trip to the back of the room and return to the stage. Performing in such a reverberant field is extremely difficult. Stage monitors provide direct sound with little delay, which provides the timing cues musicians need.

Monitors also enable performers to hear what the other musicians are playing. They may want to hear the same mix as the audience is hearing or they may want to hear their own voice or instrument louder in relationship to the other band members. For example, lead vocalists may want to hear their own voices louder than other instruments; the percussionist may need to hear the acoustic guitarists; and so on.

The sound engineer must determine, through questions and by example, what it will take to accomplish the required mixes without ruining the show for the audience or the promoter.

Avoiding Volume Wars

Most conflicts between musicians, promoters and sound engineers occur because of monitor mixes. This is because traditional floor mounted speakers cannot always achieve the volume or separation of instruments that each musician wants to hear. The primary reason for this is that the volume in the house system has to be at least three decibels louder than the volume of the stage sound so that the audience hears the properly balanced main speakers and not the monitors. The volume in the house is controlled by the owner of the venue and any laws that the community has imposed. How well a sound engineer sorts through disparate needs (musicians on stage, audience, room, promoter) can determine whether or not a show is successful.

The responsibility for reasonable monitor levels is borne by the musicians.

Generally, the single loudest instrument on stage determines the lowest possible volume level of the monitors. If the drums are the loudest instrument, the vocal monitors have to be adjusted so that the singers can hear themselves above them. If a musician with a loud instrument shares the stage with a musician playing a soft instrument, the monitor volume of the soft instrument will have to be louder than the loudest instrument so that it can be heard.

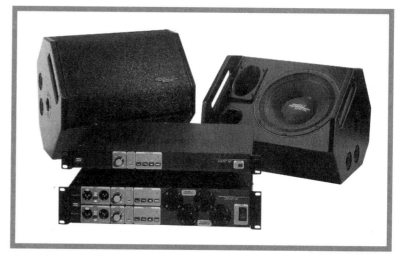

The Apogee mono-amp AE 3Ms2 stage monitoring system is suitable for concerts, clubs, discos and church choirs. The AE 3Ms2 loudspeaker contains one 10-inch woofer and one 1-inch horn tweeter and is used with the Apogee P-3 processor, which performs crossover functions and provides speaker specific equalization and driver protection. The road version of the processor has line input and speaker output connections on the front panel. A version designed for permanent installations is also available.

Groups that play loudly on stage and need high levels in their monitors make it virtually impossible for the sound engineer to turn down the volume of the mix for the audience. This is just plain and simple physics. If the musicians do not turn down the volume on stage the engineer will have to turn up the volume in the main speaker system to overpower the sound that bleeds from the stage and present a balanced mix to the audience. The quintessential example is the electric guitarist performing in a small club with a 100-watt Marshall stack. If the guitarist turns up his amplifier the engineer cannot turn down that instrument in the mix. If anyone is to hear the other instruments the rest of the mix must be at least as loud as the guitar. There is nothing else that can be done except to pull the plug on the Marshall. In a small room this volume can be disastrous and painful.

The louder the sound, the muddier it becomes due to the reflection off hard walls or ceilings that sends extraneous information back into the microphones. This is not purely an electric musician phenomenon as many acoustic artists that formerly played electric still equate loud monitor volume with good sound.

During one outdoor festival an acoustic artist who was making a comeback after his successful '70s electric career came onstage with an acoustic guitar that had an internal pickup. He needed one vocal microphone and no stage amplifier. Although I set a pair of biamped floor wedges that provided 1800 watts directly in front of his microphone, he complained that he could not hear the monitors. My estimate was that he was hearing in excess of 120 dB SPL, which borders on pain. This stage sound was so loud that it bounced off the back of the stage and made the sound muddy for the audience.

An added complexity is that an acoustic instrument heard from the monitor and/or house speakers might sound very different from what the musician is used to hearing and the monitor sound may not be able to be presented as desired.

The quieter the volume of the stage monitors, the cleaner the house mix can be while maintaining sufficient volume. The needs of each individual can cause conflict when it is not possible to achieve their desired sound. Many musicians do not care about or understand the technical difficulties and if they cannot have the mix they want on stage, will demand the services of someone who can provide that mix. In this situation, the sound engineer's job becomes conflict resolution as well as audio engineering.

When Music is a Backdrop

Although every band hopes that the audience has come to hear them, this is not always the reality. Many bands play in bars or clubs where the owner or manager wants the music to be a backdrop to conversation, drinking and eating. In this situation, the only way a band can induce an audience to listen is to win them over with great music and/or an interesting stage performance. Trying to gain attention by overpowering the ambiance of the bar or dining room with loudness will not accomplish this. Everyone loses. If playing background is not your style, it is better to recognize the limitations and use the gig as a rehearsal. You always have the choice of not returning to that venue.

Controlling Your Own Dynamics

Small groups of classical players are trained to listen to the dynamics of the other players in their group so that they can adjust their performance to the whole. Often there is no sound reinforcement. Many acoustic and jazz groups play without sound reinforcement, even when they have a drummer. Their drummers play softly so that they do not interfere with each musician's ability to hear the

others and only the vocalist is miked. In essence they are providing their own mix. Of course, this only works in small rooms that have good natural sound balance.

Engineered Dynamics

When engineers control the dynamics they must know the music. This can be accomplished if the performers send a CD or cassette in advance of their performance to let the engineer hear how they like to sound. Ideally, performers have their own sound engineers even when using a sound system and engineer that are provided by the promoter. The performers' engineer can sit with the house engineer and either give instructions about the dynamics and mix or run the mix themselves. If the house engineer is familiar with the type of music being played much will be gained.

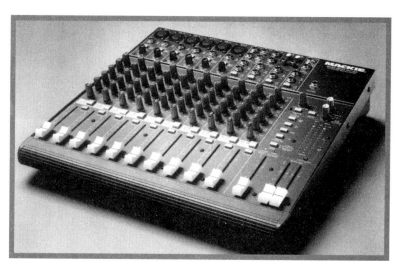

The Mackie™ MICROSERIES 1402-VLZ is a 14 (channel) x 2 (bus) stereo mic/line mixer with 60 mm faders, 3-band equalizer, 6 mic/line channels with high-headroom/low-noise microphone preamplifiers, 4 stereo channels, an extra stereo bus, and balanced inputs and outputs (including XLR outs).

Providing Musicians with the Same Mix the Audience Hears

In an ideal situation, the engineer can feed the monitors the same general mix as the house feed. This is accomplished by using a mixing bus for the monitors called the post fader send (or the AFL, after fader listen). As the input volume control is adjusted for each instrument the monitor mix tracks the changes. This allows the musicians to be in charge of their own dynamics and mix. This is the best way to produce a proper mix for the audience by a band that carries its own mixing board it runs from the stage. But if just one musician cannot bear to play his instrument at the proper level in the mix there is a problem. The Volume Wars will be on, with losers on all sides.

A surround speaker system will also provide musicians with the mix that the audience hears. These systems wrap most of the room in a sound field with the audience at its center. The stage also gets a lot of this field, which allows the musicians to hear what the audience hears. Surround speaker systems are discussed further in Chapter 6, "Main Speaker Systems."

Separate Monitor Mixes

The number of monitor mixes that are required and where the mixing engineer is stationed are dependent on the placement of the musicians on stage, room acoustics and ambiance, and the mixture of soft and loud instruments. Many separate monitor mixes could be required, necessitating a separate monitor board and mix engineer on stage. Separate monitor mixes can give each musician the exact mix they want to hear and can allow them to play without using instrument amplifiers.

From his position on stage, the monitor mixer can hear what is happening and quickly adjust to the situation. It is up to this engineer to keep the musicians content so that the house engineer can give the audience what they came to hear, a great show.

Hearing the House Mix

Ideally, monitor speakers are miniature versions of the main speakers. They do not need the excessive bass power the main speakers provide, but they should be spectrally balanced.

I used to play in a two-piece acoustic/electric band that I mixed from the stage. We never bothered with a separate monitor mix and we used a second send from the main output that was fed to a separate graphic equalizer to dump the extra bass from the monitors. It didn't take long to get used to playing with the high-fidelity mix that resulted. I heard virtually the same mix, at a slightly softer volume, that the audience heard. Many of these shows were recorded and the playback sounded exactly like what was heard on stage and in the audience.

Mixing from the Stage

Many bands do not have sound engineers and must mix their sound from the stage. To do this, they have their mixing gear on stage and must get used to hearing the same mix that the audience hears. This does take some practice. If you are attempting to integrate electric and acoustic instruments on the same stage you face a real challenge, as there is no way to know exactly what the audience is hearing from your position on stage. Guitarists have it relatively easy. They can plug in a long cord on their guitar and walk out into the room. Some use wireless setups for more flexibility. Unfortunately, the guitarist may not be the best band member to judge the overall mix, especially if they have come from an electric, hard rock environment and are used to the 100 plus decibels of a guitar speaker in their ears. They may try to balance the sound system for the same effect on the audience. Sorry, but only other guitar players want to hear it that loud. Musicians with studio experience often make better mixing choices, since they are used to softer monitor mixes and will listen to all aspects of the mix, not just their own instrument.

An excellent way to learn how to mix from the stage is to record all performances on cassette deck. This does not have to be an expensive recorder, just make sure that the levels coming from the mixing board are not too hot for the deck to handle. You can buy or build an inexpensive pad to drop the signal from +4 dBv down to -10 dBv, which lets you record with a minimum of worry. If all your instruments are played at approximately the same stage volume, a recording pulled from the main stereo output of your board will sound like the house mix and will be a good representation of what the audience hears.

After the gig, play the tape and really listen to the mix. Does the voice stand out above the instruments? Is the percussion correct? Bass is one of the toughest things to set live—does it feel correct or is it underpowering? Forget about mistakes, audience hecklers, and dead time between the songs. These are important things to consider in making a better show, but not relevant to learning to mix your band from the stage.

Using Instrument Amplifiers as Monitor Speakers

If you must use an instrument amplifier as your stage monitor for an instrument that does not require distortion, such as an acoustic guitar, it is important to use a full range speaker system that can reproduce frequencies from 20 to 20,000 Hz.

In-Ear Monitor Systems

In-ear monitors are an excellent way to improve your monitoring levels, while reducing overall stage volume. They have revolutionized the stage monitor business by providing custom headphones that are molded to fit the ears of individual musicians.

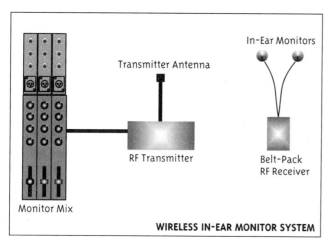

WIRELESS IN-EAR MONITOR SYSTEM

Since the transducer sits in your ear canal and is completely sealed off from the rest of the stage sound you can achieve any mix and volume you desire. Another advantage is that you will not be able to hear hecklers. Such a system is not cheap, the custom earpieces cost about $700 per pair. But consider what four good floor monitors, four amplifiers and four channels of equalization cost. And this does not factor in the space they take up in the truck and the strain on your back when you move them, or most importantly, the improvement in your presentation.

There are two types of in-ear systems: wireless and hardwired. In a wireless system, the monitor mix is transmitted from the board as a radio signal to a battery powered receiver that has a built-in amplifier. This is attached to the performer's belt and is wired to the custom molded in-ear monitor speakers. The performer controls the overall volume from the belt pack, while the monitor board provides the mix. These in-ear monitors not only provide whatever monitor levels you need, they block out most of the stage sound (so that your own levels can come down). Sort of like monitor heaven. By using a wireless in-ear system you eliminate the need for stage amplifiers and speakers.

There are many additional benefits to being completely wireless. The performer is free to walk around the stage or over to the monitor mixer to readjust the mix. There is no feedback for the performer or audience. The audience gets a cleaner, less muddied sound and the stage is visually more pleasing.

Since high-end wireless in-ear systems can cost upwards of $5000 per channel, they are not for everyone. Some singers have their own wireless monitors, while the bands will rely on conventional floor monitors. Recently, however, some manufacturers have introduced in-ear wireless monitors for less than $350 per channel that use different frequencies than wireless microphones. Even though these systems do not use custom molded earphones to attenuate the rest of the stage volume, they do reduce monitor volume onstage.

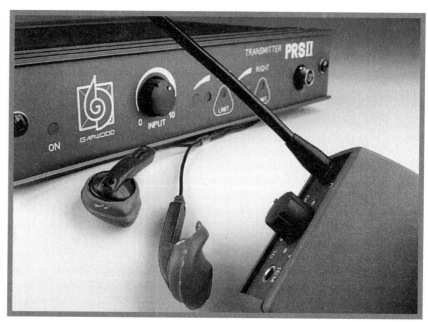

The Garwood PRSII in-ear monitor system. The custom molded ear pieces offer studio quality audio to the user. The system is comprised of a transmitter unit and a belt-pack receiver and operates on specially allocated UHF frequencies.

Caution! With in-ear systems, as with all headphones, you can achieve extremely loud sound levels and cause permanent hearing damage. The volume is usually controlled by two people—the performer (on the belt pack) and the sound engineer (on the monitor send). The engineer needs to be careful not to override the performer's volume without warning because that could cause ear damage and an upset performer. Ideally, two monitor engineers should be at hand: one to listen to the sounds the performers are hearing through in-ear systems; one to control the monitor mix for the rest of the band.

With hardwired (cabled) in-ear monitor systems, the monitor mix is transmitted through cables to a small belt pack that has a volume control. If you are already hooked up to an amplifier or direct box with your instrument, you need a wire harness for your cables. Complete wired in-ear systems are available for around $500 per channel.

Instrument Amplifiers and Monitor Speakers

In general, use as little stage amplification as is practical, and rehearse with the same amplifiers you will use on stage. If you really want to achieve great sound for the audience, get rid of all stage amplifiers and rely on the monitor mix to hear all instruments. Volume wars are eliminated, the audience gets a better mix at a lower volume, and musicians get to

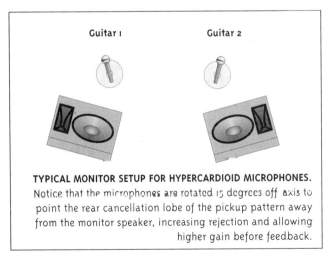

TYPICAL BLUEGRASS MONITOR SETUP. Notice the floor monitors are splayed so that the performers can face each other and each microphone is positioned so that its cancellation node faces the monitor speaker.

TYPICAL MONITOR SETUP FOR HYPERCARDIOID MICROPHONES. Notice that the microphones are rotated 15 degrees off axis to point the rear cancellation lobe of the pickup pattern away from the monitor speaker, increasing rejection and allowing higher gain before feedback.

save their hearing. One overly loud instrument amplifier can force everyone to want louder volumes in the monitors.

When you have to use instrument amplifiers, monitoring can be made simpler by having all the musicians use the same wattage stage amplifiers. For instance, if one musician has a 200-watt guitar

amplifier and everyone else is using 40-watt amplifiers, there will be difficulty in getting the volume balanced on stage. Physically separate loud and soft instrumentation on stage. A big bass amplifier that is positioned next to an acoustic guitar is likely to cause trouble since getting enough guitar volume in the monitor mix to overcome the bass may be impossible. If you have to do this, use a smaller bass amplifier, or better still, get rid of the bass amplifier and speaker and use a good preamplifier. Stage monitors usually do not put out a lot of bass frequencies, but the main system generally puts out enough to bleed back to the on-stage performer because bass frequencies are omnidirectional.

When an acoustic guitarist is performing next to a pan flutist or charango (a small South American guitar) player and someone else playing percussion, the percussionist will need an overall louder monitor level than the acoustic guitarist. That is because the sound of the percussionist's instrument must be overcome by the sound of the monitor. This can mean anywhere from 50 watts for a monitor for an acoustic guitarist, to 2,000 watts or more for a monitor to overcome the volume level of a rock drum set. Luckily, most acoustic acts do not use trap sets, and if they do, it is usually a small jazz set.

Hearing Impairment

Many electric musicians become hearing impaired at a very young age, because volume on some stages reaches 120 dB. That is far above the 85 dB level that OSHA allows in factories without requiring proper hearing protection. Performers that have high-frequency hearing loss or other hearing problems add special problems for the monitor engineer. If your ears ring after a performance damage may be occurring to your hearing and you should perform at lower volumes.

Common Loudness Decibels

220 dB SPL:	12-inch cannon—12 inches in front of muzzle
190 dB SPL:	Rocket engines, jet planes at takeoff
160 dB SPL:	Pistol at close range
130 dB SPL:	Threshold of pain
120 dB SPL:	Rock drum kit, 100 watt Marshall amplifier and electric guitar
110 dB SPL:	Heavy machinery
100 dB SPL:	Niagara Falls
90 dB SPL:	Stores and noisy offices
75 dB SPL:	Average factory
65 dB SPL:	Normal conversation
45 dB SPL:	Quiet motion picture audience
25 dB SPL:	Quiet recording rooms
0 dB SPL:	Threshold of hearing

Monitor Speaker Selection

There are three basic types of monitor speaker cabinets: side-fills, floor monitors and spot monitors. Each can be used for most circumstances, but best results will be obtained when the monitor speaker is matched to the job at hand.

Generally, stage monitor speakers are different from house speakers. They are smaller and have limited low-end frequency response (not producing frequencies below 60 Hz). They have a tighter beam in the high-frequency area that limits the amount of movement a performer has before losing the sound that comes from them. They can handle high power (100 to 1000 watts) from the amplifiers, although on a controlled acoustic stage 50 watts per monitor will often produce sufficient volume.

Side-Fills

Side-fills are generally large, full-range speaker cabinets that are positioned to point sideways across the stage. Usually they have a 15-inch bass

driver and a short-throw horn. These speakers are driven by amplifiers that produce 300 to 1000 watts of power. The mix sent to them is usually the same mix that the audience hears. Side-fills can also be used as vocal monitors for singers. In this case the monitors may be assigned their own vocal mix. When there are lots of musicians on the stage, side-fills are a good way to let everyone hear a little of everything in the mix. Unfortunately, they can contribute to volume wars and cause everyone to turn up.

If you are using side-fill monitors, positioning is critical. The speakers should be located on the front corners of the stage and point towards a common center at the back or center of the stage, usually the drummer or lead singer position. Pointing them forward will only encourage microphone feedback; and produce sounds the audience will hear in addition to the sound from the main speakers. In small venues, many musicians place them on top of the main speaker banks and point them backwards. This usually works well as long as none of the performers get too close to the stack.

Floor Wedges

Floor wedges are the monitors you see at most concerts. They come in various sizes and power ratings, and often utilize electronic crossovers and biamping. They all have one thing in common, they are positioned on the floor and project up to the performers. This allows louder levels at particular areas and avoids blasting the other musicians and bleeding-out to the audience. Properly positioned microphones that have cardioid

The Apogee Sound biamped AE-6 horizontal profile monitor (top) and AE-6B wedge monitor (bottom) are paired with Apogee P-500 processors, which perform crossover functions and provide speaker specific equalization and driver protection. The road version of the processor has line input and speaker output connections on the front panel. A version designed for permanent installations is also available.

pickup patterns will reject much of the sound from floor monitors. How big the monitors need to be for your act depends on how loudly you play. It is ridiculous to have 200 watts per monitor speaker when the house sound system is only 400 watts, but I see that all the time. In a club situation, if you cannot hear 100 watts of monitor though a good 12-inch floor wedge, then you need to reduce the overall stage volume rather than get more monitor power. Otherwise you will only force the mixing person to engage in volume wars with the band and make yourself deaf in the process.

You can use wedge-type floor monitors as replacements for electric guitar and bass speaker stacks. One manufacturer has introduced a limited-range instrument monitor that has a lead guitar speaker in a floor wedge cabinet. The idea is to project the guitar sound back to the guitarist, not the audience. This works well, as it gives the guitarist a louder monitoring level and allows for an overall lower volume in the house. If you can get over the psychological need of having a cabinet behind you, using a guitar wedge makes a lot of sense.

Any good full range monitor will work for keyboards. Since many synthesizers have pretty substantial bass output, a 15-inch monitor and an appropriate power amplifier of approximately 200 watts should be used, for large stages, 50 to 100 watts for club work. Again, you do not need lots of watts if everyone on stage exercises a little restraint.

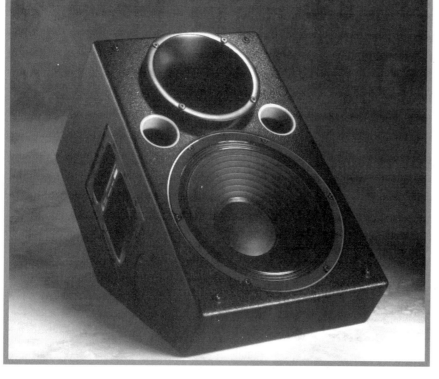

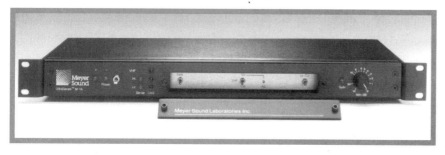

The UM-1C biamped UltraMonitor™ (shown above) from Meyer Sound consists of a 12-inch low-frequency driver and a symmetrical pattern 45-degree high-frequency horn driver. Its extremely directional high-frequency coverage pattern allows each musician to hear only the isolated mix from their monitor. The UM-1C operates as a system with the M-1A Control Electronics unit (shown below), one per channel, which contains frequency response, phase response alignment and driver protection circuitry. It requires a separate 2-channel, 300 watts-per-channel amplifier.

Spot Monitors (Close Field)

Spot monitors are small, limited range speakers. Typically, they have a pair of 5-inch full range

speakers and mount on top of a microphone stand. When used within their limitations they do a great job, but a little care is necessary or trouble will result.

The first rule is—never send bass frequencies to a spot monitor. The small speakers will not produce any real bass, and the wasted power will result in overheated voice coils and eventually, speaker failure. Getting rid of 80 Hz and below on an equalizer does the trick, or using an electronic crossover set to pass frequencies below 80 Hz. Do not attempt to run the kick drum or bass guitar though them, and size their amplifier accordingly. No more than 100 watts should be available to each cabinet under worst case conditions, an honest 50 watts is usually fine. Remember, most spot monitors are 16 ohms, so an amplifier rated at 100 watts into 8 ohms will only feed 50 watts to a 16-ohm cabinet. The good news is you can run four cabinets on a single channel and still only load the amplifier to 4 ohms. An amplifier rated at 200 watts at 8 ohms or 300 watts at 4 ohms will run these four monitors to VERY loud levels. If more power is needed the stage sound is too loud.

They are commonly used in conjunction with floor wedges and side-fills to provide added coverage.

A Custom Spot Monitor System

My last band was a two-piece electric/acoustic act featuring keyboards, electric and acoustic guitars, and sampled drums. My guitarist and I each used a custom built spot monitor that had two 5-inch speakers. The cabinets mounted on microphone booms in place of the counterweights. We used a Crown D60 amplifier, which produced 50 watts in each 4-ohm cabinet.

No other stage amplifiers or speaker cabinets were used on stage, not even for lead guitar. How did it sound? GREAT! There was no microphone feedback, no stage bleed to the audience, and the

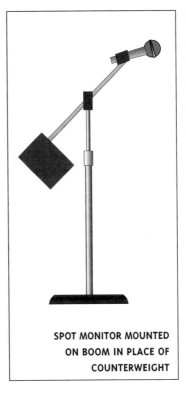

SPOT MONITOR MOUNTED ON BOOM IN PLACE OF COUNTERWEIGHT

mix was always perfect. It felt more like playing in a recording studio than anything else, and guest musicians were always impressed with how good it sounded on stage. We used this same setup for small clubs, big halls, and even outside concerts. We simply added more main amplifiers and speakers to suit the situation. The really strange thing was we rarely had to adjust the mixing board for these different gigs. The same basic mix worked in the smallest club and the largest concert. We simply turned up the output level as needed and played with reverb and echo to complement the room acoustics. After years of fighting the mix with traditional stage monitoring this was a real pleasure. Since the spot monitors acted as near field speakers (speakers designed to be listened to from 2 to 3 feet away), room acoustics did not influence our stage sound. And since the stage sound did not bleed into the audience, we could play at any level desired by the client and audience. (Do not forget who your bosses really are.)

The only problem with spot monitoring systems is that they limit performer movement. I still use floor wedges in my live recording and sound gigs since I cannot predict exactly where everyone will stand. And some artists still have the idea that if it is not loud, it cannot be good. Hopefully, they too will learn otherwise.

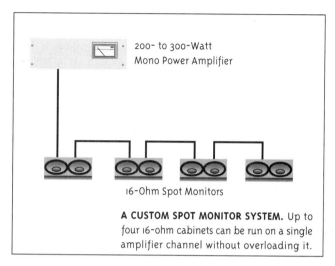

A CUSTOM SPOT MONITOR SYSTEM. Up to four 16-ohm cabinets can be run on a single amplifier channel without overloading it.

Which Monitors Do You Need?

The answer depends on where you play, room and stage acoustics, the type of gigs you do, the sound system available, your hearing needs and your budget.

If you have a sound system that suffices for most of the rooms you play, you can rent supplemental equipment as needed.

Main Speaker Systems

Chapter 6

The sound an audience hears is dependent on the quality, quantity, and placement of the main speakers. If the speakers are sized correctly to accommodate the sound level and spectral balance of the musical style and the size of the venue, there will not be any hot spots or dead zones in the audience and people will hear the desired sound no matter where they are sitting.

The maximum size, number and type of main speakers in any venue is determined by the dimensions and acoustic properties of the room, the spectral balance of the music being reproduced and the desired average and peak sound pressure levels. The goal is to reproduce the musical performance at the minimum required volume at all listening positions and deliver the sound to the back of the room at volumes that do not overwhelm those sitting in front.

Main speakers for acoustic acts must be able to reproduce the dynamics, frequencies and overtones of the instruments being played. Generally, the loudest instrument on stage determines the minimum volume levels of the other instruments and the basic level of the entire mix.

Since most acoustic instruments do not require the exaggerated bass and high tones that are common with electric instruments in concert or dance

venues, smaller speakers can be used. Instruments that produce a lot of high-frequency sounds but no low frequencies, do not need huge bass speakers for accurate reproduction, but midrange speakers and tweeters are critical. If your act is acoustic guitar and vocals, cabinets that have 10- or 12-inch bass speaker drivers will reproduce the needed bass frequencies for almost any small to midsize venue.

The loudest continuous volume of the mixed signal that is sent from the mixing board to the amplifiers is the maximum continuous average signal the speakers will have to accommodate. A speaker's average power rating indicates the maximum continuous power the speaker can handle without damage.

Peak signals derive from the sharp transients caused by sudden bursts of sound or energy—a scream from a singer, a heavy beat of the drum, an energetic picking of guitar strings. These are the sounds that cause the mixing board's VU meter needle to jump into the red. The speaker's peak power specification tells you the maximum capacity of the speakers to accommodate these transients.

The difference between the average power and the peak power (sometimes referred to as "music power" in speaker specifications) is called headroom. Having enough headroom to accurately transmit transient peaks throughout the entire sound reproduction chain without compression or limiting contributes to the uncompressed open sound of an acoustic performance.

The best method for ensuring the accurate reproduction of transients and overtones is to size the speaker system to absorb the maximum continuous power output the amplifiers are most likely to use. If the average level of the system is run at 6 to 10 dB below this maximum level the musical transients will be properly reproduced. If compressors and limiters are used to reduce dynamic range and compress peak transient signals much of the character of the acoustic instruments will be lost.

Speaker Components

Speaker systems have three main components: cabinets, drivers, and crossovers. The construction of these parts and how they are combined produces each speaker's characteristic sound and quality.

Drivers

Cone drivers consist of a paper or composite cone, flexible edge ("surround") spring loaded assembly ("spider"), voice coil (layers of copper wire wound on a hollow cylinder), a magnet assembly and a basket to contain all the components in proper alignment. When AC voltage is applied through the voice coil the varying magnetic field pushes against the magnet, which forces the cone (diaphragm) in and out. The heavier the magnet the stronger its magnetic flux and the more sensitive and efficient the speaker. Magnetic flux is the invisible lines of force that cause a magnet to attract ferrous objects (iron) or other magnetic fields to itself.

The mechanics of these components—how stiff the surround is, how much mass is in the copper, the mass and size of the cone—determine such characteristics as resonant frequency, upper frequency response, smoothness of response and power handling. These characteristics are then matched to a cabinet. Every parameter in the selection of drivers and their cabinets is critical to how they sound. Speaker drivers are not interchangeable. You cannot slap a driver into any cabinet and expect the combination to work. Mismatches prevent the whole assembly from working accurately and could cause the speaker to destroy itself.

Speaker cones act like pistons. They move the air back and forth. Small cones have to move farther

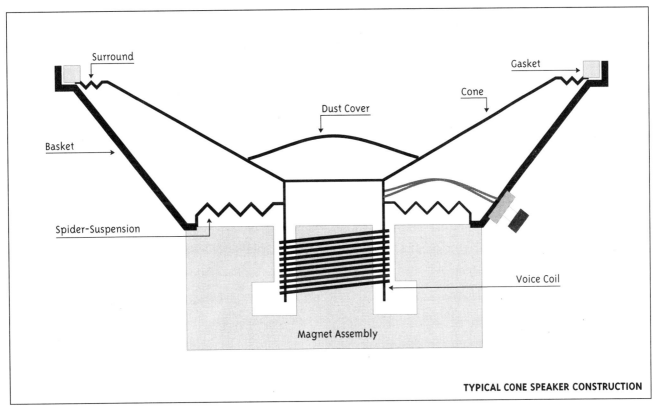

TYPICAL CONE SPEAKER CONSTRUCTION

than large ones to move the same amount of air. It is desirable for a speaker to move as much air as possible in order to transfer the most power with as little excursion as possible.

Bass drivers ("woofers") have cones that are 12, 15, or 18 inches in diameter, magnets that weigh 10 to 25 pounds, continuous power capabilities of 100 to 800 watts and frequency ranges of from 30 to 1000 Hz. Woofers are generally used just for bass reproduction. They are made large enough to push the huge quantities of air required for bass sound. Heavy cones do not do a good job of reproducing midrange or high frequencies. Usually their upper frequency is restricted to no more than 800 Hz; above that the signal is crossed over to midrange and high-range cabinets.

Bass sound reinforcement speakers have cast frames that keep their voice coils aligned with their magnet gaps (the space between the poles of a magnet where the magnetic energy is focused). They are

The Apogee AE-SB compact subwoofer system is designed as a companion to the AE-3 and AE-4 full-range systems. It uses an 18-inch diameter low-frequency cone driver that has a frequency response of 35 to 105 Hz. It is paired with the Apogee P-3 or P-4 processor, which performs crossover functions and provides speaker specific equalization and driver protection. The road version of the processor has line input and speaker output connections on the front panel. A version designed for permanent installations is also available.

built to close tolerances and have huge magnets, which allows them to be louder for a given amount of power and avoid heat buildup. Some professional bass speakers can withstand as much as 800 watts of continuous power without burning up.

Midrange speakers are smaller versions of bass drivers. They usually have cones that are no more than 12 inches in diameter, magnets that weigh 8 to 10 pounds, and continuous power capabilities of up to 200 watts. Because of the smallness of their cones and limited range of motion of their suspensions (the surround and spider) their cones respond more quickly to frequency changes and provide higher frequency response and wider range, generally 200 to 4000 Hz. This contributes to their efficiency at middle frequencies and they require less power to get the same sonic output as an equivalent bass speaker. In large arrays, they are usually coupled to midrange horn cabinets of up to 3 feet across that increase their efficiency and overall volume. This may be overkill for most acoustic acts except when they perform at large outdoor venues.

The compression driver ("horn driver"), has a frequency rating of 1000 to 18,000 Hz and continuous power capabilities of up to 100 watts. It has a 1-to 2-inch throat that feeds into a bell shaped horn. The gradual curve of the horn acts like an acoustic matching transformer and converts the high-impedance/low-pressure characteristics of air into a low-impedance/high-pressure area in the throat of the horn. This allows the diaphragm of the horn driver to grab onto thicker air, which increases power transfer efficiency. Since this small diaphragm only has to flex a little to move a lot of air through the horn it can be made very stiff and lightweight, which contributes to its efficiency. This is also a horn driver's Achilles' heel since they have a low-frequency cutoff that is dependent on the size of the horn. Generally, a horn will only act as an acoustic transformer when the sound frequency wavelengths are smaller than twice the size of the horn's mouth. Below this frequency the horn will uncouple and the driver will be working with thinner air and have nothing extra to grab. Low frequencies have longer wavelengths and if bass frequencies are fed to a horn driver they will quickly destroy it. For that reason, properly designed and implemented crossovers are important to both the sound and survivability of horn drivers.

The UPA-2C full-range speaker from Meyer Sound has a 3-inch compression driver (horn-loaded) and a 12-inch bass reflex cone driver. It operates in the frequency range of 60 Hz to 18 kHz. The speaker functions as a system with the M-1A Control Electronics unit (not shown), which contains frequency response, phase response alignment and driver protection circuitry.

The size and shape of the horn determines the low-frequency cutoff and dispersion pattern of the speaker/cabinet combination. The larger the mouth of the horn, the lower the frequencies that can be reproduced. As frequency decreases, the length of the wave increases. At 1000 Hz, the length of a single wave is about 1 foot. This increases to 5.6 feet at 200 Hz and to over 55 feet at 20 Hz. Since the mouth of the horn needs to be at least half the wavelength to work properly, a high-frequency horn that has a mouth area equivalent to 2 square feet could reproduce frequencies as low as 360 Hz before uncoupling from the air. If you do not need to reproduce low frequencies it is a waste to use a large 500 Hz horn. A much smaller horn mouth could provide the same sound dispersion pattern with increased efficiency.

Some horns use piezo drivers, lightweight, cost-effective devices that put out a lot of upper high frequencies in the 5 kHz to 15 kHz range.

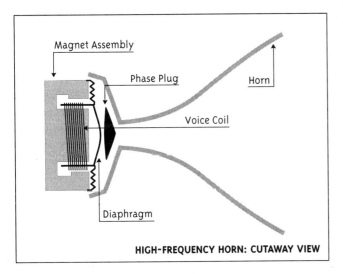

HIGH-FREQUENCY HORN: CUTAWAY VIEW

Speaker Driver Failures

A speaker driver that is given a signal that is outside of its rated frequency and power range will be rapidly destroyed. There are two basic failure mechanisms for speakers: overheating and overexcursion.

Overheating is caused by a speaker's inability to dissipate generated heat, which can cause damage to the voice coil. This can happen in two ways. First, you can continuously push too much average power for too long (usually about half an hour). Long-term moderate overheating will cause a breakdown in the glues that hold the speaker together. Second, heat from outside sources can combine with the speaker's internal heat. For example, if a speaker is used to capacity for an outdoor performance on a hot day, the added heat will be equivalent to the speaker being driven too hard.

During overexcursion, the speaker cone flexes in and out further than it should. This occurs when it is asked to handle frequencies below its rating. Supplying 100 Hz frequencies to a midrange driver that is rated to handle a low of 500 Hz will cause failure from overexcursion. The cone will move too far and either jump out of the magnet gap or bend the spider assembly. Putting the same bass frequency into a horn driver rated for 1000 Hz will quickly fry the driver at almost any power. The lightweight voice coils of high-frequency compression drivers are particularly susceptible to overexcursion and cannot survive more than a few seconds before failing.

On the other hand, bass speakers will tolerate huge amounts of unwanted high frequencies, even though they lack the ability to reproduce them. But, while they will not be damaged if crossed over at too high a frequency, they will not sound good either.

Overexcursion can also be caused by out-of-polarity wiring. All speakers in a given sound system need to be wired in the same relative polarity. This means that all speaker cones will move in the same direction when a voltage is applied to them. Most speakers are wired so that positive voltage applied to the hot terminal, or tip of a standard phone plug, will cause the cones to move toward the cabinet front. If all the speakers in a system are not wired the

same way, some cones will be moving out while others are moving in, producing an out-of-phase condition. This is especially problematic at bass frequencies, where out-of-phase speakers will cause the bass to disappear in the center of the room. If two bass drivers, in a common cabinet, are wired out-of-polarity, failure due to overexcursion can quickly result. Since one driver is pushing while the other one is pulling, the normal spring action of the air inside the cabinet is defeated and there is nothing to hold back cone excursion. The cones will bottom out a few times and pound themselves to destruction.

A 9-volt battery is a good tool to test for out-of-polarity wiring. By momentarily contacting it across the input terminals you can hear and see the speaker jump. They all should jump in the same direction with the same polarity source. If they do not, the offending speakers need to have their leads reversed.

Cabinets

A cabinet can contain bass, midrange and high-frequency drivers singly or in combination. How the cabinet is built, the type of wood, the distance from the driver to the front of the cabinet, the layout of the speakers, how they are placed in or on the cabinet, and the size of the cabinet all determine the character of each cabinet's sound. The same driver placed in different cabinets will sound different.

The design of the cabinets can help speakers produce more frequencies. Generally, the larger the cabinet, the more efficient it will be at low frequencies and the louder it will be at any given power.

The bass sounds produced by the music, the desired volume and the size and acoustics of the venue determine the number of speakers needed. To get 3 dB more sound, you must either get another speaker and give it the same amount of power or get bigger or more efficient bass cabinets or use a processed speaker system (see below).

If different types of drivers are combined into one cabinet (bass, mid and high), the designer will be concerned with time synchronization to avoid phase distortion. Phase distortion results when the bass, midrange and high frequencies of a sound do not

The Bose 402™ series full-range professional loudspeakers feature four 4 1/2-inch drivers, which are actively equalized to reproduce sound from 90 Hz to 16 kHz.

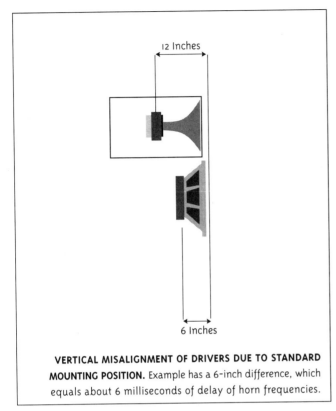

VERTICAL MISALIGNMENT OF DRIVERS DUE TO STANDARD MOUNTING POSITION. Example has a 6-inch difference, which equals about 6 milliseconds of delay of horn frequencies.

reach the listener at the same time. This causes the sound to be of longer duration than it was originally and is heard as a time smear or delay effect. The cause is usually a misalignment between the cone drivers and horn drivers, which forces the various frequencies to travel different distances through the air on their way to the audience and some will arrive sooner than others. The effect is more noticeable with staccato sounds, such as a drum strike. When the misalignment gets close to 10 milliseconds (about 10 feet of driver misalignment), a definite echo is heard. Although phase distortion effects are more subtle at small misalignments (a few inches), loss of stereo detail and imaging can still be heard, particularly when the monitors onstage are turned up loud enough so that the sound bounces off the back wall of the stage. The extra 20 to 30 feet that the sound travels will cause a 30 millisecond delay. Even if the audience does not notice subtle delay effects they will cause listening fatigue.

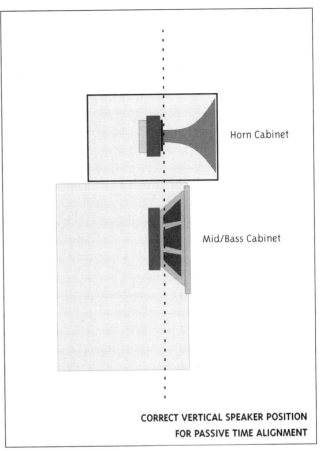

CORRECT VERTICAL SPEAKER POSITION FOR PASSIVE TIME ALIGNMENT

There are two ways to ensure that the sound from the bass, midrange, and horn cabinets travel the same distance so they present a coherent undelayed sound to the listener. One is by aligning the speaker drivers in the same vertical plane. Aligning the fronts of the cabinets will usually result in the cones not lining up.

The second is to electronically delay the "ahead" signal. Some electronic crossovers have digital delays, which delay the front-most cabinets by up to a few milliseconds. Since sound takes about 1 millisecond to travel 1 foot, this will allow you to correct up to a 2-foot misalignment in a speaker stack.

Cabinet Dispersion Patterns

Full range speaker systems can be classified as those with long-throw and short-throw dispersion patterns. To envision this, think of lights in place of

SPEAKER DISPERSION PATTERNS. In larger venues a combination of short-throw and long-throw speakers can be used. Short-throw speakers cover the front of the room and long-throw speakers project sound to the back.

speakers. Since sound behaves similarly to light in its dispersion and attenuation characteristics we can draw some analogies between lights and speaker systems.

Long-throw speakers are like spotlights. They throw a tight beam to the back of the room. Speaker ratings include an angle of coverage such as 40 by 90 degrees, the first number denotes vertical coverage, the second one the horizontal coverage. The lower the numbers the more concentrated the sound pattern and the louder it will be at the front of the path of the coverage.

If you have to provide coverage to listeners that are sitting in a distant balcony, properly positioned long-throw horns will do it. A long-throw speaker system is horn loaded to provide for adequate coverage of midrange and high frequencies. However, in small rooms this can contribute to intense hot spots since the audience is not far enough from the speakers for the sound to spread out.

Short-throw speakers are like floodlights. They throw a wide beam that fills more of the room but produces less volume. This provides coverage up close, but not to the back of a large venue. And it is difficult to provide coverage to a limited area and not have sound spill out to each side.

Long-throw speakers are necessary for outside or large indoor venues, but are not suited for standard club work. In a club situation speakers may be 50 feet at most from the farthest listener and a long-throw speaker will send a very loud beam that will blast anyone in its path and leave quiet areas on either side. You will get coverage in the back, but the people that are out of the direct path of the sound beam will receive lower volume and those directly in front will be deafened.

Short-throw speakers have wide dispersion patterns that die out rapidly and produce less bounce off of rear walls. Smaller drivers beam less and disperse more, so with all else being equal, a smaller cone driver will disperse high frequencies better than a larger cone.

Stage monitors generally require narrow dispersion patterns. This is the opposite of the requirements for most small room systems, where a short-throw (wide dispersion) speaker is usually needed to prevent beaming. Larger venues can use a combination of long-throw speakers to get to the back audience, and short-throw speakers for up front coverage. For most acoustic acts that play small venues of up to 500 people, wide dispersion speakers are the best choice. Remember that all bass is essentially wide dispersion. It is only when frequencies get above 100 Hz that directionality comes into play. High frequencies are the most directional of all. You can easily hear this when someone walks in front of a speaker and all the highs go away. Good speakers minimize this effect and put out an even response pattern without beaming.

Horn drivers come in dozens of throat patterns: elliptical, conical, and slot loaded. There are many variations and each has advantages. Specifications

from one manufacturer list a 110 by 45 degree horn in one cabinet, a 100 by 100 degree horn in another and a 65 by 65 degree horn in a third. The 65 by 65 degree horn is a long-throw unit, which will provide good coverage to the back of the room, but could miss coverage to the sides. The 100 by 100 degree horn would be a good compromise for a standard small room. The 110 by 45 degree horn is in their floor monitor that produces good side to side coverage onstage.

Some manufacturers provide a 90 by 40 degree horn with a piezo driver, which gives good width dispersion while it limits the amount of sound that is sent to the ceiling and floor. These general purpose horns work well in most situations but their frequency response and distortion characteristics are not as good as those of a more expensive horn and driver combination. However, their price/performance ratio is very good and they do provide decent sound for those on a budget.

Other manufacturers use 90 by 60 degree horns in their stage monitors and small main speakers. Here there are only two components, a 12- or 15-inch woofer and a mid/high horn. They are crossed over at 1500 to 2500 Hz, which forces the bass driver to carry the important midrange frequencies. These speaker cabinets allow you to have good up-front coverage and less sound variation in the whole room.

The goal is to have not more than several decibels of sound variation across a room so that the sound will be good at every seat in the house. Having just a few seats in an area where the sound is good ("sweet spot") is not desirable; however, if there must be a sweet spot, better it be up front. If club owners cannot seat patrons up front when you are playing they are losing money. Remember, from an owner's standpoint performance has to do with paying customers as well as personal musical style.

Heat Buildup

Sound reinforcement speakers need to be able to handle internal heat buildup, which is the equivalent of handling more power. Speakers create heat by changing electrical energy into mechanical energy. Their average power rating indicates how much heat they can disperse without problems.

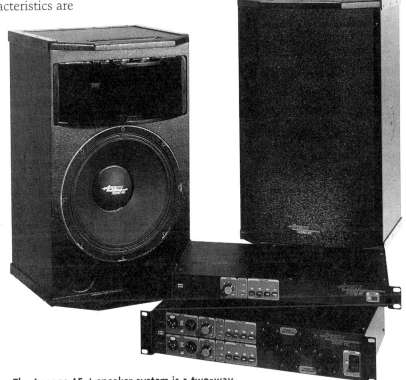

The Apogee AE-4 speaker system is a two-way, single-amped system that contains a 12-inch low-frequency cone driver and a 1-inch high-frequency horn-loaded compression driver. It has a frequency response of 60 Hz to 16.5 kHz and a 90 (horizontal) x 45 (vertical) degree dispersion pattern. It is paired with the P-4 processor which performs crossover functions and provides speaker specific equalization and driver protection. The road version of the processor has line input and speaker output connections on the front panel. A version designed for permanent installations is also available.

When the temperature of the voice coil exceeds its ability to dissipate heat, the coil overheats and comes apart ("is cooked"). You cannot feed more watts into a speaker than it is designed to handle.

On hot days, when the sun shines directly on speaker cabinets their rate of heat dissipation decreases because the heat from the sun adds to the normal build-up of heat inside the cabinets. If the power handling capacity of the speaker is being pushed to its limits this additional heat will cause overheating and eventual failure of the voice coil and magnet structure. This is a major cause of speaker failure during outside concerts.

To avoid this type of failure make sure your speakers can provide more output capability than you think you will need for hot, outdoor (or indoor) work and do not use that safety margin. That way you can provide enough volume—and have enough extra capacity (headroom) to accommodate the added heat.

Professional audio speaker designers build rugged products to help accommodate this problem. But the best way to ensure your speakers' lives is to have more capacity than you need, so you do not push them to their limits. They will also sound better.

Crossovers

Crossovers route the signal from the amplifier to the appropriate speaker driver to take advantage of the speaker's most efficient operating range. They protect speakers by not routing inappropriate signals to them. A two-way crossover divides the signal into low (woofer) and high (horn); a three-way crossover divides the signal into low (woofer), midrange, and high (horn).

Passive Crossovers

Passive crossovers are usually built into the speaker cabinet and a combination of capacitors and inductors

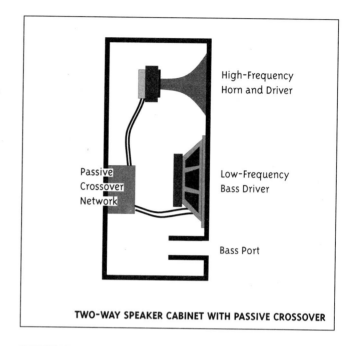

TWO-WAY SPEAKER CABINET WITH PASSIVE CROSSOVER

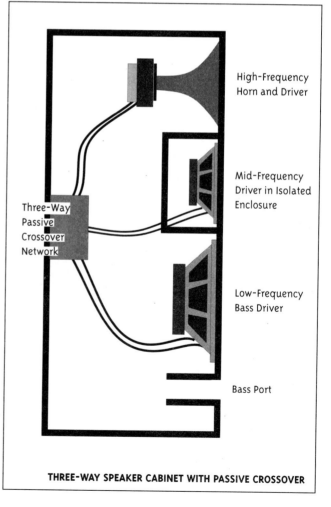

THREE-WAY SPEAKER CABINET WITH PASSIVE CROSSOVER

split the full bandwidth signal from the power amplifier into two, three, or four separate frequency bands. The main advantage of passive crossovers is that the speaker manufacturer can select crossover points and levels that make the drivers sound as good as possible and protect them at the same time. The disadvantage is that you are stuck with the crossover points that the manufacturer has selected and passive crossovers introduce some loss of power, up to one-half the available wattage. Therefore, passive crossovers are not used in professional touring sound systems.

The slope of a crossover is determined by the number of capacitors and inductors in the circuit. Slope is how quickly the unwanted frequencies are attenuated. A gentle slope of 6 dB per octave will allow more unwanted frequencies through, while a steep slope of 24 dB per octave will cut off unwanted frequencies more quickly. The simplest high-pass crossover on a horn speaker produces a 6 dB per octave frequency roll-off. (Every time the frequency is doubled the sound goes up a musical octave.) This means that if there is a cutoff frequency of 1000 Hz selected for the crossover the sound level will be attenuated by 3 dB at 1000 Hz, 9 dB at 500 Hz, 15 dB at 250 Hz, and 21 dB at 125 Hz. As the sound moves down one musical octave its volume will be reduced by 6 dB.

Many passive crossovers have an "L-pad" that enables you to reduce the volume of the horn and/or midrange driver to help balance the speaker's frequency response.

Active Crossovers

Active crossovers are separate pieces of equipment that divide the signal from the mixer or equalizer into two frequency bands that are fed to two or more amplifiers that feed into individual speakers or cabinets. Active crossovers divide the acoustic

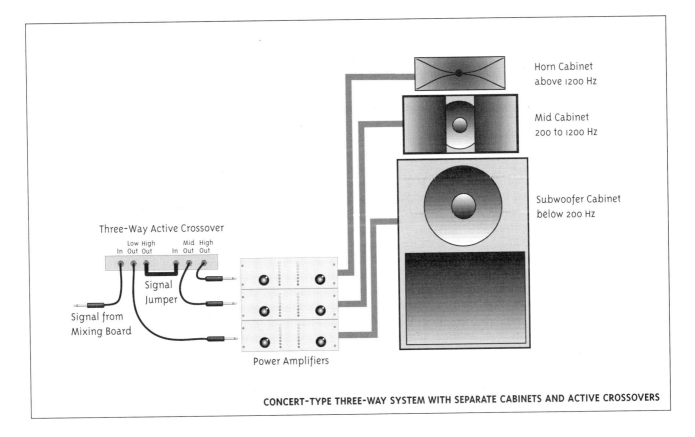

CONCERT-TYPE THREE-WAY SYSTEM WITH SEPARATE CABINETS AND ACTIVE CROSSOVERS

spectrum into bass, mid and treble, etc., which allows power amplifiers to amplify each of these frequency domains separately. The result is a cleaner sound. However, great care must be exercised when hooking up active crossovers, since it is easy to send bass notes to the horns and cause their destruction from overexcursion.

Biamping means that two amplifiers are used in conjunction with a two-way active crossover; tri-amping means that three amplifiers are used with a three-way crossover.

One active crossover can provide signals for dozens of amplifiers and speaker cabinets. Complex and steep crossover slopes can be designed, 18 dB per octave and 24 dB per octave slopes are popular, since they send much less bass spillover to the horn drivers, which allows you to drive them harder. You can easily fine-tune an active system by turning a few knobs to change the crossover points and levels. This can modify the system to the particular speaker and room requirements and allow the amplifiers and speakers to share the sonic load evenly.

Technical Characteristics

Average Power Versus Peak Power

The maximum peak power levels (in watts) needed for a performance are determined by the efficiency of the speaker system, the desired sound pressure level (SPL), and the transients of the music.

Peak power (impulse power) is the short-duration power input that a speaker is capable of handling. For instance, a high-frequency horn driver may be rated for 40 watts average power, but might easily handle 200 watts peak power. This is because its voice coil and surrounding parts are capable of moving far enough apart to transduce that amount of power briefly, but a continuous input of high power will cause overheating and rapid failure. Usually, peak power is rated in 1- to 10-millisecond bursts, which equates to 1/1000 to 1/100 of a second. A speaker must be able to handle peak power gracefully and without distortion to reproduce instruments that have lots of transients, such as percussion, horns, and vibraphones.

Average power (average operating level of the system) determines how much heat the voice coil has to dissipate. For instance, percussive instruments have very brief moments of high output power and lots of downtime. This requires huge amounts of peak power, but the overall heating effect on the speaker's voice coil is quite small.

Headroom

Headroom is the ability of a speaker system to accommodate transient peak signals. The difference between the average (continuous) and peak (transient) power speaker specification gives you the available headroom, assuming you have sufficient power available from the power amplifiers.

Power Ratings

The specifications for sound reinforcement speakers include ratings for both average and peak power. Peak level is generally about twice the average power level. However, when sound engineers talk about a 200-watt speaker, they are almost always talking about its average or continuous power. That specification most always includes the acronym "RMS," which stands for root mean square (200 watts RMS). RMS refers to the mathematical method used to calculate average power.

Consumer speakers typically provide only one power rating, which is the highest one-time transient peak that the speaker can handle. What the specifications do not tell you is the speakers' average power capabilities, which may be as little as a few watts, thereby making them totally inappropriate for sound reinforcement.

Impedance

All speakers have a rated impedance that is built-in by the manufacturer, commonly 4, 8, or 16 ohms. The impedance of the speaker load determines the amount of power that will be drawn from an amplifier's output. Most transistor amplifiers try to maintain a given voltage swing no matter how much load is applied. As the impedance decreases (thereby decreasing the amount of resistance), the power from the amplifier will increase proportionally. Halving the impedance will double the power output of an amplifier.

Modern amplifiers are usually rated for 4- or 2-ohm operation. Forcing an amplifier to drive a load that has a lower impedance than it is rated for will result in distortion, overheating and reduced power.

Single Cabinet Systems

For many acoustic acts, a single cabinet system that includes two- or three-way passive crossovers will sound great in small to medium size rooms (up to 500 seats). It will simplify hookup and setup and requires little space. You are limited by the amount

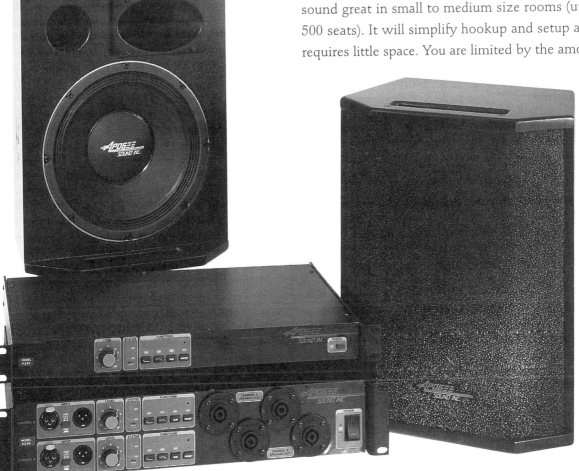

The Apogee AE-3s2 is a two-way, single-amped system that contains a 10-inch low-frequency cone driver and a 1-inch high-frequency horn-loaded compression driver. It has a frequency response of 70 Hz to 18 kHz and a 70 (horizontal) x 45 (vertical) degree dispersion pattern. It is paired with the P-4 processor, which performs crossover functions and provides speaker specific equalization and driver protection. The road version of the processor has line input and speaker output connections on the front panel. A version designed for permanent installations is also available.

of power you can put into the cabinet, but for acoustic acts, that should not be a problem. For most rooms, a stereo 200 to 400 watt-per-channel amplifier should be sufficient.

Processed Speaker Systems

Processed speaker systems are used to produce big bass sounds without big bass cabinetry—and many of them sound great. These systems electronically supplement the need for large cabinetry by adding a bass boost at selected frequencies. Bose was one of the first to experiment with this effect and their Bose 901 cabinets put out an appreciable amount of bass energy when they are properly positioned in the corners of a room and their active processor is switched into the circuit path.

Many major manufacturers are now selling active speaker processing/protection devices that not only provide frequency augmentation, but limit an amplifier's output before it damages a speaker.

Component Speaker Systems

Acoustic acts can have separate speaker components rather than one-cabinet systems. If they do, the way speakers are placed, combined and stacked on stage will affect the overall sound. The final interface you have control over is the speaker-to-room interface. This interaction changes dramatically with the types of speakers (especially bass) and their positioning in the room.

If the bass, midrange and tweeter drivers are built into different cabinets, how they are stacked is

EXAMPLES OF SPEAKER SYSTEMS FOR ACOUSTIC ACTS

Act #1:

- Two acoustic guitars, two vocalists, occasionally a small accordion or pennywhistle.
- Typical room size—less than 100 seats.
- Wattage requirements—200 to 400.

This act will not need a cabinet that produces much bass output since it will produce little sonic energy below 100 Hz. A properly designed 10- or 12-inch woofer in each cabinet should be sufficient. Midrange is important, since they will be singing most of the time, so a two-way system with a midsize horn that crosses over at 1500 Hz is preferred to a 2500 or 4000 Hz piezo tweeter because larger horns exhibit better dispersion than cone drivers and the cabinet with the larger horn will spread the sound around the room more evenly. Speaker stands should be used to get the cabinets off the floor and above the heads of the patrons (so the high frequencies will not get attenuated by the audience sitting in front).

Act #2:

- One acoustic guitar, one electric bass, vocals, some percussion.
- Typical room size—100 to 200 seats.
- Wattage requirements—400.

This act will require some bass reinforcement since electric basses require more power from reinforcement systems than do stand-up acoustic basses for two reasons: 1) they don't make any sound of their own so the speakers must provide it all, and 2) electric bass players usually play with more dynamics and like to feel the bass in the mix. Thus a cabinet that has at least a 12-inch woofer is required. A 15-inch is preferred if the bassist desires a heavy bottom sound. The percussion instruments will work fine through anything that will handle the bass guitar. The size and weight of the speakers may preclude them from being mounted on speaker stands, but that is still the best placement. Remember that the monitor cabinets will probably be small and will not handle any appreciable bass. Make sure you have a separate equalizer on the monitor chain that will allow you to dump everything below 80 Hz so the monitor speakers will not be damaged.

critical in dealing with time delays. Speakers should be aligned from the rear (not the front) so that the surfaces of their cones or diaphragms are in a vertical plane. This is because the sound originates from these surfaces, not the front of the cabinet.

Having the horns several feet in front of the midrange cabinets will certainly be noticeable.

Placement of Bass Speakers
A bass speaker's efficiency depends upon how much air it moves. Large bass drivers are generally more efficient than small ones because they push more air for a given cone movement.

The placement of speakers in relation to other surfaces is important, since how the bass cabinet is placed in a room will affect both its frequency response and how loud it is. If you suspend a bass speaker cabinet in the air 6 to 12 dB of the bass is lost. This is because the cabinet is radiating sound equally in all directions. When bass speakers are placed on the floor near a wall most of their sound will bounce into the audience and the speaker drivers will work more efficiently. Placing the speakers in a corner is even better because that further increases their output efficiency. Placing the bass speakers off the stage results in less conduction of their sound to stage microphones.

Our ability to locate sounds depends on their frequency and wavelength. The lengths of sound waves vary from about 56 feet for a 20 Hz wave to less than 1 inch for a 15,000 Hz wave. Since bass frequencies below 150 Hz are omnidirectional, we cannot localize where they originate. This allows bass speakers to be placed in corners or in front of the stage.

Although many acoustic groups do not need a big bass sound there are some acoustic percussion groups that do. If you want to have realistic percussive sound or want to do sampled instruments that produce a lot of bass, use a number of bass speakers

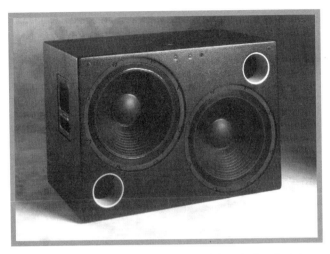

The USW-1 bass speaker from Meyer Sound has dual 15-inch bass reflex cone drivers and operates in the frequency range of 40 Hz to 100 Hz. The speaker functions as a system with the B2-EX processor, which contains frequency response, phase response alignment and driver protection circuitry.

and position them close to each other so that they act as a wall of sound. A good place for bass speakers (bins) is directly under the front of the stage. Place them side by side to keep the drivers as close to the floor as possible.

Placement of Midrange and Tweeter Speakers
Ensuring that audiences hear high frequencies is a totally different matter. Getting enough highs is not the problem, spreading them out is. High frequencies generally travel line of sight. If the audience cannot see into the throat of a high-frequency horn they will not hear it. This contributes to uneven spectral balance and the listeners that are directly in front of the horns will get too many highs and those to the side will get none.

Get the horns up as high as practical, at least 2 feet above audience ear level. This gets the listeners in front out of the direct line of sound and provides better coverage to the back of the room. If a speaker that has short-throw characteristics (wide dispersion) is used the audience on the sides will be covered.

Speaker stands are an ideal way to accomplish this, but full range systems can be very heavy. Another way to get the highs up high and the lows down low is to use a wide dispersion satellite speaker system.

One-Stack Speaker Systems

Ideally musicians will perform from a stage or in an arena that allows the sound to disperse from a center cluster above the stage (or from two speaker stacks located at opposite sides of the stage), but this does not always happen. Sometimes the room is oddly shaped. Sometimes the stage is much higher than the audience. Sometimes there is no room for two-speaker systems. In these situations, a one-stack speaker system can be the ideal solution.

Instead of placing speakers on both sides of a stage, you stack half the number of cabinets you generally use wherever they sound best. A one-cabinet system can be hung from the ceiling. This will provide great intelligibility and give you tremendous feedback control. Be sure that the ceiling structure and the cabinets can withstand the load without falling. Some clubs build a heavy shelf above the stage where cabinets can be safely placed.

Wide Dispersion Satellite Speaker System

A wide dispersion satellite speaker system offers an alternative to standard speaker placement. It can overcome the limitations of acoustic venues where getting a seat where the music sounds good can be difficult.

In this arrangement the bass speakers (bins) are placed on the floor of the stage. The speakers that contain horns and midrange drivers (satellite speakers) are placed around the room so you can adjust coverage as needed. Since the satellite speakers do not carry any of the bass frequencies they can be small. This allows placement that does not block the view of the stage. When properly deployed they create an illusion that makes the audience feel that the sound is coming directly from the players on the stage. To have the sound system be totally transparent is the highest plane to which all sound engineers aspire. Sound systems should be unobtrusive to allow for a completely intimate relationship between players and listeners.

A wide dispersion satellite speaker system can produce breathtaking sound for acoustic bands with or without electric instruments. It is ideal for the performers because the need for onstage monitors is greatly reduced. Since everyone is in the middle of the sound system there is a direct correlation between the sound mix on the stage and what the audience hears. Each performer gets to hear more of what the audience is hearing. If the band is providing its own mix from the stage, once the basic balance of the instruments is obtained in the stage monitors, the performers' dynamics and mix changes will be reproduced for the audience as well.

Another benefit is a cleaner stage and less visual competition with your act. Audiences can focus on the performers and not be distracted by the sound system.

The Bose 802® Series II full-range professional loudspeakers have eight full-range drivers and active equalization to produce sound from 55 Hz to 16 kHz. A unique injection-molded enclosure accounts for its relatively light weight (only 31 pounds).

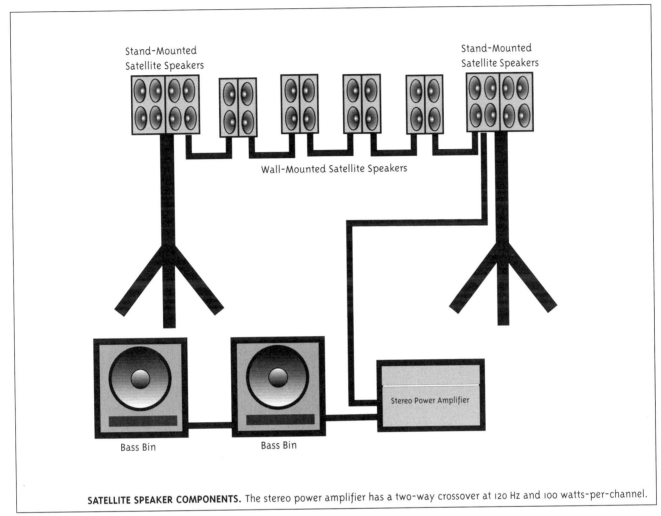

SATELLITE SPEAKER COMPONENTS. The stereo power amplifier has a two-way crossover at 120 Hz and 100 watts-per-channel.

A satellite system can also take care of acoustic problems in odd shaped rooms because coverage can be provided to a corner, the other side of a bar, and in side rooms without hot spots.

Another advantage is that these are small, lightweight systems that can be transported in small vehicles.

A satellite system will provide good sound coverage in a small room, but the size and capability of such a system can be expanded to any size venue.

There is also something about surrounding the audience in a direct sound field that seems to eliminate room response problems. There seems to be less bounce off of the walls, since the walls themselves appear as the sound source.

Delay Stacks

Delay stacks are common in very large arenas. A delay stack is an additional bank of speakers that is placed 100 feet or more from the main speakers in the middle of the audience to help augment the sound in the back of the room. In order for this to work without producing synchronization error, an electronic delay is inserted in the signal path that feeds the delay stack. The electronic delay, which is calibrated in either milliseconds or feet, can vary the amount of delay. This allows the sound from the stage to catch up with the sound from the delay stacks for the audience at the rear, eliminates echoes and produces a common wave front that helps push the sound towards the back of the venue.

The figure to the right shows a (typically) irregularly shaped and unacoustical playing area. Note that there is a seating area directly in front of the band that should not be blasted and the side area behind the low partition needs coverage. By using large satellite speakers near the stage we create a louder pull from that area, while the smaller satellites towards the back provide articulation and ample volume. The side area is covered by two additional satellites. A single bass bin is placed in a back corner for maximum output. If your act includes electric bass or synthesizer you could add a second bass bin for more volume at the lowest notes.

You now have good coverage in all areas of the room and the club owner does not lose any seats in front of the stage due to speaker placement or loudness. Careful placement of the satellite speakers lets us adjust both coverage and relative volume in all parts of the room.

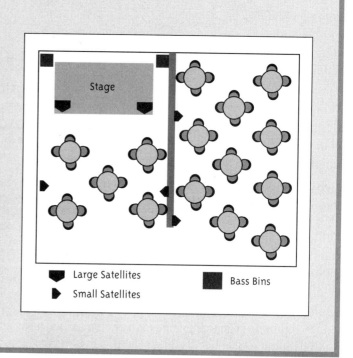

Cabinet Selection

There are two prerequisites for satellite speaker system selection. First, they must have wide dispersion patterns and second, they must be small enough to be placed where needed. If you only require a modest amount of bass, a single 15-inch bass speaker will be adequate for your whole system. Since it will only be handling the lowest notes it can be placed anywhere on the floor. You will need to use active electronic crossovers at about 150 Hz sending the mid- and high-frequency signals to the satellites and the low pass signal to the bass bins.

If you need more bass, add bass cabinets for sound below 150 Hz. Also, an 18-inch bass speaker can provide up to twice the output of a 15-inch speaker at little additional cost.

Hookups

Satellite speakers must be connected according to their manufacturer's specifications. They generally need less overall power than systems that use only front speaker stacks.

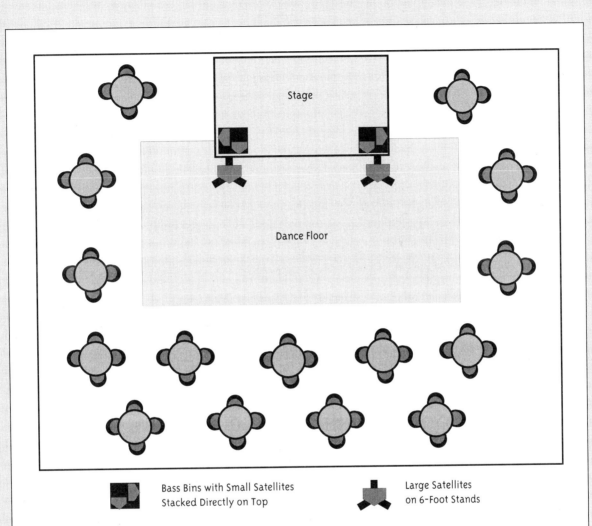

Bass Bins with Small Satellites Stacked Directly on Top

Large Satellites on 6-Foot Stands

Shown above is a typical reception or party setup. Every American Legion or fire hall has a room like this that is rented out for weddings and parties. There is usually a dance floor in front of the stage and the stage is elevated 1 to 2 feet. There are generally tables to the left and right of the stage and in the rear of the room. We place the large satellites as high as possible on speaker stands and the small satellites directly on top of the bass cabinets, close to ear level for the listeners and dancers that are directly in front. This allows the large satellites to cover the tables in the back without blasting out the people on the dance floor or at the front tables.

The small satellites cover the dance floor and side tables. The bass speakers are in a conventional placement for ease of setup and are a good place to set the small satellite speakers. Although not a true surround setup, this placement allows you to adjust coverage for the three areas of concern: the dancers, tables to the side of the stage, and listeners in the back of the room. If there is a side room you could add a satellite to provide coverage. Some additional power would be required in that room, so a separate amplifier that has its own gain control would be needed to adjust that remote volume without affecting the rest of the mix.

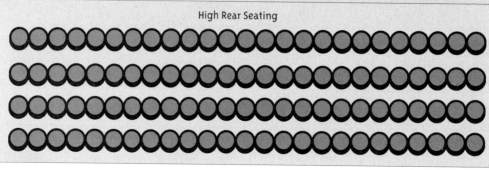

| Bass Bins | Large Satellites on 6-Foot Stands | Satellites |

Shown above is the layout of the 450-seat Kepler Theater in Hagerstown, Maryland where I regularly engineer. Large satellites are used at the front of the stage to provide direct sound. The bass bins are positioned on the stage as far forward as possible on either side of the act and the satellites are used on the side walls to wrap the audience in sound. The room is moderately dry. It has a lot of absorptive material and not much natural reverberation. There is a rise to the rear. This is really the optimal setup for a sound system of this type. Many acts that perform in this room say it is the best they have ever sounded. The entire setup is very flattering to performers and acoustic music in general.

Sound Reinforcement Amplifiers

Chapter 7

Sound reinforcement amplifiers, also known as public address (PA) amplifiers and power amplifiers, amplify the mixed sound to the desired volume with as little modification as possible. They can be stand alone rack-mounted units or be built into mixing consoles.

PA amplifiers generally have high-level (0 dBv) balanced or unbalanced inputs. The number of watts needed for a given performance is determined by how many speakers you want to drive and how loud you want them. You must double the wattage provided by the power amplifiers for every 3 dB SPL increment desired. Acoustic music sounds best at the lowest volume level that will achieve a realistic and consistent sonic field for the entire audience.

The timbre (frequency spectrum) of the instruments that are being played affects amplifier power and headroom requirements even if their volumes are equal in a mix. Acoustic instruments that do not have a great deal of bass presence, such as banjos and guitars, need less power to get a good sound and fully reproduce their transients; instruments with a lot of bass presence need more.

The best method for capturing the transients and overtones is to match the amplifier power to the maximum music power output the main speakers are rated for. If the system is run at an average level of

Power requirements of a sound system at increasing volume levels and distances

1 watt =	90 dB SPL @ 3 ft.	84 dB SPL @ 6 ft.	78 dB SPL @ 12 ft.	64 dB SPL @ 48 ft.
2 watts =	93 dB SPL @ 3 ft.	87 dB SPL @ 6 ft.	81 dB SPL @ 12 ft.	67 dB SPL @ 48 ft.
4 watts =	96 dB SPL @ 3 ft.	90 dB SPL @ 6 ft.	84 dB SPL @ 12 ft.	70 dB SPL @ 48 ft.
8 watts =	99 dB SPL @ 3 ft.	93 dB SPL @ 6 ft.	87 dB SPL @ 12 ft.	73 dB SPL @ 48 ft.
16 watts =	102 dB SPL @ 3 ft.	96 dB SPL @ 6 ft.	90 dB SPL @ 12 ft.	76 dB SPL @ 48 ft.
32 watts =	105 dB SPL @ 3 ft.	99 dB SPL @ 6 ft.	93 dB SPL @ 12 ft.	79 dB SPL @ 48 ft.
64 watts =	108 dB SPL @ 3 ft.	102 dB SPL @ 6 ft.	96 dB SPL @ 12 ft.	82 dB SPL @ 48 ft.
128 watts =	111 dB SPL @ 3 ft.	105 dB SPL @ 6 ft.	99 dB SPL @ 12 ft.	85 dB SPL @ 48 ft.
256 watts =	114 dB SPL @ 3 ft.	108 dB SPL @ 6 ft.	102 dB SPL @ 12 ft.	88 dB SPL @ 48 ft.
512 watts =	117 dB SPL @ 3 ft.	111 dB SPL @ 6 ft.	105 dB SPL @ 12 ft.	91 dB SPL @ 48 ft.
1024 watts =	120 dB SPL @ 3 ft.	114 dB SPL @ 6 ft.	108 dB SPL @ 12 ft.	94 dB SPL @ 48 ft.
2048 watts =	123 dB SPL @ 3 ft.	117 dB SPL @ 6 ft.	111 dB SPL @ 12 ft.	97 dB SPL @ 48 ft.
4096 watts =	126 dB SPL @ 3 ft.	120 dB SPL @ 6 ft.	114 dB SPL @ 12 ft.	100 dB SPL @ 48 ft.
8192 watts =	129 dB SPL @ 3 ft.	123 dB SPL @ 6 ft.	117 dB SPL @ 12 ft.	103 dB SPL @ 48 ft.

at least 6 to 10 dB below this maximum it will have enough headroom to properly reproduce the musical transients.

Headroom refers to how much reserve capacity a system has for additional signal level beyond its average level. In a power amplifier, good headroom implies that transients will be transmitted. If an amplifier is continuously run at peak power no transients above that will be reproduced. If there is sufficient amplifier power to obtain normal sound levels and still have a reserve, the system will have sufficient headroom. A 3 to 6 dB difference between peak and average power is sufficient for most live applications. A 20 dB difference is considered excellent for critical listening, but more may be required if you want to faithfully reproduce the transients from percussion and horn instruments. Twenty decibels is equal to a ratio of 100:1 so a high-fidelity system may be only putting out 1 watt of average power but needs 100 watts for the peaks.

Although oversizing amplifiers beyond the speakers' power loading capacities in the quest for headroom is a valid method for reproducing the entire musical spectrum, including transients, experience has shown that someone will crank up the volume and turn the speakers into confetti and scrap metal. If you are using oversized amplifiers, use restraint and do not overpower your speaker system. You can provide electronic safety measures such as limiters and security covers (mechanically affixed plates that cover the limiter and crossover controls).

Amplifiers that are too small to accommodate the required levels will clip. When this occurs over an extended period of time (a few minutes), a large amount of high-frequency ultrasonic harmonics will be produced, most of which will be routed to the high-frequency horn drivers (tweeters) and blow them out.

The average levels going to a horn driver are normally quite low (20 to 30 watts), even from a

400-watt amplifier. This is because the efficiency of a horn driver is usually about 10 dB more than the cone drivers in a system. Thus 40 watts of power delivered to a horn will be as loud as 400 watts to the rest of the speakers.

Using Compressors and Limiters

While the use of compressors and limiters can reduce the dynamic range of the signals and help avoid clipping loud transients, it will also raise the average power level closer to the peak power available from the amplifiers. While this will make a smaller amplifier sound louder, it will put tremendous stress on main speaker systems that do not have enough average power dissipation to accommodate it. Short-term musical peaks do not produce a lot of heating effects in an amplifier, but high average output power will cause the temperature of the output transistors and heat sinks to rise. This heat must be removed by air circulation or thermal shutdown can occur.

Headroom often disappears in metal and rock sound systems because they normally use compressors and limiters to reduce peak transient signals and average levels are often raised to the peak output of the amplifiers to make the system louder.

Maintaining adequate headroom in an acoustic performance is very important because transients contribute a large part of the character of acoustic instruments. The ability to reproduce transients without clipping makes the sound more open and spacious. If compressors and limiters are used, the transients that occur will be truncated.

However, many people equate high amounts of compression with quality, which is why an otherwise clean sound system with plenty of headroom is often made to sound louder by using compressors and limiters, even for acoustic acts. This is because listeners have been conditioned to a heavily compressed sound by radio and by rock 'n' roll recordings. Back in the days of AM radio, engineers learned they could extend the transmitting range of their radio signal (and boost their revenues) by getting the average levels up as high as possible. Volume wars occurred as different stations in the same market competed for listeners by trying to get their spot on the dial louder than the other stations. This heavily compressed sound became the standard by which *live* music was judged (rather than the other way around). Since music is a consumer driven product, we tend to get what we ask for. The earliest CDs of old rock 'n' roll recordings used the final mixes made for vinyl and retained the original compressed and high-frequency boosted sound. The result was harsh sounding CDs. Today, many recordings are remixed to take out the compression and extra highs, which results in more natural sounding music.

Acoustic musicians now have the opportunity to eliminate this processing during their performances and reeducate their audiences to listen to a more natural sound. Much care should be taken not to drive the amplifiers or any other part of the system into clipping and undermine the advantages gained by having enough headroom.

Spectral Balance

The spectral balance of the particular music and its frequency range affect its average and peak power requirements. How much power the amplifiers need to deliver depends on the instrumentation. Each musical group produces vocal and instrumental frequencies that need to be amplified, either with enough wattage capability at the amplifier stage or by boosting the average signal with limiters and compressors. The amount of bass frequencies required are generally the first consideration when you figure out the amount of watts needed and how to use them in a sound system.

Crown® Micro-Tech® series compact power amplifiers contain proprietary "Output Device Emulation Protection" (ODEP) to prevent amplifier shutdown during operation and increase the efficiency of output circuitry. In the event that more power is required than the output transistors are capable of delivering, ODEP's circuitry immediately and proportionally limits their drive level rather than shutting down the amplifier. The MT-600 delivers 325 watts of power into 4 ohms; the MT-1200 delivers 480 watts into 4 ohms; and the MT-2400 delivers 800 watts into 4 ohms.

For instance, dance music (rap, hip hop, disco) usually has very heavy synthesized bass notes that are an octave or two lower than any stringed bass could produce and kick drums that produce a combination of high average and transient signals that have extended bass frequencies. This requires amplifiers and speakers capable of reproducing bass frequencies below 100 Hz at substantial volumes. To get the average signal as loud as possible compression is added to the individual instruments and vocals and to the mixed signal. This causes as much as several thousand watts to be concentrated in this narrow power band (up to 100 Hz).

Mainstream middle-of-the-road pop music usually has much less bass and produces mostly midrange and high frequencies. This means that smaller power amplifiers (for below 100 Hz) and smaller bass speaker cabinets can be used. Many acoustic guitar and vocal acts produce very little energy below 100 Hz, meaning that only 100 watts of bass amplification may be required even for a large room. Banjos produce virtually no bass, so buying a 2000-watt amplifier for the bass speakers in a bluegrass band is unnecessary. Symphonic music does not produce a great deal of average power, but does produce very high and low frequencies and sudden transients with as much as 30 dB differences. In fact, the dynamic range of an orchestra can approach 100 dB, a range impossible to record and reproduce without some level riding and compression.

Some equalizers have a real-time display that shows the frequencies that are being produced. This shows the spectral content of a musical program.

Size and Number of Amplifiers

Acoustic acts with normal efficiency speakers should be able to work small rooms with 100- to 200-watt amplifiers, medium rooms with 200 to 400 watts, and large rooms and outside concerts with 1000 watts and up. Watch the clipping indicators at your next performance; all amplifiers should be adjusted so that simultaneous clipping occurs above the maximum required sound level. If the lights are blinking at a very regular basis, then you need to either turn down the volume of the whole sound system, or add amplifiers and speakers (double the wattage to get a reasonable increase in volume), or boost your average power through

limiting and compression when music with lots of transient peaks is performed. Generally speaking 1 dB variation is the smallest difference we can hear and every time you increase volume 3 dB, you double the amount of power (wattage) needed.

But be careful not to get into a volume war scenario. You want to provide good coverage to your audience without destroying their hearing. Also, every time you want to increase power, you have to determine whether your speakers are up to the task. If not, you may need additional cabinets, cables and crossovers for your system.

Amplifier and Speaker Hookups

Specifications for power amplifiers usually provide a recommended nominal impedance and a minimal load impedance. Some power amplifiers may be severely damaged if they are operated below their recommended minimal output impedance. Most amplifiers should not be made to drive loads below 4 ohms unless they are specifically rated for this duty.

Amplifiers come in two basic configurations: mono or stereo. Mono amplifiers drive only one set of speakers at time. As long as the speaker impedance does not go too low the amplifier will function fine. Mono amplifiers can also be used with electronic crossovers to drive various banks of bass, midrange and treble speakers.

Stereo amplifiers offer more flexibility. They can be used as dual mono (acting as two separate mono amplifiers) or bridged mono amplifiers. When bridged, both sides of the power amplifier are electrically combined to form a single amplifier and drive a common speaker load.

In the simplest configuration, each side of the stereo amplifier sends a separate signal, one channel for the main speakers, the other for the monitor speakers. This allows separate volume control of each signal.

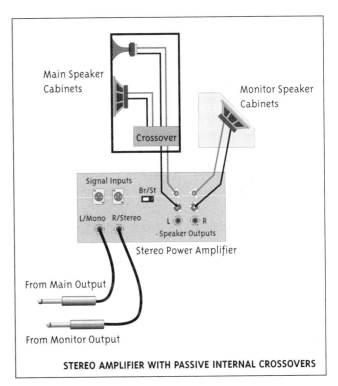

STEREO AMPLIFIER WITH PASSIVE INTERNAL CROSSOVERS

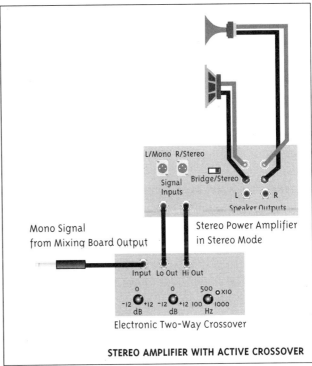

STEREO AMPLIFIER WITH ACTIVE CROSSOVER

Another choice is to feed each side of the stereo amplifier with a signal from a two-way electronic crossover, and allow one side of the amplifier to drive the bass speakers and the other to drive the horns.

Power Loading

Knowing the relationship between amplifier power output and speaker loads is extremely important, particularly when you connect multiple speakers.

Transistor Amplifiers

The impedance (rated in ohms) of the speaker load determines the amount of power that is drawn from an amplifier. The voltage swing of a transistor amplifier is fairly constant no matter what the load is. Voltage swing, rated in volts RMS, is dependent on the power supply of the amplifier. A 300-watt amplifier may have a plus and minus 75 volt supply which allows its output signal to swing from -65 to +65 volts. As the impedance decreases the power that is drawn from the amplifier increases proportionally. However, this works only to a point, since the power supply and output transistors must be capable of delivering the increased amperage. Most consumer amplifiers are designed and rated for 8-ohm or 4-ohm operation, however, many new professional grade amplifiers are rated for 2-ohm operation. Generally, as the load impedance is halved the power drawn is approximately doubled (some wattage will be lost in the extra heat production). For example, an amplifier rated at 100 watts for driving an 8-ohm load should deliver close to 200 watts for a 4-ohm load and 400 watts for 2-ohm loads. Remember that the amplifier must be rated for the impedance load you want to drive since amplifiers that are rated for 4-ohm operation only will usually overheat and self-destruct with a 2-ohm load.

Tube Amplifiers

Tube amplifiers handle power loading differently than transistor amplifiers. To help users match speaker loads, tube amplifiers have a set of taps, marked 4, 8, 16, 25.5, 70.7, etc., on their output transformers. If you want to connect to a single 8-ohm speaker you select the 8-ohm tap and the amplifier will deliver its full rated power. If you need to drive 16 single-ohm cabinets, you select the 16-ohm tap, and full power is still available.

The 70-volt setting found on public address amplifiers is for a 70-volt line, where a single amplifier is used to drive dozens of small speakers over a single long wire. Each speaker has a 70-volt to 8-ohm transformer with a wattage tap. This allows you to

The Apogee DA-800 power amplifier has a THD of .007% (at a 4-ohm load) and uses bipolar transistor technology. In stereo mode, it provides 910 watts of power into 2 ohms; 975 watts into 4 ohms; and 660 watts into 8 ohms. In bridged mode, it provides 1820 watts into 4 ohms and 1880 watts into 8 ohms. An on-board microprocessor continually monitors all critical internal functions and sends status reports to the front panel information displays. Information includes output voltage, output wattage, load impedance, attenuation levels, and phase state. All Apogee DA series amplifiers can be remotely monitored and controlled by any PC with Apogee's AmpNet™ software.

balance the volume of each speaker individually by setting the taps to 2 watts, 4 watts, 8 watts, etc.

The most important rule is—never run a tube amplifier unloaded, which is without it being hooked up to a speaker or resistive load such as a power soak. If you do, the output tubes will glow cherry red and may destroy themselves and the surrounding circuitry in a few seconds or the output transformer will short out and render the amplifier a complete loss.

Routing

Speakers can be connected together in three ways: parallel, series, or series/parallel. In parallel, the positive leads of all the speakers are connected together to the positive (+) output of the amplifier; and the negative leads of all the speakers are connected to the negative (-) output of the amplifier. If your speaker cabinets are rated at 8 ohms each, a single 8-ohm speaker may draw 100 watts from a given amplifier. Two 8-ohm speakers paralleled onto a single amplifier channel will present a 4-ohm load to the amplifier, and will draw double the output power of the amplifier (200 watts) and split the 4-ohm load between them, so that each speaker presents an 8-ohm load and still receives 100 watts of power. Four 8-ohm speakers paralleled onto a single channel will present a 2-ohm load that will draw 400 watts from the amplifier, with each speaker receiving 100 watts of power.

In a parallel hookup, the power is equally divided between both speakers, so that while each speaker is not louder, the combination of the two or more sound sources is louder.

If a 100-watt stereo amplifier is used (two outputs per side), then each side can drive two 8-ohm speaker cabinets (and each of those speakers will present a 4-ohm load to each amplifier channel. This means that you can bring two speaker cabinets for small gigs and four cabinets for the larger rooms, without any amplifier adjustments or fear of causing speaker damage.

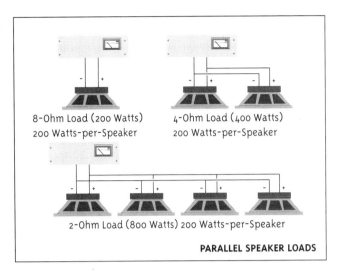

PARALLEL SPEAKER LOADS

In a series speaker hookup, the positive lead of each speaker is hooked to the negative lead of the next speaker in the chain. This connection will increase the impedances presented to the amplifier. Thus two 8-ohm speakers connected in series to an amplifier rated at 100 watts will present a 16-ohm load and draw 50 watts; two 16-ohm speakers will present a 32-ohm load; and three 8-ohm speakers will present a 24-ohm load. Typically, series connections are only used for banks of small speakers or spot monitors that are driven with relatively high-powered amplifiers (400 watts into 8 ohms or more).

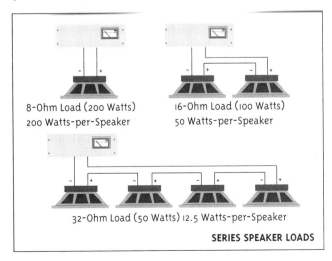

SERIES SPEAKER LOADS

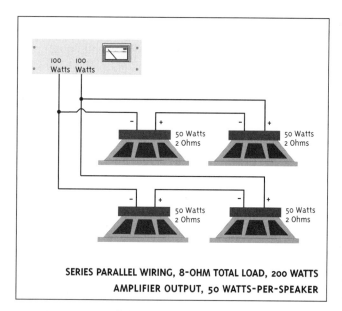

SERIES PARALLEL WIRING, 8-OHM TOTAL LOAD, 200 WATTS AMPLIFIER OUTPUT, 50 WATTS-PER-SPEAKER

A series/parallel connection is used to subgroup speakers in order to achieve a needed load impedance from a high-powered amplifier (1000 watts). It is very useful when four or more speakers are contained in a single cabinet. With four 8-ohm speakers, two groups of two speakers each are connected in series, which creates two 16-ohm subgroups; hooking them in parallel to the amplifier presents a total load impedance of 8 ohms. Thus, the output of a single amplifier will be divided equally among the four speakers (250 watts each).

Bridge Mode

Many modern stereo amplifiers can be run in "bridge mode." This allows both sides of the amplifier to be used to drive a common speaker load. A selector switch inverts the phase (polarity) of one of the amplifier's channels. It takes the mono signal from the left input, inverts it and patches it internally to the right amplifier. The speakers are then hooked up across the two hot terminals instead of the ground. Now the amplifier is capable of driving higher-impedance speakers with higher wattage.

For instance, an amplifier might be rated at 200 watts-per-channel into 8 ohms, 350 watts into 4 ohms, and 600 watts into 2 ohms. If you use the amplifier to drive two full range 8-ohm cabinets rated at 500 watts each in stereo, you will not get the full output power of the amplifier or use the speakers fully, since each cabinet will only be powered by 200 watts.

If the same amplifier is run in bridge mode, it will output 600 watts into 8 ohms or 1200 watts into 4 ohms. Since each cabinet will be sharing half of the bridged output, 600 watts will be available per cabinet for a total of 1200 watts. This is a 3 dB increase in sound output level over the 600 watts that costs nothing beyond a wiring change. (This is because each amplifier channel acts like it is driving a 2-ohm load, which is where maximum output usually occurs.) This is not a magical trick that gets extra wattage from the amplifier. It is just a better way to match the speaker load to the amplifier's output stage for maximum power transfer.

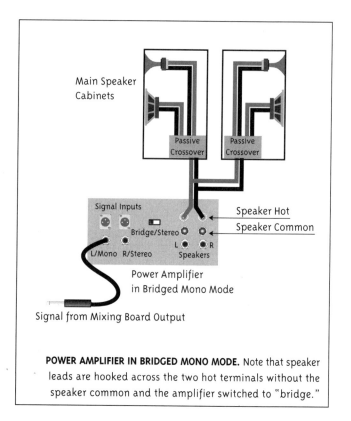

POWER AMPLIFIER IN BRIDGED MONO MODE. Note that speaker leads are hooked across the two hot terminals without the speaker common and the amplifier switched to "bridge."

Amplifier Speaker Connections

There are three types of amplifier speaker connectors commonly in use: quarter-inch phone, five-way binding post, and Speakon™.

The most common are quarter-inch phone jacks. Unfortunately, the signal input and speaker output jacks can be confused because they look the same. The output jack is labeled "Speaker" (or "Spkr") and the input jack is labeled is "Input" or "Channel A" or "Channel." Moreover, although the small-gauge shielded cable that was designed for the connection between your guitar and an instrument amplifier resembles and is physically interchangeable with the cables that connect power amplifiers with main speakers, its use can result in loss of signal power and meltdown of the cable; also its quarter-inch plug will short out the amplifier every time it is plugged into a speaker jack.

Power amplifiers usually have five-way binding posts. These allow you to strip speaker wires and wrap them around the amplifier's terminals. Speaker wires can be poked through the hole in the center of the threaded binding post, used with a lug connector, or soldered into a banana plug, which is plugged into the center hole of the binding post.

Banana plugs can be screwed or soldered to heavy speaker wire. They allow quick connections and eliminate the wrapping of bare wire ends. They have long been used on professional sound systems since they can carry much higher currents than a quarter-inch phone plug and do not short out during insertion.

Some power amplifiers space their five-way binding post outputs so that a dual banana plug can be inserted to connect speaker common and speaker hot for normal stereo or dual-mono operation, or to connect speaker hot (left) and speaker hot (right) for bridged mono mode.

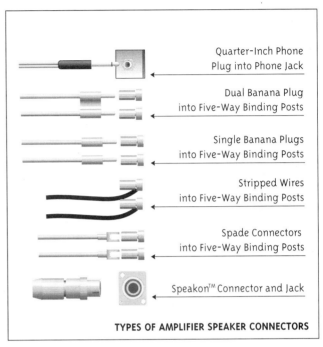

TYPES OF AMPLIFIER SPEAKER CONNECTORS

Many newer amplifiers use Speakon™ connectors that are manufactured by Neutrik. These are high-amperage plugs and jacks that can connect four or eight wires without shorting out during plug-in, which allows them to be plugged in under power. They have strain-relief bodies that protect wire from being pulled out of plugs. The four-wire version can provide biamped power for professional cabinets and the eight-wire version can provide up to four separate signals, useful for active three-way or four-way crossover systems.

Amplifier Controls

Inputs

Balanced XLR inputs are useful for larger sound systems where the amplifier rack is located onstage and a mixer is in the audience. The same audio snake that is used to carry multiple microphone signals will work to carry a line-level balanced signal to the amplifiers. And because these are balanced inputs there is better rejection of outside electrical interference. Also, ground loops between the board and the amplifiers can be avoided.

Stereo or Bridge Mode

This switch allows you to use the amplifier as two independent channels (stereo) or use both sides of the amplifier to drive a single load (bridge mode).

Attenuators

Attenuators (commonly referred to as volume controls) allow you to calibrate the operating gain levels of the entire sound chain. For instance, you may turn up the gain of an electronic crossover and turn down the gain of the amplifier. This reduces cable induced hum and allows the crossover to operate a little further above its noise floor.

Turn On Protection

A tremendous power surge occurs when an amplifier is first turned on, which can cause a noticeable thump in the speakers. Look for amplifiers that have the following features for protecting speakers.

Some amplifiers have a relay in their output that disconnects the speaker from the amplifier until stability has been achieved.

If you have a whole rack of amplifiers, turning them on all at once will probably trip a circuit breaker and shut down the whole system. Some manufacturers are offering sequenced startup for multiple amplifiers ("switched start circuitry"), which provides a few seconds of delay for the power-on of each amplifier in the rack.

Amplifiers that have direct current (DC) sensors prevent damage to speakers if an amplifier develops a direct current (DC) condition, such as when an output transistor shorts out. This sensor causes a relay to disconnect the speakers before they are damaged.

Limiters

Some amplifiers contain soft clipping circuits. These are essentially built-in limiters that reduce gain at the moment of clipping. They allow you to run the amplifier louder before noticeable distortion sets in. And because they are built-in and calibrated for the specific amplifier you do not have to set them up.

Fans

PA amplifiers get hot and heat is the enemy of electronics and will cause failures. Built-in fans and heat sinks help avoid this problem. Heat sinks are metal surfaces that dissipate heat when air comes in contact with them. Fans circulate the air over the heat sinks.

The problem with fans is that they produce noise. Some metal fans sound like turbines winding up, while others just rattle on every bass note. For an acoustic act playing in an acoustically elegant room, any extra noise that degrades the purity of the sound may be distracting and therefore totally unacceptable. At outdoor concerts, the fan noise will never be noticed.

Most amplifiers have a thermal relay that turns them off when excessive temperatures are reached. Unfortunately, this causes system shut-down until the fans have sufficiently cooled the amplifiers. To keep air circulating, do not block the fan openings.

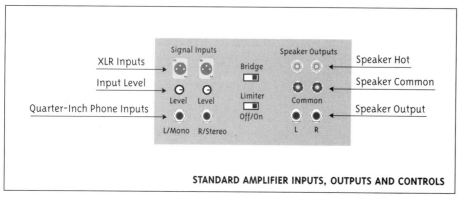

STANDARD AMPLIFIER INPUTS, OUTPUTS AND CONTROLS

Methods for Reducing Fan Noise

1) Use amplifiers that have dual-speed fans. At low speed their sound is hardly discernible. Some amplifiers have constantly variable speed fans, which have sensors that track the temperature of the output transistors. This is a nice touch, since it keeps the fans from having to shift from high to low over and over.
2) Make sure amplifier racks are located as far from the audience as possible.
3) Bring an additional fan (window fans are great) that has a speed control and use it on the amplifiers in addition to their own fans. When you are playing outside in the sun, a floor fan directed at the back of the amplifier rack will remove an impressive amount of heat and still be pretty quiet compared to the amplifiers' internal 4-inch box fans.
4) In extreme heat situations put a tub of ice or dry ice in front of the fans.

Technical Characteristics
Power Ratings

Amplifiers are rated in continuous watts root mean square (RMS), a mathematical formula that is used to calculate an amplifier's average power. The formula uses sine waves as reference sources. The rating is a convenient and agreed on language for comparing the outputs of different amplifiers and relating them to the power handling abilities of the speakers. For instance, the Mackie M-1200 is rated as 600-watts RMS at 2 ohms-per-channel or 1200-watts mono at 4 ohms bridged.

Reactive Load

Reactive load describes the complex impedance interactions from speakers that an amplifier drives. These impedances are affected by the changing resistances in the circuitry that are produced by capacitors and inductors. These changes are dependent on the frequencies of the signals involved.

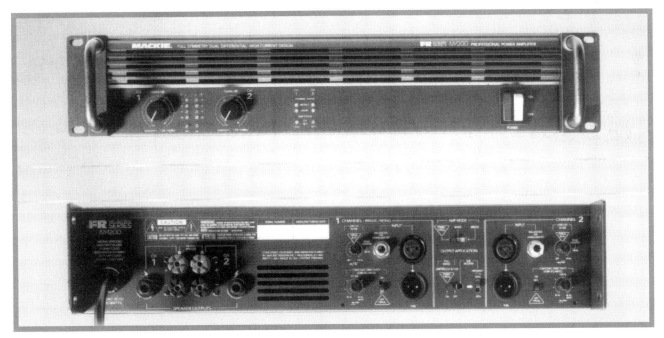

The Mackie™ M-1200 FR Series power amplifier provides 600 watts-per-channel at 2 ohms-per-channel; 400 watts into 4 ohms and 225 watts into 8 ohms. In bridged mode, it provides 1200 watts into 4 ohms and 800 watts into 8 ohms. It features a clipping eliminator, switchable subwoofer crossover, low-cut filter and horn compensation. It has a THD of 0.05% (at a 4-ohm load). A hot temperature LED indicator warns you in advance of a short circuit during setup or operation.

Capacitors act like electric springs, where energy can be stored and later released. The air that is trapped inside a speaker cabinet contributes to the cabinet's capacitive reactance because it also acts like a spring. Capacitors pass more signal (have less resistance) at high frequencies. This can produce a shunting effect in long signal wires between amplifiers and speakers. When small gauge wire is used for runs of a hundred feet or more it will cause two effects. First, a general loss of sound level from the speakers, since some amplifier power will be wasted in heating the wires rather than moving the speaker cones. Up to half of an amplifier's power (3 dB) can be lost in the wires. Second, frequency response corruption will occur, due to the fact that speaker cabinets do not have constant impedance across the entire audio spectrum. A speaker cabinet rated at 8 ohms might go down to 5 ohms at some frequencies and up to 15 ohms at others, causing frequency response irregularities.

Inductors are the opposite of capacitors. Induction occurs when a wire interacts magnetically with a magnetic field. This magnetic field grows and collapses with the strength of the current flow, thus storing energy in the iron core and copper windings of the inductor in much the same way that a flywheel on an engine does. The lower the frequency, the lower the value of the inductor's resistance and the more signal will pass through. Since audio speakers are mostly wires and magnets they have large amounts of inductance. Because inductance is also a frequency dependent value, a loudspeaker's impedance (a combination of its inductance and resistance) will vary over the audio range. A speaker that is rated for 8 ohms can vary its impedance from 4 ohms up to 30 ohms or more at various frequencies.

The better an amplifier's ability to handle complex reactive loads the better (or louder) it sounds compared to others that have equivalent power ratings. This is because they have a higher "damping factor." This factor is dependent on the amplifier's output transistors' reserve capacity, how much negative feedback capacity was designed into the amplifier and the number of transistors it contains (more transistors in the output stage equals lower output impedance).

To minimize power loss, use wire that is heavier than the minimum required. The lower the gauge the heavier (and more expensive) the wire. Use 12 gauge for runs of 50 to 100 feet with 2-ohm speaker loads; use 14 gauge for runs of 50 to 100 feet with 4-ohm speaker loads; and 16 gauge for runs of less than 50 feet. Generally, short speaker cables (3 feet or less) that are used with instrument amplifiers are 18 gauge. Most quarter-inch phone plugs are not suited for wires that are heavier than 14 gauge. However, there are large-bodied screw-type phone plugs that can accommodate up to 12-gauge cable if the insulation is not too thick.

Some engineers like to use 10-, 8- or even 6-gauge speaker wire. Those cables are sometimes termed "monster cables." And even though there are measurable losses in all speaker cables, no matter how heavy, monster cable enthusiasts claim their amplifiers run cooler, stereo imaging is much improved and phase distortion is noticeably reduced. The trade-off for these benefits is weight and expense.

Total Harmonic Distortion

Total harmonic distortion (THD) measures the accuracy of the sound reproduction and rates it in percent such as 1% or .1%, etc. Sound reinforcement amplifiers display low harmonic distortion, typically under .2%. But there is no practical advantage to amplifiers that have lower THD. (The rating is based on one continuous frequency—which never happens in the real world during a musical program.)

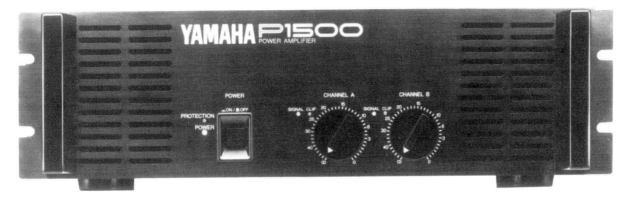

YAMAHA® P1500 power amplifier, part of the P series models, has a power rating of 150 watts-per-channel. In bridged mono mode, the amplifier provides 420 watts. All P Series models function at less than a 0.1% Total Harmonic Distortion (THD) reading from 20 Hz to 20 kHz, at 8 ohms, both channels driven. Rotary attenuators are recessed to reduce accidental setting changes during operation.

Transient Intermodulation Distortion

Transient intermodulation distortion (TIM) is a distortion caused by rapid signal swings that the amplifier's internal feedback loop cannot deal with. An amplifier's slew rate determines its ability to handle very fast signal swings, such as those generated by trumpets, drums, piano, etc. Sound reinforcement amplifiers that have high slew rates eliminate these transient distortions. Slew rate is quantified in volts-per-microsecond and above 20 volts-per-microsecond is considered to be adequate.

Intermodulation Distortion

Intermodulation distortion (IMD) results when two widely spaced frequencies are simultaneously reproduced. For example, a 30 Hz and 5000 Hz tone that are amplified at the same time can cause extra distortion products that would not exist if only one of the signals was present. From a listening standpoint, this causes a muddiness in the high frequencies whenever a bass note is present. Modern amplifiers usually exhibit very low IMD so this rating is not often specified.

Crossover Notch Distortion

All power amplifiers have two or more sets of output transistors. One set amplifies the positive part of the voltage swing; the other amplifies the negative part. When a signal approaches 0 volts there is a small distortion that is introduced when it crosses over to the other set of transistors. The point where the positive swing goes to negative is called the crossover point. If the circuitry in the amplifier is not perfectly matched at that point there will be a little notch that is especially noticeable at low volumes as a gritty sound. This is called crossover notch distortion. If an audience is exposed to it for hours at a time listening fatigue will occur since the brain must work to turn off the discomfort these distortions produce. Most all transistor amplifiers display some crossover notch distortion. Specifications for crossover notch distortion are usually included in the manufacturer's literature. A low crossover notch distortion rating is -95 dB below full output.

Choosing an Amplifier

Your main PA amplifiers do not need to be the most modern or most expensive to do a good job. Make sure you have enough of them so that they are not constantly overdriven and overheated and they will last for many years.

Amplifiers should be mounted in a rack and be prewired for ease and consistency of system set up and safety. Use heavy duty rack mounting. The

weight distribution of the amplifier determines how easily it will mount and whether it will survive a fall from its rack without its parts ripping loose. Very heavy amplifiers should be secured at the front and back of the rack for increased safety.

Since the transformer is the heaviest component in any amplifier, its secure mounting is paramount to the ability of the amplifier to survive shipping. Many amplifier manufacturers insist that the power transformer be removed and shipped separately if the amplifier is coming in for repair. This is especially true of early tube amplifiers, which generally have huge transformers.

Output connectors should be heavy-duty and clearly labeled.

The size and weight of any amplifier is dictated by the size of its power transformer, which usually accounts for over half the amplifier's weight. Powerful transformers are heavy because the amount of power that can be supplied is directly proportional to the weight of copper and iron involved. An amplifier can weigh 80 pounds for a stereo unit with 600 watts-per-channel.

Lightweight amplifiers were introduced in the mid '80s. These amplifiers use smaller transformers in combination with a "smart" high-frequency switching circuitry that accomplishes the same transformations without the weight and with no appreciable degradation in signal quality.

Shipping

If you must ship an amplifier that cannot have its transformer pulled, use the gentlest shipping service available. Air shipping is generally much kinder to amplifier components than is trucking.

Mixing Boards

Chapter 8

The mixing board is the central nervous system of a sound system. It can modify, blend and process signals for a variety of purposes—and then have that blended (mixed) sound amplified to appropriate levels and distributed to main speakers (for the audience); monitor speakers (for the musicians); tape recorder; and uplinks to radio, television and computers. It also provides the sound engineer with the means to monitor audio signals through a combination of meters and headphones.

Some boards can be used for sound reinforcement and studio recording.

The things to look for in a mixing board are the number of signals it can route and process; the number of instrumental and vocal signals from microphones and direct boxes that it can accommodate; the number of submixes it can provide; and how much sound processing or conditioning is available for each signal. The provisions for handling balanced and unbalanced signals, transformer quality, routing, and access to circuitry are also important features.

A good board permits convenient attachment of processing devices (such as limiters) on each input channel and submaster to allow you to add effects to any part of a mix without affecting other sounds.

Also note, the higher the signal level you can supply to the input channels, the easier sound can be produced without hiss or hum. Most of the noise in mixing boards is caused by their resistors, transistor junctions, power supply transformers and by environmental contamination from fluorescent lights and incandescent light dimmers. A high signal-to-noise ratio is desirable because it implies less hum and hiss.

You cannot always tell from the technical specifications what a board will sound like and how easily it will get the job done. Generally, you can try out a board for a session to see how it performs with your act. If you bring good headphones and a vocal microphone to the equipment store, you can learn the basic sound and characteristics of many boards without a lot of time and hassle. Set up each mixing board at the same output level then go from one to the other and compare. Check all the sends, returns, and equalization. Does the signal sound noisy when it is routed through the submasters? Is the equalization smooth? Listen for distortion on the peaks. A drum machine is a good source since you can easily hear distortion when internal clipping occurs.

Sound Quality

Every mixing board has a sound of its own due to different kinds of amplifiers and transformers and varied equalization capabilities.

The more equalization capability a board has (e.g., four bands as opposed to two) and the greater its headroom, the better it can sound, especially during complex mixes with many instruments. Headroom is the signal level capacity available after all gains and levels have been achieved throughout the signal path. The nominal gain is how much gain is required to bring all instruments up to their desired level in the mix during normal playing. Headroom is how much reserve capacity a system has for accommodating peak levels beyond the average level. You can run peak signals through a mixing board that is already at 0 VU without causing distortion ("punching the signal") to as much as 10 dB.

A board that has good internal headroom will be very forgiving of channel fader and input pad settings and produce good signal-to-noise ratios for a variety of input levels and gain settings. Boards that do not have much headroom can be made to sound good, but are very unforgiving of too much or too little signal on their internal buses. They will make the engineer work harder just to keep them from distorting or adding hiss. Remember that each piece of equipment in the signal chain has its own desired nominal level and headroom. Improper settings and cabling between components can corrupt the entire system's headroom. (Chapter 10, "Preparing for the Show" will go into more detail.)

A board's sound can make a big difference for acoustic acts that perform in quiet rooms. If you use a board within its limitations of gain and headroom, distortion will be reduced or eliminated.

Multiple Boards

There may come a time when you run out of input channels on your main board. Maybe you will need extra channels for a warm-up act, or have to dedicate a separate channel for each of your acoustic guitars to tweak the equalization for each one separately. Some boards have "sub-in" connectors that allow you to plug the output of another (slave) board into the buses of the master board. Each slave board acts like a submix of the large board.

You can also use external bus mixers (add-on mixers). These are not separate mixing boards, they have no internal power supply and no output faders. They are submaster units that have more input channels than are provided on a main mixing board. Their manufacturers supply special connectors to hook them up to the main mixing board.

Maintenance

A mixing board is a major investment. Here are a few tips on keeping it running: 1) Use a case; 2) cover the board when it is not in use; 3) keep food and drinks away from the board; 4) do not use any cleaners without checking the board manufacturer's literature; 5) do not use contact cleaner sprays—use a silicon lubricant cleaner that leaves zero residue and avoid cleaners that contain carbon tetrachloride and any that are not safe for all plastics.

Routing Signals

Bands need to evaluate how much flexibility a board will give them for routing signals. Most situations minimally require that the signal go to the audience (house speakers) and to the musicians (monitor speakers). They may require separate mixes for each monitor speaker so that each performer can get a different mix. They may require that signals can be routed to separate processors and want the flexibility of being able to send signals to DAT or cassette tape recorders, radio broadcast feeds, or multitrack recorders.

Routing flexibility can be ascertained by looking at the channel connectors located on the back of the board. Generally, the more direct outputs, inserts and inputs per channel, the easier the board will be to interface. Also, look for balanced XLR connectors on the main output channels.

Built-In Preamplifiers

The primary function of a built-in preamplifier is to raise the operating power of a microphone or other transducer to the levels required for proper operation inside a mixing board. A board that has good quality preamplifiers will have noise specifications superior to -100 dBv with many now exceeding -125 dBv.

Use outboard preamplifiers to make up for any built-in preamplifiers' shortcomings. Outboard preamplifiers have line-level outputs that go into the line-in jacks on the mixing board's input channels. (See Chapter 4, "Effects, Sound Processing and Outboard Preamplifiers.")

Built-In Amplifiers

Most mixing boards do not contain amplifiers because they generate heat and hum and add extra weight to an already heavy item. Generally, boards that do have them offer a maximum of 400 watts-per-channel.

Amplified boards must be kept within 50 feet of speakers to avoid the signal loss that occurs when power is run through long cables. Watch out if you are still using amplified boards from the '70s since many suffer from a variety of ills such as noise, distortion, and possibly the worst processing device ever invented: spring reverbs. Spring reverbs consist of transducer coils that are located on one end of a 6- to 12-inch spring. Once the spring is excited, vibrations travel up and down it at the speed of sound until all the energy is dissipated. A receiver pickup on the other end of the spring produces an electrical signal that is amplified and added back into the main mix. Any sudden noise will cause the spring to "boing" and make a whole band sound like it is playing "Slinkys." Another problem is their extreme sensitivity to mechanical shock. Someone walking on stage will cause the spring to shake and crash against the side of its housing, which will result in a metallic thunder through the PA speakers.

Many guitar amplifiers use spring reverbs. They are an integral part of the classic electric sound and there is no digital equivalent.

Modern amplified boards are easy to hook up. If your act can be mixed with a small number of channels (no more than 12 inputs) and you need only one monitor send and 100 to 250 watts of main power is sufficient, a board that has a built-in amplifier may be a good option for your act.

Signal Conversion

For a board's electrical circuits to function in synchronization with incoming signals their parameters must be matched to those of the equipment the signals are to be routed to. Unbalanced signals that come into the board from tape recorders, preamplifiers, keyboards, and so on must be converted into a format the input channel will accept, so they can be routed without degradation.

Not all mixing boards accept balanced and unbalanced signals. Read the specifications and look at the types of connectors on the input channels. A three-pin XLR connector indicates a balanced input that will accept a signal from a level matched balanced output.

Microphone input circuits include transformers or integrated circuit stages that have common mode rejection (CMR) circuits to cancel out interferences from hum and radio transmissions.

The output from a typical low-impedance microphone is a balanced signal, which rejects hum and radio frequency interference and allows for long microphone lines. Most professional processing gear, such as equalizers and electronic crossovers produce a balanced output. An unbalanced output can be plugged into a balanced input without harm, but some balanced outputs can have their output transistors destroyed if they are shorted out by being plugged into unbalanced inputs. Check the manufacturer's specifications to be sure.

A phone jack (quarter-inch) connector (line level input), needs to receive an unbalanced signal, such as that produced by keyboards, guitar pickups, electric guitars, tape recorders, etc. The "line-in" connectors on most mixing board input channels are unbalanced. Even if you do plug a mono unbalanced plug into a TRS balanced input, no harm is done. But you do not get any CMR cancellation.

If a signal from an unbalanced output, like a keyboard, is plugged directly into a microphone input on the board without pad or trim control, it will cause input channel clipping and overload because the signal is too strong. Approximately 1 volt (+2 dBv) is output by a keyboard and the microphone input expects to see only a fraction of a volt (-40 dBv).

Using a cable adapter to convert an XLR input connector to a quarter-inch phone jack will usually compromise the sound, because the signal levels are not matched and no isolation is provided. If you plug a cable adapter from a guitar into a balanced XLR input channel that has 48-volt phantom power, you run the risk of damaging the electronics in the guitar. If you use a cable adapter to send the line level output of a board you are using as a submixer into a balanced microphone level XLR connector you will supply too much signal, distort that channel and possibly short out the phantom power supply of the input channels in your main mixer. (This can happen regardless of the main power supply voltage, 120-volt or 240-volt.)

To properly connect an unbalanced signal to an XLR connector, first convert it into a low-level balanced signal by sending it to a direct box or impedance matching transformer and then to the XLR input. Any other solution has the potential to cause distortion and other problems.

Remember, however, that one incorrectly placed quarter-inch-to-XLR adapter can corrupt the board's CMR and leave you susceptible to outside interference. For instance, running a long high-impedance cable from a guitar to a direct box will cause problems. All high-impedance runs must be kept as short as possible.

How can you tell what type of signal your instrument produces? If you do not know, look at the output connector. If it is a quarter-inch output, you can generally assume it is going to produce an unbalanced mono signal, but check the operator's manual if there is any doubt. If a guitar's pickup is

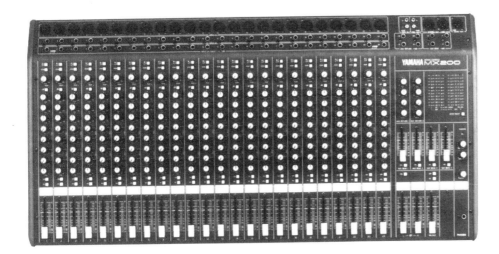

The YAMAHA® MX200 series stereo mixing board is available with 8-, 12-, 16-, and 24-input channel configurations. It has four auxiliary sends (two pre and two postfader), two stereo auxiliary returns and stereo and mono output buses. The front panel allows for convenient handling of connections. Each input channel can accept balanced TRS phone jacks, balanced XLR signals (phantom power is supplied) and unbalanced signals.

passive and it uses no batteries, it will probably produce a low-level unbalanced signal of between -40 dBv and -10 dBv. The actual level depends on the type of transducer element (piezo or magnetic) and its placement on the instrument. If there are a battery and graphic equalizer built into the guitar it is probably going to produce an unbalanced signal that has more kick, maybe as much as 0 dBv. Some new acoustic guitar pickups have an XLR output that sends a balanced signal that is anywhere from -40 dBv to 0 dBv depending on the setting of its built-in volume control. Some of these guitars will use phantom power and you may have to insert a quarter-inch cheater plug into the guitar's unused phone jack output, just to turn on the electronics.

Boards that are designed especially for PA work usually have an XLR connector and a quarter-inch phone jack on each input channel, but you cannot use both at once. Some boards have a mic/line switch that allows you to select either input, other boards use a built-in switch that disconnects the XLR input whenever the line input has a plug inserted.

Boards that are designed for keyboard use will have quarter-inch phone jack connectors on their input channels and may also have from two to six XLR input connectors.

Disc jockeys use boards that have stereo pairs of RCA connectors for playing compact discs and tape cassettes. These boards can be used as keyboard submixers in a pinch but they do not have the flexibility for instruments or vocals. Since they lack equalization controls on each input and generally have no separate effects buses, they do not allow very much control of the sound.

Channel inputs that are labeled "phono" are specially equalized for magnetic phonograph cartridges and are unusable for anything else.

Transformers

Modern boards generally utilize integrated circuits to provide CMR although they do not function as perfectly as transformers. Integrated circuits do not provide the electrical isolation needed to reduce the hum caused by ground loops. Only transformers do this.

When a board uses integrated circuits to accomplish compatibility between balanced and unbalanced signals at the input channels the possibilities of ground loops increase. Any instrument or device that uses wall outlet power (AC) might cause a ground loop.

Unfortunately, high-quality audio transformers are heavy and expensive. They weigh up to one-half

pound each and cost more than $50. Thus, it becomes very expensive to use a transformer on every input channel of a 16- or 24-channel board. As a compromise many boards have integrated circuits at the input channels and transformers on the main outputs.

One way to have the advantages of transformer isolation without the expense of buying a board that includes them on every input channel is to use a direct box and plug its signal into the board. You can place a direct box (active or passive) that has a ground lift switch between an electric instrument and a snake before plugging into the board. Passive direct boxes are essentially impedance-matching isolation transformers that you plug in where needed.

Read the manufacturer's specifications under the heading "transformer input" to find out which signal converters are in your board. (See Chapter 3, "Internal Pickups, Direct Boxes and Instrument Amplifiers" for an explanation of direct boxes and impedance mismatch problems.)

Mixing Board Features and Controls
Input Channels

Input channels accept the signals that are output from microphones, pickups, instruments, signal processing equipment, preamplifiers, tape recorders and computers, and provide the means to amplify and control them. They allow the sound engineer to operate on the signals (modify, process, amplify them) and prepare them to be mixed and routed appropriately. Generally, the balanced signals from onstage microphones and pickups are sent through an audio snake (long multichannel cable) to the mixing board. Each individual channel is plugged into a separate microphone input channel. These are usually labeled "Mic" or "Mic Input."

Boards that have anywhere from 4 to 32 input channels are in common use for acoustic and electric bands and 48- to 128-channel boards are being used in television and large recording studios.

You can usually determine the number of input channels on a board by counting the number of faders, since most of the time each controls one input channel. The exceptions to this are the stereo tape or CD input channels that are common on radio station mixing boards, which have two inputs per fader and some modern boards that have two or four specialty channels for tape and CD playback and effects returns.

Each input channel will provide some or all of the controls discussed below. Once the signals from every microphone input channel have been adjusted to the satisfaction of the sound engineer and the band they will be sent to the mixing board's output section and eventually to the power amplifiers and speakers.

Volume Control

Faders, also known as potentiometers, or "pots," control the volume for each channel. Normally these are numbered starting from the left side of the board, although some English boards start numbering from the right. Faders can be either slider types or rotary. They can be controlled manually at the board—or from a remote control device such as a computer.

Rotary faders can be excellent for a live performance that does not demand the smooth multiple-channel fades that are necessary for studio recording. Their main disadvantages are that it is difficult to fade more than one channel per hand at a time and they do not offer a quick visual indication of their settings. If you require a lot of mixing changes during your performance rule out boards that have rotary faders.

An ideal situation for a board that has rotary faders is with a one- or two-person acoustic act that mostly performs in small venues. These boards are

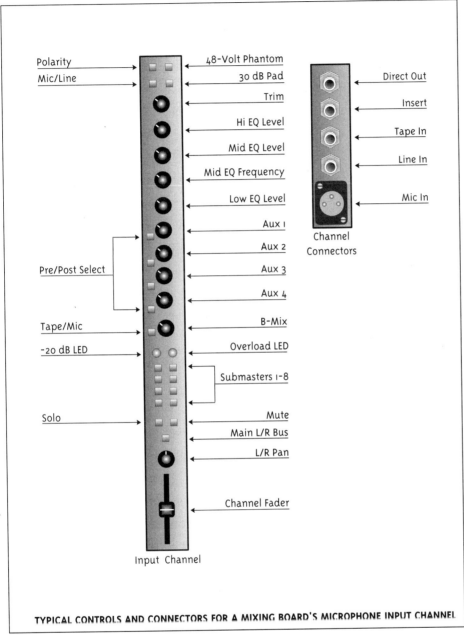

TYPICAL CONTROLS AND CONNECTORS FOR A MIXING BOARD'S MICROPHONE INPUT CHANNEL

easy to set up and operate and can provide as good a sound as something bigger and more expensive.

Try to avoid boards that have stacked potentiometers, where two or three concentric controls rise like a miniature wedding cake. They are not only hard to adjust, they are extremely fragile and are difficult and expensive to replace.

Most high-end boards have 100-millimeter faders; however these are not cheap to design or produce and some manufacturers compromise and use inexpensive 60-millimeter, short-throw faders that cannot produce a good fade-out. If you are not doing a lot of level adjustments and fade-outs during performances, you may be satisfied with a board that has short-throw faders yet meets other selection criteria.

Good faders are very smooth and accurate. When you run them up and down they move easily and provide accurate and even level changes. Cheap faders are hard to move precisely and may have a gritty feel. Some develop areas of "dropout" or dead spots after a few years. With a cheap fader, even a small movement may produce a sound that is too loud or jumps into feedback.

Boards that have professional faders usually provide easy access for their repair. Each fader assembly will have its own wiring harness and mounting screws. Avoid a board that requires you to completely disassemble it just to clean or replace one potentiometer or switch.

Look for sealed faders. If you can see metal contacts and wires below a fader when viewed from the top of the board, it is not sealed and if anything spills on the board it will be funneled into the contact area and cause all kinds of problems.

Equalizers

Equalizers allow the adjustment of volume in selected frequency ranges. The amount of sound modification and conditioning you can do to individual instruments and vocals from the mixing board is affected by how much equalization (EQ) adjustment each input channel provides and how that adjustment is selected or made.

The simplest boards have a low-band (bass) and high-band (treble) control for each channel. This is the minimum workable configuration for most sound reinforcement. Others add midrange controls.

Four-channel equalizers that have at least two parametric frequency bands to control both frequency and bandwidth (Q) are available on many midpriced boards. The parametric function allows you to tune the equalizer to specific frequencies, which is handy for controlling feedback and making subtle timbre adjustments.

External graphic equalizers have either 10, 15 or 31 bands and each band controls a narrow group of frequencies.

There are two types of channel EQ: shelving and peaking. Shelving EQ affects all sound either below a set frequency (for low [bass] control) or above a set frequency (for high [treble] control). The frequency response curve of shelving EQ resembles a ledge or shelf. Most of the response graph is level, until the "shelf" is reached. From that point it quickly slopes to a new level, either below or above the original.

Peaking EQ is normally midrange EQ, which affects a group of frequencies clustered both above and below a center frequency. The frequency response graph of this EQ resembles a speed bump (for frequency boost). How wide this "bump" is depends on the Q (width) control. High-Q (narrow width) produces a frequency response bump as narrow as 1/6 octave. Low-Q (wide width) produces a

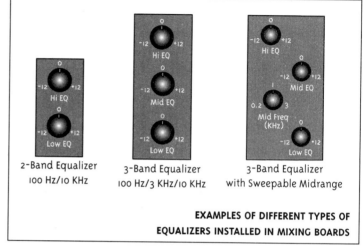

EXAMPLES OF DIFFERENT TYPES OF EQUALIZERS INSTALLED IN MIXING BOARDS

frequency response bump as much as 3 octaves wide. High-Q settings are used to "notch out" feedback frequencies. Low-Q settings are used to modify the overall tonal qualities of instruments and vocals.

Some midrange controls also allow you to select the center of the frequency band they affect (usually labeled "FREQ"). For instance, a tone control might be adjustable from 200 Hz to 2000 Hz for lower midrange equalization. This allows you to boost or cut particular frequencies in the mix without affecting adjacent frequency bands.

The bandwidth of some equalizers is adjustable (variable Q) from 0.1 to 3 octaves. This is how wide a frequency range is affected relative to the center frequency that is selected by the frequency control. With the width control set to 1, and a selected center frequency of 1000 Hz, a range one octave wide will be affected, allowing you to cut or boost frequencies in the 500 to 2000 Hz range from -12 to +12 dB. When the width control is set to 0.1, a frequency range of only 100 Hz is controlled, which allows you to notch-out a problem frequency. Wider Q widths affect up to several octaves of frequencies and are good for enhancing the overall tonal balance of an instrument, such as adding more bass to a small-bodied guitar.

A tone control group that allows you to adjust only the center frequencies of each band is said to be quasi-parametric. Tone controls that adjust both frequency and width are said to be fully-parametric or simply, parametric. If you have two complete sets of these controls per channel, you have a two-band parametric, while four sets would be a four-band parametric. Many boards have at least one band of fully-parametric EQ, plus low- and high-frequency shelving controls. Some have two bands of parametric plus two fixed-band equalizers that allow four separate areas to be adjusted.

EQ defeat, usually labeled "EQ IN/OUT," is a switch that bypasses the tone controls to allow instant comparison of any equalization to the original signal. It permits the tone controls to be switched out of the signal path.

Buses and Auxiliary Sends

Multiple input signals are combined (mixed) at buses in preparation for further electronic modification on their way towards a selected output (main speakers, monitors, tape recorder). Think of each bus as a highway that has entrance ramps for each input and exits for each return channel. Stereo mixes require two buses for a given signal. Monitor, auxiliary and effects mixes require only one. Many small acoustic acts will not need more than four buses. Before you purchase a board, define your current and future requirements. Some boards are advertised as eight-bus boards because they have eight tape buses. In reality they have eight tape outputs, two main outputs, and six auxiliary sends, giving a total of 16 buses. The simplest boards have at least one bus, the main output. The solo (cue) bus allows you to hear a single instrument or voice in headphones (or cue wedge) before it is added to the main mix. This is used during monitor setup to get a basic mix without the sound going to the main speakers, or to troubleshoot during a performance. It allows the engineer to listen to each input channel in turn to identify the source of a problem sound.

Auxiliary sends can be derived from before (prefader) or after (postfader) the microphone input channels' volume controls. Prefader sends are most useful when you need a signal that does not change with the fader position.

The mix for most stage monitors is derived from prefader auxiliary sends. This allows the sound engineer to change the mix in the main sound system without affecting the mix that is being sent to the musicians. This feature is useful for attaining maximum monitor volume before feedback. It also allows the engineer to set a monitor mix that remains constant while the faders are used to mix the sound that is being routed to the main speakers.

Most boards have one or more monitor sends ("Mon 1," "Mon 2") for each input channel.

A postfader auxiliary send ("After Fader," "Postfader" or "Post") can be used for acts that do not need loud volume in their monitors. Since this mix is affected by any adjustments of the input faders and equalization controls, it allows the musicians to hear the same mix that is being sent to the audience.

The auxiliary sends ("Aux 1," "Aux 2," or "EFX 1," "EFX 2") can be switchable prefader and postfader controls located on each microphone input channel. They control the signals that are to be affected by any parallel processing devices. Parallel processing is used when the sound engineer wants to vary the amount of processing (reverb, flanging or echo) for different instruments before routing their signals to the final mix. The effects devices are plugged into the auxiliary outputs of the board and their signals are routed to the microphone input channels the engineer wants to apply effects to via a line-in jack on a spare input channel, or to the effects return input, which has its own fader control.

Auxiliary sends enable the sound engineer to control how much signal (relative volume) from each channel gets sent to the effects boxes, and how loud the total effect will be. When a channel's auxiliary send is off its signals are removed from the final mix. Each effects send can be routed to one effects device, so if you want lots of effects happening at the same time and total control, the more effects sends on the board the better.

(For more information, see the segment "Parallel Routing: Processing Devices" in chapter 4.)

Pan Pots

Pan pots enable you to position signals between the right and left channels of speakers, headphones or tape recorders. This produces a quasi-stereo mix from monophonic sources. With very few exceptions most live and recorded instruments are mono in nature since they are usually picked up with a single microphone or pickup. By altering the balance of the sound level for a particular instrument between the left and right output channels through use of the pan control we fool the brain into believing there is a real stereo acoustic image. As an example, many pop recordings of the '60s had all the vocals panned to the left and all the instruments to the right. Most modern stereo mixes place vocals and bass in the center, drums across both channels, guitars spread left to right, and add an overall reverberation. Many engineers will not use this type of stereo panning during a live performance because of its complexity and the inability of most of the audience to perceive the stereo balance in a live situation anyway. Some bands, like Pink Floyd, use four-channel (or more) surround sound during their live performances.

VU Meters and LEDs

VU (volume units) meters and LEDs (light emitting diodes) both provide visual monitoring of signals, but they do not provide the same type of information.

VU meters indicate the perceived volume of the music (how loud a sound is to the human ear), a feature that is desired in sound reinforcement. But they provide little information about the actual peak signals that occur, which can be 10 dB louder than the meter indicates. This is not usually a problem in live sound, where the sound engineer can hear an instrument that is clipping and make the necessary adjustments. During recording, however, peak signals are deadly, especially in digital recording sessions where uncorrected peak signals can render a track useless.

LEDs are signal indicators that can be used to designate both the presence of a signal (green) or a signal that is overloaded (red). Red LEDs provide an indication that a transient signal has reached a preset overload level (OL) and something should be turned down. Overloads are usually caused by momentary musical transients that exceed a circuit's ability to reproduce them without distortion. This is important information during both recording and live sound.

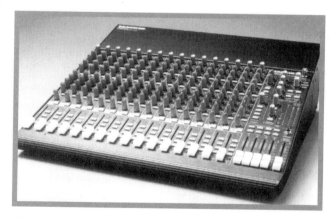

The Mackie™ CR1604-VLZ mixing board has 16 studio-grade microphone preamplifiers; four submaster buses; inserts on every channel that are prefader and pre-EQ and inputs that can accept virtually any output impedance. It can be used as a sound reinforcement mixer, monitor mixer, microphone preamplifier, portable recording console and as a separate drum mixer with equalization for live recording.

Bar graph displays (arrays of LEDs or fluorescent lights) give instantaneous readouts of peak signal levels. Since there is no mechanical action, as with a meter movement, their reactions to signals are instantaneous. Some bar graph displays have a "peak hold" feature, which allows you to see if any transients hit 0 VU and caused distortion. Some peak holds automatically reset themselves after a few seconds, others store the peak levels indefinitely in a digital latching circuit, which is manually reset by the operator with a "reset peak" switch. As the peak audio level gets higher and higher, the indicator is pushed up and latched in the highest position reached. This function is most useful when recording to a digital tape deck, since you can easily see if a recording exceeded a particular level.

Some modern LED displays use a combination approach. A slow filter (electrical circuit that mimics the needle movement of a VU meter) provides a VU-like response while a single LED dances to the peak signals. These work very well in most situations and are cheaper to design and manufacture than quality VU meters.

Microphone/Line Switch

The microphone/line switch allows you to select which input connector will be used. "Microphone" indicates a balanced signal from the XLR jack and "line" an unbalanced signal from the quarter-inch phone jack, such as the output of a tape recorder or CD player.

Pad and Trim

Pad switches and trim controls provide each input channel with the range of signal that it is happiest with. If the signal is too large it will cause distortion inside the board, if too small, hiss or other noise will be added. Pad and trim controls enable you to fine-tune signal levels.

The pad switch cuts down the amount of signal entering the console and prevents overloading of microphone preamplifiers. A pad switch will attenuate a signal by a preset amount, 10, 20 or 30 dB.

Commonly, 30-dB pads are used before the input channels on a mixing board to reduce the signals from loud instrument amplifiers, microphones, direct boxes, etc., and percussion to levels where preamplifier circuits will not overload and cause distortion (clipping).

The trim control adjusts how much signal is sent to the rest of the input channel's circuits, which ultimately affects its headroom and signal-to-noise ratio.

Some cheaper boards do not provide pad and trim controls and you have to accomplish their functions with either external in-line pads or by careful adjustment of the attenuation controls on direct boxes. In-line pads are external resistor circuits that resemble pairs of XLR connectors set back-to-back. They reduce signal levels by 10 or 20 dB. Generally, the output signal from the audio snake is plugged into the in-line pad before it is sent to the mixing board's microphone input channel.

If the signal is so strong that the fader on a particular channel can only be pushed up less than one-third before overload, the channel should be attenuated with a trim control, pad, or in-line pad.

Mute Switch

The mute switch is used to mute ("kill") a selected input channel and shut off its feed to the main, tape, and postfader auxiliary buses, while it makes the signal available to the monitor buses and solo bus. It is commonly used to listen to a channel's signal through headphones, without adding it to the rest of the mix, to allow the sound engineer to adjust gain and equalization. It is also used to kill live but unused microphone channels because they promote muddiness and feedback. For example, if the guitarist

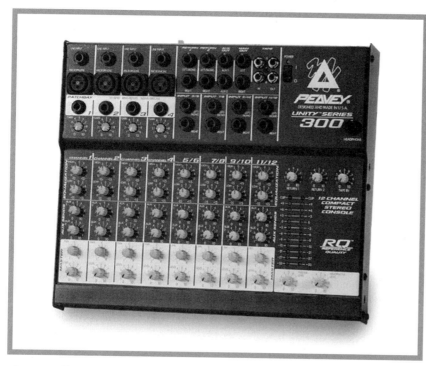

The Peavey® Unity™ 300 RQ mixing board has 12 inputs with 2-band equalization on each input, two auxiliary sends per channel, two stereo auxiliary returns and switchable 48-volt phantom power. Its low-noise transistor microphone preamplifiers are the same as those used in Peavey's most expensive consoles.

switches to a mandolin that uses a different input channel you mute the guitar channel, rather than pull its fader down and readjust it when the guitar is used again.

Channels that have mute switches often have an LED near the mute control that alerts the operator when the channel has been muted.

Most engineers use auxiliary sends that are set to prefader for the monitor sends. This allows them to set a monitor mix that is not affected by the channel fader position. Unfortunately, most mixing boards derive the prefader auxiliary from before the mute switch, which leaves the monitor send for each channel turned on even when the channel is muted. This is an invitation for feedback from an instrument that is set down by a performer and muted by an engineer that does not turn down the monitor send at the same time. Some mixing boards allow you to wire them internally so that their prefader auxiliary is muted with the main signal, but it is usually derived from before the channel EQ, which does not allow it to affect the monitor signal from each instrument. The preferred monitor bus is a prefader auxiliary that is post-EQ and post-Mute. This is available as an option on some boards.

Low-Cut Filter

The low-cut ("rumble") filter is a switch on each input channel that drops out sounds below 60 or 80 Hz. Since most vocals and many instruments have very little sonic energy below these frequencies engaging this filter will not affect the sound of a voice and will prevent the microphone from picking up low notes from other instruments and from room sources such as air conditioners and dancers' feet.

Polarity Reversal Switch

This switch allows the sound engineer to change the polarity of a signal to avoid phase cancellations such as those that occur when two microphones are placed opposite each other on the same instrument.

Auxiliary (B-Mix) Inputs

Some boards have an additional switched auxiliary input per channel ("B-Mix," "B-Monitor," or "Tape Return"), which doubles the possible inputs for multitrack mix down. These are keyed to output jacks. Their stereo outputs can be routed to a tape recorder, radio station feed, or separate monitor amplifier and etc.

Each B-Mix section has its own controls for pan, volume, and equalization. The B-Mix allows the engineer to listen, through headphones, to the signal that is being sent out of the board and make adjustments to it. However, the B-Mix channels do not have separate auxiliary controls, so you cannot get a monitor or effects send from them, which makes them unusable as extra input channels in a live sound reinforcement setting.

Some manufacturers advertise these auxiliary channels as input channels, calling a 16-channel board a 32-input board. The 16 extra channels can send signals either directly to the main outputs to be included in the house mix, or to other devices such as a 2-track tape deck.

They are also useful for virtual track mix down in the studio using MIDI. Since one of the great advantages of MIDI is the ability to keep all sounds separate until the final moment of mix down, you need lots of mixing channels. Suppose you have an 8-track recorder. Having a 16-channel board that has B-Mix inputs allows you to mix all eight tracks from the tape recorder and still have 16 microphone or line input channels open for other tracks such as multiple voice modules from your favorite analog or digital synthesizer. So instead of spending the money for a 20- or 24-channel board, you can get by with a 16-input board that has a B-Mix input on each of its eight microphone input channels.

Phantom Power

Phantom power is the power supplied to condenser microphones and direct boxes from a specially designed mixing board circuit. The circuit is built into the mixing board's microphone input channels. It works by applying a DC voltage (typically 18 to 48 volts) on pins two and three of the XLR connector. Microphone input channels have transformers or operational amplifier stages that exhibit common mode rejection (CMR) at DC frequencies, they block the 48 volts from the rest of the input preamplifier. There is a switch on each input channel (or bank of channels) to activate phantom power.

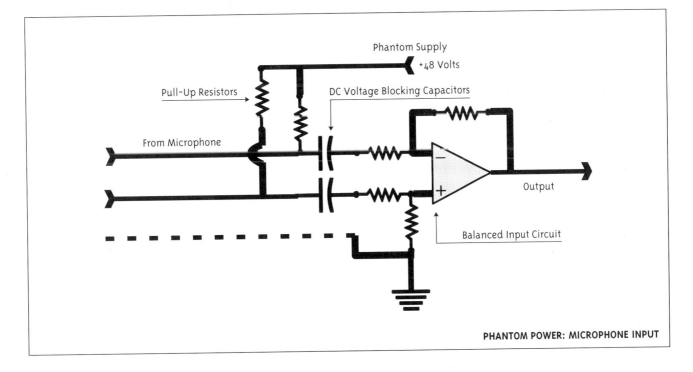

PHANTOM POWER: MICROPHONE INPUT

Many active direct boxes utilize phantom power, as do some acoustic guitar preamplifiers.

The headroom of a microphone's electronics can be improved by the voltage supplied by phantom power. This is because there are 48 volts available for the microphone's electronics, which increases its power supply over its original 1.5 or 4.5 volts. Microphones that can use dual power (battery and phantom) have their circuits designed so that the higher voltages available with phantom power will not damage their circuitry, but a compromise is made during battery operation, which limits headroom and the microphone's ability to handle high SPLs. Lower voltages are fine for normal volume levels, but percussive instruments can overload microphone preamplifiers that do not have enough headroom.

There are a few risks involved with using phantom power. Plugging a ribbon microphone into an energized phantom input can damage the ribbon. Using quarter-inch-to-XLR cable adapters (not direct boxes or transformers) can feed damaging voltage back to the sound source, such as the pickup in an acoustic guitar. Always use a direct box or an in-line transformer (cable that consists of a quarter-inch input and a transformer), which will step down the impedance and change an unbalanced signal to a balanced one before sending it out through its XLR output. (See Chapter 3, "Internal Pickups, Direct Boxes and Instrument Amplifiers.")

Submaster

This is a mixing board within the main board. It allows you to group signals from individual input channels for level control or processing before routing them to the mixing board's main output. With a four-submaster board you can assign vocals to sub one, percussion to sub two, backing instruments to sub three and lead instruments to sub four. The submasters are then routed to the main outputs. This way, the volume of the balanced mix from many microphones can be raised or lowered in the main mix with a single fader. This is also handy for harmony vocals. It eliminates the need to adjust three or four faders at the same time to cause a harmony swell.

Grouped signals can be routed to outboard processors via the submaster insert jack with insert cables. Grouping all vocals to a submaster channel and using a compressor/limiter is an effective way to prevent vocal peaks from getting into the mix. This allows processing of a group of channels without affecting other sounds.

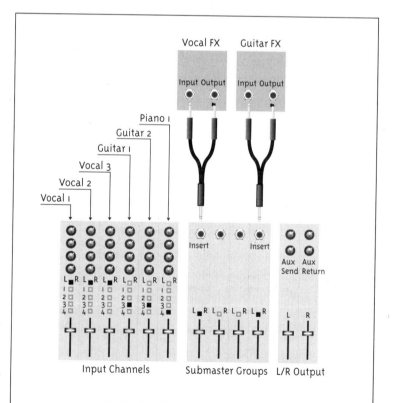

ROUTING SIGNALS TO SUBMASTER GROUPS. The vocal signals from the microphone input channels are routed to a submaster group and then to an outboard processing device using an insert cable. The guitar signals are routed to another submaster group and on to a second processing device. The submaster groups are each routed to the main outputs of the mixing board.

The YAMAHA® M2000 series are 8-bus mixing boards that are available with 16-, 24-, 32- or 40-input channel configurations. They have programmable MIDI muting systems, six auxiliary sends with four full-featured returns and direct mono assigns.

Microphone Level In

The balanced microphone signals from the audio snake are plugged into the three-pin XLR inputs usually marked "Mic In."

Line In

Unbalanced (line level) signals are routed to the channel's unbalanced quarter-inch jack usually marked "Line In."

Tape In

"Tape In" is a line-in input. They sometimes have special internal routing to the B-Mix bus, which allows the B-Mix to act as a monitor bus for a multitrack recording.

Direct Out

A direct out is an unbalanced or balanced output usually marked "Direct Out" that allows the signal from a microphone's input channel to be routed to other devices such as another mixing board or tape recorder. However, some boards do not have direct outs on all of their input channels. You must look at the specifications of the board to determine if the direct outs are balanced or unbalanced. Most modern boards will allow you to insert a mono plug into a TRS balanced output jack, which converts it to an unbalanced output, without any damage to the circuitry.

Channel Inserts

Channel inserts usually have quarter-inch tip ring sleeve (TRS) stereo connectors marked "Insert" that let you route signals to devices such as outboard processors and limiters and return them to the input channels. These prefader inserts allow you to process signals from individual channels without affecting the others. (Note: When a signal is routed out of the board it must be returned to the same channel via an insert cable.)

Many boards allow you to use the channel inserts as direct out feeds if you insert a mono quarter-inch plug to the first "click" of the stereo jack. This provides an output from that channel without breaking the signal path within the board.

Submaster Channel Insert

Signals that are grouped together and sent to a particular submaster can be routed to outboard processors and returned to the board. As with individual channel inserts, an insert cable will be needed.

Main Mix Fader

Most mixers can deliver stereo (L and R) signals from the main panel sends to the main speakers. Most of the time there is a way to change the output level of the main output bus, which feeds the house speakers, with a master level fader that is located on the right side of the board. This control allows you to adjust the overall volume of the entire mix.

Auxiliary Return

The auxiliary return allows a signal that has been sent out via one of the auxiliary buses to be returned and added to the house mix. For instance, a reverb is sent a mix from several channels, maybe a little of the lead voice, some backup vocals, and lots of guitar. Once the reverb has processed the signal it returns it to the board via either a spare microphone input channel or an auxiliary return jack. Auxiliary returns are line-level inputs that are hardwired to the board's output bus. If microphone input channels are available, it is advantageous to return the signal through them so that equalization adjustments can be made. Some also have simple tone controls (lows/highs) and a fader control that allow you to adjust the level of the effects in the main mix.

Auxiliary Send Masters

Auxiliary send masters are final output level controls for the various output buses. They function as master volume controls on the signals that are sent to reverbs and other processors.

Monitor Level Control

The monitor level control functions as the master volume control for the monitor sends. It allows you to turn up the entire monitor mix with a single control.

Bus Assign Switches

Bus assign switches allow you to route signals to various buses without affecting the rest of the board. These are separate and independent from the other controls such as solo and mute. They allow signals to be taken directly from an input channel and be routed through a submix channel for limiting or other processing.

Monitoring

Most boards have a monitoring section that has one or more outputs to allow the operator to listen to the signals of the main bus, monitor bus and auxiliary buses through headphones as desired. A cue, PFL, or solo switch is provided on each microphone input channel to enable you to listen to it separately from the other channels and not disturb the main mix. A B-Mix switch allows you to listen to and modify a signal that is routed out of the board to a tape recorder, monitor speakers or radio station feed without disturbing the signal that goes to the main mix.

A small headphone amplifier in the mixing board and its accompanying controls should enable the headphones to be turned up loud enough to overcome room noise. Make sure it supplies enough power to get the job done.

By using an insert cable on the output jack of the headphone output, the signal can be fed to a power amplifier and near-field speakers (specially designed to be listened to from less than 3 feet away) rather than to headphones. Many engineers prefer to listen to mixes through near-field speakers because they can more accurately judge reverb and bass equalization levels than from the sound of the main speakers (which will mix in some of the acoustic properties of the room and stage). Some engineers use the same kind of speaker that is used for monitoring onstage as their near-field speaker (known as a cue wedge) to more accurately hear what the musicians are hearing.

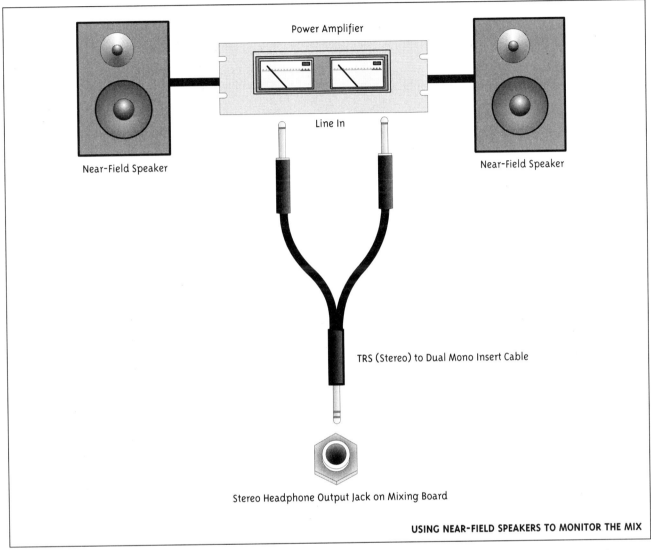

USING NEAR-FIELD SPEAKERS TO MONITOR THE MIX

Headphones

Closed headphones are the only choice for sound reinforcement work because they eliminate most acoustic leakage and allow you to hear only the information coming in and going out of the board and not the sound from the stage and speakers. Do not use open-air phones, since much of the live sound from the sound system will bleed in and spoil the mix.

Some headphones require more power than others because they have a high-input impedance. Low-impedance (50 to 200 ohms) headphones can be driven to louder levels than the high-impedance (250 to 1000 ohms) ones, but be cautioned that headphones can easily reach SPLs that exceed 130 dB, which quickly causes hearing damage.

In-Ear Monitors

In ear monitors are custom designed headphones that fit in your ear canal. They provide superior room isolation (> 26 dB) over any headphone system and allow accurate mixes at low SPLs. They are popular with many acts for onstage monitoring and can also be used by a recording engineer to maintain isolation from a loud room and get a good mix to tape.

Microphones and Pickups: Placement and Usage

Chapter 9

The more musicians understand about how microphone and pickup choices affect the setup of a sound system and the mix that is produced in the monitor and main speakers, the better the chance they have to get good results from their sound systems.

The means by which signals travel through various pieces of sound reinforcement equipment, the type and use of monitor speakers, how loud performers want their monitors, the room's ambiance, and the skill of the sound engineer, all affect what is heard by musicians and listeners. A great microphone will not compensate for a poor sound system, an unskilled engineer or a lackluster performance, but it can give you a good basic signal to start with, and maybe even inspire a better performance.

Choose a microphone that complements your voice or instrument while it minimizes the sounds of other instruments and monitors that bleed into it.

What You Hear

Many musicians do not understand that listeners hear instruments and voices differently from the people who are playing or singing. Often, musicians are shocked the first time they hear their recorded voice or instrument played back.

Sound travels between a singer's mouth and ears two ways: through the air and by bone conduction.

The singer gets a different mix than does the listener, who hears only what is in the air. A singer hears extra resonances from the hollows in their head and loses some high frequencies because their ears are not in a line with their mouth. You generally sound more "nasal" and less "bassy" in real life.

Acoustic guitar players experience many of the same problems. Since guitars are held close to and in front of the body, the performer hears a much bassier sound than someone who is sitting in front of the guitar. Ask acoustic guitarists to set equalization for a guitar and they often roll off the high frequencies and boost the bass. This is exactly what they hear when they are playing the instrument on stage, but it may not be what the designer of the guitar meant for the audience to hear. Additionally, a guitarist is normally out of the line of sight of the strings, and their high frequencies need direct line of sight to be heard well. In fact, most acoustic instruments have been designed to sound good to listeners at least 10 feet away. Even though all sound waves have the same basic shape, how they disperse in air and are absorbed by materials greatly depends on their wavelength (ergo their frequency). Bass frequencies have waveforms that are very long, from about 5 feet for a 200-Hz sound up to 50 feet for a 20-Hz sound. These long waves tend to wrap around everything and leak through any crack in a sound barrier. High frequencies are very directional. Their wavelengths are very short (a few inches) and are easily absorbed by soft material such as carpets or draperies.

To understand this difference more clearly, ask another musician to play your instrument for you so that you can experience what an audience hears and you can acclimate to your instrument's sound. This hearing practice will help you to produce a better sound for your audience; and will make it easier for you to communicate with your sound engineer.

The mix that musicians hear on stage through their monitor speakers is generally different than the mix the audience hears. A technique that is used by some sound engineers to enable musicians to understand these differences is to record the main mix with a DAT recorder during a sound check so that the musicians can hear not only the sound of their own instrument, but its relationship with the mix. Another technique is to temporarily send the main mix (house mix) into the monitor speakers (at a lower volume to prevent feedback). The latter technique works well with acoustic instruments that are closely balanced in sound level, and also with electronic instruments such as sampled keyboards. It does not work with loud drum kits and electric rock 'n' roll guitars, since there is too much volume on stage for the mix to be heard in the monitors without feedback.

Once musicians hear the house mix the engineer can provide variations in equalization, tone and balance so that they can understand what the mixing board is capable of in the context of the room's coloration. That way, what the musicians want can be balanced with what can be accomplished with the available tools. Of course, all parties have to understand that there are physical limitations to every sound system. You will never get an acoustically soft instrument to match the level of a screaming electric guitar without making some compromises in sound quality and playing technique. When each party understands the common goal of playing for the audience, sound checks are quicker and less stressful.

Choosing Microphones

There are no hard and fast rules for choosing microphones and pickups or for placing them on stage.

In general, you will want to use only low-impedance microphones that have three-pin XLR connectors. High-impedance microphones, which typically have quarter-inch phone plugs and on/off

switches, are intended for basic public address systems. There are also some rather expensive convertible professional microphones that allow you to switch their impedance internally to 50, 250 or 600 ohms. Low-impedance microphones generally sound better and their signal is not subject to high-frequency loss on long cable runs. They are better at rejecting electrical interference from light dimmers and CB radios.

Although many rock 'n' roll sound engineers and musicians have been conditioned to using cardioid microphones because of their proximity effect that boosts bass frequencies, acoustic acts are increasingly substituting omnidirectional microphones because their sound reproduction is more accurate when they are used to pick up the complex sound fields of acoustic instruments.

Microphones and Room Dynamics

The signal a microphone produces is affected by the sound field around it, the placement of monitor speakers, the location of other instruments, room ambiance, etc. The same microphone can sound entirely different in another venue or when performers change positions.

Microphones do not hear the same way that the human ear/brain combination does. Our brains selectively tune out extraneous sounds we do not want to listen to; a microphone hears everything within its pickup pattern. Their placement is critical because the interaction between stage acoustics and room acoustics has a noticeable affect on how a microphone sounds. An improperly placed microphone will reproduce stage noise and pick up sounds from other instruments, which will compromise the sound of the instrument or voice that it is meant to reproduce.

To overcome this problem place the microphones as close to the sound sources as practical (close miking) and keep the overall volume of instrument amplifiers and monitor speakers as quiet as possible. If the stage volume escalates and the sound that comes back from the monitor speakers is louder than the sounds of the instruments, feedback will be created that could damage ears and speaker systems.

Getting enough gain to get all of the instruments loud enough in the house mix is the primary job of the sound engineer. Music mixes sound best when the correct microphones are selected and properly placed and the stage volumes are kept low enough so that there are no cross-microphone cancellations or feedback. Often, moving an instrument just an inch or so in a particular direction provides more feedback control than a bank of equalizers. Once sufficient levels for all the instruments are reached a mix can be created that is pleasing to both the audience and the musicians. (More information on setting up sound systems for mixing is found in Chapter 10, "Preparing for the Show.")

Outdoor Effects

Humidity and temperature affect the tuning and playability of your instruments and will alter the sound produced by a microphone. Also, there may be ambient noise to overcome, such as traffic sounds, crickets or aircraft, etc. These problems can be overcome by careful equalization and pickup selection.

Learning Microphone Techniques

Using microphones and pickups properly is a learned technique, almost like playing a musical instrument. And like instruments every microphone has certain ways it needs to be used to produce the sound you desire.

The following information about microphone and pickup positioning and voice training with microphones, is also useful during sound checks.

MICROPHONE SELECTION CHART

Numbers in parentheses refer to manufacturer's name. (See key at bottom of next page.)

Application	Premium	Professional	Basic
Performance Vocal (dynamic)	D3900 (1) ATM61HE (2) N/D857B (4) BETA 58A (6) RE 20 (4)	D3700 (1) ATM41HE (2) N/D157B (4) SM58 (6) C420 (1) SDM 350 (7) M160 (7)	D65S (1) N/D157B (4) BG3.0 (6)
Performance Vocal (condenser)	C535EB (1) ATM89A (2) BETA 87 (6) KMS 150 (8)	C5900 (1) ATM31 (2) SM87 (6) CM200 (3)	BG5.0 (6)
Studio Vocal	C12VR (1) AT4050 (2) RE-20 (4) 421 (5) SM7 (6)	C414 (1) AT4033 (2) BETA 87 (6)	C3000 (1) ATM31 (2) BG5.0 (6)
Ensemble Vocals	C12VR (1) AT4050 (2) SM81 (6)	C414 (1) AT4033 (2) SM94 (6) MC-711 (7)	C3000 (1) ATM33 (2) BG4.0 (6)
Kick Drum	D112 (1) ATM25 (2) RE20 (4) 421 (5) SM91A (6)	D112 (1) PRO25 (2) BETA 57 (6)	D3500 (1) ATM61HE (2) SM57 (6)
Snare Drum	AT837R (2) 441 (5) BETA 57 (6)	ATM63HE (2) SM57 (6)	 BG3.0 (6)
Toms	C418 (1) ATM35 (2) 421 (5) SM98A (6) MD 421 (5)	C418 (1) ATM25 (2) GLM100B (3) BETA 57 (6)	D3500 (1) SM-57 (6)
High-Hat/Cymbals	C414/460 (1) AT4051 (2) SM81 (6) U64 (8)	C391 (1) AT4041 (2) SM94 (6)	D190E (1) PRO37R (2) BG4.0 (6)
Conga	C414B (1) ATM25 (2) 421 (5) BETA 57 (6) MD 421 (5)	C460/C3000 (1) ATM61HE (2) SM98A (6) C 418 (1)	 ATM41HE (2) SM57 (6)
Marimba	C414B/TLII (1) AT4033 (2) SM81 (6) MD 421 (5)	C391B (1) AT4051 (2) BETA 57 (6) C418 (1)	D3600 (1) ATM25 (2) SM57 (6)
Stand-Up Bass	C414B (1) AT4033 (2) SM81/SM7 (6)	C391B (1) ATM35 (2) GLM100 (3) SM94 (6)	D3600 (1) ATM25 (2) PL5 (4) BG4.0 (6)

Application	Premium	Professional	Basic
Trumpet/Trombone	C414B (1) AT4022 (2) SM98 (6)	C409 (1) ATM25 (2) BETA 57 (6)	D3600 (1) ATM61HE (2) SM57 (6)
Clarinet	AT4051 (2) SM81 (6)	AT4041 (2) SM98A (6) C 419 (1) M260 (7)	ATM61HE (2) BG4.0 (6)
Flute	AT4051 (2) SM81 (6)	AT4041 (2) BETA 58 (6)	ATM61HE (2) BG4.0 (6)
Saxophone	ATM35 (2) SM9A (6) SM7 (6)	ATM25 (2) CM700 (3) BETA 57 (6) C 419 (1)	ATM61HE (2) SM57 (6)
Accordion	ATM35 (2) AKG 414 (1)	ATM15A (2) BETA 57 (6) AccPickup (9)	PRO 95 (2) SM57 (6)
Hammer Dulcimer	C414B (1) CM700 (3)	C406 (1) ATM35 (2)	
Lap Dulcimer	C414B (1) AT4051 (2)	C391 (1) AT4041 (2)	D3600 (1) PRO37R (2)
Acoustic Guitar	C414B (1) AT4051 (2) CM700 (3) SM81 (6) U64 (8)	C391B (1) AT4041 (2) GLM100 (3) BETA 57 (6) SM11 (6) ATM15A (2)	D3600 (1) ATM61HE (2) B54.0 (6) SM57 (6)
Mandolin	AT4051 (2) ATM35 (2) SM81 (6) AKG414 (1) U64 (8)	ATM61HE (2) ATM15A (2) BETA 57A (6) M100 (11)	SM-57 (6)
Banjo	AT4051 (2) ATM35 (2) SM81 (6)	ATM15A (2) ATM15A (2) BETA 57A (6) Banjo (11)	SM57 (6)
Violin	AT4050 (2) ATM35 (2)	AT4033 (2) ATM15A (2)	AT873R (2)
Cello	AT4050 (2) ATM35 (2) SM81 (6)	AT4033 (2) ATM15A (2) BETA 57 (6) CM100 (11)	
Harmonica	D3600 (2)	D3500 (2) BETA 58 (6) Hot-Harmonica (9)	D190 (2) SM58 (6)
Piano	C3000 (2) C414 (2) AKG 414 (1) U64 (8)	CM700 (3) BETA 57 (6) P-PUP (10) PZM-6D (3)	
Vibraphone	MD 421 (5) U64 (8)	BETA 57 (6) VibMIDI (9)	SM57 (6)

(1) AKG (2) Audio-Technica (3) Crown (4) Electro-Voice (5) Sennheiser (6) Shure (7) Beyerdynamic
(8) Neumann (9) K & K Sound Pickups (10) Barcus-Berry Pickups (11) Fishman Transducers®

Microphone Positioning

Learning the proper way to position a microphone requires the microphone of choice, the instrument you wish to use, a set of headphones and a tape recorder. Listen to yourself play through headphones to get an immediate idea of the sound, then play back the tape for confirmation. The headphones should be comfortable, open-back types that allow you to hear the rest of the room's sounds. Whatever headphones you choose, acclimate yourself to them by listening to a few recordings of the musical style you are interested in. The idea is to memorize the desired sounds of the instruments.

Analog cassette decks work fine as long as you use high-quality tape and the deck has Dolby or dbx noise reduction (systems that reduce the hiss produced by cassette tape). The optimal deck allows you to use metal particle (chrome) tape and has Dolby C or dbx.

Of course, DAT decks are great for such experiments and they do not have the high-frequency saturation problems that plague the cassette medium. But they do have limitations because transients that make their VU meters jump pass zero will be distorted. (Digital decks do not respond to any audio signals above 0 VU.) To avoid this, use a limiter between the output of the mixing board and the input of the DAT deck, which will clamp any volume rise above a given threshold by compressing its dynamics.

Voice Training with a Microphone

A 4-track cassette "portastudio" can be a good voice training teacher. Use two tracks to record music you want to practice with then record your singing on track three while you listen to the music on tracks one and two through headphones. While you are recording, watch the VU meter on your microphone channel to help you maintain good levels. If you are singing too loudly, back off from the microphone a bit, maybe 3 to 6 inches. If you have a soft part lean into the microphone and make it work for you. The key is to limit the dynamics that are put on the tape (or into the sound system).

Next, play back all three tracks and get a basic music-to-voice balance. Then, mute the music tracks and listen to your vocals. Try to honestly evaluate your voice. Do you hear a lot of "p" popping, gasping, dropped pitch or other flaws? Even though the music will mask a lot of these problems, they are still there, and will contribute to the clutter of the track. Record again, and attempt to fix at least one of your problems. Using this technique during a few rehearsal sessions will train you to use a microphone properly and help you to eliminate bad habits.

Feedback

Feedback is possible whenever sound from a monitor or main speaker gets picked up by a microphone. If the gain of the system is high enough this sound will be recycled until it becomes a self-reinforcing feedback squeal, which will grow until the limits of amplifier power and speaker capabilities are reached. This all happens much quicker than we can read about it. In less than a second, a sound system can be driven into maximum runaway feedback by simply placing one microphone in front of a monitor speaker.

Feedback loops are influenced by the pickup pattern of the microphones, their distance from speakers, the equalization on the individual channel and overall system, and the positions of reflecting surfaces. An instrument microphone might be fine by itself, but when you walk up to it with a flat guitar body, its reflection of the sound coming from the monitor speaker back into the microphone can send the system into feedback.

When there is a very strong signal going into the microphone and the gain of the entire system

can be raised to clipping level without getting feedback—the sound engineer has achieved the loudest sound that system can produce. Just about any microphone can be used on a close-miked vocalist to get enough gain before feedback to drive a sound system into full clipping. However, that same microphone may not be able to be amplified loud enough to reproduce the sound of a nylon-stringed guitar to the desired level. This has nothing to do with the available power in the sound system, but with the gain required to reach the desired sound level. You do not need very much gain with a loud vocalist to achieve full output level. But a soft guitar may need more gain than can be achieved before the sound coming back from the speakers to the microphone is louder than the guitar itself and feedback occurs. The problem is that loud instruments may indeed be louder in the microphone than the desired sound of the acoustic guitar. A microphone that has a good pattern control can help by rejecting the sounds of the undesired instruments and monitor speakers while it provides additional pickup from the guitar itself.

If an instrument has an internal pickup or microphone, keep a hand ready on the channel mute switch when a player sets down the instrument in a stand or on the floor. When the damping effect of a human body is removed, most instruments that have hollow chambers will start resonating in the bass frequencies and feeding back on their own. It is a good idea to have a mute switch on the microphone or on the floor for the musician to engage before setting the instrument down.

Miking Vocalists

No two voices are alike: facial expressions, how much singers project and how they sing all affect the choice and placement of microphones.

When there are multiple vocalists many sound engineers counsel the use of the same microphones for all. Using similar microphones reduces the potential for feedback and simplifies equalizing the frequencies that can contribute to feedback. If microphones with markedly different frequency responses are used they can increase feedback through additional "response peaks" and cause the engineer to continuously try to balance their equalization ("chasing equalization"). The resulting mix will be a compromise at best.

Regardless of the type of vocal microphones used in any given situation they should be of equivalent quality and similar patterns. Attempting to use an equalizer or the built-in tone controls on the mixing board to match the sound of both omnidirectional and cardioid vocal microphones on the same stage can be a lesson in frustration, since the proximity boost of the cardioid microphone will be absent from the omnidirectional microphone. This will result in either the cardioid sounding boomy or the omnidirectional sounding thin, depending on the way the engineer adjusts the equalization controls on the mixing board.

In most situations, cardioid pattern, condenser or dynamic microphones are safe choices. Vocalists that work with high volume in their monitor speakers should avoid using omnidirectional microphones, because they will pick up more of the monitor signal. By learning to use a cardioid microphone correctly,

The Four Parts of a Feedback Path: Microphone, Amplifier, Speaker and Return Path from Speaker to Microphone. Feedback occurs when a sound from a speaker is picked up by a microphone and reamplified many times.

vocalists can avoid the muffled, jagged sound that results when they sing off-axis from the microphone (unless that is what is desired).

However, an omnidirectional microphone will give the truest reproduction of the sound of your voice, if the stage is sufficiently quiet and the sound engineer can keep the volume in the monitors low.

Vocalists that want a really throaty, intimate sound should use a microphone that has a proximity effect, which most standard cardioid pattern microphones have. Vocalists that do not want this effect can use cardioid microphones that have slotted chambers. These produce a more accurate sound, but sound thin when compared to regular cardioid microphones unless additional bass boost is added to their channel.

Microphones should be evaluated for sensitivity to noise. Some great sounding microphones will pick up every finger movement and by doing so, spoil the mood. Be sure to test the microphone to see that it has a good breath/pop filter. Use, "Peter Piper picked a peck of pickled peppers" for a test phrase. A foam windscreen will reduce pop noises,

The Shure® SM58 and Shure® BETA 58a™ are among the top choices for vocalists because of their ruggedness and reliability. The SM58 is a dynamic cardioid microphone with a frequency response of 50 to 15,000 Hz. The BETA 58a supercardioid microphone has maximum isolation from other sound sources, minimum off-axis coloration and a frequency response of 50 to 16,000 Hz.

protect the microphone and keep dirt out. A good windscreen will not significantly reduce a microphone's high-frequency response, but if it does, a few decibels boost at 8 to 12 kHz is usually all that is needed to correct it.

Vocalists can also use electret condenser microphones, but if they sing loudly the microphone's internal preamplifiers can clip and cause a compressed or squashed sound. To avoid this use high-quality batteries that produce a good voltage or use the mixing board's 48-volt phantom power. (Be sure to verify that your board puts out a true 48 volts.) To prevent distortion, engage the microphone channel's input pad when miking loud sources.

Miking Wooden Bodied Stringed Instruments

Acoustic guitars, mandolins, harps, dulcimers, lap dulcimers, stand-up basses, violins, cellos, bouzoukis, charangos, etc. all have resonant chambers that produce bass frequencies in addition to the high frequencies that are projected by their strings. These instruments radiate sounds from multiple sources:

The AKG® C 420 headset MicroMic is a condenser cardioid microphone with a full bandwidth frequency response. The miniature gooseneck allows precise placement of the microphone near the mouth. The C 420 can also be used for flutes.

their strings, which vibrate the air directly and produce harmonic overtones and their resonating chambers, which contribute additional tones and texturing. The challenge is to reproduce the sound from both sources for the audience, unless the performer desires otherwise.

The choice of microphone and/or pickup depends on the sound the performer wants, the method of performance (whether the performer remains stationary or moves), room dynamics, and the other instruments and vocals that are being performed at the same time. A solo acoustic guitar (with or without a vocalist) may be beautifully captured with one or two microphones, while the same instrument used in combination with percussion, keyboards and other instruments, may need a combination of microphone and pickup. And sometimes a room's acoustics are such that no sound reinforcement at all is the ideal option.

Internally mounted bridge pickups are popular for reproducing the vibrations of stringed instruments. A big problem for all contact pickups, however, is their potential for bass feedback because they boost the low-frequency sounds produced by resonating chambers. But this is only a concern for acoustic/electric acts that want to play loud and like to hear themselves loud in the monitors.

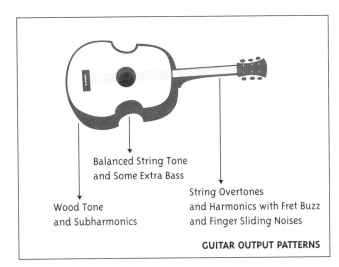

GUITAR OUTPUT PATTERNS

The Fishman® M-100 mandolin pickup is embedded in an adjustable ebony bridge. No holes or alterations to the instrument are required.

Using Only Microphones

For stringed instruments, a single medium cardioid microphone that is positioned a few inches from the sound hole towards the neck is a good place to start. The microphone should be from 2 to 6 inches away from the body of the instrument. Closer is better if you are trying to overcome a feedback problem, further is better for a natural sound. If the microphone is too close it might be struck during a performance.

Move the microphone up the neck if the instrument sounds too boomy, or towards the sound hole for more bass. If the microphone is placed too far up the neck it will not pick up the sound produced by the resonating chamber. The engineer can use the mixing board's equalization controls and/or the musician can use the equalization controls or low-frequency roll-off switch on their microphone to correct imbalances in the sound, such as not enough high-frequency reproduction. Sometimes two microphones are used, one is positioned at the juncture of the neck and body, the other a few inches from the bridge. This can provide a very big sound in the final mix.

An omnidirectional microphone will give a more accurate sound to stringed instruments. However, these microphones will not cancel the sound from monitors or other instruments, but if the performance is quiet and the volume in the stage monitors is kept low, feedback will not be a problem. This is also a good choice for recording stringed instruments.

Although either a dynamic or condenser microphone can be used, the latter will more accurately reproduce a string instrument's high-frequency detail and transients because it has extended response in the important 12 to 15 kHz range. Their lightweight diaphragms respond more quickly to changes in air pressure, which makes them a better choice for those instruments that have a lot of high-frequency detail. However, if you are playing through a sound system that has a limited capability for reproducing this detail, the extended response of the condenser microphone will add little.

The microphone's cardioid pattern will boost the bass response of an instrument that is positioned close to it (a few inches). This can produce a desired bass warming effect for an instrument that is bass deficient. Conversely, it can make an instrument that is bass heavy sound extra "boomy." Selective equalization of the bass frequencies can reduce the boomy effect.

You can also use pressure zone microphones (PZMs), which use electret elements. These microphones are mounted on the faces of instruments.

Solo Guitars

An omnidirectional microphone placed 1 foot away is optimal for solo guitars in a

The Beyerdynamic MC-711 is a low-noise omnidirectional microphone with a frequency response of 40 to 20,000 Hz and a low-frequency roll-off switch.

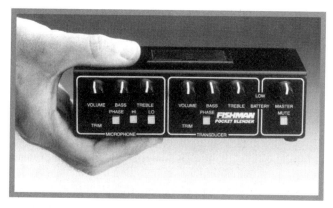

The Fishman® Pocket Blender™ is mounted on a microphone stand and enables a musician to mix the signals from a microphone and pickup used on a guitar and other stringed instruments and send the mixed output signal to the mixing board. It has controls for volume, bass, treble and phase control for the microphone and pickup and many effects sends options.

recording situation. In addition, a cardioid microphone can be positioned 1 to 2 feet to the side of the guitar to pick up the bass frequencies and provide more flexibility for tone control during mixing.

Magnetic Pickups

Magnetic pickups fit in the sound hole and pick up magnetic vibrations from steel strings. They do not produce a true acoustic sound because they do not transmit any of the wood and cavity resonance that gives acoustic instruments most of their tonal character. Acoustic musicians that want very loud monitor levels may have to sacrifice acoustic sound for the more electric sound of a magnetic pickup to limit feedback problems. In that case, a good tube direct box or preamplifier can help reintroduce some warmth (even-order distortion) to the otherwise brittle sound of the pickup and the engineer can boost the frequencies that are below 500 kHz. This can be done with a bass tone control that is set to about 6 dB of boost in the 100 Hz range. The engineer can also use an outboard parametric equalizer and set its "Q" control as wide as possible. (The "Q" control varies the width of the affected frequency band.)

Microphones and Pickups: Placement and Usage

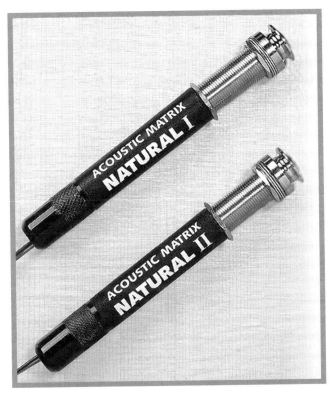

The Fishman® Acoustic Matrix is a copolymer active acoustic guitar pickup. Because guitar size, type of wood, playing style, size of venue and playing context present different challenges to capturing a guitar's ideal voice, two choices of preamplifiers are offered, the Acoustic Matrix Natural I and Natural II. The short distance from the under-saddle pickup to its internally mounted preamplifier maintains the integrity of the information-loaded pickup signal.

Magnetic pickups can also be paired with microphones that will capture the resonance of the wood body.

Microphone and Bridge Pickup Combinations

Plucked stringed instruments work well with a combination of internal pickups (bridge transducers) and external microphones. The pickups get the attack of the strings and the external microphones provide wood tone, air tone and resonance. This setup allows musicians to work close to the microphone for emphasis, and to back away while playing rhythm. This reduces the workload of the mixing personnel and gives control of the dynamics back to the musicians.

During the sound check, a mix of the two signals should be sent to the monitors so that the musicians can get a feel for how they are working the microphones, even if during performance only one signal is sent to the monitors to avoid feedback problems.

All cardioid microphones have a bass boost when used closer than a few inches away from the sound source. Their positioning is critical. Some cardioid microphones have a bass roll-off or music/voice switch. The music position is for full low-frequency response at a distance. If you are getting too much bass from close positioning switch to voice or bass roll-off.

Another choice is to use a microphone that has slotted chambers that reduce the bass boost caused by the proximity effect. Position it on a short boom from 2 to 6 inches away from the sound board in front of the sound hole a little towards the neck. A combination of an internally mounted miniature microphone and a contact bridge pickup (as shown in the diagram below) also works well.

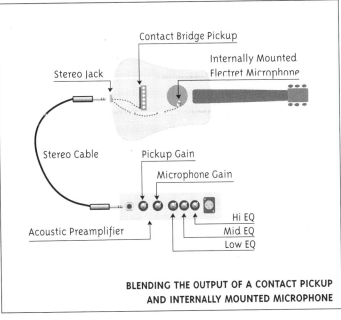

BLENDING THE OUTPUT OF A CONTACT PICKUP AND INTERNALLY MOUNTED MICROPHONE

Nylon-Stringed Guitars

Most nylon-stringed guitars are picked with the fingers and produce a very soft signal. Miking presents a special problem when you are trying to obtain enough gain in the mixing board's microphone input channel to enable the soft overtones to be heard above other instruments and not incur feedback.

If you are in a quiet stage situation or are performing solo, a good quality omnidirectional microphone, positioned 1 foot away, will sound fabulous.

The best way to obtain high gain before feedback is to mike the guitar very closely with a tight patterned cardioid dynamic microphone that is set 2 to 3 inches away from the sound hole and slightly below the strings.

PZMs are especially good for nylon-stringed guitars. They pick up more of the direct sound of the instrument and less of the stage/room reverberation. This helps bring the relatively soft levels above the levels of other onstage instruments.

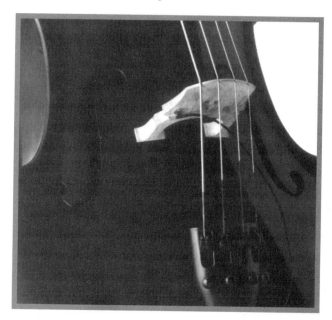

The Fishman® C-100 Cello pickup employs a patented floating mount that allows it to sense the desirable tonal-producing vibrations while ignoring undesirable overtones and extraneous body noises.

Since the strings are nonmagnetic, you cannot use a magnetic pickup, however, an electret condenser microphone can be employed with success. Use a clip-on holder to position it a few inches away from the strings. For acoustic balance from all the strings set the microphone so that all the strings are equidistant from it. Sometimes boosting the high strings is desired (engineers call this effect the ability to "cut" or cut through). When this is the case set the microphone closer to the treble strings.

Violins, Cellos and Other Bowed Instruments

Because violinists and fiddlers move their instruments as they play, the best sound reinforcement choices are condenser microphones that clip directly to the instrument, bridge pickups, or a combination of both. Condenser microphones work well most of the time for live stage pickup, but breathing noises can be picked up and produce less than a musical effect. Careful placement that keeps the microphone out of the breath stream is necessary and adding a pop filter can help. Use double-sided tape to attach the microphone to the body of the instrument, slightly to the side of the strings.

On a quiet stage, you can position a cardioid condenser microphone about 6 inches above the violin. Make sure that the microphone has good off-axis response and can tolerate speech because sometimes fiddle players want to talk or shout into their microphones.

Stand-Up Bass

An omnidirectional pattern microphone works very well for live use. Simply wrap the base of the microphone with open-cell packing foam and insert it under the tailpiece with its element positioned towards the bridge or to the side. The foam isolates the microphone from direct contact

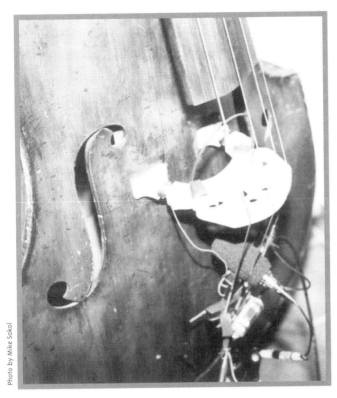

Ralph Gordon, bassist for a variety of ensembles, from bluegrass to big band jazz, uses the Rice Audio Bass Pickup System and a Shure® SM 98A microphone with foam windscreen. (Shown above.) Ralph Gordon's mixing rack includes an A R T TUBE MP preamplifier for the pickups; a Mackie™ 1202 mixing board for mixing the signal from the pickups and the microphone; and an Alesis M-EQ 230 for final equalization. (Shown below.)

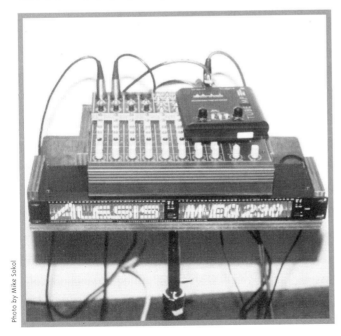

with the instrument and prevents damage to the finish and the pickup of unwanted sounds. It also wedges the microphone into the groove formed by the tailpiece and body and keeps it from falling out.

Large diaphragm condenser microphones work well when positioned under the tailpiece and the open part of the microphone points towards the body of the instrument. An additional electret condenser positioned a few inches above the surface of the bass next to the strings on a short gooseneck will add more wood tone to the sound.

The combination of a bridge pickup and condenser microphone will produce good results and give the sound engineer flexibility in signal routing. Be aware however, that the curved front of a bass can reflect sounds into the microphone and cause feedback. To avoid this place the floor monitor at an angle to the bass and equalize the monitor to remove frequencies that are below 100 Hz.

The problem with using only a piezo pickup is that there is a big difference in the sound between bowing and plucking the strings. The bowing produces a raspy sound compared to the plucked sound. Some bassists use a pedal equalizer that is set for a high-frequency roll-off to take the edge off the bowing sound.

An omnidirectional microphone positioned in the tailpiece will work most of the time for traditional music. For new age, bluegrass and Celtic music, a more electric sound is useful, which means using a combination of piezo bridge pickup and electret condenser microphone.

Many acoustic bassists do not like the emphasized bottom end that electric bass players usually demand. If the bassist is playing through a big sound system that has an extended low-frequency response, the sound engineer may need to roll off a few decibels below 40 Hz to make the musician comfortable.

Resonator Guitars

Resonator guitars are shaped more or less like traditional acoustic steel-stringed guitars, but all similarity ends there. They are held horizontally and a "steel" is used for glide effects. Resonator plates are positioned in the front sound board of the unit, which give the instrument its metallic sound. The flavor of the instrument is dependent on its resonators and using just a microphone will be satisfactory only if the stage volume is relatively low.

A cardioid microphone can be positioned 6 to 12 inches above the instrument, or you can use a condenser microphone on a gooseneck that is attached to the guitar's body. The amount of resonator tone can be changed by moving the microphone further from or closer to the plates. This is not a very loud instrument and the sound engineer will need to get reasonable gain before feedback. If the competing instruments are acoustic, obtaining sufficient volume from the resonator guitar will not be a problem. If, however, you are playing next to a drum set and an electric bass you will need a contact pickup, either external or internal, to get the instrument's sound sufficiently loud in the mix.

If a more electric sound is desired, a piezo bridge transducer can be used, as long as it is paired with a microphone (internal or stand mounted). Piezo pickups will not hear the sound of the resonators. This combination allows higher gain before feedback and reduces the coloration that may result from sounds of other instruments bleeding into the guitar's microphone.

Many new resonator guitars are being manufactured with built-in bridge transducers and condenser microphones that allow tonal balance of their sound.

Banjos

Banjos are a special class of resonator instrument. They are relatively loud due to their drum-like construction and system gain before feedback is rarely a problem in miking them. The sound desired by the player becomes the critical factor in microphone or pickup choices. Some musicians want their banjo's sound reproduced exactly; others want to reduce some of that lower midrange honk by equalization; still others want the sound altered by electric guitar style processing.

Microphone Only

For banjo players that want to reproduce the true banjo sound, a hypercardioid or tight patterned cardioid microphone is placed about 8 inches in front of the instrument at the junction of the neck and the resonator body.

Banjos produce a tremendous number of high-frequency overtones, many of which sound unpleasant. A condenser

Mr. Doubtchild plays Mississippi blues using a resonator guitar with no internal pickup. A limiter was patched into the vocal microphone channel to control the different volumes of the voice and harmonica. He is using a Shure® BETA 57™ on the resonator guitar and a Shure® BETA 58™ for his vocals.

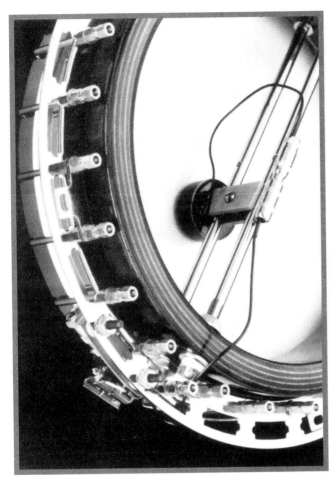

The Fishman® banjo pickup is a magnetic inductor-type.

microphone that is mounted on the surface of the banjo will emphasize these sounds and thus should be used with caution. Be sure that the microphone can handle the SPL. Some of the nasal twang can be removed by using the mixing board's microphone channel input equalizer to reduce some of the upper midrange (2 to 4 kHz) frequencies.

Pickups

A magnetic pickup will exaggerate a banjo's metallic sound, which may be desirable if the musician wants it to sound like an electric banjo; they will not reproduce a traditional acoustic banjo sound.

The combination of a bridge pickup and a magnetic pickup can be useful if each one is routed to either separate stage amplifiers or mixing channels. These two channels can be blended to provide the desired amount of direct string attack and resonant sound. You can even add a third channel, such as a condenser microphone placed above the surface of the head, to add some acoustic sound to the overall mix.

Reeds, Brass and Woodwinds

In these instruments, sound is produced by exciting a column of air, which then moves through some type of expansion or resonant chamber, such as the bell of the horn. The size of the chamber determines the lowest notes that can be played and their loudness. The bigger the chamber the louder and deeper the instrument.

In clarinets, saxophones, and oboes the primary sound comes out of the bell of the instrument. Additional resonances are produced from the sound holes and body of the instrument. Even though these sounds contribute to the total timbre of the instrument, only the main chamber is miked (except in special recording studio situations).

Horns such as trombones and trumpets also push all their sound out a bell. Their sound pattern is similar to the beam effect produced by a vocalist—they

The AKG® C 419 MicroMic is a hypercardioid condenser microphone developed for brass/wind instruments. It has a flat frequency response with a slight high-frequency peak. It has a rubberized nonmarring clamp and an elastomer suspension gooseneck for precise positioning.

produce a lot of high-frequency transients that contain rich overtones and have an attack spike in their sound, which can tax the peak level capabilities of a sound system or tape recorder.

Ideally, microphones should be lined up directly with the outputs of the instruments to capture their beams. A horn section that is swaying to a beat is a classic sound engineering problem. It can be solved by positioning microphones a foot or more from the instruments, which makes volume level changes less noticeable as the instruments move, and placing the horn section as far away from the drums, bass and other percussive instruments as possible.

Clip-on microphones work well with tubas and French horns.

Most brass instruments produce sounds that have strong attack transients. They require microphones that will not overload and cause distortion, as well as preamplifiers and amplifiers that have sufficient headroom to accurately reproduce sudden peak transients that can be 20 to 30 dB above the average signal level.

For these instruments, cardioid microphones that can handle high sound pressure levels and ribbon microphones are used with great success because they will not overload the signal. Ribbon microphones are particularly useful because they give one a feel for the actual dynamics of the instrument while compressing the spikes gracefully.

Tube-type preamplifiers work great for horns, because their natural soft compression lessens the spikes without noticeable distortion, which reduces the problem in the downstream amplifier and speaker sections. Since the output of the preamplifier is at line level, the pad at the mixing board's microphone input channel should be turned to line level.

Clarinets and Saxophones

Brass and reed instruments that produce rich, high-frequency overtones, but not spiky sounds, such as clarinets and saxophones, provide more latitude for microphone choices. Condenser microphones capture and accentuate the high shimmery overtones and bring out the high-frequency detail of these instruments. However, since they are fairly loud instruments, some care must be used to avoid overload. Place the microphone about 6 inches from and point it directly towards the bell of the instrument.

Some musicians clip an electret condenser to a gooseneck on the bell; a disadvantage here is the loss of the ability to work the microphone, which many musicians do to accomplish subtle dynamics.

In outdoor arenas and for performers that like to dance with their instruments while they play, microphones that have broad polar response patterns work well. Use either a medium cardioid microphone (forgiving if the musician moves around a bit) or an

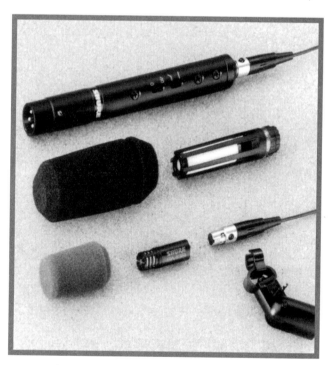

The Shure® SM98A is a complete miniature condenser microphone system that features an extremely uniform cardioid pickup pattern and a frequency response range of 40 to 20,000 Hz. Its ability to handle sound pressure levels up to 144 dB makes it ideal for horns and percussion instruments.

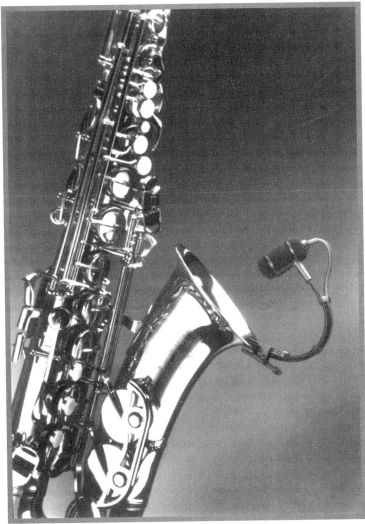

The Audio-Technica ATM35 is a fixed-charge (electret) condenser microphone with a cardioid polar pattern. It is shown with Audio-Technica's AT8418 UniMount® microphone instrument mount.

omnidirectional dynamic microphone if you do not have lots of other instruments that are producing interfering sounds.

Saxophones can be worked successfully by placing the microphones 6 inches from their bells, depending on what else is happening on the stage.

When there are three or four brass players playing in unison, two microphones placed 3 feet away and about 3 to 4 feet apart will help the sounds blend together gracefully if the musicians are good at balancing their sounds with each other.

Trumpets can be miked successfully from 1 to 2 feet away, which allows the musicians to move and still provides adequate coverage.

Even when working in a room that may not need amplification for the horns, microphones are useful for the sound engineer to add reverb to warm up the sound with little rise in volume.

Flutes, Recorders, Andean Flutes and Pipes, Wooden Pan Pipes

These are technically woodwind instruments, but there is an extra breath—a kind of whistling action—that is generated very close to where a good deal of the sound comes out. Thus, two sounds are generated—a breath sound and the instrument sound.

In miking these instruments, the engineer has to be careful not to overload the microphone with the air blasts, which have such low-frequency components that they can cause the microphone's diaphragm to bottom out. When that happens you hear something that sounds like "thonk."

Hypercardioid dynamic microphones are good choices. Positioning the microphone an inch or two under the air blast from the lips usually works, as long as the musician is aware that the microphone will pick up breath sounds. Performers that have learned to work the microphone move slightly away when they take a breath, but how they are miked depends on their technique. It is best to use a microphone that has a good built-in pop filter and use an additional pop filter on the outside to cut down on the breath noises.

Some pickups are available that replace a flute's tuning slug.

Some wooden flutes, such as the American Indian flute can be miked with an internal condenser

The Beyerdynamic M 260 is a hypercardioid microphone with a frequency response of 40 to 20,000 Hz suitable for use with flutes and clarinets.

microphone, but moisture buildup can cause serious reliability problems. Be sure the microphone is removed from the instrument immediately after the performance and put a packet of moisture absorber in the microphone case.

Percussion Instruments

There are two main groups of percussion instruments. One group has a percussive (resonant) chamber and a skin stretched over it that is struck. Congas, shell toms and steel drums fall into this group. The second group, called striker instruments, do not have a resonant chamber. Wood blocks, scrapers, shakers, cowbells and the jangles of a tambourine fall into this group.

There are a multitude of ways to mike drums, but a decision must first be made as to whether the sound should be natural or processed. Processing can produce an unnaturally big, deep and loud sound or an electronic one by a variety of methods. Microphones can be set very close to the resonant chambers, reverb can be added and gated reverb controls can be used to truncate the sound and electronic drum triggers may be substituted for drum sticks. Although a processed sound is commonly used by electric rock 'n' roll acts, some bands do combine acoustic and percussion instruments and

The Shure® SM57 cardioid dynamic microphone is widely used for miking drums, percussion and instrument amplifiers.

want them engineered to produce a natural sound they combine with their processed full trap sets. Making the acoustic instruments sound natural and as loud or louder than the trap set is an engineering challenge. Natural sound occurs when the engineer preserves the instrument's natural flavor and dynamics.

Trap Sets

A trap set typically consists of a snare, kick, shell toms, high-hat, cymbals and floor toms. For a trap set that uses both heads on the kick drum, a dynamic cardioid microphone positioned 2 or 3 inches in front will produce the most natural sound. The outer head is usually tuned a little loose to produce more resonance. Foam or blankets can be placed inside the drum to help reduce overtones.

All other parts of the trap set can be miked much further away, up to a foot or more. Place one microphone in front of the kick drum, one over the snare between it and the high hat, and a pair of overhead condenser microphones 3 feet apart a foot above the cymbals.

Drummers can also use miniature condenser microphones that tie-tack directly to their shirts. They behave like PZMs and deliver the same sound to the audience that the drummer hears. They also produce a great jazz sound. In this situation, however, the balance of the sound is controlled by the drummer, not the engineer.

If the drummer sings, use a microphone that has good pattern control. A medium cardioid patterned microphone with good off-axis response is the best choice for the drummer's vocals.

Snare drums are typically miked from underneath, about 2 to 4 inches from the bottom head and slightly off center. This positioning allows the microphone to pick up the sound of the snares (the wires hung on

the bottom head). They can also be miked both top and bottom. However, when two microphones are placed on opposite sides of a vibrating surface, the polarity of one of them must be reversed to prevent phase cancellation, which will make the instrument very bass deficient and "phasey" sounding. A reverse polarity cable, which reverses pins two and three on the connector of one of the microphones can be used and some mixing boards have polarity reversal switches on their microphone input channels.

For a processed kick drum sound, cut an off-center circular hole approximately 6 inches in diameter in the front head. This allows you to place a microphone on a short stand right in the hole. If the drum has been properly damped this placement will produce a huge kick sound and lots of bass undertones. You can also leave the front head off entirely and place the microphone inside the drum and point it towards the kick area. Since there is no front head, the bass resonance of the drum is diminished. This produces a popular, larger-than-life sound, particularly when reverb is added and the gated reverb control is used.

The sounds of shell toms and floor toms travel perpendicularly from their surfaces straight down through their bottoms. They are miked from the top with the microphone pointed straight down, slightly off center, and at least 6 inches away so that sticks do not hit them. Miking the direct center may cause frequency cancellations, because the center is the focal point where frequencies build up and produce extra resonances.

A good compromise to use instead of placing a microphone on each drum is to set one dynamic cardioid microphone for each pair of shell mounted toms. You can set two microphones a few feet above the cymbals and about 3 feet apart from each other. Roll off the bass frequencies by using the built-in tone controls on the input channels of the mixing board and you can get good separation even at an extended distance from the cymbals. Two microphones also give a nice stereo effect for recording.

Shock mounts should be used when condenser microphones are placed on top of the drums. They keep low-frequency signals from overloading the input and help produce cleaner signals.

Talking Drums and Djambos

For West African talking drums and Djambos, which are simultaneously hit and flexed, an omnidirectional dynamic microphone is ideal because these drums produce lots of acoustic output over a wide frequency range. If the drums are played loudly, their sound can leak into other microphones. In this situation, the musician must play more softly or be isolated as far as possible from the other musicians on stage. If the sound of the drums is too loud in the monitors it will leak into other microphones, muddy the sound and possibly produce feedback. Placing a medium cardioid microphone on a short boom underneath these drums will capture most of their sound. The closer you

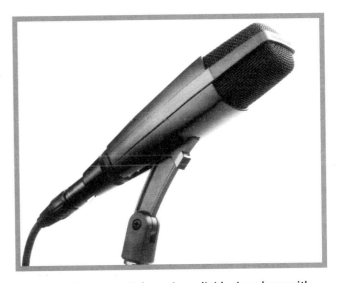

The Sennheiser MD 421 II dynamic cardioid microphone with 5-position bass roll-off is an improved version of the classic MD 421 microphone. Its large diaphragm easily handles the range and sound pressure level of even the most powerful kick and tom drums.

mike these drums, the more the microphones will ignore sounds produced by other instruments.

Some drummers want both the front and back of their drums miked. To prevent phase cancellation, be sure to reverse the polarity on one of the microphones by using a reverse polarity cable or the polarity reversal switch on the microphone's input channel.

Steel Drums

The sound from a steel drum disperses evenly from the bottom because of its convex shape, so that is the best place to mike them. Use an omnidirectional microphone.

Scrapers and Gaelic Drums

Percussion instruments that are scraped or popped produce ultrasonic frequencies and wind blasts that can cause diaphragm overexcursion in microphones and overloads in preamplifier circuitry. A good choice is a heavy-duty dynamic microphone and an added windscreen.

Gaelic drums, which resemble rather large and somewhat hairy tambourines, produce very low-frequency sounds, especially when played with sticks. They need to be miked from the back at 6 to 8 inches away. They may have a metal shaker that is activated when the drum is shaken and they are sometimes hit on their edge (like a rim shot, but without the metallic overtones). Microphone placement is a balancing act—how loud do you want the click sound as opposed to how much you want to reproduce the low frequencies.

Congas

A supercardioid microphone placed about 4 inches above the head and slightly off center is a good place to start. You can also place a second supercardioid microphone under the conga and point it toward the sound hole. To prevent phase cancellation, be sure to reverse the polarity on one of the microphones by using a reverse polarity cable or the polarity reversal switch on the microphone's input channel.

Shakers

Shakers can be loud. Even the smallest shaker "eggs" are loud enough to cut through other instrumentation. They produce such loud ultrasonics, they can overload just about anything you put in front of them. A standard cardioid dynamic microphone will do a good job. Route its signal to a tube preamplifier to roll off and soft-limit the ultrasonic frequencies before sending it to the mixing board's microphone input channel.

Tambourines

Some tambourines have a stretched head and jangles, some have no head at all. If you are miking a tambourine that has a head, place the microphone perpendicular to the head to pick up the bass tones. If you are interested in only the sound of the jangles, a side position works well. A good condenser microphone will produce the sparkly tone of the metal and cut through the rest of the mix. Use a medium cardioid on normal volume stages and a hypercardioid on very loud stages that have lots of monitors.

Accordions

Accordions are an engineering challenge since they have large sound dispersion patterns that are relatively low in volume. Also, since their bellows are pumped during playing, the bass side moves back and forth about 12 inches.

The Shure® BETA 57™ cardioid dynamic microphone works well for accordions because of its smooth off-axis response.

Although some accordions have built-in pickups, the majority are strictly acoustic and must be miked.

If there is only a moderate amount of gain (volume boost) required, a pair of omnidirectional microphones works fine when positioned 6 inches away. A short boom will allow the musician to move the setup without too much trouble. If a microphone can be placed slightly to the front of the bass keyboard the signal level changes caused by the movement of the bellows will be minimized. Be careful not to get the treble microphone too close to any particular sound hole. You will not only pick up a tremendous amount of wind noise, but those few notes located near the microphone will be boosted to obnoxious levels.

When higher gain is needed, dynamic cardioid microphones will be required.

Some accordions have a single built-in electret condenser microphone; their disadvantage is that they pick up the closest notes and make some parts of the keyboard louder than others. The best solution is to place multiple microphones that have their own little mixer, down the front of the instrument to help even out the volume between the microphones.

Bagpipes and Uilleann Pipes

The sound generated from these instruments cuts through just about everything else on stage. Miking them is difficult because if you have a quiet instrument next to them the bleed through will be enormous. If you can move the bagpipe player away from the quieter instruments you will have a much easier time providing monitoring and getting some separation in the mix.

The best option is to use a medium patterned cardioid microphone placed 2 to 3 feet away. An omnidirectional microphone may also be a good choice, but placing it too far back (more than 3 or

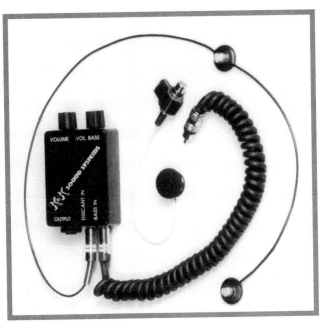

The accordion microphone system and control box from K & K Sound Systems features three miniature electret condenser omnidirectional microphone capsules especially designed for the accordion. The two microphones for the descant side are installed below the cover of the key mechanics. The bass microphone is installed below the bass keys cover or inside the bass reed block. Both sides have separate volume controls.

4 feet) may result in its capturing the sounds of other instruments. There are no pickups made for bagpipes.

Although Uilleann pipes are quieter than full bagpipes they are tricky to mike because they have a pipe that hangs on the bottom as well as pipes that go up. The best method is to use two microphones, one for the bottom pipe and one for the top pipes. I have used both omnidirectional and medium cardioid dynamic microphones with good results. Reversing the polarity is not needed here since the two microphones are picking up different sounds, not the opposite polarity of a common sound.

Harmonicas

Harmonicas ("harps") come in two basic types, acoustic and electric.

The acoustic harmonica has some of the same problems as the accordion. Acoustic harmonica

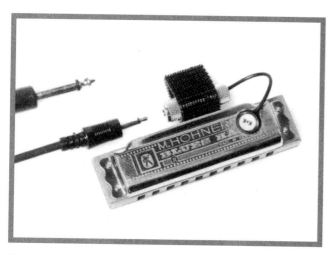

The Hot Harmonica piezo-ceramic pickup from K & K Sound Systems is attached with instant glue to the casing or reed block.

Phil Wiggans of Cephas and Wiggans playing delta blues on his harmonica. He is using a Shure® BETA 58™.

players use dynamic unidirectional microphones to amplify the actual sound of the instrument. Set the microphone a few inches away to capture a wide slice of sound. Most of the time a microphone that has a built-in pop filter will work satisfactorily.

Some manufacturers have designed special pickups for acoustic harmonicas that have built-in volume controls. Their unbalanced outputs must be plugged into a direct box. They are not ideal for musicians who like to move in and out of the microphone or change harmonicas. They are most useful when a musician wants to play harmonica while playing the acoustic guitar.

Some harmonica players use close miking techniques and route the signal to a limited-range instrument amplifier that produces a stylized sound. A high-impedance dynamic "bullet" microphone that is used with an open-back instrument amplifier cabinet will produce a refined sound useful for both country and rock music. The player cups the ball of the microphone and harmonica together to produce a very "forward" sound. A dynamic cardioid microphone can be mounted in front of the cabinet's speaker or placed on a short boom stand to mike the instrument amplifier cabinet.

Harps (String)

Every harp has a resonator chamber that has a big hole. It is positioned close to the musician and produces a fairly soft sound. The cavity contributes all of the bass output that the harp produces.

Two microphones are used to successfully capture the sound of a floor mounted harp. Either a condenser or dynamic microphone is placed on the floor pointing up towards the resonator; and a condenser microphone is set near the strings to capture high-frequency detail. Remember, though, when two microphones are used on a common instrument, and each is placed on opposite sides

of a vibrating surface, the polarity of one of the microphone's signals must be reversed.

Mounting a microphone inside the hole will generally produce too much feedback for live sound reinforcement.

Folk harps (zithers), which are normally positioned on the lap, do not have resonating chambers but they do have a sound board. A cardioid condenser microphone positioned about 6 inches above the strings is a sensible choice.

Hammer Dulcimers

Hammer dulcimers are fairly loud compared to lap dulcimers and acoustic guitars. While almost any microphone will pick up the sound, a pair of dynamic or condenser cardioid microphones positioned 2 feet apart and 1 foot above the dulcimer works nicely. A single microphone, placed about 2 inches directly above the right edge of the sound board (as viewed by the musician), produces a surprisingly balanced sound with lots of gain before feedback.

Some dulcimers have built in contact pickups, but these only pick up the string tones and not the warm resonances coming from the wood. A cardioid pattern microphone placed underneath the instrument will add to the mix and help reproduce those sounds.

Vibraphones and Xylophones

Two medium cardioid dynamic microphones placed 8 to 12 inches above the instrument and 2 to 3 feet apart work well. They should be placed so that they are a little in front of the instrument and angled at approximately 30 degrees from vertical to point at the center of the blocks. A vibraphone has a motor and belt that produces a tremolo effect and care must be taken not to pick up the motor sounds. Equalize out frequencies below 80 Hz and add a suspension mount to the microphones to eliminate infrasonic pickup.

Pianos

Grand and Baby Grand Pianos

A lot of sound comes from the bottom of a grand piano. They should not be placed on carpets because that dampens their sound. When you want the piano to sing, put it on a hard surface.

A PZM taped to the inside of the lid and pointed down, with the lid half or fully closed, will capture the sound nicely. One or two microphones placed above the strings with the lid open will sound very natural on a stage where there are no other instruments, but they will pick up other sounds from the stage and cause feedback or a muddy mix. Cardioid pattern condenser microphones and bidirectional microphones work well here.

An ideal method is to open the lid, place a cardioid condenser microphone in the air at eye level and point it at the middle of the lid. The sound comes out of the strings, hits the lid, and is reflected to the microphone. Some engineers like to place an

The vibraphone MIDI pickup system from K & K Sound Systems features 42 piezo-ceramic pickup elements (five spares), two straight collecting rails for permanent mounting, two 25-pin signal cables and a MIDI Master unit with 37 MIDI sensitivity controllers, one for each bar.

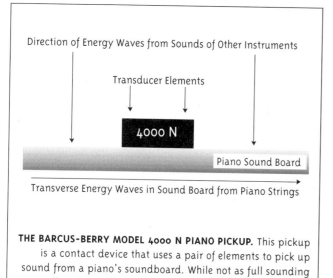

THE BARCUS-BERRY MODEL 4000 N PIANO PICKUP. This pickup is a contact device that uses a pair of elements to pick up sound from a piano's soundboard. While not as full sounding as well-positioned microphones on an acoustically balanced stage in a quiet concert hall, the pickup does a great job without the expense and hassle of setting up several microphones. On a loud stage or in a reverberant room, it is one of the best methods of getting a good piano sound.

omnidirectional microphone underneath the piano as well. When this is done the polarity of one of the microphones must be reversed.

Another technique is to use a piezo contact pickup that mounts above the strings along the full length of the instrument. However this reproduces only the direct string sound without any room or body resonances from the instrument. To compensate, engineers will either tape a microphone to the underside of the lid or underneath the sound board and blend the two sounds while mixing. You have to experiment to find the proper polarity in this instance. A good way is to turn on the solo switch on both the microphone and pickup channels simultaneously. Have both channels' pan controls set to center. If you are in-phase, the sound will have a lot of bass response. If you are out-of-phase, either channel will have bass, but turning them both on will cause a big drop in the bass sound. Reversing the phase of one channel with a reverse-polarity cable or channel switch will restore the bass response.

Upright Pianos

The choices depend on the desired sound. If a honky-tonk sound is wanted, take the lid off to expose the strings and set two dynamic microphones 6 to 8 inches away from the strings. If you want real string sizzle, then condenser microphones are the proper choice. You may need to roll off some of the bass, especially in the monitors, to avoid bass feedback.

Most traditional players prefer that the back of the instrument is miked to pick up the instrument's full resonance. Placing an omnidirectional microphone under a blanket that is draped over the back of the piano will confine and isolate the sound. This does have a marked affect on how the piano sounds, so do not spring this on an unsuspecting band.

Microphone Maintenance

You can keep good microphones operational for decades if these few simple rules are followed:
1) Store them in plastic bags—dust is a microphone killer.
2) Transport microphones in foam-filled cases.
3) Use foam pop filters whenever possible to keep moisture and saliva from clogging the screens. These filters will also cushion the microphones in case they fall. Wash the pop filters periodically.
4) Do not drop microphones. Use counter-weighted stands and avoid long boom extensions. Make microphones the last things you put on stage and the first items you remove when the gig is done.
5) Protect microphones from wind blasts, especially outdoors. Use wind socks and foam pop filters.

Preparing for the Show

Chapter 10

Musical preparedness is the only thing more important than technical readiness. Advance technical planning is important to the success of any performance.

A band may encounter one or all of the following. The venue has an installed sound system and house engineer; the concert promoter hires a sound reinforcement company to provide a sound system and engineer(s); and/or the band provides a sound system and engineer (who may also be a performer).

One person from your band should be responsible for technical coordination and interfacing with the engineers that will be supplying and/or operating the sound system. Some personal managers take on this responsibility, but you should be sure that yours is capable of making and communicating the proper technical decisions.

Touring with Your Own Sound System

If you bring your own mixing personnel and sound system to each job, everyone's task is defined. Since this is the system you always use the sound check should go faster and more smoothly than when working with an unfamiliar sound system and engineer. Your engineer is intimately familiar with all your songs and has had a great deal of practice in correctly

adjusting the mix for each song and knows when to emphasize the leads and add special effects.

Working with a familiar board has many benefits. It becomes another instrument and in case something goes wrong the instinctive grabbing of the correct mute switches by your engineer will be appreciated by everyone.

If you will be recording the performance, advance arrangements must be made even if you are bringing your own equipment and sound truck as this will add to the complexity of the load-in, setup and sound check.

Room Dynamics

Bands should find out what the typical ambient noise levels are in the venues they will be performing in, since this affects their sound reinforcement requirements. The dynamic range they require is calculated by adding the dynamic level they usually perform at to the ambient sound level of the room. For example, if a room's ambient noise is 70 dB SPL and a band needs 20 to 30 dB SPL, the sound reinforcement system must be capable of producing 90 to 100 dB SPL for the band to be heard. The amplifiers, speakers and mixing boards required will have to produce those levels. Usually an ambient level of 70 dB SPL will allow an acoustic band to be heard at their desired dynamic level without having to overpower the room with high volume. Playing in a noisy venue requires a loud mix and trying to use instruments and song arrangements that have lots of dynamics can be an exercise in frustration in such a room.

Bands should also learn whether noise level regulations are in effect, as clubs and outside venues must comply with them. Sometimes this involves a decibel meter with a chart recorder or member of the "sound police." Unfortunately, fines and performance bans are possible for exceeding the musical "speed limit."

House Systems

Many venues have their own mixing boards and speaker systems and you will be expected to use them and the house mixing personnel. The house engineer will be familiar with the system and the room, but may not be familiar with your particular songs or musical style. Sending a CD or cassette of your music or a performance video will help the sound engineer understand your music and sound needs. You should call the engineer to confirm the receipt of these materials and discuss any other requirements. Establishing a good relationship with the house engineer is extremely important. Most engineers are technically competent, but if you make unreasonable demands or try to blame them for your own musical incompetence really bad things may happen. There is no single knob on a mixing board labeled "SUCK," but it is very easy for an engineer who has been treated badly during a sound check to retaliate sonically during the show. Yes, this is very unprofessional and most engineers would never stoop to causing feedback or muting your microphone on purpose, but it is difficult to do your best mixing job for someone when you would really like to kick their behind. Try to establish a friendly, professional relationship with the house engineer right from the start.

Be prepared for overworked, underpaid, tired, cranky and temperamental sound, production and lighting people. Do not expect to be treated like a prima donna, just get to work as quickly and professionally as possible.

If you have special requirements, such as wanting the sound engineer to make a reference tape for your show, ask in advance. Some venues may charge extra fees if you run a tape of any kind during your performance. A common request is for use of the stage after a sound check for additional practice. This must be communicated in advance to the promoter and sound engineer so that the time can be set aside.

Raymond's last day as the band's sound technician.

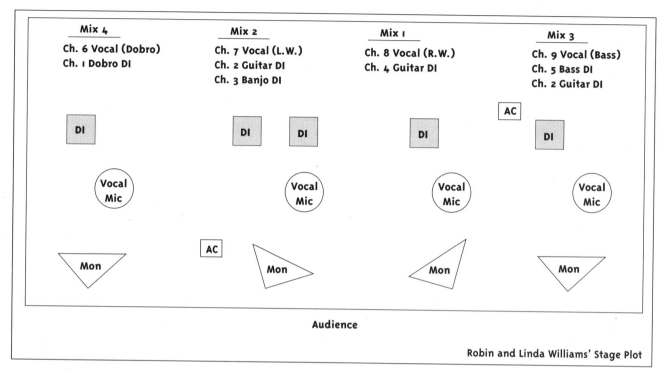

Robin and Linda Williams' Stage Plot

Stage Plot

A stage plot shows the approximate onstage location of the musicians and their instruments. It should be sent to the sound engineer along with the names of the musicians, the instruments they play, and their microphone preferences well in advance of the show date. Even if this information accompanies your sound reinforcement contract, it may not be sent to the sound engineer who will be responsible for your show. A stage plot enables the engineer to set up the system you have specified in time for your sound check.

Develop a stage layout that has as much pertinent detail as possible. For instance, the keyboards should be designated by type and output configuration. Using the words "electric piano with quarter-inch unbalanced output" or "microphone level XLR" means much more to a sound engineer than brand name and model. If your bass amplifier has an XLR output from the preamplifier note it on the stage plot rather than saying "direct box on the bass," since a direct box is hooked up between your instrument and the amplifier and is not the same thing as a microphone-level XLR output from the preamplifier of your bass amplifier.

"Male lead vocalist" and "bass guitar vocalist" are good labels, while "Chuck's amp" does not mean anything to someone who does not know who Chuck is or what kind of amplifier he has. Provide visual clues such as "brown acoustic" and "blond acoustic" if the guitarist will be switching guitars midperformance. All acoustic guitars look about the same from 100 feet away. Do not make the engineer guess which one is being picked up.

Be ready with an extra copy of the stage plot to indicate revisions and last minute changes. Good sound engineers are flexible. If you had to fire the tuba player at the last gig and replace him with a stand-up bass player, engineers will understand and try to accommodate you. Just be sure to let the engineer know as soon as possible.

If you have special lighting needs they should be communicated with a separate lighting plot.

Sound Reinforcement Contracts

Many bands use formal sound reinforcement contracts to specify their technical requirements. For venues that provide a sound system, you will send a list of your technical requirements: the number of input channels on the mixing board, the number of channels for stage monitor speakers and the types and numbers of microphones and stands. Also, to make setup go as quickly as possible you should provide a stage plot that shows the location of the performers, instruments, amplifiers and microphones. Supply a list of needed special equipment. If you are bringing your own sound engineer you should request that he or she be allowed to provide sound check and mix instructions to the engineer who operates the equipment.

Be honest and realistic about your sound system requirements. Overspecifying a system you do not need will cause unnecessary friction with the engineers that have to move it.

Even if you have specified equipment in a sound reinforcement contract, you must still find out what the acoustics of the venue are; whether the house can provide stage amplifiers or preamplifiers; the condition and tuning of the piano, etc. Do not take anything for granted.

Most promoters work with local sound companies and know how much sound systems cost and what the local venues require. Most sound reinforcement companies will bring an unusual microphone, preamplifier or stage amplifier if they have it and are asked in advance.

If the venue does not have everything you need, and that need is not specified by contract, you will have to supply it yourself.

Load-In and Sound Check Times

Set a load-in time for equipment that provides for setup and testing well in advance of sound check time. Check all cables and connections.

Find out where to load your equipment from and make sure you know in advance about any problems such as an elevator that is not functioning.

Set a sound check time that is at least two hours before performance time so last minute changes can be accommodated and you are not conducting the sound check when guests start arriving. Many venues have a one-hour before show cutoff so the audience can be seated.

Robin and Linda Williams

Photo by Irene Young

SAMPLE SOUND REINFORCEMENT CONTRACT

This contract for sound reinforcement services is entered into as of _____ , 19___ , between the parties identified below.

1. Name of Purchaser _____

PURCHASER ADDRESS

CITY/STATE/ZIP

PHONE

2. Name of artist or band _____

3. Name and address of venue _____

4. Date of event _____

5. Number of sets, duration and time allotted for breaks _____

6. Time of first set _____

7. Maximum audience expected _____

8. Load-in and parking
Venue is available for load-in and set up at (date) _____ (time) _____

Parking shall be provided for _____vehicles, (specify size) near load-in entrance.

9. Sound check
Venue is available for sound check at (date) _____ (time) _____
 a. Artist requires a (_____) hour sound check and technical setup period. Purchaser shall not allow the audience to enter the place of performance until such time as sound check and technical setup have been completed. Artist shall complete the setup and sound check (_____) hour(s) prior to the time of performance, provided that Purchaser makes the place of performance available for said setup at least (_____) hours prior to time of performance.

10. Sound system
Purchaser agrees to provide a complete sound system consisting of—
 a. The main mixing board shall have—
 (_____) microphone input channels
 (_____) bands of EQ
 (_____) postfader auxiliary sends
 (_____) volts phantom power
Preferred manufacturers and models are (_____).
Purchaser agrees to provide a safe platform or space in the audience within 50 to 100 feet of the stage in order to set up mixers to mix the sound for the show. Platform or area should be _____ feet by _____ feet.

 b. Outboard gear shall consist of—
 (_____) grand piano tuned to A 440
 (_____) digital reverb(s)

(_____) digital delay(s)
(_____) outboard compressors
(_____) one-third octave graphic equalizers
(_____) CD player
(_____) cassette player/recorder set up for record and playback

c. The main speaker system will consist of a stereo biamped or triamped system with (_____) bass drivers, (_____) midrange drivers and (_____) compression drivers capable of providing even coverage for the venue. Purchaser agrees to provide adequate space for placement of speakers. The space needed for the speakers will be ___ feet by ___ feet. This area must be capable of supporting the weight (_____ lbs.) of the speakers safely.

d. A separate stage mixing board will be provided consisting of—
(_____) microphone input channels
(_____) bands of EQ
Preferred manufacturers and models are (_____).
In order to provide a pre-EQ mix, (_____) one-third octave equalizers will be provided as well as a separate reverb unit.

e. The stage monitors shall consist of—
(_____) floor wedges, consisting of one 15-inch or two 12-inch woofers plus one high-frequency horn.
(_____) side-fills, consisting of one 15-inch or two 12-inch woofers plus one high-frequency horn.

f. Purchaser shall provide the following microphones—
(_____) cardioid condenser microphones. Preferred manufacturers and models are (_____).
(_____) cardioid dynamic microphones. Preferred manufacturers and models are (_____).
(_____) supercardioid microphones. Preferred manufacturers and models are (_____).
(_____) hypercardioid microphones. Preferred manufacturers and models are (_____).
(_____) omnidirectional microphones. Preferred manufacturers and models are (_____).
(_____) other. Preferred manufacturers and models are (_____).

g. Onstage equipment shall consist of—
(_____) active direct boxes (_____) regular microphone stands
(_____) preamplifiers (_____) AC boxes
(_____) boom microphone stands (_____) other

h. Power. Purchaser agrees to provide at least _____ amps single phase and _____ volts of power.

i. Other special equipment _____

Any alterations or deviations from the above items involving extra cost of equipment or labor, or substitutions of equipment, are subject to written agreement.

11. Personnel
Purchaser agrees to provide the following sound engineers to operate the equipment:

NAME PHONE

NAME PHONE

12. Security
Purchaser agrees to hire adequate security for stage and backstage areas and accepts full liability for any stolen articles and/or destruction of Artist's equipment.

Mixing Board

Before specifying a mixing board in your contract, determine how many input channels your band needs by adding up the number of instruments, vocals, direct boxes, preamplifiers and effects you will use. Add one or two extra channels for contingencies.

Input channels on mixing boards usually come in multiples of 12 or 16. You can reasonably request at least a 12-channel board for your 8 inputs, or a 16-or 24-channel board for your 15 inputs.

Here is an example of a band's input needs:

- (8) channels needed for vocal and instrument microphones
- (1) XLR direct out from bass guitar amplifier
- (4) direct boxes
- (2) extra channels
- (15) channels total

If the board must supply phantom power, specify it.

You must indicate the number of monitor mixes you need as this tells the house engineer what the mixing board must supply and whether a separate monitor mixing board is required. Having a separate board enables the monitor engineer to provide different equalization and volume for each instrument or voice in the monitors completely independent from the house or recording mix. Small venues rarely provide a separate monitor board, usually you have to live with the monitor mix from the main board. If your instrument requires radical equalization to achieve a certain sound or to fix a problem, supply a preamplifier, direct box and equalizer onstage. That way, the equalized signal can be sent to the main mixing board and the consistency of your sound will be better from performance to performance.

If recording or broadcast feeds are involved, let the engineer know. The more mixes that have to be provided, the more sophisticated the board has to be. If more than three mixes are involved another board and engineer should be used.

Microphones and Direct Boxes

Specify the number and types of microphones, direct boxes and microphone stands you need. Most bands provide their own pickups and instrument amplifiers. Here is an example—

- (4) vocal microphones (cardioid condenser)
- (6) instrument/amplifier microphones— (cardioid dynamic)
- (4) direct boxes (band will supply if preferred)
- (4) microphone stands that have short booms, for vocals
- (2) straight microphone stands for instruments
- (2) miniclips or microphone stands that have short booms, for stage amplifiers
- (2) microphone stands that have long booms, for instruments

Monitors

Be realistic about monitoring requirements. Most acoustic groups can provide a breathtaking sound with no more than two monitor mixes. A separate monitor speaker for each musician is preferable and if each speaker has its own volume control or separate power amplifier channel a very nice stage sound can be achieved without an extended sound check. The fewer monitors there are onstage the less possibility there is for bleed-in to the microphones, which will muddy the sound. Monitor sounds can echo off ceilings and other hard surfaces and leak into

the audience. They can color the sound from the main speakers and alter it. Sometimes monitors are so loud that the engineer is forced to turn down the main speakers to keep the room volume under control.

The quieter the stage monitors, the easier it is for the house speakers to maintain a clean sound at the desired volume. If you think you need more than 100 watts per cabinet on an acoustic stage it is time to rethink your monitor philosophy, check your hearing, or buy in-ear monitors.

Unless there is a dedicated monitor board onstage that is run by a knowledgeable engineer the chance for disaster increases with each additional mix. This is especially true if there are multiple acts in the show as it is nearly impossible to know what each musician wants without a complete rehearsal for every song.

Power Outlets

Even if you play without a sound reinforcement system you may still need AC power for effects, electric piano or an onstage amplifier. You may have unusual requirements, like the Celtic band that uses a small electric blanket to warm the goatskin head on their lap drum. Check to ensure that power is available where you need it and that it supplies the required voltage.

Sound System Setup

Whether the venue has a sound system or the band or a sound reinforcement company is providing one, the sound engineer and/or sound reinforcement company that is responsible for setup and mixing should arrive well ahead of the band load-in, set up the stage according to the stage plots that have been received, and check the equipment. If the band is doing live recording, or if a radio or television station has requested a live feed, extra time will be taken and a second engineer may be on hand. Extra time will be needed to check cabling and wiring.

Band Setup

Have your amplifiers and instruments ready to be placed on stage when the sound engineer is ready. If there are multiple acts, you may be asked to set up backstage first. If you are the only act, you will probably place your instruments where you want them on stage and the sound engineer will set the microphones, stands and cabling, etc. Get the instrument and amplifier cases off the stage as soon as possible.

Try to standardize these procedures as much as you can. Just knowing you can get set up without undue problems is a confidence booster and reduces the worrying about all the technical details before a performance. Experienced sound engineers are very easy to work with in contract sound situations. They have seen it all, had everything go wrong at one time or another, and have developed methods that get the job done with the least amount of hassle.

My own sound system organization borders on mania. All cables are individually labeled and marked for length. All inputs are clearly noted and color-coded cases are used for speaker wires, microphone wires, stands, and other gear. This system has kept me sane during some pretty strange gigs.

Avoid the temptation of jamming during setup, it is too hard to give and hear directions if everyone is playing and adjusting their instruments. Once your instruments are in place take a short break while the sound engineer places the microphones. Have one person from the band available during this time to answer questions, after all, the engineer may have never miked a set of bagpipes before. Suggestions about prior successful microphone placement may be helpful, but if the engineer has a different idea try it to see how it works. Most sound people have a variety of microphones and techniques and they may work better than yours.

Instrument Amplifiers

Unless your musical style dictates it, leave the big amplifiers at home. Small, combination amplifiers that have a speaker and amplifier in one box are quicker and simpler to set up. Power is not an issue, even a 10-watt guitar amplifier will produce much more acoustic energy than the most vigorously played acoustic guitar. If you use external effects units and processors rack mount them in a road case with all their wiring in place. That way you will not be fighting connection problems when you should be tuning your instrument.

Power Soaks

If you want to use instrument amplifiers at full power to emphasize distortion effects but not to produce loud volume onstage or overpower the main speakers, use a power soak. This device contains a large resistor that soaks up (absorbs) the excess wattage and reduces it. The signal from the output of the amplifier is sent via a quarter-inch phone plug to the power soak, which is connected to the input of the instrument amplifier's speaker cabinet with another quarter-inch phone plug. This will tame a 100-watt amplifier down to a 10-watt output and keep the instrument amplifier's volume down. Master volume controls also work, but are a little too easy to overcome with a quick twist of a knob. Power soaks will not damage your amplifier and work in all situations.

AC and Phantom Power

Batteries have a way of dying at the worst possible moment so put in fresh ones before each gig. It is cheap insurance. If your equipment has an input for an AC adapter, use it. If your instrument preamplifier can use phantom power from the mixing board, select it. Be sure to carry spare batteries. AC adapters fail occasionally and phantom power is not always available.

Direct Boxes

One of the best ways to ensure consistency of sound is to bring your own direct boxes for your acoustic instruments' pickups. Each brand and type of direct box sounds a little different (because of impedance loading) and slightly changes the signal that goes to the mixing board. Using the same unit every time eliminates one variable in your overall sound. Make sure you have spare batteries if it is an active box and know how to change to phantom power. If you are using a direct box on any type of AC powered instrument such as an electric piano, be sure the box has a ground-lift switch to assist in eliminating ground loops.

Instrument Stands

Bring your own stand for your instrument. It is one less worry for the engineer and you will have a stand that actually fits. You can also get special hangers that thread onto standard microphone stands. You can stash a few of these in your guitar case and eliminate the need for guitar stands.

Fix Bad Cables

Take a few minutes while packing for a gig to count and test all your cables. This small investment in time will save you from frustration someday.

Standard operating procedure is to tape the ends of a suspicious cable until you can verify and repair it if necessary. This prevents someone else from grabbing that cable later in the gig and reminds you to fix or pitch it. The best way to check a cable is to use a cable tester. Typically, these testers have jacks for XLR, quarter-inch phone and RCA cables. They test for proper polarity, shorts and open circuits. For a thorough test, wiggle the plugs and wires and watch for intermittent problems. Also, connect the cables to a phantom powered input and check for "crackle" sounds.

Be sure to verify proper polarity of all XLR cables. A reversed polarity microphone cable may not produce a noticeable problem in a live performance, but will cause all kinds of grief during any type of recording. The most insidious problem is reversing the polarity of one channel of a stereo recording. The results will sound fine on headphones, thin on stereo speakers, and completely trashed on monophonic playback.

Pack a Soldering Tool and Solder

Invest in a 30- or 40-watt soldering pencil and a spool of 60/40 rosin core (resin flux) solder plus a small screwdriver and diagonal cutters. Learn to use them. Armed with these simple tools you can fix cables in an emergency.

Sound Checks

When a venue or promoter provides a sound engineer, you must clearly communicate your needs. There are lots of ways to run a sound check. If your band has a standard procedure let the sound engineer know the sequence. Try to communicate without being too demanding. It is the sound engineer's job to do whatever is possible to make the musicians comfortable and provide a good mix for the monitors and the house.

The band's spokesperson should be at the mixing board with the sound engineer to communicate the balance that is desired. This person should be skilled in communicating technical ideas. The engineer will be able to make the technical adjustments, such as a 3 dB boost at 8 kHz or a roll off of everything above 5 kHz.

Unless you have very complex requirements, a 1-hour sound check should suffice. Be aware of time constraints, as promoters usually want to clear the stage of musicians before customers are allowed in.

The sound engineer will use a microphone at the mixing board to communicate instructions through the monitor speakers to the musicians.

In multiband shows, each band is asked to come on stage one at a time and set up their instruments and amplifiers (if any) where they would most like them to be. Be sure to arrive in plenty of time. Percussionists are usually first, since they take the longest to set up and check. A basic backbeat will help the engineer set the microphones and adjust the monitors and equalization. Some engineers like to do the monitors first without the house system, but some do them simultaneously.

Remember, the sound of the softest instrument will have to be heard above the sound of the drums on the stage. Drumming that is too loud bleeds into microphones and causes muddiness in all speaker systems.

Guitars and other stringed instruments come next. The sound engineer will adjust the monitors' positions and turn up the instruments' microphones and pickups until they are on the edge of feedback. Then the musicians will be asked to move in circles of 3 or 4 feet to help the engineer find the loudest and softest feedback points and place the musicians in the nulls (where feedback is lowest). The engineer will adjust the position of the monitor speakers and microphones as instruments are added and continue testing until the best possible positioning for all musicians is reached.

To ensure the master output levels have been properly set, the sound engineer will direct each musician to produce their loudest sound. The channel trim is then turned up until the output meter hits around -6 to -3 VU. If the trim pots are set too high the engineer will have to pot the fader down very low. If the trims are set too low the engineer will be forced to turn the channel up to 10 for soft passages, which may add hiss and hum.

The overload LED light shows if the inputs are overloaded when the engineer is adjusting ("riding") gain. If the display lights, the trim pot should be turned down for that channel or its pads should be engaged. This is needed on loud instruments that use sensitive condenser microphones or other high-output microphones. The basic hint is if any input slider is above 8 or below 5 on a scale of 10, its trim should be adjusted so its nominal position is in the 7 to 8 range for the performance.

The musicians should let the engineer know of any problems or needs during the checking of individual instruments. They should also remain in constant communication with each other to ensure that an adjustment for one will not interfere with the needs of someone else. Instrument pickups that are sonically unbalanced can cause feedback problems and other imbalances. An acoustic guitar pickup that produces too many high frequencies is prone to feedback and the engineer must adjust its equalization to get a good sound in the house speakers and monitors. The use of a good direct box will eliminate the need for a lot of equalization, except for leakage and feedback control.

If the mixing board is wired so that equalization adjustments are prefader, adjustment to the individual instrument's pickup channel's equalization will not affect how it sounds in the monitors. When there is a problem instrument, the engineer will try to provide an outboard preamplifier and equalizer that are dedicated to it so that an equalization curve can be developed that will get the instrument to sound good before its signal is sent to the board. A musician who has been alerted to this problem should buy an outboard preamplifier and equalizer. A 31-band graphic or parametric equalizer is ideal for this situation. When passive pickups are used, a good preamplifier will bring up their operating levels to those that are required for noise-free operation in most equalizers (about 0 dBv in most cases). Most acoustic guitars that have built-in active pickups have sufficient level to drive an equalizer directly.

Next, the vocals are checked, starting with the lead vocalist. Most engineers start with the monitor sends off, the equalization flat, and the input trim all the way down. First, the trim is set and then the levels are brought up slowly in the house speakers and the monitors. This helps to avoid feedback. Last, the equalization is adjusted.

Once an initial volume has been set in the monitors and mains for the lead vocal, the other vocals are set one at a time. The band may be asked to sing a cappella harmony to help check the basic balance. If the vocalists do not need to hear all the other instruments in their monitors at full volume, a 10- or 12-inch floor monitor will suffice as long as it has appropriately loud midrange drivers. There is generally no need for biamped monitors for acoustic acts that play at realistic volume levels.

Next, the musicians do a simple song, beginning with a few instruments and adding more every eight bars or so. The band can start a song with percussion and add the bass, rhythm, lead, and vocal as the sound engineer cues them. This allows the engineer to adjust levels and equalization for each instrument until the whole group is playing. Lead vocals and harmonies are added last. Then the instruments are readjusted to fit under the vocals. Finally the sound engineer will cut the instruments and ask the vocalists to sing a cappella to double-check harmonies. Many bands have a sound check song that uses all their instruments, and covers their lead singing and harmony possibilities. This is a real time-saver that assures nothing is forgotten.

Test any instrument variations you have. For instance, if the accordion player doubles on coronet do a tune with each instrument. Once the band and engineer are satisfied that everything is right, play a

little of your opening song to check that the all important first notes of the performance will be balanced correctly. Give a set list that indicates instrument changes to the engineer.

Once the basic stage volume and equalization levels have been adjusted, the sound engineer will add reverb and delay to the mix that goes to the audience and adjust overall volumes. A little reverb enhances just about every musical style. If an individual vocal or instrument is too soft in the mix, the engineer should try to make everything else softer rather than crank up its volume. This mixing down counteracts the tendency the volume has to creep upwards.

Finally, the musicians will be asked to give their impressions. Can they hear what they need in their monitors? Are any changes necessary?

If you have to rehearse songs or arrangements after the sound check, be sure to get permission from the promoter or engineer. There may be other bands to sound check, or the hall may have to be used for something else.

Quick Sound Checks

There is a method for accomplishing a quick sound check if a band is late or in a festival venue. Often these situations have only a 5- to 10-minute setup period and no sound check. Once the instruments and microphones are placed and input channels are assigned to the instruments and vocals, ask the band to start with a simple song that begins with just a few instruments, add a player after each four bars or so. This allows the engineer to develop a quick, rough mix until the band is going full tilt. This on-the-fly sound check can be done in less than a minute, and the audience never knows it.

If there is more time the sound engineer can verify each microphone and direct send and check basic monitor levels by starting with channel one and having each musician sing or play a note. Then the engineer will work through the entire microphone list and verify that everything is plugged in where it belongs. Once each input channel is verified, the band should play a little of their first song so that there are no surprises.

Sound Engineer Setup Basics

Here are the sequences, procedures, technical information and tips that sound engineers use during setup and sound checks to get a good sound in the monitors and house speakers. If one of the members of your band is acting as sound engineer, these are the things you need to know.

Normalize the Mixing Board

Set all volume levels to zero, all equalization flat, and turn off all pads and sends. This prevents loud pops and bursts of feedback when the instruments are hooked up. Most of the time you will be "hot-plugging" while the board is powered up and the main amplifiers are on. The feedback can be deafening if you connect an instrument to a live channel. Make sure that the phantom power is off. Some microphones (ribbon microphones in particular) can be damaged by the 48-volt surge.

Label Everything

Use tape and a marker you can see when the lights are low to label the channels. Use terms that will make sense to anyone, "lead guitar," "bass guitar direct box," "left vocal," "piano," etc.

At festivals, where there is a lot of microphone movement between acts, use colored windscreens. This helps when you have to change microphone stands. RED VOC, BLU VOC and YEL VOC are easy to recognize onstage even after a quick setup and no sound check. You should mark each microphone stand base and microphone with its mixing board

channel number. This helps stage technicians do quick setups and rapidly identify channels for the house engineer. Mark direct boxes with their channel numbers. Group things together, vocals (channels 1-6), instruments (7-10), percussion (11-14), and direct boxes (15-20).

Adjust Gain

Each instrument's input channel gain has to be properly adjusted to allow maximum volume before clipping. This has to be done every time you set up unless you use the same board every night with the same band at the same venue. Even then, you still have to periodically adjust the inputs' trims to offset "level creep," the mysterious force that causes all trims and faders to work their way up to maximum output. You can mark the normal levels with tape or adhesive dots, so you can easily get back to what worked.

Start by setting the master output levels on the board to their nominal setting, usually around 7 on a scale of 1 to 10. Every board has a different optimal point. Set the channel faders at around 3 and turn up the gain on each input to get the signal out of the noise floor to reduce self-noise. Some boards have a very low noise floor, but not much headroom in their mix bus. Their output faders should be set to 10 and the inputs should be trimmed back to get proper output levels or internal board distortions will result.

Equalization

Equalization may not be needed or desired in an acoustically neutral room. Most of the time, however, sound engineers are not that lucky. Feedback and poor intelligibility are the norm and equalization is the usual way to try to overcome the imbalances and imperfections.

Equalization is used to change the sound character (timbre) of an instrument or voice and to eliminate microphone feedback by reducing a particular frequency. To effectively manipulate timbre you must understand something about the spectral balance of every instrument you mix, and to control feedback you must be able to identify a squeal's frequency so it can be notched out quickly. Some engineers prefer to attenuate frequencies outside of an instrument's primary spectrum to limit the possibilities of leakage and feedback. For instance, dropping the bass out of the mandolin or cymbal microphone will help clean up the mix, since even if bass frequencies bleed into the microphone they will not be amplified.

First, set the main speaker system equalization so that the spectral balance is within a few decibels of flat. Use a real-time analyzer (RTA) if you can. Then start adjusting the channel equalization for each instrument. This is where taste and experience are invaluable. In acoustic mixing you generally want to capture the exact sounds of the instruments, and augment them only enough so that the rear seats get a volume that approaches that of unamplified instruments. Excessive volume is a distortion of an instrument's sound. Listen to the unamplified sounds of the instruments. This is what you want them to sound like and you should be able to set the channel equalization to fit that sound. (Microphone selection is also critical to the sound and a discussion of this is included in Chapter 9, "Microphones and Pickups: Placement and Usage.")

If you have control over specific frequencies you will use the midrange controls the most because those frequencies cause the most trouble with feedback and intelligibility. Many boards have a low-frequency cut filter, which acts as a rumble filter below 80 Hz. This really helps if there is low-frequency rumble from an air conditioner, footsteps or wind.

Effects and Other Sound Processing Equipment

The most common form of effect is the addition of a compressor or limiter to microphone input channels. If your board has a channel insert, you use an insert cable from the channel insert to the compressor. An insert cable that has a stereo plug is connected to the insert jack of the channel that is to be processed. If there is no insert point on each channel you must insert the compressor or limiter at the submix or main output of the board, which means that you are going to limit more components of the mix. Properly adjusted compression or limiting of the main output provides speaker protection against overload, but does not help the overall sound.

Effects such as reverb and echo are engaged in parallel by sending their signals to an effects or auxiliary bus and then to an outboard processor such as a digital reverb or delay. The processed signals are brought back into the board either through an auxiliary return or spare input channel. The return level is carefully selected to add the desired amount of effects. Parallel effects are normally used on several sounds at once. You adjust the effects send from each channel to get as much or as little send for each instrument as desired. The amount is determined by the character of the instrument. For instance, a hammer dulcimer sounds like it is playing in a reverb chamber to begin with (known as "wet" sound), adding reverb will cause it to lose all definition. Human voices are very "dry" sounding (no inherent reverb) so reverb is added to provide warmth and body. The amount of reverb can change from song to song and will depend on tempo, playing style and mood.

Outboard effects can be a large part of how a song sounds and returning them to a spare input channel is more flexible than using the auxiliary returns on your board. This allows you to equalize the effect return and add just the right amount of reverb to the monitor mix. The performers will be happy and if all else is adjusted properly there will not be any increase in feedback potential.

Setting the Main Mix

Since acoustic acts do not usually play at loud volumes, setting the controls can often be done without feedback. Set the main power amplifier's input control so that 0 VU on the board corresponds to 0 VU on the power amplifier of the main speaker system. This is also done on the main speaker's equalizer, electronic crossover or limiter. The important thing is to provide each piece of gear with the proper signal level. If you boost the signal a lot at the graphic equalizer and then cut it back at the crossover, you may be clipping the equalizer during loud passages. Ideally, the VU meters on the mixing board will correspond to the available power from the main amplifiers so that 0 VU produces full amplifier output.

Matching Amplifier, Speaker and Mixing Board Output Power

To avoid speaker burnouts, match the output power from each amplifier with the maximum power capabilities of each speaker. Select an amplifier whose maximum output is just above the peak power capability of the speaker. This will provide the headroom you need to capture transients. If you are using speakers that are underrated for the available power, the amplifier's volume must be reduced appropriately so that its output will be less than the maximum input capability of the speaker.

The best balance between headroom and noise floor is achieved by setting the output level of the mixing board so that the reading on the VU meter corresponds to the continuous power output of the amplifiers. This can be accomplished with or without a signal generator (device that puts out a continuous 1 kHz tone [pink noise]).

If you are using a signal generator, for a power amplifier that has a VU meter feed the output of the generator into one of the line-level input channels of the mixing board or, alternatively, first route the generator's output to the input of a direct box and then to one of the microphone XLR input channels of the mixing board. Turn on the signal generator and adjust its volume control to about midpoint, making sure it does not cause clipping at the input channel. If the input channel's peak light is on, either adjust the channel trim control or turn down the output of the generator until the light goes off. Turn the gain of the microphone input channel fader to between 5 and 8 (on a scale of 10), making sure the channel is not distorting and adjust the level of the main output faders until the VU meter reads -10 VU.

Then adjust the main amplifier's attenuator control (or its associated crossover level control), until it also reads -10 VU. This will allow the mixing board's VU meter to track with the power amplifiers. The transients will be reproduced cleanly if you do not exceed 0 VU on the mixing board when music is being performed.

If the power amplifier has an overload/peak LED, but no VU meter, then you can only set calibration at clipping level. Disconnect the speakers (to prevent damage), set the output level of the mixing board to read +3 VU. Now adjust the main amplifier's attenuator (or its associated active crossover level control) until its overload or peak LED light is triggered. Shut off the signal generator and reconnect the speakers. The mixing board's VU meter should now track the level of the power amplifiers.

If you do not have a signal generator, connect a CD player to the appropriate input of your mixing board and play a CD. See how the mixing board's and the amplifiers' VU meters track (e.g., when the mixing board's VU meter is hitting 0, the amplifiers' VU meters should be doing the same). For an amplifier without a VU meter, notice if the overload indicator goes on when the mixing board's VU meter rises above 0 VU. If the level indicators of both the mixing board and the power amplifiers are not tracking properly, adjust the amplifier's volume control (and/or its associated crossover level control) until they do. By backing off the amplifier's attenuator control, the transients will be reproduced cleanly.

When you have a biamped or triamped situation, the primary amplifier is adjusted first, and the other amplifiers are adjusted to match its output. In a biamped system, the primary amplifier is usually the one that powers the bass speakers; in a triamped system, the primary amplifier is the one that powers the midrange speakers. Careful adjustment of these controls during a sound check will make for a feedback free, fine sounding performance.

If the outputs of the horn speakers are too loud, turn down the horn amplifier's volume, rather than adjust the equalization. Avoid the temptation to turn the amplifier power up or you will be spending money on new speaker drivers. If you use a 500-watt amplifier on a 50-watt speaker, sooner or later some mistake will cause the full output of the amplifier to be sent to the speaker and destroy it. To avoid this, install security controls on the amplifier's volume knob to ensure that it cannot be turned up beyond the power handling capacity of the speaker.

Setting Up the Monitors and Monitor Mix

In the simplest scenario, the monitor signal is the same feed as the house mix. This happens if your system has only one power amplifier and you use a monitor speaker that has an internal volume control and is hooked to the output of the main amplifier. Internal speaker volume level controls are rheostats (large potentiometers) that can dissipate the large amount of heat that is generated

when a speaker is directly attenuated. This works only when the band's instruments are balanced volume-wise and the vocals are at the same levels as the instruments.

In a more complicated scenario, a separate monitor mix can be derived from the board. If the board is going to provide a mix to the monitors, see if the monitor send is pre- or post-EQ by adjusting the highs on an instrument while listening to the stage monitor. If the monitor speaker gets the equalization change, then the send is post-EQ. If not, then it is pre-EQ. Post-EQ is better for small bands that are not trying to get maximum sound level before feedback. Changes that you make to the sound of an instrument on its channel's equalizer will be heard by the audience and the musicians. Many early mixing boards used a pre-EQ send for the monitors. This provided a stable monitor mix that would not go into feedback if someone adjusted a channel equalizer, but the sound of the vocals and instruments could not be equalized individually in the monitor mix. You were stuck with the basic sound of each microphone and instrument.

With single-bus monitor systems, start by setting every channel's monitor send to 0 and the monitor bus output control to some nominal level, 5 or 7 on a scale of 10. This gives a little room to move without overloading ("clipping the bus"). Turn the house speakers up to midlevel, slowly bring up the individual channel faders while adjusting their input trim pads. Once a slider is at 70% of full travel move to the next channel. After you have a rough main mix, slowly turn up the monitor send on each channel until sufficient level has been reached or the system is ready to feed back and then back it down a bit.

If you have a two-bus monitor system, you can tailor each monitor channel individually. For instance, the singer may want to hear only herself and the rhythm guitar in her monitor, while everyone else wants some percussion in their mix to get timing cues. Do not start a volume war. If someone cannot hear a particular instrument, try turning everything else down a little in the mix instead of boosting the soft instrument.

Do not add extra monitor channels unless you can provide a separate equalizer for each one. A 10-band graphic equalizer is minimum and a 31-band graphic or 4-band parametric will provide the most flexibility. Some of the switchable 30-band mono/15-band stereo units are nice since they are convertible to one-third octave (30-band) control for a single output channel and two-third octave (15-band) control when you need two mixes. Without good equalization, additional mixes can cause more problems than they are supposed to solve. Do not attempt "rock-monitor" levels for acoustic music. Although it may be possible to approach electric music decibel levels with an acoustic instrument, it is not desirable.

Monitor Mixing from the Stage

If one of the band members mixes and performs at the same time it is advantageous to use a postfader bus for the monitor mix. This gives a better indication of how the mix actually sounds in the house and changes that are made to individual microphone channels will be heard by the musicians and the audience. This way the mixer hears the consequences of any mixing action immediately.

Monitor Mixing from a Remote Location

The monitor send is usually accessed before the mixing board's channel equalization and faders. It is independent from the house mix and equalization changes in the main speakers. The engineer can make changes to the house sound without affecting what the musicians hear.

Some sophisticated acoustic artists teach themselves to listen to their own instruments and adjust them without hearing a monitor mix that is different from the house mix. On a low-decibel stage, multiple channel monitor mixes or even a separate mix may not be necessary. By using an effects bus (postfader and equalizer) for the monitor send, channel level and equalization changes will affect the mix in the monitors as well as in the main speakers and give the performers a good idea of the house mix.

Microphones and Monitor Levels
The goal is to maximize the sound of the miked instrument (by turning up the level) and minimize the bleed from other instruments that can color its sound and produce feedback. That goal is compromised when the stage monitors are loud because the acoustic energy from the monitors interacts with the sound boards of the instruments and bounces into the microphones.

Very loud stage monitors will affect and muddy the sound of all the instruments onstage and cause problems during mixing. An instrument that is in front of loud monitors (that might be on the edge of feedback) sounds different than one without loud monitors. The problem will be exacerbated if there are a lot of low frequencies from other instruments or the room itself. To deal with this problem, a sound engineer will try to get the equalization of the monitors as flat as possible and dump all the bass frequencies below 60 Hz to lessen feedback and increase intelligibility.

Feedback problems increase when internal pickups are used because of their low-frequency feedback potential. One way to avoid feedback is to use pickups in combination with interior or exterior microphones and produce two signals that are sent to the mixing board. When a microphone is attached to an instrument that has a pickup the sound that is produced by both signals is consistent, even if the musician is moving around. The engineer can send the pickup's output signal to the monitors and adjust the tone of the final mix with the equalization controls on the mixing board's microphone input channels. Be aware, however, that sending only one of the signals to the musician via the monitors may be very disconcerting to one who is used to hearing the same sound that the audience hears. The advantages, however, are that this allows maximum gain before feedback and a more stable monitor mix for the other musicians.

The musician can also send two signals from the pickup: one signal goes to the instrument amplifier, which is miked. The signal from the microphone is routed to a mixing board input channel. The second signal is sent from the instrument's quarter-inch output to a direct box and then to another microphone input channel. This gives the sound engineer three signals to work with (the third signal is from the instrument's interior or exterior microphone). Each is routed to a different input channel, which provides great flexibility in shaping the sound for the final mix.

The signal from a pickup can also be routed from a microphone input channel to an outboard parametric equalizer to attenuate any particular frequencies before they cause feedback. Fixing equalization problems at the output of the instrument provides a better signal for the mixing board.

A stereo equalizer that has one side dedicated for the main signal and one side for the monitor channels is an excellent choice. It can adjust the monitor mix without affecting the sound in the main speakers. Some mixing boards have separate equalization controls for the monitor and main mixes.

Attempting to fix a problem on one microphone input channel by adjusting the overall equalization control on the main panel of the mixing board will

affect the equalization of everything else and not produce a pleasing mix for either the main or monitor speakers. A problem channel should be fixed by sending its signal to an outboard processor, such as an equalizer, limiter or compressor.

Other methods for preventing feedback caused by pickups in acoustic instruments include using a rubber plug that completely fills the sound hole of the instrument. The disadvantage is that it will produce a "stuffy" sound. Although you can get higher volume the sound will be altered. Also, installing a reverse polarity cable from the pickup to the direct box or using a microphone input channel's phase reversal switch can reduce some of the bass frequencies.

Mixing

Sound engineers are judged on their ability to effectively process signals and mix them so they accommodate the needs of the devices and people they are routed to: audience (via main speakers), musicians (via monitor speakers), tape recorder, radio broadcast, etc.

The job in acoustic music engineering is to reproduce sound as accurately as possible in the stage monitors and in the house speakers adding effects only as needed to make a "musical" mix. Technical details aside, the ultimate tools sound engineers have are their ears and musical taste.

Mono, Stereo, and Beyond

Most small club and theater acts should be mixed mono because most listeners will not be in the sweet spot between speakers and will hear a bad mix. One compromise is to mix the music to center mono on the pan controls and return the effects stereo. Then you can have the instruments mixed properly for everyone in the room and add some stereo depth to the reverb.

If your acoustic band likes to enter from the back of the room and pass through the audience while playing their instruments (especially dramatic with a dark room and lit stage), let the engineer know in advance, so he or she can slowly turn up the onstage microphones as the musicians arrive. Bring the main faders down until all the musicians get in position at their microphones and then slowly pot up the house send to normal levels. This effect is very cool and avoids any shock to the audience as the sound changes from pure acoustic to reinforced levels.

Special Problems

Here are some special problems and emergencies that can arise during performances and how they are usually dealt with.

Fires

Occasionally there will be problems with a piece of electrical equipment and a fire will result. This can happen when someone replaces a fuse in an amplifier with a bigger one. A quick blast with a fire extinguisher will assure the safety of the room, but a little planning can prevent complete loss of the equipment.

Electrical Shock

Nobody likes to get shocked. But musicians lay their lives on the line every time they pick up an amplified instrument that is not properly grounded. Nothing breaks your concentration like a nasty shock. Here are a few do's and don'ts.

Outside gigs near pools and golf courses are especially dangerous. Carry plastic tarps and if a storm comes up cover your amplifiers and speakers, grab your instruments, and get to safety.

Do not remove the ground plug from your amplifier's power cord. Although this is a quick fix when you have to use an ungrounded outlet, and it sometimes eliminates ground loop hum, the

shock hazard is great. Older amplifiers are especially susceptible to this problem. If your amplifier has an ungrounded plug and a ground switch, have the plug replaced with a grounded one by a qualified technician. If you connect it to a mixing board via a direct box, use a transformer isolated direct box, which will prevent ground loop hum and keep your amplifier grounded. This is the key to not getting shocked. If your amplifier's power transformer has a little leakage (caused by insulation breakdown due to age) it is possible for all metal parts of the chassis to drift up to the full potential of the line voltage, 120 volts. The ground plug's job is to drain off these normal leaks before any real voltage potential occurs and your amplifier and your body become energized at full line voltage.

If you touch a grounded microphone with wet lips while holding an amplified guitar in sweaty hands you will never forget the experience, if you live through it. A plug-in AC tester should be used every time you set up to test each outlet you will use (you will be amazed at the number of faults you find).

Buzzes and Hums

Hum is usually caused by grounding or shielding problems. The most common shielding problem occurs when an unshielded speaker cable is hooked up to the direct send of a guitar. This is the first place to check. Ground loops are the next place to check, and a whole chapter could be devoted to their origin and elimination. A ground loop is caused when two pieces of equipment are each hooked to ground (through their power plugs) and are also connected together by a shielded cable. All grounds are not created equal and there will be a difference in voltage between the two ends of the shielded cable. This induces large currents that get into all the equipment. The trick is to break one of the ground connections, so that the cable shield does not carry any ground loop current. A transformer isolated direct box that has a ground-lift switch is usually the best option. The transformer provides a gap between the two grounds and breaks the current path while it allows the audio signal to pass unaffected. You can sometimes eliminate a ground loop with a ground-eliminator plug on the power cord, but this can be dangerous. If there is a short in the amplifier it can send the full

Important Rules in Case of Fire

Rule #1: Do not throw water on an electrical fire. Bad things will happen, from wrecked gear all the way up to death by electrocution.

Rule #2: Use the proper fire extinguisher. A standard chemical extinguisher will put out a fire in your amplifier, but you will not like what is left. Chemical extinguishers produce a residue that will corrode every wire and electrical component in your amplifier in a matter of minutes. Of course, if there is nothing else available use what you have to guarantee the safety of the house. A better choice is a Halon extinguisher. These were designed for computer fires and do not leave a corrosive residue. Normally, they are painted white and are rated for electronic equipment. The next choice is the standard CO_2 (carbon dioxide) extinguisher that is common to many stages. CO_2 will put out a fire in your amplifier without corrosion, but the quick temperature shock (-200 degrees F) will probably crack all the tubes. Still, this is a small price to pay for stopping a fire, and preventing the complete destruction of your equipment.

circuit breaker capacity of the line (20 amperes or more) into the mixing board via its input connections, not a pretty sight.

Switchcraft makes a self-switching plug that is great for acoustic guitars that have direct sends. There is a small pin that protrudes about an eighth of an inch from the shoulder of the plug. When the plug is not in a jack an internal switch shorts out the cable and eliminates buzzes and hums. When the plug is inserted into the jack of a guitar, the last eighth-inch of travel opens the switch and turns on the channel. This plug also prevents loud pops when musicians pull them out of their instruments.

Bad Cables

Always keep a few spare cables within reach. It is much faster to replace than repair.

Feedback or Rattles

You can find out what is rattling or distorting without shutting down the band by listening to each input channel separately via the solo switch and headphones. A quick fix between songs or sets will impress the band and allow the audience to enjoy the seamless show they paid for. Nobody likes listening to someone shouting "test, test, test…." into a microphone to find out what is wrong.

Difficult Room Acoustics

Not all rooms are great sounding—adjust to each situation as best you can.

Reverberant rooms require using microphones that have tight directional patterns. They pick up as much direct sound as possible and ignore the room's acoustics.

Recording Performances

Chapter 11

A recording of a band's performance can be the most cost-effective method for generating the master tape for producing records, cassettes and CDs. Bands send them to club owners, booking agents and concert promoters as auditions; to record companies they seek contracts from; and use them as income generators through sales at gigs, stores, and by mail order. Bands like live recordings because the excitement generated by the audience produces a special electricity that is not often duplicated in a recording studio.

This chapter discusses your choices for recording your act in a professional manner and illustrates the techniques involved.

Choosing the Venue

There are two major considerations for selecting a venue. The first is finding one where you are comfortable performing; the second is finding one that has favorable acoustics.

If you have a favorite club or concert stage, put it at the top of the list. Consider those places where you received the most energy and audience reaction. Either book a gig there or rent the venue and invite your friends to a private recording party.

Next, evaluate the acoustics. If you perform without a sound reinforcement system, look for a

quiet room. One without an interfering bar, kitchen, street noise or electrical interferences from dimmers, two-way radios, etc.

If you perform with a sound system, look for venues that allow you to hear yourself and other band members in the monitors at low volumes. Quieter rooms are preferable.

Tape Recorders

The best recording mediums are DAT, quarter-inch half-track and half-inch or 1-inch multitrack analog reel-to-reel tape recorders. Cassette recorders and quarter-track reel-to-reels are less preferable, although cassette recorders can be used to make records of performances or for rehearsals. The cassette medium is particularly unforgiving of sloppy engineering and will make your recording sound awful unless it is handled with great care. The used equipment market is glutted with professional analog reel-to-reel decks and moderately priced DAT recorders, so most small bands can afford a professional tape medium for field recording.

If you plan to reproduce your material on CDs, use a DAT tape recorder that records at the 44.1 kHz sample rate, the universal digital mastering standard. Music that is recorded and edited with a sampling rate different from 44.1 kHz must be converted to the universal standard. If you do not plan to go to CD, a 48 kHz sample rate provides better high-frequency response.

Analog: Reel-to-Reel

Analog tape recorders convert electrical signals to magnetic ones and imprint those signals as patterns on recording tape. This tape consists of a plastic backing that is coated with metallic particles that respond to the electrical signals. The recording head on the tape recorder functions like an electromagnet and aligns those particles into magnetic patterns that are analogous to the sound being recorded.

A higher tape speed increases the area of tape that is exposed to the recording signal and produces better frequency response and signal-to-noise ratio. Use the highest tape speed possible. Professional tape recorders use 30 or 15 inches-per-second (IPS).

Recording tapes differ with regard to their magnetic coatings, thickness and their type of backing. Each displays different abilities to receive and retain the magnetic signal at any given tape recorder speed and each requires different magnetic strengths to record the signals properly. Bias is the process of adding an ultrasonic signal to the audio signal that is being recorded. Magnetic particles respond nonlinearly and disproportionately within any magnetic field. Adding the correct amount of this inaudible, high-frequency signal charges the magnetic particles on the tape and they react more linearly. Without the proper amount of bias, the recording will be very distorted and contain frequency response errors. The bias required depends on tape formulation.

The type of coating, the amount of bias and the width of the tape are the characteristics that determine frequency response, dynamic range, signal-to-noise ratio (how much hiss will be present), and saturation levels (how much audio information the tape will hold before distortion or signal loss occurs). The greater the area of tape that is exposed to the audio signals, the less likelihood that the signal will be distorted. Quarter-inch analog tape is not as good as half-inch tape and the eighth-inch format of cassette multitrack recorders is the most problematic.

A good 1.5 mil thick tape prevents print-through echo, an effect that occurs when some of the magnetic signal leaks into adjoining layers. This produces an echo effect that is most noticeable in soft passages.

Wider tape widths have the headroom that allows you to record louder. You can average 0 VU

and allow the peak levels on the VU meter to hit +3 or +6 VU. Recording with the meters above 0 VU is generally required to get a good signal-to-noise ratio and to get above the noise floor of the tape.

Once the VU meters are pushed beyond 0 VU soft compression occurs due to tape saturation. The transient peaks are rounded and their volumes are reduced gracefully. The staccato peak that would result in dropouts on digital tape is replaced with a pleasing distortion that has more even-order harmonics, which produce a warm, flattering sound. Some engineers deliberately drive signals above 0 VU because that imparts additional musicality and can make a variety of instruments sound fuller. This is a favorite technique for recording drums, horns and vocals.

Analog decks work well and their tapes are easier and less expensive to edit on than DATs in postproduction. Some professionals prefer to use maximum tape widths to achieve the best performance (with or without noise reduction). For example, they use half-inch tape for 4-track recording, 1-inch tape for 8-track, and 2-inch tape for 16- or 24-track. Excellent reel-to-reel decks can be bought at bargain prices due to the rush to digital recording mediums in the early '90s. Countless records have been recorded this way and a professional reel-to-reel deck with good noise reduction can actually exceed the frequency limits and signal-to-noise ratio of the 16-bit, 44.1 kHz digital format.

Noise reduction helps quiet the hiss that all analog tapes have. Both Dolby and dbx make professional noise reduction units, either built-in or as outboard devices. During recording the dynamic range of the signal is compressed and then uncompressed when played back.

Dolby S is a popular professional multiband system that provides 10 dB of low-frequency noise reduction and up to 24 dB of high-frequency noise reduction. It is now available on many semi-professional and consumer cassette tape decks. Some recorders use dbx type II, which provides up to 30 dB of noise reduction. Dolby A, used in professional reel-to-reel recorders, provides 10 dB of low-frequency noise reduction and up to 15 dB of high-frequency noise reduction. Dolby B reduces hiss approximately 10 dB; Dolby C by 20 dB.

The other advantage of a professional reel-to-reel deck is that you can monitor "off-tape." Although this is an expensive option on a DAT deck, most open reel decks use three tape heads: erase, record and playback. This allows you to listen to the actual recording a fraction of a second after it hits the tape and judge distortion, frequency response, and other qualities. By selecting either *source* or *monitor,* you can listen to what is going to or coming from the deck and assure yourself that something is indeed being recorded. It is heartbreaking when the performance of a lifetime is missed because the recording head is dirty or the tape stock is bad. (If you record enough you will eventually get a reel of bad tape and Murphy's Law says that it will be used during the most important, electrifying gig of your life.)

Analog Cassette
The last resort for field recording is standard cassette. Its slow tape speed, narrow track width and high frequency emphasis make it the least desirable recording medium. In order to make the medium work at all, cassette recorders have built-in equalization circuits that boost the high frequencies by as much as 16 dB. This means that the high frequencies in the musical program being recorded will be boosted by that amount and overload the circuitry and produce a terrible sounding high-frequency distortion.

Their high-frequency overload characteristics and lack of headroom make recording directly to cassette an iffy proposition. Even seasoned recording

engineers have difficulty with it. Percussive sounds will quickly cause distortion even though the meters say everything is fine. Instruments such as maracas and shaker eggs will overload any cassette deck instantly because of the ultrasonic frequencies they produce.

To reduce this ultrasonic frequency problem, record at lower VU levels. This is subject to experimentation until you get a reasonable recording. Use a cassette deck that has a Dolby or dbx noise reduction system and select the highest bias tape that can be used. When using dbx noise reduction, try running the VU meters at -3 VU or -6 VU for the average signal to gain some headroom for unpredictable musical moments. You can also engage the MPX filter found on many cassette decks. This is normally used to attenuate the 19 kHz pilot tone of an FM radio by filtering out any signal above about 15 kHz. This helps reduce ultrasonic overload.

Metal alloy (unoxidized) tape is most desirable, followed by chrome (chromium dioxide or CrO^2) and ferric (ferric oxide). High-bias chrome and metal tapes have lower hiss and greater ability to reproduce high-frequency sound. Try a variety of tapes from different manufacturers since some brands will give you more headroom and more controlled distortion than others. If you want to get serious, have your deck biased for a particular brand of tape. This should be done by a professional and it allows you to wring the maximum performance from your machine. Any good deck repair shop can set the bias, azimuth, and equalization on a cassette deck in an hour. Be sure to tell the technician that you plan to record live music, so the bias levels can be optimized by the technician as high as possible with the least high-frequency saturation.

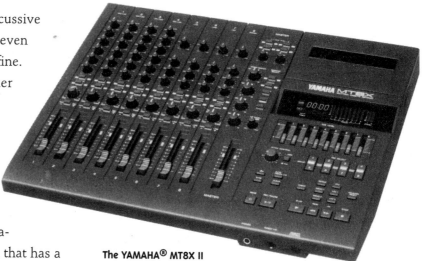

The YAMAHA® MT8X II incorporates an 8-track cassette recorder and 14-channel mixer in one unit and provides dbx noise reduction. It was designed for location and small recording studio applications.

The higher the tape quality and the better the noise reduction system, the less tape hiss will be heard on playback. It is not true that noise reduction screws up the dynamics of the recording medium. This is only true for misaligned tape decks and bad tape. However, noise reduction, especially dbx, does amplify frequency response problems. If your tape's frequency response is down 3 dB at 12 kHz, it will be down 6 dB at the same frequency using dbx, but this is a small price to pay for the increased signal-to-noise ratio (15 dB with Dolby A, 10 dB with Dolby B, 20 dB with Dolby C, 24 dB with Dolby S and 30 dB with dbx). This effect is most noticeable with dbx and least noticeable with Dolby B.

I have recorded hundreds of hours of music and sound effects on a high-quality portable cassette deck using metal tape and dbx noise reduction. These recordings were usually very good, except for the occasional high-frequency overload that produced some distortion when the tape ran out of headroom.

If you attempt recording with ferric tape and no noise reduction your results will be disappointing at best. You will always be riding the middle ground

between distortion and tape hiss and if the recording levels are not perfect there will be problems.

Analog-to-Digital Conversions

Musicians that record on analog tape and master to DAT have reported that the analog-to-digital conversion can result in dropouts, pops and clicks. They urge people to listen to the DAT master before sending it to the manufacturer, no matter who is responsible for making the conversion.

Digital Audio Technology (DAT)

Many musicians are now using this medium. DAT is especially attractive since tape stock is inexpensive, operation is like any basic cassette recorder or VCR, and the sound is comparable to compact disc.

There are some caveats. You must record with enough headroom to accurately reproduce transients without overloading the analog-to-digital converters. Think of -10 VU as your target recording level, with peaks not to exceed -3 VU. As soon as the signal goes above 0 VU the distortion will sound atrocious. This is because digital decks do not respond to any audio signals above 0 VU. To avoid this, use a limiter or compressor on the input of the DAT recorder to clamp any volume rise above this threshold, or ask the band to limit some of their own dynamics. Once the DAT tape has recorded a distorted signal it cannot be transferred to analog and fixed. It is there forever.

Some of the better DAT recorders have built-in analog limiters that allow you some overload headroom, but the best plan is to avoid hitting 0 VU. If the overall sound is good except for a few peak hits, turn down the recording level slightly and try again.

The second caveat is that editing DAT tape is much more difficult than editing analog tape. If editing is necessary, you have three options. The first is to transfer the music to analog tape, which can be easily edited by manual splicing. This requires a

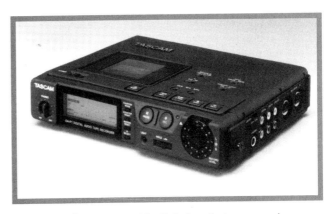

The TASCAM® DA-P1 portable digital audio tape recorder was designed for field use. It features XLR-type mic/line inputs with phantom power and unbalanced RCA connectors for input and output.

digital-to-analog conversion. The disadvantage here is that there will be some loss of musical information, particularly in the high and low frequencies because of inherent drawbacks in the digital-to-analog and analog-to-digital conversion technology.

A second option is to load the digital signal into a digital audio workstation (DAW) and use the editing software that is available. Many multimedia computers have 16-bit sound cards that allow you to transfer the entire performance from a DAT to your hard drive for editing. Be aware that stereo 44.1 kHz 16-bit sampled audio requires at least 10 megabytes of disk space per minute of program. Even a short tape requires hundreds of megabytes of hard drive and 800 to 1000 megabyte drives are required for digital editing. The disadvantage of this option is expense. Studios will charge for real-time loading of information and its manipulations. If you buy your own equipment and software there is a big learning curve. Also, the sound cards that come with most computers are adequate for games, but not for music editing. You will need a professional sound card and a S/PDIF or AES/EBU link to the DAT deck for the highest quality transfer.

A third option is to make a DAT-to-DAT copy (only good for resequencing the songs). The problem

with this option is that it is tricky. The engineer must learn the record engage interval of the DAT machine and time the playback so that the record engage click occurs on the down beat of the next song. However, you can buy a DAT editor that allows you to accomplish this electronically.

Since the introduction of the Alesis Digital Audio Tape (ADAT) format, many bands can afford to do multitrack live and studio recordings. The ADAT format uses S-VHS high-band video tape as its recording medium, and essentially acts like an 8-channel DAT recorder.

The real genius of the ADAT system is that multiple decks can be slaved together to act as one 16- or 24-track recorder. This means you do not have to trade in an existing deck when you want to upgrade from 8 to 16 or 24 tracks. Just buy another ADAT machine and hook it up. You can connect 16 decks this way, which will give you 128 tracks to play with if you are so inclined.

Microphones

Use the highest quality microphones you can afford. Try several microphones and placements before settling on one best choice for each instrument.

Professional quality cardioid microphones are a good place to start. However, all cardioid microphones exhibit a bass proximity boost and singers will sound bassier than they really are and instruments that are close miked will have more bottom end. They also contribute to the general low-frequency rumble heard in a lot of recordings. This can be corrected by using your mixing board's low-frequency roll-off equalization to dump the infrasonic energy below 60 Hz, which will give you a better vocal mix and less competition from rhythm and bass instruments.

You should also consider using good omnidirectional microphones. If you do not need loud stage monitors and stage isolation is reasonable, you will get a much more realistic recorded sound with an omnidirectional microphone. Any given omnidirectional microphone will have a flatter frequency response than an equivalent cardioid directional microphone and the proximity effect will be absent. These microphones are especially good for instruments that have complex sound fields, such as accordions, harps and bagpipes. You can put several cardioid microphones close to a single instrument to get all its various sounds, but a

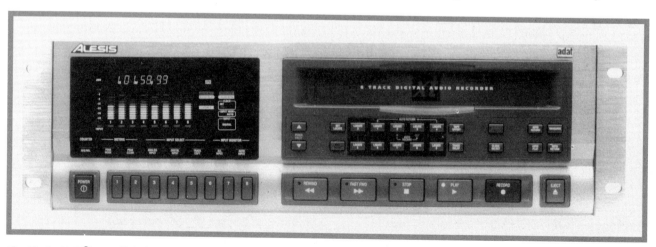

The Alesis-ADAT®-XT™ digital 8-track recorder has a digital editor that allows you to make copy/paste digital edits between machines or within a single unit, as well as make a digital clone of any track (or group of tracks) and copy it to any other track (or group of tracks) on the same recorder. Tapes made on other ADATs can be used with the XT.

The Neumann® KM 184 is a small-diaphragm, cardioid condenser microphone capable of handling sound pressure levels of 138 dB before overloading. It has very low self-noise, making it suitable for recording acoustic guitar, piano and classical music performances.

single omnidirectional microphone will capture the entire sound field and give a better sound without the phase irregularities that result from a close multimicrophone setup.

Try to get the same type of microphone for all the singers. Minor timbre differences between different brands may not be noticeable during performance, but they will stick out in a recording. Chapters 2 and 9 provide more complete information on microphones.

Follow the Rule of Thirds

Multiple microphone placement for recording live music can be properly approached when you understand the rule of thirds: the microphone that is to pick up the sound of a single instrument should not be any further away from the instrument than one-third the distance to the next microphone. This will give you sound separation between the various microphones. Microphones that are placed too far from instruments and too close to each other produce multiple echoes, the hallmark of the garage-band sound. Placing the microphones too close to the instruments (especially those with complex sound fields), will produce an unnatural sound. Compromises must be made to get the best possible results from each circumstance.

Method of Recording

Your method of recording depends on the type of music you play, your goals, and your budget. If you do not have your own equipment, you can purchase live recording services from sound reinforcement companies, recording studios, or companies that specialize in live recording.

Use a Separate Bus on the Mixing Board

Generally, a tape that is recorded from the line-out on a mixing board (the same mix the audience hears) will sound unbalanced because the sound system has to boost the quiet sounds on the stage more than the loud sounds. The signal that is sent to the main speaker bank will generally have more vocals than instruments in its mix because the stage instruments are usually louder than the singers. This forces the person who is mixing the house PA to boost the vocals to compensate. What you need is a way to get a separate mix that goes only to the recording deck. The mixing board should allow you to use a separate bus to send a mono mix to the main speaker bank and still derive a stereo mix from the main-out that goes to the recording deck. A B-Mix bus is perfect for getting a separate 2-track mix. Headphones are used to monitor the mix directly from the recording deck. Hooking up the board in this manner allows you to set a relative mix level for both the recording and sound system that will track each without extra effort. If an instrument has a lot of volume on the stage, such as bagpipes, then its signal to the main sound reinforcement speakers can be reduced while it is being recorded at an appropriate volume. If you recorded directly from the feed to the power amplifiers the bagpipes would sound very low in the recorded mix. There is a certain amount of guesswork that must be balanced with serendipity when you do field recording. Do not be discouraged if your first attempts sound distorted or unbalanced. Simply record at your next gig and make adjustments that are based on your mistakes.

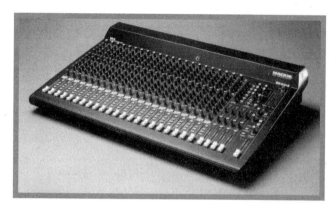

The Mackie™ SR24•4 four-bus console enables you to group together combinations of 24 channels to any of four submix buses. Its double-bused sub outs enable it to be used for 8-track recording.

Remote Mixing Board

If space and equipment are available you can split the sends from each microphone and direct box to two mixing boards. One board becomes your recording console. Ideally, it should be located in a separate room away from the noise and commotion of the main room. The engineer who is running the recording mix should use closed headphones to maintain isolation from the house mix. One excellent method is to use custom molded in-ear monitors. They offer tremendous isolation from the room and are perhaps the best way to get an accurate mix in a noisy environment.

If an isolated room is available, set up near-field recording reference monitor speakers and use them instead of headphones to get a better idea of the final product during the mix. Near-field monitors are small speakers that have been designed to sound correct when placed about 3 feet away from your ears. Since they are very close to you, they mask the acoustics of the listening room and allow for better mixes in rooms that have poor acoustics. The optimal placement for near-field speakers is within 2 to 3 feet of the engineer. If you are in a dressing room backstage, you will need a communication system to give instructions to start and stop the band and have the microphones moved. A video camera and monitor can provide the recording engineer with a good idea of who is on which microphone. Most theaters have a hardwired talk back system, but if not, Clear-Com systems can be leased and work well, or walkie-talkies are an inexpensive solution. Be aware, however, that keying the microphone on a handheld radio may cause its signal to be picked up as interference by a microphone line or mixing bus. Plain old hand signals and a runner may be the answer. Listen for the band's introduction and record the whole set. Then pick what you want to keep. Record everything, do not miss a song even if you think you already have the ultimate performance in the vault.

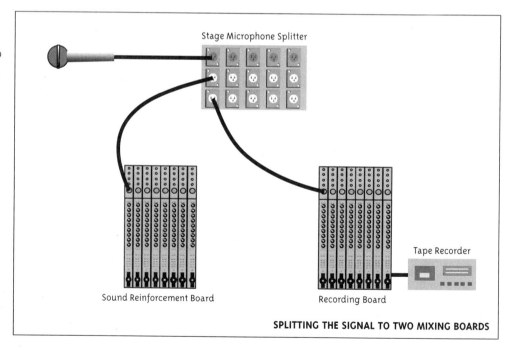

SPLITTING THE SIGNAL TO TWO MIXING BOARDS

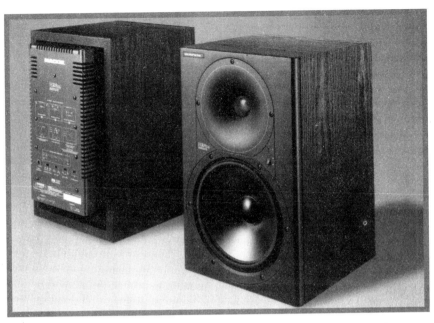

The Mackie™ HR 824 studio monitor is a biamped near-field speaker containing a 150-watt amplified woofer and a 100-watt amplified tweeter. It contains a built-in limiter to prevent overload.

Acoustic Stereo Microphones to 2-Track

Music that requires no sound reinforcement and is acoustically balanced without amplification can be recorded beautifully by positioning paired microphones in just the right place. The signals can be routed to a mixer first or be recorded directly on tape. This method requires that the musicians control their performing dynamics. Natural room acoustics and audience response will be captured in the recording.

The microphones should be high-quality, sensitive and quiet. Their type of directionality depends on the music, room and recording method used. If the room's tone and reverb complement the music and you desire to include that as part of the recording (classical music, choral singing, some types of folk music, etc.), then high-quality omnidirectional microphones are an excellent choice. A good set of cardioid patterned microphones can also produce great results. Many manufacturers make mounting brackets that will space two microphones appropriately, about 12 inches apart at an angle of 110 to 140 degrees. The spacing and angle are subject to experimentation for each recording situation. When less room sound is desired and more direct sound is needed (e.g., a choral group in a stone church), use directional microphones.

Listen during a rehearsal or sound check and find a place where the sound is balanced and place the microphones there. Often, that spot is located approximately 8 to 10 feet from the band and 8 to 10 feet in the air. You must experiment. Moving microphones a few inches can make a big difference. You may also need to reposition the musicians or ask them to change positions when they perform solos.

Start by positioning the microphones as far back from the band as the width of the act and listen to the balance on headphones. If there is too much room echo in the mix move the microphones closer. If a particular instrument needs to be louder have it moved a few feet closer to the microphones. Remember, if you get the microphones too close the instruments directly in front of them will be much louder and more direct sounding than those to the side. The only way to judge the mix properly is to record a song and listen to it. Once the proper instrument balance has been achieved it becomes simply a matter of coaxing a good performance out of the musicians.

Remember, this recording method is only useful with acts that use little or no stage amplification. It works great with fife and drums, harp and violin, stand-up bass and acoustic piano, etc. It is less useful for acts that use amplified electric guitars and a PA system for vocals.

A more specialized miking technique is termed "midside" stereo. A pair of microphones is positioned one above the other: one is a unidirectional microphone (cardioid), the other is bidirectional (also called figure 8). It does not matter which is placed above and which below as long as they are in the same vertical plane. The pickup pattern of the cardioid microphone points straight toward the act; the two lobes of the bidirectional microphone point left and right. This configuration works beautifully for symphonic music and any music that does not need a sound reinforcement system. The room's acoustics will contribute to the realism of the recording.

Another specialized technique is to used a binaural microphone, a specialized device that resembles a person's head and has miniature microphones where the ear canals would be. This microphone is generally used for recordings that will be played back on headphones to provide a surround sound (sound coming from all directions). There is, however, a decoding method that will allow a binaural program to be played back through loudspeakers and retain most of the surround characteristic.

Multiple Microphones/Direct to 2-Track

In this method, individual microphones are placed on each instrument in standard close miking positions. In a sound reinforcement situation, this signal is split by a microphone splitter box and is sent to two mixing boards, one records, the other reinforces the sound. This allows two completely different mixes to be done at the same time. Some mixing boards provide a B-Mix bus that allows you to produce a completely separate 2-track mix that is independent from the house mix. This is important in a situation where vocalists and instrumentalists are performing simultaneously and the PA system must supply a lot of vocal amplification and little or no amplification for instruments that are loud on stage. If you record

The Neumann® KU 100 binaural head microphone system is a human head replica with high quality condenser microphones inside the ears. It is used for binaural pickup to create realistic stereo recordings and as an acoustic research tool.

the PA feed directly to tape the balance sounds like all vocals and no instruments. If you must record from the PA board directly to tape put the vocals on one channel and the instruments on the other. You can balance the vocal/instrument mix later.

Multitrack Recording

It is easier to record on 16 or 24 tracks than direct to 2-track because you do not have to worry about the mix balance during recording. If you select the correct microphones and place them properly all you have to do is get each instrument and vocal on its

own channel and keep the recording levels out of the red. You can then mix the tape in a recording studio and make decisions about effects, equalization and volume and add extra tracks.

If you have a small act (up to a combination of eight musicians or vocalists), the music can be recorded with a single 8-track recorder since the signal from each singer or musician can be assigned a separate track. This technique requires either a sound reinforcement board with at least eight separate recording buses and direct outs, or eight microphone preamplifiers to derive separate signals from each microphone and route them to line inputs on the mixing board. Since most multitrack decks do not have input level controls you must use a mixing board that has output controls for the tape bus. You can use the "direct-out" jack on each input channel of the mixing board to provide the individual signals.

Even if you have more than eight signals to deal with you can still use an 8-track recorder and combine some of the signals together. You could designate four channels of your recorder to the drum (trap) set: 1) kick; 2) snare; 3) left toms and cymbals and 4) right toms and cymbals. Since the mix of the other drum sounds is less critical than the all important kick/snare balance, a good drum mix can be achieved without too much work. The other four channels on the recorder could be 5) stand-up bass; 6) acoustic guitar; 7) piano; and 8) vocals.

If your act consists of two acoustic guitars and two vocalists, you may want to use internal pickups (direct instrument sends) and properly positioned microphones to record each signal to separate tracks. If you have spare tracks, consider using them for audience response. When you mix the sound of the pickups with the acoustic sound of the microphones a very interesting sound will result. The audience response microphones are important when you are recording for a radio broadcast; without them applause will sound thin. A single-point stereo microphone will provide audience realism without adding phase problems. This is a specialized microphone that has two capsules in one housing. One capsule has a cardioid pattern and the other is bidirectional. These microphones are priced from less than $100 up to several thousand dollars.

DAT recorders are pretty cheap to feed. Some formats use half-inch S-VHS tape, which costs $8 to $16 for 40 minutes of recording time. Other formats use 8 mm video tape for 110 minutes per tape at a cost of $10 to $15. This allows recording three live sets for less than $25, a steal compared to analog tape. Tape for a standard 1-inch analog reel-to-reel deck costs $60 or more per reel and you get just 15 or 30 minutes of recording time depending on tape speed. Using analog tape you can easily spend many hundreds of dollars on tape stock before your project is complete.

At the other end of the monetary spectrum, multitrack reel-to-reel recorders with 24, 48, or 64 channels can be used. Every microphone and instrument on stage gets its own tape channel. A few microphones are placed in the audience for that all important crowd response. Back in the studio, the levels, tones, and processing for each instrument can be assigned and mixed as desired. You can add extra instruments or vocal harmonies to round out the arrangements. If sufficient microphone isolation was used on stage you can overdub flawed performances. While these recordings offer the utmost in mix-down flexibility, few small acts can afford recording in this fashion. A remote multitrack recording session with sound truck and personnel costs thousands of dollars a day.

Multitrack Monitoring

Listening to a multitrack deck to check for potential problems is a little more difficult than plugging a set

of headphones into the output jack. You need to premix the multiple tracks to two tracks so that you can have some idea of what is happening. If you are using a board with a built-in monitoring system you can use the tape returns to make a rough "field" mix during the session. This can usually be done with the B-Mix bus set for tape returns. This mix can be live recorded to a cassette tape or DAT deck as a reference to decide which takes should be mixed later and which are outtakes. Your final mix will occur in the recording studio and your field mix is used to make sure that all instruments are being recorded without distortion as it is easy to forget to assign an instrument to an individual track during this complex type of recording.

Ensuring a Good Live Recording

You cannot expect good results from your live recording if you do not preplan. Mistakes and problems that are quickly forgotten during the performance will be relived a thousand times during tape playback. It is important to remember the following things.

Pick Your Songs in Advance

Plan your set list so that you do not forget a song you really want for the recording. Do not change the list at the last minute.

Do the Simple Stuff First

Do not start a recorded set with your "symphonic musicale concert" that leaves the whole band drained and the singer hoarse. Start with the simple tunes and progress to the more complicated songs. Remember, the song sequence can be altered in postproduction.

Know the Words to the Songs

Practice until you know that no amount of nervousness will make you forget the words. The pressure of recording can be much worse than facing an audience.

Put Fresh Strings on Your Instruments, New Reeds in Your Wind Instruments, and New Heads on the Drums

If they sound dead in the room they will sound even deader on tape.

Check Your Tuning Before Each Song if Possible

You will hear (and cringe at) each note that is off. This is how most people qualitatively judge a recording. Tuning cannot be fixed in the mix.

Fix Your Instruments Before the Gig

Buzzy frets, bad intonation, creaks and rattles—all these and more will be picked up on the recording. Once they are in the mix there is no way to get them out.

Trim the Arrangements

Sure the audience really likes that 6-minute guitar solo in your showcase tune, but since the tape will not show your backflip right before the guitar bursts into flames, the recording will seem a little dragged out. Shorter is better for everything from a demo tape to a CD that will get airplay on the radio. For popular songs, distill the arrangements down to the best parts and hit your hooks up front. For traditional music, avoid long introductions and keep the pace lively. You need to impart energy to the performance audibly, since your fancy footwork will not be seen.

Listen to the Mix in a Different Location

If you are using one of your extra buses for recording do not use the same amount of reverb on both the main sound reinforcement and recording buses since you can tolerate more reverb in a live situation and the room's acoustics will mask any added effects. Listening to the playback in the cold, harsh reality of

your living room or car often shows a recording that has too much reverb, bass and vocals, all by-products of mixing for the live environment.

Practice with Headphones
Get a set of closed headphones. Low-impedance headphones (50 to 200 ohms) can be driven to louder levels than high-impedance headphones (250 to 1000 ohms), so unless you want to bring a separate amplifier just for headphone monitoring get the low-impedance ones.

Practice listening to some CDs of music that is similar to yours for a few weeks before your live recording sessions. Try to memorize what they sound like in your headphones. Music that is heard in headphones sounds totally different than when listening to it over speakers. You should learn what your favorite mixes sound like over headphones ahead of time. Listen to the type of music you will be recording, in advance of the recording session, through the headphones you will use. Your live-to-tape mix will never sound any better than it does on your headphones, so really think about your selection.

Custom in-ear monitors are a great way to mix live recordings. You can hear a very accurate version of what is going to tape because you do not have to contend with headphone leakage. This is especially important if the mixing location is less than quiet. With in-ear monitors you can get in excess of 26 dB of isolation from the sounds around you and this allows you to hear the mix as it really is. However, bass notes from the main speakers will still affect your body no matter how much isolation your headphones provide. They will tend to make you mix-in less bass than is desired on the tape. Although many acoustic acts will not present this problem since most of their instruments do not produce a lot of bass and their house mixes are lower volume than electric acts, large drums such as kicks and timpani will cause live-mixing problems.

Trial and error is the only way to learn how well a live performance will translate into a finished product. For an important recording, try to record the sound check and listen to it without the band playing. This will allow you to adjust instrument levels before the performance.

Do Not Play Too Loud
The louder the musicians play through their amplifiers on stage, the more difficult it will be to get a good recording. If the instruments are played softly the sound engineer can boost them in the main speakers and get a reasonable volume for the audience. However, the sound engineer can also turn the volume up in the house too loud and degrade the recording, since echo from the room will get back into the stage microphones.

There is a well-documented psychoacoustic effect, known as the Fletcher-Munson curve, which causes the spectral balance of low-volume sounds to appear to have less bass to the human ear. As the volume level is raised our ears perceive more bass in the mix even though the spectral balance is identical. The sound engineer can use this effect and boost the bass response of the main sound system when the stage volume continues to be soft. Sometimes just increasing the bass makes the sound seem fuller even though the average volume level of the mix is the same.

Another problem with playing loudly during recording is that it excites every resonance in the room. If this occurs the monitors have to be turned up to get above the stage sound level and all the signals start bleeding into the microphones, which makes separation between the instruments nonexistent. This cluttered sound will be recorded and cause a "veil" over your mix.

If you must play loudly, try to balance the levels of all the instruments. Recording an acoustic mandolin next to a screaming Stratocaster and Marshall stack is possible, but usually not worth the work involved. If you must record such a setup use physical barriers known as gobos. A gobo can be made simply by setting up your road case between instruments and draping it with furniture pads. Professional gobos are made with Sonex™ acoustic foam and lead-core plywood.

If you use stage amplifiers, set them so that everyone's sound is balanced on stage. Small studio amplifiers work great for this. Ten to 20 watts is sufficient for a guitar amplifier on a small stage.

Even when the acoustics of a location are optimal, the recording engineer must ensure that monitor levels do not affect the clarity of the overall recording. The idea is to get the widest signal-to-noise ratio (SNR) possible, which is achieved when the room is quiet and the musicians do not have their monitors at loud levels. When monitors are turned up the SNR shrinks and a muddy recording results. Sounds that leak into microphones from other instruments further complicate the situation, and any feedback from the main PA will ruin the take.

Cooperation between the sound reinforcement personnel, recording engineer, and the band is extremely important. Equipment is often shared, particularly when the signals from the microphones go first to a microphone splitter and then to the sound reinforcement and tape recording console. Care must be taken to avoid cluttering the stage with gear and cables.

The recording engineer should use the sound check to verify equipment setups and adjust recording levels. If the monitors are too loud the consequences should be explained to the band members to persuade them to perform at lower levels.

Tracking Sheets

It is important for the recording engineer to keep good notes for each song so you can easily find desired selections and sequence them. Most engineers use a "tracking sheet" for each song. (See sample tracking sheet on page 188.) It lists the instruments each track contains, equalization, effects, start and stop times, and time codes (if digital). If multiple performances are recorded, the tracking sheet will contain notes on good and bad takes, false starts, mistakes, lengthy improvisations, great solos, and so on. This saves postproduction time that would be used to look for the best takes of each song or to figure out which song needed to be faded out before a long improvisation.

Tracking sheets are also important in the studio when you overdub harmonies, add instrumentation or special effects, and mix.

The most important information is the position on the tape where each song starts and stops. Digital tape decks use an embedded time code that reads the same on every digital machine of the same format, regardless of manufacturer. When you know the locations of your songs (or locations of any problems during the take), you can punch in the numbers and arrive there in seconds.

Cassette and reel-to-reel analog recorders use tape counters. You fast forward or rewind to the desired number. Tape counters on machines from different manufacturers are not compatible.

Tape Care

Once the recording has been completed, label the tape and its box clearly. After every use, the tape should be allowed to wind to the end at playing speed (or at the tape recorder's "spooling" mode). Winding slowly provides constant, proper tension and ensures that the tape winds evenly on the reel without any edges sticking out. Tapes that are wound at

fast speeds usually result in a tape that is packed more loosely on the reel, with edges hanging out, resulting in physical damage. Having the tape tails out reduces print-through echo when rewinding for playback. Tapes should be boxed when not in use. Store them in a dry environment, between 65° and 75°F.

Keep tapes away from magnetic fields and airport x-ray machines. If you ship tapes, mark the boxes clearly with the message "Magnetic Tape: Keep Away from Electromagnetic Fields."

Make a backup copy of the final mix and put it in a safe place as insurance against loss or damage.

Some recording engineers like to get two pristine tapes of the final mix by setting up and recording on a second recorder simultaneously. If the mixing levels are set digitally, the recording engineer can make as many master mixes as desired.

Location Recording Services

Location recording services usually charge by the half-day or day. If the equipment and personnel have to travel out of town they usually charge for mileage. Get bids. You may be able to negotiate lower rates by booking consecutive days.

Remember, the most effective recordings are made when the recording company can split the microphone inputs and isolate its equipment. This is usually done with a transformer isolated microphone splitter. The signal from each microphone and direct box is sent down three separate snakes to the FOH console, the monitor console, and the recording console, which is usually located behind the stage or in a dressing room. This allows each engineer to work without interfering with the others. The recording engineer can get signals that are not affected by level and equalization changes made by the FOH or monitor engineers, and vice versa.

If you want direct to two-track recording, check out sound reinforcement companies, since the only extra piece of equipment they need to perform this is a good tape recorder. Sound reinforcement companies should also be contacted if you want a multitrack recording mixed live to two-track during the performance, since they are adept at live mixing.

If you need a remote unit with 16- to 32-track equipment, recording studios and companies that specialize in location recording are your best bet. You will have to book studio time for mixing, which can take many hours for a complex album. However, the total price of live recording may be less expensive than doing the entire recording in a studio.

Payment for studio and location recording is usually COD and advance deposits are required as protection against last minute cancellations.

SAMPLE TRACKING SHEET
(Use one sheet per song.)

Artist _____

Song Title _____

Date _____

Noise Reduction Used _____

Track Counter Start ☐

Track Counter Stop ☐

TRACK ASSIGNMENTS

	1	2	3	4	5	6	7	8
Instrument								
Vocal								
EQ								
Effects								
Other								

	9	10	11	12	13	14	15	16
Instrument								
Vocal								
EQ								
Effects								
Other								

Mastering and Manufacturing Cassettes and CDs

by Diane Sward Rapaport

Chapter 12

Preparing a tape for duplication is called mastering and the result is called the master. The process used to prepare music to meet manufacturing specifications for CDs is called premastering.

If you want to produce both CDs and tapes, each master must be specially formatted for its particular medium. Each has its own requirements for equalization, alignment tones, noise reduction and tables of contents. Some engineers prefer to provide different mixes for analog and digital products, to take advantage of the greater dynamic range available in the digital domain. (Information on producing, mastering and manufacturing vinyl records can be found in *How to Make and Sell Your Own Recording,* by Diane Sward Rapaport.)

Make sure that the entire length of your program can be accommodated in your chosen format.

Cassettes: The standard analog cassette is a C-45, which plays 22 1/2 minutes on each side; however, manufacturers will quote prices for cassettes of different lengths.

Compact discs: The 4 3/4-inch CD holds 74 minutes of music. The CD single plays 22 minutes.

Be aware that some manufacturers experience difficulty with playing times that approach the maximum limits. Check time tolerance limits before you begin mastering or premastering.

You will obtain the best results by mastering from your original finalized mixes, not from copies. Each time your music is transferred, information and quality may be lost. Fewer transfers mean fewer errors and better chances of accurately reproducing the quality of your final mixes.

Preediting

Preediting is the process of selecting which takes of songs you want, deciding final levels, determining compression and equalization needs and making sequencing decisions for the master.

Sales and promotional considerations should play a part in deciding the selection and sequencing of songs, as should tempos and thematic and musical continuity. DJs, club owners, concert promoters, record company producers, publishers, etc., may listen to only the first 30 seconds of the first and last songs on each side of your recording.

You can make an audition tape for booking agents, club owners and promoters that contains 30- to 60-second portions of your songs.

During preediting, you will decide whether to fade-in on some songs, or fade-out to avoid applause or too long an improvisation, and whether or not to add effects.

It is important that all the songs are at the same overall volume ("song to song balance"). Some songs may have been recorded at different sound levels than others, a problem that occurs when recording has occurred over several performances or when live performance tracks are included with studio takes. The instructions given to the engineer can be as specific as adding 3 dB at 100 Hz to song 4, take 2, or matching the sound levels of songs 5 and 6 to song 1, take 4. The level of the entire tape can be boosted for a "hotter" sound, but it should not have peaks above 0 VU dB, to ensure good digital reproduction.

Although you cannot change the relative levels of different instruments in a direct to 2-track recording, you can solve some frequency response problems without remixing. Reverb can be added and particular frequencies can be boosted or compressed. If you are going to reproduce analog cassettes from a digital tape master, use compression to reduce the master's dynamic range to meet the requirements of the tape.

Organize your editing decisions and write clear instructions. The process will go more efficiently and the instructions will serve as a checklist when you listen to the edited tape.

Sequencing and Editing

Edits can be made before or after the tape has been sequenced; and one or both processes can be done in the analog or digital domain, however, cassette recordings will need to be copied to an analog quarter-inch or half-inch open reel tape deck, since it is impossible to accurately splice cassette tape.

Sequencing the master tape in the analog domain involves manually cutting the tape into separate songs and determining by mood, feel, key changes, etc., how many seconds of silence you want between them. A white grease pencil is used to mark the splices and a razor blade is used to cut the tape at the desired angle on a special editing block. The recording is then put together with special splicing tape.

Some engineers prefer using blank tape for the seconds of silence, others use special leader tape of paper or plastic that does not carry sound.

Editing is tedious, and splicing and repasting must be precisely done. Good editors can often take out pops, clicks, flute breaths, and other extraneous sounds.

Several feet of blank leader tape ("padding") must be placed at the beginning and end of the tape to allow for threading a tape recorder properly.

Tape splices last about a decade; so be prepared to resplice any analog tape that is older.

With DAT, resequencing can be accomplished with a second DAT recorder and fresh tape. However, some DAT recorders have digital editors that enable you to assemble composite tracks for digital editing and resequence the tape without using a second recorder.

Copying songs to a computer program will also allow you to perform digital edits and sequencing. If the original recording is analog, an analog-to-digital conversion must be made first. Listen to the conversion to verify that it is accurate.

Depending on the complexity of its arrangement, a 3-minute song can require 30 megabytes or more of hard disk space. Most digital audio work stations (DAWS) have 4 to 8 gigabytes of hard disk storage and 48 megabytes of random access memory (RAM) to accommodate these large memory needs.

Generally, copying songs to a computer is done in real time, but advances in digital transfer technology have shortened this transfer time in some studios. When requesting quotes, ask about transfer time charges.

The advantage of working in the digital domain is that once a song has been loaded into the computer, sequencing, level changes, equalization, and level compression can all be done internally, and the various versions can be saved until you are satisfied with the result.

Cassette Masters

Master audio tape formats include 2-track half-inch analog at 15 or 30 inches-per-second (IPS) (less preferred are 2-track quarter-inch masters at any speed); and digital audiotape (DAT) at 44.1 or 48 kHz. Other formats are recordable CD, computer disks, SONY 1610 and 1630 video tape, VHS video tape, Beta video tape, and CD-ROM.

How do you know what type of master to provide? Ask the manufacturer. Use their experience to find out what is required and what is best for your music. Since there are digital tape machines available in virtually every cassette and open reel format, make sure the manufacturing facility can accommodate them and that they are properly prepared.

Cassette manufacturers usually accept analog cassette masters and digital cassette masters recorded at either the 44.1 or 48 kHz sampling rates. Digital tapeless bin manufacturing requires a digital master.

Master Tape Preparation: Analog

The proper preparation of the master tape and accompanying documentation is essential to the manufacturing process. During preparation of the master, the engineer will precisely time each song

Digital Bin Masters

Some manufacturers offer digital bin masters as an alternative to the half-inch running master. The signal is stored in a computer's RAM and the duplicator's slave cassette decks record copies directly from the digital bin master. Various trade names for this method include DIGalog™, DHS™, and DAAD™. The tape used for the end product is chrome or ferric cobalt.

Manufacturers offering this type of duplication say that the end result is of higher sound quality than real-time cassette duplication. Producing analog tapes with this method avoids the progressive deterioration that occurs when a half-inch analog running master passes through the bin loop's heads. After 5000 to 7000 reproductions, there is a noticeable deterioration in audio quality.

and place it into the desired sequence, leaving 3 to 6 seconds of plastic leader or blank tape between songs on tape masters and the required seconds of silence on digital masters.

The engineer will provide appropriate alignment tones (calibration tones) at the start of each master so that the manufacturer's machines can be aligned identically with the machine on which the master was produced. These tones permit adjustment of playback level and equalization. If noise reduction is used, special tones that are keyed to the particular type of reduction (Dolby A, Dolby SR, dbx, etc.) must be added for proper decoding. Check with your manufacturer before you begin preparing your master to determine their requirements.

A matrix number used for identification throughout the manufacturing process, is assigned to the master tape for each side of the cassette. This number should end with either "-1" or "-A" for the first side of the cassette and"-2" or "-B" for the second.

Your documentation must include everything that is on the master—sequence, start and stop times, information about EQ, alignment tones, noise reduction, and any special requirements the engineer requests from the manufacturer, such as additional sound enhancement.

CD Premastering

The conversion of your master tape to industry standards and an accurately filled out SMPTE log will be done best by a facility that specializes in CD premastering.

CD mastering is begun by converting your master to the universal standard used by CD manufacturers: a three-quarter-inch U-matic video tape, prepared in Sony PCM 1610 or 1630 format with a sampling frequency of 44.1 kHz. The sampling rate means that a sample of the analog signal is taken 44,100 times per second.

Some manufacturers will accept tapes prepared on other formats such as JVC half-inch VHS videotape or JVC three-quarter-inch U-matic video tape with a sampling frequency of 44.1 kHz. They will, however, convert the data to Sony PCM 1610 or 1630 by making a tape transfer or using a format converter that changes the data directly.

Masters that have a sampling rate different from 44.1 kHz will be converted to the universal standard. This is best accomplished with a format converter. Using a digital-to-analog and analog-to-digital converter is less preferable because there may be signal degradation. Converting the music back to an analog master before making another conversion to video tape should be avoided entirely because signal degradation will be considerable. The most common errors in masters received by manufacturers are—the sequence indicated on written documentation does not correspond with the sequence on the master; the times indicated on the written documentation do not correspond with the times on the master; DAT masters are supplied with songs at either incorrect sampling frequencies or with mixed sampling frequencies; pops, clicks and dropouts; insufficient documentation; and inaccurate cue sheets.

CD Master Preparation

For CD manufacturing, the engineer will provide a SMPTE log. The log indicates precisely the beginning and end of all information (tones, blank space and songs). It starts at the beginning of the program tape and must be continuous to the end of the program.

The engineer will indicate whether a high frequency boost or emphasis was used in recording any track by writing "on" or "off" for each track of music, will indicate whether any fades were used, and note exact locations of any disturbing effects and noises.

An accurately filled out tape log is extremely important because a manufacturer uses it to insert the P&Q subcode on the compact disc. This subcode conveys information to your compact disc player about the total number of selections on the disc, start and stop times of tracks, and other information. If the log is inaccurate, compact disc players may not properly reproduce the music on your disc.

Before sending the tape for manufacturing, you and the engineer should listen to it very carefully. Unless there are instructions about changing equalization or sequence, the manufacturer should duplicate what you send. If there are errors on your master, without any indications that they should be corrected, there will be errors on your product. Your engineer should also make sure that the tracks and track times noted on the tape are consistent with what is noted in the log.

Safety Masters

Once a satisfactory master tape has been completed, you should make a safety copy for insurance against loss, and store it someplace away from your office or studio.

Many studios prefer digital storage as protection against loss of audio information. But some engineers believe that analog tape loses what it is going to lose in the first day or two, and after that the loss of audio information is very slow. Digital formats lose information in the analog-to-digital conversion and remain stable afterwards.

Editing DATs for Mastering

Musicians that have recorded on DAT and want to equalize or resequence the music have three options.
1) Transfer the music to analog tape, which can be edited manually.
2) Use editing software.
3) Make a DAT-to-DAT copy.

The problem with the first option is that there will be some musical information lost because of inherent drawbacks in conversion technology.

The second option is expensive: studios charge for the real-time downloading of information and its manipulation.

The third option is tricky. The engineer must learn the record engage interval of the DAT machine and time the playback so that the record engage click occurs on the down beat of the next song.

Sometimes an analog-to-digital conversion can result in dropouts, pops and clicks. Listen to your DAT master before sending it to the manufacturer.

Choosing a Manufacturer

The major control you have over the manufacturing of your recording is in the selection of the manufacturer. It is extremely important to take the time to contact manufacturing plants for information; become comfortable with the language used; get to know the people involved; discover what is and is not negotiable; and budget appropriately.

You should begin your research long before you start recording. Ask for price lists, samples of work, and the names of labels using their services. You should make it clear that once you receive information and standard prices, you will be soliciting firm price quotations. This lets them know that they will be competing with other manufacturers. Refrain from making a definite commitment to any firm until all your questions are answered and you have agreed on details and prices.

Often, the brochures you receive from manufacturing firms are written in language that assumes you are familiar with all the processes and variables. If you are not, ask questions. Some firms have toll-free phone numbers, web sites and e-mail addresses. Keep copies of all your correspondence and make notes of phone conversations.

Check the reputations of the firms you consider by asking artists, producers and engineers that have used their services. At the very least, they can give you some idea of the problems that might arise.

Time and Money

Once you have delivered the master (and packaging materials), the average delivery date for product is three to six weeks. It is important to contract for a firm delivery date in your manufacturing contract before you make a down payment.

The best way to estimate manufacturing costs is to list the services for each format you require and request that each item be quoted separately. That way you can make fair comparisons. Costs will drop significantly with increased quantities.

Be sure to have all agreements in writing, including final price quotes and delivery times. Try to make specific agreements about what errors the manufacturer will be responsible for, and under what circumstances.

You will be asked for an advance deposit and must make payment in full before your order is shipped. Once you have used a firm several times, you may be able to establish an account, and sometimes receive a reduction in prices.

Most manufacturers offer packages that combine CDs and cassettes. Some offer extra services, such as putting selections of your work on sample CDs that are mailed to retailers and radio stations. To evaluate the value of the packaged price, have the costs of each item quoted separately.

Resources and Selected Bibliography

Consumer and Trade Publications

Acoustic Musician
P.O. Box 1349
New Market, VA 22844
(540) 740-4005

Bass Player
411 Borel Avenue
Suite 100
San Mateo, CA 94402
(415) 358-9500

Electronic Musician
6400 Hollis Street
Suite 12
Emeryville, CA 94608
(510) 653-3307

EQ
460 Park Avenue South
9th Floor
New York, NY 10016
(212) 378-0400

GIG
460 Park Avenue South
9th Floor
New York, NY 10016
(212) 378-0400

Guitar Player
411 Borel Avenue
Suite 100
San Mateo, CA 94402
(415) 358-9500

Keyboard
411 Borel Avenue
Suite 100
San Mateo, CA 94402
(415) 358-9500

Mix
6400 Hollis Street
Suite 12
Emeryville, CA 94608
(510) 653-3307

Pro Audio Review
5827 Columbia Pike
Suite 310
Falls Church, VA 22041
(703) 998-7600

Pro Sound News
460 Park Avenue South
9th Floor
New York, NY 10016
(212) 378-0400

Sound & Communications
25 Willowdale Avenue
Port Washington, NY 11050
(516) 767-2500

Sound & Video Contractor
Intertec Publishing
9800 Metcalf
P.O. Box 12901
Overland Park, KS 66212
(913) 341-1300

Systems Contractor News
460 Park Avenue South
9th Floor
New York, NY 10016
(212) 378-0400

Trade Organizations

Audio Engineering Society (AES)
60 East 42nd Street Room 2520
New York, NY 10017
(212) 661-8528

National Academy of Recording
Arts and Sciences (NARAS)
3402 Pico Boulevard
Santa Monica, CA 90405
(310) 392-3777
(Other chapters are located across
the United States.)

National Association of Music
Merchants (NAMM)
5140 Avenida Encinas
Carlsbad, CA 92008
(619) 438-8001

Society of Professional Audio
Recording Services (SPARS)
4300 10th Avenue North
Lake Worth, FL 33461
(407) 641-6648

Selected Bibliography

The following books are the author's personal recommendations and are not intended to be a complete listing of audio and music business books.

Anderton, Craig. *MIDI for Musicians.* New York: Music Sales Corp., 1986.

Davis, Don and Davis, Carolyn. *Sound System Engineering,* (2nd Ed.). Indianapolis, Indiana: Howard W. Sams & Co., 1987.

Davis, Gary and Jones, Ralph. *The Sound Reinforcement Handbook,* (2nd Ed.). Milwaukee, Wisconsin: Hal Leonard Publishing Corporation, 1989.

Eargle, John. *The Microphone Handbook.* Commack, New York: Elar Publishing, Inc., 1982.

Halloran, Mark, Ed. *The Musician's Business and Legal Guide,* (Revised 2nd Ed.). Upper Saddle River, New Jersey: Prentice-Hall, Inc., 1996.

Pohlmann, Ken. *Principles of Digital Audio,* (3rd Ed.). New York: McGraw-Hill, 1995.

Rapaport, Diane Sward. *How to Make and Sell Your Own Recording: A Guide for the Nineties,* (Revised 4th Ed.). Upper Saddle River, New Jersey: Prentice-Hall, Inc., 1992.

Woram, John M. and Kefauver, Alan P. *The New Recording Studio Handbook,* (Rev. Ed.). Commack, New York: Elar Publishing Company, Inc., 1989.

Index

A

accordions
 microphone selection, 131
 miking techniques, 146–47
acoustical cancellation, 22
acoustic foam, 186
acoustic instruments
 frequency ranges, 5
 microphone selection chart, 130–31
 miking techniques, 134–50
 accordions, 146–47
 bagpipes and Uilleann pipes, 147
 banjos, 140–41
 hammer dulcimers, 149
 harmonicas, 147–48
 percussion instruments, 144–46
 pianos, 149–50
 reeds, brass, and woodwind instruments, 141–44
 resonator guitars, 140
 stringed instruments, 134–39
 string harps, 148–49
 vibraphones and xylophones, 149
 mixing with electric instruments, 67
 monitoring systems, 65
 recording methods, 179–84
 sound reproduction systems and, 1–2
 sound wave patterns, 128
 speaker systems, 75–76, 88
 See also electric instruments
acoustic stereo microphone to 2-track recording method, 181–82
active crossovers, 85–86, 99
active direct boxes, 37–39, 122
active pickups, 34
active splitters, 13
Alesis Digital Audio Tape (ADAT) format, 178
alternating current (AC), 7, 113, 160
ambient noise levels, 152
amperage, 7
amperes, 7
amplifiers
 biamping with, 86
 choosing, 107–8
 controls, 103–4
 electric shocks from, 169–70
 fans, 104–5
 headphone, 124
 mixing board, 111
 mono vs. stereo, 99
 setting up, 165–66
 shipping, 108
 speaker hookups, 87, 99, 100–103
 technical characteristics, 105–7
 transistor vs. tube, 100–101
 See also instrument amplifiers; power amplifiers
analog cassette tape recorders, 175–77
analog limiters, 177
analog reel-to-reel tape recorders, 174–75
analog signal processors, 51
analog-to-digital conversions, 177

Andean flutes, 143
antenna systems, 20–21
artistic validity, 2
attack time, 53–54
attenuation, 10
attenuator controls, 10
 on direct boxes, 38, 39
 on power amplifiers, 104, 166
audience response microphones, 183
audio chain, 13–14
Audio Engineering Society (AES), 11
audio snake, 13
aural exciters, 56
auxiliary inputs, 120–21
auxiliary returns, 124
auxiliary send masters, 124
auxiliary sends, 117–18
average power, 76, 86

B

baby grand pianos. *See* pianos
backdrop music, 65
back plate, 17
bagpipes, 147
balanced signals, 9
 mixing boards and, 112
 signal matching with, 35
banana plugs, 103
band setup, 159–61
bandwidth, 116
banjos
 microphone selection, 131
 miking techniques, 140–41
bar graph displays, 119
bass, stand-up. *See* stand-up bass
bass drivers, 77–78
bass sounds
 dispersion pattern, 82
 frequency range of, 5
 power requirements and, 95, 97–98
 proximity effect and, 23
 sound wave patterns, 128
 speaker overexcursion and, 79–80, 86
 spot monitors and, 73
 stage mixing and, 67, 70
bass speakers
 described, 77–78
 placement of, 89, 90
biamped system, 86, 166
bias levels, 174, 176
bidirectional microphones, 24, 149, 182
binaural microphones, 182
binaural stereo recognition, 16
bipolar transistors, 38
B-Mix bus, 179, 182, 184
B-Mix inputs, 120–21
B-Mix switch, 124
board effects, 52
boom stands, 32
bowed instruments, 138
brass instruments, 141–44
breath/pop filter, 134

bridge mode, 28, 102
bridge transducers. *See* internal pickups
buffer, 9
bus assign switches, 124
buses, 117, 124, 179
buzzes, troubleshooting, 170–71
bypass switch, 59

C

cabinets, speaker, 80–84
 dispersion patterns, 81–83
 heat buildup in, 83–84
 satellite speaker systems, 92
cables
 bad, 171
 overview, 10–13
 testing, 160
capacitance, 8
capacitors, 105–6
cardioid microphones, 22–23, 129
 for accordions, 147
 for acoustic harmonicas, 147–48
 for acoustic stringed instruments, 135, 138, 140
 for bagpipes and Uilleann pipes, 147
 for hammer dulcimers, 149
 for percussion instruments, 144, 145, 146
 for performance vocals, 133–34
 for pianos, 149
 for recording performances, 178, 181, 182
 for reed, brass, and woodwind instruments, 142
 for string harps, 149
 for vibraphones and xylophones, 149
cassette tape recorders, 175–77, 186
cassette tapes
 manufacturing, 193–94
 mastering, 189–92
 standard playing time for, 189
CDs. *See* compact discs
cello
 microphone selection, 131
 miking techniques, 138
channel equalization, 116
channel inserts, 123
channels, input, 114
"chasing equalization," 23, 133
chrome recording tape, 176
clarinets
 microphone selection, 131
 miking techniques, 142–43
Clear-Com systems, 180
clip-on microphones, 142
clipping
 transistor amplifiers, 44
 tube amplifiers, 45
closed headphones, 125
close miking, 129
common mode rejection (CMR) circuits, 112
compact discs (CDs)
 manufacturing, 193–94
 premastering, 189, 192–93
 standard playing time for, 189
component speaker systems, 88–90
 bass speaker placement, 89
 midrange and tweeter speaker placement, 89–90
compression drivers
 described, 78–79
 dispersion patterns, 82–83
compression ratio, 54
compressors. *See* limiters and compressors
computer editing, 177, 191
condenser microphones, 17
 for acoustic stringed instruments, 136, 138, 139
 electret, 18–19
 for hammer dulcimers, 149
 for percussion instruments, 146
 for performance vocals, 130, 133
 for pianos, 149, 150
 pressure zone, 19
 for string harps, 148–49
conductors (electrical), 7
cone drivers, 76–77
congas
 microphone selection, 130
 miking techniques, 146
conical throat patterns, 82
connectors
 amplifier speaker, 103
 overview, 10–13
continuous power rating, 41, 86
contracts, sound reinforcement, 155–59
crossover notch distortion, 107
crossovers, speaker, 84–86
 active, 85–86
 passive, 84–85
cue switch, 124
current, 7
custom spot monitor system, 73
cycles-per-second (CPS), 3
cymbals, 130

D

damping factor, 106
DAT. *See* digital audio technology
DAW (digital audio workstation), 177, 191
dBm, 6
dBu, 6
dBv, 6, 25
dBV, 6
dB VU, 6
dbx noise reduction, 175, 176
decibels (dB), 6, 70
decibel sound pressure level (dB SPL), 6
 microphones and, 26–27
delays
 digital, 81
 speaker system, 81, 91
delay stacks, 91
design parameters, 2
digital audio technology (DAT)
 as master tape format, 191
 as recording medium, 128, 132, 174, 177–78, 183
 tape editing, 177, 193
digital audio workstation (DAW), 177, 191
digital bin masters, 191

digital delays, 81
digital signal processors, 51
digital stage box, 13
digital-to-analog conversions, 177
direct boxes, 37–40
 active, 37–39, 122
 explained, 37
 hookup diagrams, 38, 40, 43
 mixing boards and, 114
 passive, 39–40, 114
 phantom power and, 122
 setting up, 160
 speaker simulator, 40, 43
 specifying in contracts, 158
direct current (DC), 7
direct current sensors, 104
directional response patterns, 21–25
 bidirectional microphones, 24
 cardioid microphones, 22–23
 hypercardioid microphones, 24
 lavaliere microphones, 24
 omnidirectional microphones, 22
 polar response patterns, 21–22
 shotgun microphones, 24–25
 supercardioid microphones, 23–24
Direct Out jack, 123, 183
disc jockeys, 113
discriminator circuit, 20
dispersion patterns, 81–83
distances, power requirements, 96
distortion
 amplifier, 42–43, 44, 45
 cassette tape, 175–76
 creating as special effect, 56
 DAT tape, 177
 microphone, 26
 mixing board, 110
diversity systems, 20–21
Djambos, 145–46
Dolby noise reduction, 175, 176
drivers, speaker, 76–80
 bass, 77–78
 compression, 78–79
 cone, 76–77
 failures of, 79–80
drums
 microphone selection, 130
 miking techniques, 144–46
 sound checks for, 161
dry sounds, 165
dulcimers
 microphone selection, 131
 miking techniques, 149
dynamic microphones, 16–17
 for accordions, 147
 for acoustic harmonicas, 148
 for acoustic stringed instruments, 136
 for hammer dulcimers, 149
 for percussion instruments, 144, 146
 for performance vocals, 130, 133
 for string harps, 148–49
dynamic range, 3, 26

dynamics, 3
 engineered, 66
 group-controlled, 65–66

E

ears
 damage to, 70
 in-ear monitors and, 67–69
 structure and function of, 15–16
echo, 55, 165
editing
 computer, 177, 191
 DAT tapes, 177, 193
 master tapes, 190–91
effects devices
 aural exciters, 56
 board, 52
 enhancers, 56–57
 flangers, 55–56
 instrument, 51–52
 MIDI controllers and, 52, 57
 phase shifters, 56
 serial routing and, 59–60
 setting up, 165
electret condenser microphone, 18–19, 139, 142, 147
electrical interference, 8, 29
electrical shocks, 169–70
electric instruments, 2
 instrument amplifiers for, 42
 mixing with acoustic instruments, 67
 See also acoustic instruments
electricity, 7
 grounding procedures, 47–48
electronic signal processing, 51
elliptical throat patterns, 82
embedded time code, 186
emergencies
 electric shocks, 169–70
 fires, 169, 170
emulator boxes, 40
engineers. *See* sound engineers
enhancers, 56–57
ensemble vocals, 130
EQ defeat switch, 117
equalization
 amplifier controls, 46
 chasing, 23, 133
 mixing board controls, 110, 116–17
 setup basics, 164
 sound checks for, 162–63
 stage monitors, 168–69
equalizers
 mixing board, 116–17
 outboard, 58–59
Eustachian tube, 15
even-order harmonics, 4
expanders, 55
external bus mixers, 110

F

faders, 10, 114–15, 124
fans, amplifier, 104–5

feedback
 from microphones, 132–33
 monitoring systems and, 63, 68, 73, 168–69
 troubleshooting, 171
ferric recording tape, 176
field-effect transistor amplifier, 45
field effect transistors (FETs), 38
field mix, 184
figure-eight microphones, 24, 182
filters
 pop, 29–30
 rumble, 30
fire emergencies, 169, 170
five-way binding posts, 103
flangers, 55–66
flat response, 26
Fletcher-Munson curve, 185
floor wedge monitors, 71–72
flutes
 microphone selection, 131
 miking techniques, 143–44
folding microphone stands, 32
folk harps, 149
four-channel equalizers, 116
frequencies, 3
 dispersion patterns, 82
 nominal range, 3–4
 speaker failure and, 79–80
 subsonic, 4
 ultrasonic, 4
 wireless microphone, 20
frequency distortion, 175–76
frequency range, 3, 5
frequency response, 25–26
fundamental frequency, 4

G

Gaelic drums, 146
gain, 7, 164
gated reverb, 55
gobos, 186
grand pianos. *See* pianos
graphic equalizers, 58, 116
grounding
 electric shock and, 169–70
 instrument amplifiers, 47–48
ground loops, 8
 hum reduction and, 113–14, 170–71
guitars
 acoustic
 microphone selection, 131
 miking techniques, 134–39
 nylon-stringed, 138
 sound wave patterns, 128
 electric, 42
 resonator, 140
 sound checks for, 161
 See also acoustic instruments; electric instruments

H

hammer dulcimers
 microphone selection, 131
 miking techniques, 149
hardwired in-ear monitors, 69
hard "Y" cables, 13
harmonicas
 microphone selection, 131
 miking techniques, 147–48
harmonic overtones, 4
harps (string), 148–49
head module, 13
headphones
 live recording mixes and, 185
 mixing board, 124–25
headroom, 86, 110
 balancing, 165
 instrument amplifier, 41
 mixing board, 110
 power amplifier, 41, 95–96
 recording tape, 174–75, 176
 speaker system, 76, 84
hearing
 damage to, 70
 ear anatomy and, 15–16
 in-ear monitors and, 67–69
 performer vs. listener, 127–28
heat
 amplifier fans and, 104–5
 speaker failure and, 79, 83–84
Hertz (Hz), 3
Hertz, Heinrich, 3
high-band VHF, 20
high-frequency horn drivers, 79
high-frequency overload, 175–76
high-hat, 130
high sounds, 6
hookups
 direct boxes, 38, 40, 43
 satellite speaker systems, 92
horn drivers
 described, 78–79
 dispersion patterns, 82–83
house engineer, 152
house mix, 66, 67, 166
How to Make and Sell Your Own Recording, 189
humbucking coils, 29
hums, troubleshooting, 170–71
hybrid tube/transistor amplifiers, 45–46
hypercardioid microphones, 24, 143

I

impedance, 8
 headphone, 185
 microphone, 28, 128–29
 source, 8–9, 28
 speaker, 87, 99
 power loading and, 100–101
 reactive load and, 105–6
impedance matching, 9, 28
inches-per-second (IPS), 174, 191
inductance, 8

inductive coupling, 8, 29
inductors, 105–6
in-ear monitors, 67–69, 125, 180, 185
infrasonic frequencies, 4
in-line microphone transformer, 10
in-line pads, 10, 119
inner ear, 15–16
input channels, 114
input controls
 amplifier, 103
 mixing board, 114
input impedance, 28
input transducers, 13, 15
insert cables, 12
instrument amplifiers, 40–48
 choosing, 48
 explained, 40–41
 field-effect transistor, 45
 grounding, 47–48
 hybrid tube/transistor, 45–46
 monitoring systems and, 67, 69–70
 power output from, 41
 setting up, 160
 signal routing for, 46–47
 speakers for, 41–43
 tone controls, 46
 total harmonic distortion and, 46
 transistor, 43–44
 tube, 44–45
 volume wars and, 48–49
 See also power amplifiers
instrument effects, 51–52
instrument stands, 160
insulators, 7
interference
 electrical, 8
 multipath, 20–21
 radio frequency, 8, 9
intermodulation distortion (IMD), 107
internal pickups, 33–37
 choosing, 37
 explained, 33–34
 magnetic, 35–36, 136–37
 microphone/pickup combinations, 137, 141
 passive vs. active, 34–35
 piezoelectric bridge transducers, 36–37, 140
 problems with, 135
 signal matching with, 35
IPS (inches-per-second), 174, 191

K
kick drum
 microphone selection, 130
 miking techniques, 145

L
labels, 163–64
lap dulcimer, 131
lavaliere microphones, 24
leader tape, 190
LED lights, 118–19, 162
level creep, 164

LF cut-off, 30
LFO (low-frequency oscillator), 55–56
LF shelf, 30
limiters and compressors, 52–54
 attack time, 53–54
 compression ratio, 54
 explained, 52–53
 power amplifiers and, 97
 release time, 54
 setup basics, 165
 threshold, 54
line-in connectors, 112, 123
Line In jack, 123
listening fatigue, 63, 81
load-in time, 155
location recording services, 187
long-throw speakers, 82
loudness, 6
 decibel examples, 70
 limiters and compressors and, 52–53
 recording performances and, 185–86
low-band VHF, 20
low-cut filter, 30, 120, 164
low-frequency oscillator (LFO), 55–56
L-pad, 85

M
magnetic flux, 76
magnetic pickups, 35–36, 136–37, 141
main mix fader, 124
maintenance
 microphone, 150
 mixing board, 111
mandolin, 131
manufacturing cassettes and CDs, 193–94
marimba, 130
mastering process, 189–93
 analog tape preparation, 191–92
 audio tape formats, 191
 CD master preparation, 192–93
 DAT editing and, 193
 digital bin masters, 191
 preediting, 190
 safety masters, 193
 sequencing and editing, 190–91
master level fader, 124
matching
 impedance, 9, 28
 signal levels, 9, 35
matrix number, 192
metal alloy recording tape, 176
Mic In jack, 123
microphone capsules, 20
microphone/line switch, 119
microphones, 15–32, 127–50
 buying, 30–31
 directional response patterns, 21–25
 bidirectional microphones, 24
 cardioid microphones, 22–23
 hypercardioid microphones, 24
 lavaliere microphones, 24
 omnidirectional microphones, 22

polar response patterns, 21–22
shotgun microphones, 24–25
supercardioid microphones, 23–24
electrical interferences, 29
features, 29–30
humbucking coils, 29
pop filters, 29–30
shock mounts, 30
feedback, 132–33
maintenance, 150
mixing board inputs, 123
positioning, 132, 179, 181
for recording performances, 178–79, 181–82
room dynamics and, 129
rule of thirds, 179
selecting, 128–29
vocal/instrumental equipment chart, 130–31
specifying in contracts, 158
stage monitors and, 168–69
stands for, 32
technical characteristics, 25–29
distortion, 26
dynamic range, 26
frequency response, 25–26
noise floor, 27
output/input impedance, 28
phantom power, 28–29, 121–22
proximity effect, 27
self-noise, 27
sensitivity, 25
slew rate, 26
sound pressure levels, 26–27
transients, 26
types of, 15–21
condenser, 17
dynamic, 16–17
electret condenser, 18–19
pressure zone, 19
ribbon, 19–20
wireless, 20–21
See also miking techniques
microphone splitters, 13
MIDI connector, 11–12
MIDI controllers
B-Mix inputs and, 121
effects devices and, 52, 57
instrument amplifiers and, 46
midrange sounds, 5–6
midrange speakers
described, 78
placement of, 89–90
midside stereo technique, 182
miking techniques
accordions, 146–47
acoustic stringed instruments, 134–39
bagpipes and Uilleann pipes, 147
banjos, 140–41
feedback and, 132–33
hammer dulcimers, 149
harmonicas, 147–48
magnetic pickups, 136–37, 141
microphone/pickup combinations, 137

microphone positioning, 132
midside stereo, 182
percussion instruments, 144–46
pianos, 149–50
reeds, brass, and woodwind instruments, 141–44
resonator guitars, 140
string harps, 148–49
vibraphones and xylophones, 149
vocalists, 133–34
voice training with, 132
See also microphones
mixing boards, 109–25
amplified, 111
audio chain and, 13
features and controls, 114–24
headphones, 124–25
maintenance, 111
monitoring systems, 66–67, 69, 124–25
multiple, 110
normalizing, 163
overview, 109–10
performance effects, 169
preamplifiers, 111
recording methods and, 179–84
remote, 167–68, 180
setting up, 165–66
signal conversion, 112–13
signal routing, 59–61, 111
sound quality, 110, 162
specifying in contracts, 158
stage mixing and, 67, 167
transformers, 113–14
monitoring systems, 63–74
choosing, 74
duplicating house mix on, 66, 67, 166
engineered dynamics and, 66
group-controlled dynamics and, 65–66
hearing impairment and, 70
in-ear, 67–69, 125
mixing board, 66–67, 69, 124–25
multitrack, 183–84
overview, 63–64
performers' need for, 64
separate monitor mixes and, 66–67
setting up, 166–67
specifying in contracts, 158–59
stage speakers
dispersion patterns, 82
floor wedges, 71–72
instrument amplifiers and, 67, 69–70
microphones and, 168–69
side-fills, 70–71
spot monitors, 72–73, 74
volume wars and, 64–65, 167
monitor level control, 124
monitor mix, 166–67
mono amplifiers, 99
mono circuits, 11
mono mixing, 169
monster cables, 106
MPX filter, 176
multipath interference, 20–21

multiple microphone/direct to 2-track recording method, 182
multitrack monitoring method, 183–84
multitrack recording method, 182–83
musical instrument digital interface controllers. *See* MIDI controllers
music power, 76
mute switches, 119–20

N

near-field speakers, 124, 125, 180
noise floor
 balancing, 165
 microphone, 27
noise gates, 54–55
noise reduction, 175, 176, 192
nylon-stringed guitars, 138

O

odd-order harmonics, 4
off-axis coloration, 23
ohms, 7
omnidirectional microphones, 22
 for acoustic stringed instruments, 129, 136, 138–39
 for bagpipes and Uilleann pipes, 147
 for percussion instruments, 145, 146
 for performance vocals, 134
 for pianos, 150
 for recording performances, 178–79
 for reeds, brass, and woodwind instruments, 143
one-stack speaker systems, 90
open-air headphones, 125
outboard equalizers, 58–59
outboard preamplifiers, 57–58, 111
outdoor concerts
 microphones and, 129
 speaker failure and, 79, 84
out-of-polarity wiring, 79–80
output impedance, 8–9, 28
output noise, 27
output transducers, 14
overexcursion of speakers, 79–80
overheating of speakers, 79
overload level (OL), 118

P

PA amplifiers. *See* power amplifiers
padding, 190
pads, 10
pad switches, 119
pan pots, 118
parallel routing
 processing devices, 61, 117–18
 speakers, 101–2
parametric equalizer, 58–59, 116, 117, 136
passive crossovers, 84–85, 99
passive direct boxes, 39–40, 114
passive pickups, 34
peak hold feature, 119
peaking equalization, 116
peak power, 76, 86
percussion instruments
 microphone selection, 130
 miking techniques, 144–46
 recording, 183
 sound checks for, 161
performances
 preparing for, 151–71
 recording, 173–88
 special problems during, 169–71
PFL switch, 124
phantom power, 18
 microphones and, 28–29
 mixing boards and, 121–22, 160
 turning off, 163
phase cancellation, 146
phase distortion, 80–81
phase shifters, 56
pianos
 microphone selection, 131
 miking techniques, 149–50
pickups. *See* internal pickups
piezo drivers, 79, 83
piezoelectric bridge transducers, 36–37, 140
pink noise, 165
polarity reversal switch, 120
polar response patterns, 21–22
 for bidirectional microphones, 24
 for cardioid microphones, 22
 for hypercardioid microphones, 24
 for omnidirectional microphones, 22
 See also directional response patterns
pop filters, 29–30, 134, 143
portastudio, 132
positioning microphones, 132, 179, 181
post-EQ monitor send, 167
postfader sends, 66, 117
potentiometers, 114–15
pots, 10
power amplifiers, 95–108
 audio chain and, 14
 choosing, 107–8
 compressor and limiter use, 97, 104
 controls, 103–4
 fans, 104–5
 mono vs. stereo, 99
 overview, 95–97
 power rating, 41
 power requirements chart, 96
 setting up, 165–66
 shipping, 100
 size and number requirements, 98–99
 soft clipping circuits, 104
 speaker hookups, 99, 100–103
 bridge mode, 102
 connectors, 103
 power loading, 100–101
 routing, 101–3
 spectral balance, 97–98
 technical characteristics, 105–7
 transistor vs. tube, 100–101
 See also instrument amplifiers
power loading, 100–101
power outlet requirements, 159
power output, 41

power ratings
 amplifiers, 105
 speakers, 86
power requirements
 bass sounds and, 95, 97–98
 sound reinforcement amplifiers, 95–97
 volume level and distance chart, 96
power soaks, 43, 160
preamplifiers
 mixing board, 111
 outboard, 57–58, 111
 with pickups, 34–35
preediting process, 190
pre-EQ monitor send, 167
prefader sends, 117
premastering process, 189
 CD master preparation, 192–93
 formats for, 192
preparing for performances, 151–71
 band setup, 159–61
 house sound systems, 152
 mixing, 169
 room dynamics, 152
 sound checks, 161–63
 sound engineer setup basics, 163–69
 sound reinforcement contracts, 155–59
 sound system setup, 159
 stage plot, 154
 touring with your own sound system, 151–52
 troubleshooting special problems, 169–71
pressure zone microphones (PZMs), 19, 136, 138, 144, 149
problem solving. See troubleshooting
processed speaker systems, 88
processing devices
 in audio chain, 13
 parallel routing for, 61
 serial routing for, 60, 61
producing cassettes and CDs, 189–94
 editing DATs for mastering, 193
 manufacturing process for, 193–94
 master tape formats, 191
 preediting process, 190
 premastering formats, 192
 preparing analog masters, 191–92
 preparing CD masters, 192–93
 safety masters and, 193
 sequencing and editing process, 190–91
 time and money required for, 194
proximity effect, 23, 27, 129, 137, 178
public address (PA) amplifiers. See power amplifiers
punching the signal, 110
PZMs. See pressure zone microphones

Q

"Q" control, 136
quarter-inch phone plugs
 amplifier speaker connector, 103
 instrument amplifiers, 43
 internal pickups, 35
 mixing boards, 112–13
quasi-parametric equalization, 117
quick sound checks, 163

R

radio frequencies (RF)
 interference from, 8, 9, 29
 for wireless microphones, 20
radio frequency interference (RFI), 8, 9, 29
random access memory (RAM), 191
rattles, troubleshooting, 171
RCA plugs, 11
reactive load, 105–6
real-time analyzer (RTA), 164
recorders, 143
recording performances, 173–88
 choosing the venue for, 173–74
 headphones and, 185
 location recording services for, 187
 loudness and, 185–86
 microphones for, 178–79
 quality assurance tips, 184–87
 recording methods, 179–84
 acoustic stereo microphones to 2-track, 181–82
 multiple microphones/direct to 2-track, 182
 multitrack monitoring, 183–84
 multitrack recording, 182–83
 remote mixing boards, 180
 separate mixing board bus, 179
 studio mixing and, 183
 tape care and, 186–87
 tape recorders for, 174–78
 analog cassette, 175–77
 analog reel-to-reel, 174–75
 analog-to-digital conversions and, 177
 digital audio technology, 177–78
 tracking sheets for, 186, 188
 uses for live recordings, 173
recording tape characteristics, 174–75
reed instruments, 141–44
reel-to-reel tape recorders, 174–75, 186
release time, 54
remote mixing boards, 167–68, 180
resequencing, 191
reset peak switch, 119
resistance, 7–8
resistive splitters, 13
resonator guitars, 140
response peaks, 133
reverb, 55
 mixing, 124, 163
 percussion miking and, 144, 145
 setup basics, 165
reverberant rooms, 171
reverse polarity cable, 12, 161
RFI (radio frequency interference), 8, 9, 29
ribbon microphones, 19–20
RMS (root mean square) power rating, 41, 86, 105
room dynamics, 152
rotary faders, 114–15
RTA (real-time analyzer), 164
rule of thirds, 179
rumble filter, 30, 120

S

safety masters, 193
sampling rates, 51, 174, 192
satellite speaker systems. *See* wide dispersion satellite speaker systems
saxophones
 microphone selection, 131
 miking techniques, 142–43
scrapers, 146
sealed faders, 115
self-noise
 amplifier, 48
 microphone, 27
sensitivity, microphone, 25
sequencing masters, 190–91
serial routing, 59–60, 61, 101
setting up
 the band, 159–61
 sound engineer basics, 163–69
 sound systems, 159
 See also preparing for performances
shakers, 146
shelving equalization, 116
shielded cables, 12
shock mounts, 30, 145
short-throw faders, 115
short-throw speakers, 82
shotgun microphones, 24–25
side-fill monitors, 70–71
signal conversion, 112–13
signal generator, 165–66
signal matching, 9, 35
signal processing, 51
 See also sound processing
signal routing
 explained, 59
 instrument amplifiers, 46–47
 mixing boards, 111
 parallel, 61
 serial, 59–60
signals
 balanced, 9, 35, 112
 delaying, 81
 unbalanced, 9, 35, 112
signal-to-noise ratio (SNR), 3, 110, 186
single-bus monitor systems, 167
single cabinet speaker systems, 87–88
single-point stereo microphone, 183
slave (mixing) boards, 110
slew rate, 26
slider-type faders, 114
slopes, crossover, 85, 86
slot loaded throat patterns, 82
slow filter, 119
SMPTE log, 192
snare drums
 microphone selection, 130
 miking techniques, 144–45
SNR (signal-to-noise ratio), 3, 110, 186
soldering tool, 161
solo switch, 124
sonic purity, 1–2

sound cards, 177
sound checks, 161–63
 quick, 163
 specifying time for, 155
sound engineers
 role of, 3
 setup basics for, 163–69
 venue provided, 152
sound pressure levels (SPLs), 2, 6
 headphones and, 125
 microphones and, 25, 26–27
 speakers and, 86
sound processing
 aural exciters for, 56
 effects devices and, 51–52
 enhancers for, 56–57
 explained, 51
 flangers for, 55–66
 limiters and compressors for, 52–54
 MIDI controllers and, 52, 57
 noise gates and expanders for, 54–55
 outboard equalizers for, 58–59
 outboard preamplifiers for, 57–58
 phase shifters for, 56
 reverb and echo in, 55
 setup basics, 165
 signal routing and, 59–61
sound reinforcement amplifiers. *See* power amplifiers
sound reinforcement contracts, 155–59
 load-in and sound check times, 155
 microphone and direct box specifications, 158
 mixing board specifications, 158
 monitoring requirements, 158–59
 power outlet requirements, 159
 sample contract, 156–57
sound reproduction theory, 1–2
sound systems
 audio chain, 13–14
 connectors and cables, 10–13
 contracts for, 155–59
 design parameters, 2
 evaluating, 2–3
 non-necessity of, 2
 practicing with, 3
 setting up, 159
 terminology, 3–10
 touring with your own, 151–52
 transparency of, 90
 venue provided, 152
source impedance, 8–9, 28
speaker emulators, 40
speakers, 75–94
 amplifier hookups, 99, 100–103
 bridge mode, 102
 connectors, 103
 power loading, 100–101
 routing, 101–3
 components, 76–86
 cabinets, 80–84, 92
 crossovers, 84–86
 drivers, 76–80
 component systems, 88–90

dispersion patterns, 81–83
failures, 79–80, 84
heat buildup, 83–84
instrument amplifier, 41–43
 monitoring systems and, 67, 69–70
monitor, 70–73
 floor wedges, 71–72
 microphones and, 168–69
 side-fills, 70–71
 spot monitors, 72–73
near-field, 124, 125
one-stack systems, 90
overview, 75–76
placement of, 89–90
power amplifier hookups, 99–103
processed systems, 88
protecting
 with amplifier turn on protection, 104
 with limiters and compressors, 53
setting up, 165–66
single cabinet systems, 87–88
technical characteristics, 86–87
wide dispersion satellite systems, 90–94
 components, 91
 diagrams illustrating, 92, 93, 94
speaker simulator direct boxes, 40, 43
speaker stands, 90
Speakon connectors, 103
spectral balance, 97–98
spectral signature, 4–6
spider assembly, 76
splitters, microphone, 13, 187
SPLs. *See* sound pressure levels
spot monitors (close field), 72–73
 custom system example, 73, 74
spring reverbs, 111
squid configuration, 13
stage box, 13
stage mixing, 67, 167
stage plot, 154
stage sound bleed, 73
stands
 instrument, 160
 microphone, 32
 speaker, 90
 spot monitor, 73
stand-up bass
 microphone selection, 130
 miking techniques, 138–39
steel drums, 146
stereo amplifiers, 99
stereo/bridge mode switch, 104
stereo circuits, 11
stereo equalizer, 58
stereo mixing, 169
stringed instruments
 microphone selection for, 131
 miking technique for, 134–39
 sound checks for, 161
 See also acoustic instruments; electric instruments
studio vocals, 130
submaster channel inserts, 123

submaster mixing board, 122
subsonic frequencies, 4
supercardioid microphones, 23–24, 146
surround, 76
"sweet spot," 83
switched start circuitry, 104

T
talking drums, 145–46
tambourines, 146
tape care, 186–87
tape counters, 186
Tape In jack, 123
tape recorders, 174–78
 analog cassette, 175–77
 analog reel-to-reel, 174–75
 analog-to-digital conversions and, 177
 digital audio technology, 177–78
tape splices, 191
technical characteristics
 microphones, 25–29
 power amplifiers, 105–7
 speakers, 86–87
testing cables, 160
THD (total harmonic distortion), 46, 106
threshold, 54
TIM (transient intermodulation distortion), 107
timbre, 4, 95
toms, 130
tone controls, 46
total harmonic distortion (THD), 46, 106
tracking sheets, 186, 188
transducers
 input, 13, 15
 output, 14
transformers, 10
 mixing board, 113–14
transformer splitters, 13
transient intermodulation distortion (TIM), 107
transients, 6, 26
transistor amplifiers, 43–44
 amplifier power and, 100
 tube/transistor hybrids, 45–46
transistors, direct box, 38
trap sets, 144–45
triamped system, 166
trim controls, 119, 161–62
trombones, 131
troubleshooting
 bad cables, 171
 buzzes and hums, 170–71
 difficult room acoustics, 171
 electrical shock, 169–70
 feedback or rattles, 171
 fires, 169, 170
TRS (tip/ring/sleeve) phone plugs, 11, 123
trumpets
 microphone selection, 131
 miking techniques, 143
TS (tip/sleeve) phone plugs, 11
tube amplifiers, 44–45
 amplifier power and, 100–101

miking horns and, 142
tube/transistor hybrids, 45–46
turn on protection, 104
tweeter speakers
 described, 78–79
 placement of, 89–90
two-track recording, 187

U

UHF systems, 20
Uilleann pipes, 147
ultrasonic frequencies, 4
 cassette tape distortion and, 176
unbalanced signals, 9
 mixing boards and, 112
 signal matching with, 35
unidirectional microphones. *See* cardioid microphones
unshielded cables, 12–13
upright pianos. *See* pianos

V

velocity microphones, 19–20
venues
 band setup, 159–61
 built-in sound systems, 152
 choosing for recording performances, 173–74
 difficult acoustics in, 171
 room dynamics, 152
 sound checks, 161–63
 sound engineer setup basics, 163–69
 sound reinforcement contracts, 155–59
 sound system setup, 159
 stage plot, 154
vertical speaker alignment, 81
VHF systems, 20
vibraphones
 microphone selection, 131
 miking techniques, 149
video tape formats, 191, 192
violin
 microphone selection, 131
 miking techniques, 138
vocals
 microphone selection, 130
 miking techniques for, 133–34, 179
 monitoring systems and, 71
 sound checks for, 162
voice coil, 76, 84
voice training, 132
Volta, Alessandro, 7
voltage, 7
voltage swing, 100
volume
 instrument amplifiers and, 41, 48–49
 limiters and compressors and, 52–53
 monitoring systems and, 64–65, 71, 167
 power requirements, 96
 sound checks for, 162–63
volume controls, 10, 114–15
volume unit (VU), 6
VU meters, 6
 mixing board, 118
 tape recorder, 174–75, 176, 177

W

watts, 7
wedge-type floor monitors, 71–72
wet sounds, 165
wide dispersion satellite speaker systems, 90–94
 cabinet selection for, 92
 components, 91
 delay stacks for, 91
 described, 90–91
 diagrams illustrating, 92, 93, 94
 hookups for, 92
winding tapes, 186–87
windscreen, 134, 146
wireless in-ear monitors, 68–69
wireless microphones, 20
 diversity systems, 20–21
 frequency bands, 20
wiring, out-of-polarity, 79–80
wooden pan pipes, 143–44
wood tone, 36
woodwind instruments, 141–44
woofers, 77–78

X

XLR connectors, 11
 direct boxes, 37
 instrument amplifiers, 47
 internal pickups, 35
 mixing boards, 112–13
 testing, 160–61
xylophones, 149

About Jerome Headlands Press, Inc.

Jerome Headlands Press produces books that provide practical business, legal and technical information for musicians, visual artists and others that work in entertainment and the arts.

Our other books (all published by Prentice Hall) include—

How to Make and Sell Your Own Recording: A Guide for the Nineties (revised fourth edition), by Diane Sward Rapaport, published in 1992, which has been a friend and guide to more than 125,000 musicians, producers, engineers and owners of small recording labels and has helped to revolutionize the recording industry by providing information about setting up recording labels independent of major label networks.

This is the bible for musicians...anyone about to embark on a first release can profit from the information, even if they already have a major label contract.
—Jon Sievert, Guitar Player.

The Musician's Business and Legal Guide, Revised 2nd Edition (a presentation of the Beverly Hills Bar Association Committee for the Arts), compiled and edited by Mark Halloran, Esq., published in 1996, which provides understandable information on key legal and business issues that affect all music business professionals. The 25 contributors are prominent entertainment lawyers and business experts.

Talent is still essential, but success in today's music industry also requires knowledge. This book provides it, covering a remarkable range of topics with clarity and depth. It's a one-volume, six-credit course in the music business. Do your career a favor and study it carefully!
—Don Gorder, Chair, Music Business/Management Department, Berklee College of Music.

The Visual Artist's Business and Legal Guide (a presentation of the Beverly Hills Bar Association Committee for the Arts), compiled and edited by Gregory T. Victoroff, Esq., published in 1994. This comprehensive resource, written by prominent art lawyers, professionals and business experts, can improve artists' chances for success. It provides valuable legal and business information.

This book will tell you how to protect your work, your integrity, your character and your right to enjoy the returns of your own labor. The annotated analyses of actual legal agreements include such hard-to-control areas as public art, and institutions that are notorious for avoiding legal agreements with artists. This work covers important issues for a variety of visual artists, gives artist advocates a call to arms, and provides educators, managers and artists with some important tools to avoid getting ripped off.
—Joan Jeffri, Director, Research Center for Arts Culture, Columbia University and Coordinator, Program in Arts Administration, Teachers College, Columbia University.

Jerome Headlands Press books are designed by Julie Sullivan, Sullivan Scully Design Group, in Flagstaff, Arizona.

Jerome Headlands Press, Inc.
PO Box N
Jerome, Arizona 86331